Preserving
Digital Materials

Ross Harvey

Preserving Digital Materials

K · G · Saur München 2005

Bibliographic information published by Die Deutsche Bibliothek
Die Deutsche Bibliothek lists this publication in the Deutsche Nationalbibliografie;
detailed bibliographic data is available in the internet at http://dnb.ddb.de.

∞

Printed on acid-free paper
© 2005 K. G. Saur Verlag GmbH, München

Typesetting by Florence Production Ltd., Stoodleigh, Devon, Great Britain.

Printed and bound by Strauss GmbH, Mörlenbach, Germany.

ISBN 3-598-11686-1

Contents

Preface

Preserving Digital Materials investigates the current practice of librarians and recordkeeping professionals in digital preservation. A strong claim can be made that preservation of digital materials is *the* single most critical issue faced by members of the library and recordkeeping professions. Much information about digital preservation is available in print and on the web, and the quantity is increasing, but most practitioners do not have the time or the technical expertise to evaluate and synthesize it. Few single-volume guides to the complex issues surrounding digital preservation exist; most books about the preservation of library and archival material are largely concerned with the preservation of physical artifacts and collections and pay little attention to the serious issues raised by digital materials.

Preserving Digital Materials fills this gap in the literature. It provides an introduction to the principles, strategies and practices applied by librarians and recordkeepers to the preservation of digital materials. It aims to improve digital preservation practice in libraries and recordkeeping environments. It does this by taking stock of what we know about the principles, strategies and practices that prevail and by describing the outcomes of recent and current research. The incorporation of practice from both the recordkeeping and the library communities, to which is added the experiences of other relevant communities such as the geoscience community, provides some new ways of viewing and thinking about aspects of digital preservation.

Christine Borgman notes that 'digital preservation looms as one of the greatest challenges of information management technology and policy' (Borgman, 2000, p.66). The problem has been more colourfully described as the 'dark archival underbelly' of 'the wonderful world of digitized information and on line everything' (US-InterPARES Project, 2002, p.1, quoting the *Boston Globe*, 10 February 2000). The National Library of Australia's *Digital Preservation Policy* neatly sums up the challenges to 'ongoing accessibility of digital resources':

- The volume and growth in the amount of material to be maintained
- Widespread use of relatively unstable media
- Rapid changes in the availability of hardware, software and other technology required for access
- The diverse and frequently changing range of file formats and standards
- Uncertainty about the significant properties that must be maintained for different digital resources
- The recurrent, critical and demanding nature of the treats to accessibility
- Uncertainty about strategies and techniques for addressing the threats
- The high costs of taking action
- Administrative complexities in ensuring timely and cost-effective action is taken over very long periods of time
- New models of ownership that impose property and other rights-based constraints
- The as-yet ambiguous intentions and capabilities of a range of agents with a potential impact on accessibility (National Library of Australia, 2002).

Failure to address these challenges will result in the loss of significant quantities of digital information. The paradigms that shape the environment in which we now function have changed. In comparison with traditional library and recordkeeping practice, significantly different issues are being raised by the increasing reliance in today's society on information in digital form, both born digital and digitized from paper-based, film-based, or other media. The benign neglect that may have sufficed in the past to preserve information will no longer be enough: active intervention is required.

The preservation of digital materials poses many challenges for which pre-digital paradigms offer little assistance. One challenge is that preserving digital materials requires constant maintenance, relying on complex hardware and software that are frequently upgraded or replaced. Another is the increasing quantity and complexity of digital materials, which 'tax current preservation strategies designed to archive relatively simple and self-contained collections of data and documents' (Workshop on Research Challenges in Digital Archiving and Long-term Preservation, 2003, pp.viii–ix). The range of stakeholders who have an interest in maintaining digital materials for use into the future is wide. A 2003 report begins with the words

> The need for digital preservation touches all our lives, whether we work in commercial or public sector institutions, engage in e-commerce, participate in e-government, or use a digital camera. In all these instances we use, trust and create e-content, and expect that this content will remain accessible to allow us to validate claims, trace what we have done, or pass a record to future generations (NSF-DELOS Working Group on Digital Archiving and Preservation, 2003, p.i).

We cannot expect a technological quick fix: 'the challenges of maintaining digital archives over long periods of time are as much social and institutional as technological' (Workshop on Research Challenges in Digital Archiving and Long-term Preservation, 2003, pp.viii-ix). The authors of *Preservation Management of Digital Materials: A Handbook* see the issues as technological, organizational and legal (Jones & Beagrie, 2001, section 2.2). These and many other factors

combine to make the task difficult, with – at present – only a few clear pointers to the way ahead.

Both the library community and the recordkeeping community (archivists and records managers) have energetically sought solutions to the challenges of digital preservation, but to date there has been relatively little sharing of outcomes. For example, much of the archives profession's thinking about defining the authenticity of records in digital form is little known to the library community, as is the continuum approach to archives and records (a concept closely associated with Australian recordkeeping practice), which allows an integrated approach to managing electronic records and has proved to be a powerful tool for dealing with electronic records. Developments such as these have considerable potential to assist practice in other information and heritage communities, who need to learn more about them. This book goes some way towards addressing this need by providing examples from recordkeeping practice.

Although much high-quality information is available to information professionals concerned with preserving materials in digital form, most notably on the web, its sheer volume causes problems for busy information professionals who wish to understand the issues and learn about strategies and practices for digital preservation. *Preserving Digital Materials* is written for librarians and recordkeepers. Its synthesis of current information, research, and perspectives about digital preservation from a wide range of sources across many areas of practice makes it of interest to a wide range of information professionals – from preservation administrators and managers, who want a professional reference text, to thinking practitioners, who wish to reflect on the issues that digital preservation raises in their professional practice. It will also be of interest to students in these fields. *Preserving Digital Materials* is not a how-to-do-it manual, so is of little assistance for those who want to learn how to carry out technical procedures. It is not primarily concerned with digitization and makes no distinction between information that is born digital and information that is digitized from physical media.

This book addresses four key questions which give the text its four-part structure:

1. Why do we preserve digital materials?
2. What digital materials do we preserve?
3. How do we preserve digital materials?
4. How do we manage digital preservation?

Chapters 1 to 3 address the first question: why do we preserve digital materials? They examine key definitions and their relationship to ways of thinking about digital preservation, note some of the reasons why preservation is a strong professional imperative for librarians and recordkeepers, indicate the extent of the preservation problem for digital materials, and look at the reasons why a digital preservation problem exists. The question 'what digital materials do we preserve?' is noted in chapters 4 and 5. Chapter 4 examines the issues of selection of digital materials for preservation, and chapter 5 notes the questions relating to what attributes of digital materials we need to preserve. The question 'how do we preserve digital materials?' is covered in chapter 6, 7 and 8. An overview of digital preservation strategies is provided in chapter 6, and chapters 7 and 8 describe specific strategies. Aspects of the question 'how do

we manage digital preservation?' are noted in chapters 9 and 10. Chapter 9 describes the major digital preservation initiatives and collaborations. Chapter 10 examines some of the issues that digital preservation faces in the future. The Appendix, comprising six case studies, provides examples of Australian digital preservation practice that illustrate a range of activities in organizations of varying sizes and with varying resources.

The reader should be aware that this book presents a Western view of preservation, a view not necessarily embraced by people of all cultures. The reader should also note the words in Article 9 of the UNESCO *Charter on the Preservation of the Digital Heritage:*

> The digital heritage is inherently unlimited by time, geography, culture or format. It is culture-specific, but potentially accessible to every person in the world. Minorities may speak to majorities, the individual to a global audience. The digital heritage of all regions, countries and communities should be preserved and made accessible, creating over time a balanced and equitable representation of all peoples, nations, cultures and languages (UNESCO, 2004).

Preserving Digital Materials uses many Australian examples. Australia has had and continues to have a major influence on the rest of the world in digital preservation. Australian practice in digital preservation – from the library, record-keeping, audiovisual archiving, data archiving and geoscience sectors – is often at the forefront of world best practice. The contention that many Australian digital preservation initiatives are considered as international best practice can be readily demonstrated. One example is Beagrie's 2003 report *National Digital Preservation Initiatives* (Beagrie, 2003), written to advise the Library of Congress as it develops its NDIIPP (National Digital Information Infrastructure and Preservation Program). Beagrie, at that time director of the United Kingdom's JISC Digital Preservation Focus, considered initiatives in Australia, France, the Netherlands, and the United Kingdom – countries selected because their digital preservation activities were considered to be current best practice. Of Australia Beagrie notes:

> For a country with a relatively small population, Australia has a relatively large number of leading-edge online projects across all sectors. Archiving these online materials has become a significant area of effort for Australia's memory institutions, and both the NLA [National Library of Australia] and the national archive activities and guidelines are frequently cited internationally as exemplars in this area . . . There is an active electronic records management/archive sector in Australia. Work at Monash University, the PRO [Public Record Office] of Victoria, and the National Archive of Australia has earned an international reputation (Beagrie, 2003, p.14).

The National Library of Australia provides a good example of Australian activity in digital preservation. A senior member of its executive could claim, after a study tour of national libraries in 2002, that 'the National Library of Australia is still in the forefront of digital archiving and preservation activities among national libraries' (Gatenby, 2002b). In the 1980s, in common with many other

research libraries, it began acquiring digital information resources whose value and significance required their long-term retention. However, unlike most other research libraries, the National Library of Australia has been active in digital preservation since at least 1994, practically at the dawn of history in digital preservation's timeline. It founded one of the world's first library digital preservation sections in 1995 and an archive of online publications, PANDORA, in 1996, again one of the first in the world. Furthermore, it has actively shared its experience and expertise with the rest of the library community, not just within Australia but internationally. In fact, much of the National Library's experience is available to anyone who cares to locate it on the Library's web site. As one example, the Library's *Digital Archiving and Preservation at the National Library* web page (www.nla.gov.au/initiatives/digarch.html) provides an outline of its digital preservation activities and links to its numerous policies, staff conference presentations, and relevant web sites. The National Library's PANDORA Project has been acknowledged as deserving 'particular mention and commendation for the open and collegial atmosphere' in which it is being undertaken, 'an approach which encourages shared learning and dialogue' (Brindley, 2000, p.130), and it is closely observed 'to see how feasible the approach is' (Smith, 2003, p.22). The National Library's activities are applied to a wide range of concerns: the preservation of Australian online publications, archiving web sites, legal deposit, a web subject gateway for preservation resources, its Digital Services Project, persistent identifiers, metadata, research into migration, a digital archiving system, authenticity, intellectual property rights management, digital audio-video archiving, and guides and codes of practice for creators and publishers of digital material. The National Library's experience and expertise are frequently sought out, one recent example being authorship by its staff of the UNESCO *Guidelines for the Preservation of Digital Heritage* (UNESCO, 2003). Not only is the Library's expertise sought, but there has been export of talent to the United Kingdom: Deborah Woodyard was, until recently, at the British Library and Maggie Jones is now at the Digital Preservation Coalition.

It is not just the National Library of Australia's activities that cause so much Australian digital preservation practice to be described as international best practice. From the National Archives of Australia have come theoretical and conceptual developments that have assisted thinking in digital preservation. One example is the National Archives of Australia's concept of non-custodial or distributed-custody archives. The significance of the distributed custody model lay in the heightening of awareness that the responsibility for preservation is not solely that of the archives, but with digital records must be considered at the point when the record is created. The National Archives of Australia has since reverted to a custodial model in which digital records are moved to the National Archives and converted to XML (Heslop, Davis & Wilson, 2002). Another important conceptual development originating in the Australian record-keeping community is the continuum model developed by Sue McKemmish and Frank Upward at Monash University. This model has allowed changes in thinking about custody of records – who owns the records, and who should therefore take the responsibility for their preservation (Upward, 2005). The Recordkeeping Metadata Project at Monash University has also been influential. Another example from the Australian recordkeeping community is VERS (the Victorian Electronic Records Strategy), which aims to 'reliably and authentically

archive electronic records created or managed by the Victorian government'
(www.prov.vic.gov.au/vers). Significant expertise also resides in institutions
outside the cultural heritage institutions, such as CSIRO (the Commonwealth
Scientific and Industrial Research Organisation), the Australian nuclear industry,
and the defence sector. Geoscience Australia, for example, manages a digital
archive of over 700 terabytes and has carried out large-scale data recovery
from tapes. The Australian Defence Force Academy's Authenticated Australian
Editions project is addressing issues, such as authenticity of digital objects, that
cultural institutions need to know more about (idun.itsc.adfa.edu.au/ASEC/
aueledns.html).

As noted above, there is a considerable amount of high-quality information
available about preserving materials in digital form, and much of it is
available on the web. The accessibility that this provides is countered by the
impermanence of much web material, as noted in several chapters in this book.
All URLs in this book were correct at the time of writing.

Producing a book of this nature involves the input of many, and I have bene-
fited from discussions with many colleagues over the last three years. In
particular, I wish to acknowledge the following individuals for their ideas and
support: Tony Dean for suggesting the example of Piltdown Man; Liz Reuben,
Matthew Davies, Stephen Ellis and Rachel Salmond for case studies; Alan
Howell, of the State Library of Victoria, and staff of the National Library of
Australia, in particular Pam Gatenby, Colin Webb, Kevin Bradley, and Margaret
Phillips, for their assistance with clarifying concepts. Some of the material in
this book is based on interviews with Australian digital preservation experts,
whose assistance and encouragement was invaluable. Alan Howell, Heather
Brown and Peter Jenkins provided examples used in this book, and their
assistance and the permission of the State Library of South Australia is grate-
fully acknowledged. Thanks are due to Ken Thibodeau, CLIR, ERPANET, and
UNESCO for permission to use their material. I am grateful to my employer,
Charles Sturt University, who supported me by providing study leave in 2003.
I was fortunate to be based at the National Library of Australia as a National
Library Fellow from March to June 2003, and I would like to thank its Director
General, Jan Fullerton, and other staff of the National Library for this generous
support. Finally, I acknowledge the unfailing support of Rachel Salmond in this
and others of my endeavours.

Chapter 1

What is Preservation in the Digital Age? Changing Preservation Paradigms

Introduction

Digital images are produced without the intermediaries of film, paper or chemicals and as such 'never acquire the burden of being originals *because they do not pass through a material phase' (Sassoon, 1998, p.5, quoting Bruce, 1994)*

To preserve, as the dictionary reminds us is to keep safe . . . to maintain unchanged . . . to keep or maintain intact. But the rapid obsolescence of information technology entails the probability that any digital object maintained unchanged for any length of time will become inaccessible (Thibodeau, 1999)

Any discussion about the preservation of digital information must begin with the consideration of two interlinked areas: changing preservation paradigms, and definitions of terms. Without a clear concept of what we are discussing the potential for confusion is too great. In library and recordkeeping practice we are moving from collection-based models, whose principles and practices have been developed over many centuries, to models where collections are not of paramount importance and where what matters is the extent of access provided to information resources, whether they are managed locally or remotely. As these models are not yet commonly agreed upon or applied, the situation is one of considerable flux. Archivists, for example, have considered, debated and sometimes applied the concept of non-custodial archives, where there is no central collection, to accommodate the massive increase in growth of digital records. Librarians manage hybrid libraries, consisting of both physical collections and distributed digital information resources, and virtual libraries. Other stakeholders with a keen interest in digital preservation manage digital information in specific subject areas, such as geospatial data or social science data. In the past this material, where it existed, was maintained as collections of paper and other physical objects.

These changing models of library and recordkeeping practice are generating a need for new definitions. The old terms do not always convey useful meanings in the digital environment and can, in fact, be misleading, and, on occasion, harmful. In library and recordkeeping practice we are changing from a preservation paradigm where primary emphasis is placed on preserving the physical object (the artifact as carrier of the information we wish to retain), to one where there is no physical carrier to preserve. What, for example, does the term *preservation* mean in the digital environment? How has its meaning changed? What are the implications of these changes? The phrase *benign neglect* provides an example of a concept that is helpful in the pre-digital preservation paradigm, but is harmful in the new. It refers to the concept that many information carriers made of organic materials (most notably paper-based artifacts) will not deteriorate rapidly if they are left undisturbed. For digital materials this concept is positively harmful. One thing we do know about information in digital form is that actions must be applied almost from the moment it is created, if it is to survive. Nor are the earlier paradigm definitions sufficient to accommodate new forms, such as works of art that have digital technologies as part of them, or time-defined creative enterprises such as performance art.

This chapter examines the effect of digital information on 'traditional' librarianship and recordkeeping paradigms and notes the need for a new preservation paradigm in an environment that is dynamic, highly changeable, and has many stakeholders, often with competing interests. It considers the differences between 'born digital' and digitized information, and defines key terms.

Changing paradigms

It is now commonplace to hear or read that we live in an information society, one of whose primary characteristics is the widespread and increasing use of networked computing, which in turn relies on digital data. This is revolutionizing the way in which large parts of the world's population live, work and play, and how libraries, archives, museums, and other institutions concerned with documentary heritage function and are managed. New expectations of these institutions are evolving.

The significance of this change is readily illustrated by just one example. The internet is rapidly becoming the first choice for people who are searching for information on a subject, and a new verb, to *google* (derived directly from Google, the name of a widely used internet search engine) has entered our vocabulary, as illustrated in this quote: 'students prefer 'Googling' to using search tools in the library's online catalogs' (George, 2003, p.6). The sheer size and rate of growth of the internet mean that, currently, no systems have been developed to provide comprehensive access to it. The systems that do exist are embryonic and experimental, and the quality of the information available on the web is variable. Attempts to estimate the rate of the internet's growth have included counting the number of domain names over several years. There has been a dramatic increase since 1988 (see Figure 1.1).

These major changes – it is not too extreme to call it a revolution – raise the question of how we keep the digital data we decide is worth keeping. The everincreasing quantities being produced do not assist us in finding an answer: 'Large organizations routinely add terabytes of storage capacity, and more and

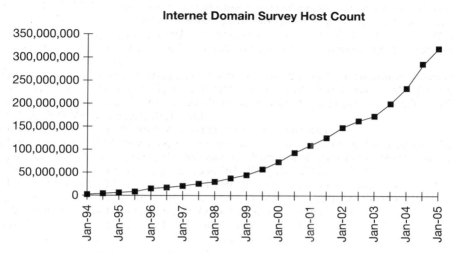

Source: Internet Software Consortium (www.isc.org)

Figure 1.1 Growth Rate of the Internet
(From www.isc.org/ds/, viewed 24 March 2005)

more individuals can afford laptop and desktop computers with tens of giga-bytes of storage' (Workshop on Research Challenges in Digital Archiving and Long-term Preservation, 2003, p.vii). Nor does the rapidity with which changes in computer and information technology occur. The challenges are new and complex for nearly all aspects of librarianship and recordkeeping, including preservation.

There has also been a change in the ways in which information is produced and becomes available to its community of users. The internet is only one of these ways. In the pre-digital (print) environment the processes of creation, reproduction and distribution were separate and different; now, 'technology tends to erase distinctions between the separate processes of creation, repro-duction and distribution that characterize the classic industrial model of print commodities' (Nunberg, 1995, p.21). This has significant implications for preser-vation, especially in terms of who takes responsibility for it and at what stage preservation actions are first applied. For instance, in the industrial-mode print world, securing (acquisition) of the artifact – the book – so that it could be preserved occurred by means such as legal deposit legislation, requiring publishers to provide copies to libraries for preservation and other purposes. If the creator is now also the publisher and distributor, as is often the case in the digital world, who has the responsibility of securing (acquiring the information)? These points are noted in more detail later in this book.

The need for a new preservation paradigm

The digital revolution is changing the professional practice of librarians, record-keepers, and all other information professionals. The paradigm shift in how

libraries, archives and information agencies conduct their activities can be crudely and naively described as the change from acquiring, storing and providing access to information resources in physical forms, to acquiring, storing and providing access to digital information resources. Preservation activities are also part of this new paradigm. The principles that lie behind preservation practices, and the techniques themselves, are not exempt. (Webb (2000a, 2000b) provides examples of the effects of these changes on preservation practice in Australia.)

The pre-digital preservation paradigm is based on principles such as the following (based on Cloonan (1993, p.596) and Harvey (1993, pp.14,140):

- When materials are treated, the treatments should, when possible, be reversible
- Whenever possible or appropriate, the originals should be preserved; only materials that are untreatable should be reformatted
- Library materials should be preserved for as long as possible
- Efforts should be put into preventive conservation, and aimed at providing appropriate storage and handling of artifacts
- Benign neglect may be the best treatment.

The definitions associated with the old preservation paradigm are firmly rooted in the conservation of artifacts – the physical objects that carry the information content. In fact, the term 'materials conservation' is sometimes used. For example, in the museum environment definitions are phrased in words such as these: '*Materials Conservation* includes all actions taken to safeguard objects and the information contained in them', and '*Preservation* aims to stabilize an object in its current condition with the least possible intervention' (AMOL, 2003). The definitions provided in the IFLA *Principles for the Care and Handling of Library Materials* (Adcock, 1998), widely adopted in the library and recordkeeping contexts, articulate principles firmly based on maintenance of the physical artifact. The definition of *Conservation* notes that its aims are to 'slow deterioration and prolong the life of an object', and that of *Archival quality* emphasizes the longevity and stability of materials in the words 'a material, product, or process is durable and/or chemically stable, that it has a long life, and can therefore be used for preservation purposes' (Adcock, 1998, p.4). *Medium/media* is defined as 'the material on which information is recorded. Sometimes also refers to the actual material used to record the image' (Adcock, 1998, p.5). The point here is that the old preservation paradigm considers information content and the carrier as one and the same, although this changed in the declining years of the old paradigm as large-scale copying programmes, especially microfilming programmes, were implemented. To these definitions we should add *Restoration* (from the 1986 version of the IFLA *Principles*): 'Denotes those techniques and judgements used by technical staff engaged in the making good of library and archive materials damaged by time, use and other factors' (Dureau and Clements, 1986, p.2).

That pre-digital paradigm thinking does not transfer well to the digital environment is easily illustrated, as these two articles from one issue of an Australian librarianship journal indicate. One article describes the Parish Map Project, which 'is providing access, in full colour, to an important historical archive in New South Wales' (Read, 1999, p.45). It is apparent from this article that preservation in this project is viewed as retaining the original paper artifacts and

restricting their use, while providing digital copies for access. No mention is made of how the longevity and integrity of the digital copies might be ensured. The second article notes the First Families 2001 programme which aims to 'collect and preserve the life stories of Australia's diverse cultural heritage in an online database' (Van de Velde, 1999, p.5). Preservation is mentioned only three times: in the title, the abstract and on the first page. The reader could easily deduce from the report on this project that collecting the material is the same as preserving it.

Cox indicates how a different way of thinking is needed in the recordkeeping community and suggests four elements of a new preservation paradigm for electronic records. He notes, for instance, that recordkeepers 'have long seen centralization or custody of records as crucial to their work', but this is not feasible for electronic records: transferring electronic records to the custody of archives 'may undermine their very long-term use' (Cox, 2001, p.95).

As Marcum notes in her preface to a 2002 survey about the state of preservation programmes in American college and research libraries,

> the information landscape has changed, thanks to the digital revolution. Libraries are working to integrate access to print materials with access to digital materials. There is likewise a challenge to integrate the preservation of analog and digital materials. Preservation specialists have been trained to work with print-based materials, and they are justifiably concerned about the increased complexity of the new preservation agenda (Kenney and Stam, 2002, p.v).

What is the new preservation agenda? How has the preservation paradigm changed? Pre-digital preservation paradigm thinking does include some useful understanding of digital preservation. For example, it recognizes that copying (as in refreshing from tape to tape) is the basis of digital preservation; it does not, however, engender an understanding of the complexity of copying – which is more than simply preserving a bit-stream, but must take account of a wide range of other attributes of the digital object that also need to be preserved. This recognition is encapsulated in British Standard BS4783 Part 2, dating from 1988, which focuses on procedures for refreshing digital data by copying it from magnetic tape to magnetic tape at regular intervals, and on the best storage and handling of these tapes.

Hedstrom in 1998 provided early recognition of the need for new preservation paradigms and of the enormity of the challenges we face in digital preservation, noting that 'digital preservation adds a new set of challenges for libraries and archives to the existing task of preserving a legacy of materials in traditional formats' (Hedstrom, 1998, p.192). However, old-paradigm preservation thinking has led to the characterization of some current thinking about digital preservation as 'a myopic focus on technical problems (such as preserving digital objects) and a concomitant neglect of the bigger picture (for example, public policy, among other issues)' (Cloonan, 2001, p.232).

Not only are there additional technical challenges, but there are also new challenges resulting from the quantities of digital information being produced. Hedstrom again: 'Our ability to create, amass, and share digital materials far exceeds our current capacity to preserve even that small amount with continuing value' (Hedstrom, 1998, p.192). Specific examples from scientific areas, such as

determining long-term global climate change, and biomedicine, are provided in a 2003 report which contends that 'much more digital content is available and worth preserving' (Workshop on Research Challenges in Digital Archiving and Long-term Preservation, 2003, p.2). New ways of thinking about preservation and new skills are needed.

In essence the whole of this book is about new ways of thinking about preservation. At this point, however, it is useful to consider some of the key elements of new paradigm preservation thinking. The first of these is the need to actively maintain digital information over time from the moment of its creation. Interruptions in the management of a digital collection will mean that there is no collection left to manage. Unlike most collections of physical objects, collections of digital materials require 'constant maintenance and elaborate "life-support" systems to remain viable' (Workshop on Research Challenges in Digital Archiving and Long-term Preservation, 2003, p.7). In addition to these technical issues there are other issues – social and institutional (political in the broadest sense) – for 'even the most ideal technological solutions will require management and support from institutions that go through changes in direction, purpose, and funding' (Workshop on Research Challenges in Digital Archiving and Long-term Preservation, 2003, p.7).

Another key element is the scale and nature of the digital information we wish to maintain into the future, and the preservation challenges these pose. The complexities of the variety of digital materials are described in this way:

> Digital objects worthy of preservation include databases, documents, sound and video recordings, images, and dynamic multi-media productions. These entities are created on many different types of media and stored in a wide variety of formats. Despite a steady drop in storage costs, the recent influx of digital information and its growing complexity exceeds the archiving capacity of most organizations (Workshop on Research Challenges in Digital Archiving and Long-term Preservation, 2003, p.7).

Arising from these key factors is the need for new kinds of skills. Current preservation skills and techniques are labour-intensive and, even where appropriate, do not scale up to the massive quantities of digital materials we are already encountering. The problem cannot simply be addressed by technological means: 'Digital collections require curation and processing to ensure their longevity, protect their integrity, and enhance their value for use in the future' (Workshop on Research Challenges in Digital Archiving and Long-term Preservation, 2003, p.7).

What kind of person will implement the new policies and develop the new procedures we require to maintain digital materials effectively into the future? New kinds of positions, requiring new skill sets are already being established in libraries and archives. Key selection criteria for a Digital Preservation Specialist at the State Library of Victoria, Melbourne, advertised in May 2003, included:

- Demonstrated knowledge, expertise and level of excellence in digital object management

- Sound knowledge of, and practical competence with, computers and the nature of digital information, archiving of data, physical formats, computer systems and the Internet
- Familiarity with contemporary and superseded software and media and demonstrated understanding of the emerging field of digital archiving, taking account of short and long term access and preservation needs of collection material.

But more than new skills and new ways of thinking are required. We need to redefine the field of preservation and the terms we use to describe preservation activities.

Changing definitions

As already suggested, pre-digital preservation paradigm definitions do not convey useful meanings when they are applied to digital preservation. What are they?

> Currently 'conservation' is the more specific term and is particularly used in relation to specific objects, whereas 'preservation' is a broader concept covering conservation as well as actions relating to protection, maintenance, and restoration of library collections. The eminent British conservator, Christopher Clarkson, emphasizes this broader aspect when he states that preservation 'encompasses every facet of library life': it is, he says, 'preventive medicine . . . the concern of everyone who walks into, or works in, a library.' For Clarkson conservation is 'the specialized process of making safe, or to a certain degree usable, fragile period objects' and 'restoration' expresses rather extensive rebuilding and replacement by modern materials within a period object, catering for a future of more robust use.' He neatly distinguishes the three terms by relating them to the extent of operations applied to an item: 'restoration implies major alterations, conservation minimal and preservation none.' (Harvey, 1993, pp.6–7)

These definitions are based on the assumptions that deteriorated materials or artifacts can be made good by restoring them, and that we can slow down, perhaps even halt, the rate of deterioration by taking appropriate measures such as paying attention to careful handling and appropriate storage. The principles on which old-paradigm preservation practice was based, and in which these definitions are rooted, are almost entirely oriented towards artifacts – the preservation of the media in which the information is stored. These principles were altered as large-scale mass preservation treatments and practices, such as mass deacidification or microfilming, were implemented. For example, reformatting programmes (microfilming and photocopying) moved the paradigm towards a recognition that information content could be preserved without the need also to preserve the original media. In a prescient conjecture about how these preservation principles will change in the future, Cloonan in 1993 asked 'Which principles will be practiced? . . . Will our very concept of permanence change in the next generation . . . ? The answer . . . is likely to be "yes"' (Cloonan, 1993,

p.602). She suggests that our preservation concerns in the future will be about the preservation of knowledge, not the preservation of individual items, and that 'we must continue to save as much information as possible, regardless of the format or the means by which it is stored and disseminated' (Cloonan, 1993, p.603).

But these definitions simply do not work with digital materials. Why not? Cloonan suggests part of the answer – 'the preservation of knowledge, not the preservation of individual items' – but there is much more. She suggests that, while it is easy to indicate what a library preservation programme consists of – 'disaster recovery planning, collection development policies, environmental controls, integrated pest management, proper storage, physical treatment, refor-matting, migration, staff and user education, and the like' – we are still not any closer to what preservation is really about, what its 'essence' is. 'Is preservation merely a set of actions? Is it a way of seeing? Or a way of interpreting informa-tion? Is copying preservation? Is reformatting?' (Cloonan, 2001, pp.232–233).

Others have described the changes from old to new preservation paradigms and the development of new definitions in terms of transformation. Conway suggests that consensus about 'a set of fundamental principles that should govern the management of available resources in a mature preservation program' has been reached in the analogue world and are the same in the digital world. They

> in essence, define the priorities for extending the useful life of informa-tion resources. These concepts are longevity, choice, quality, integrity, and accessibility (Conway, 2000, p.22).

However, these concepts have been transformed to accommodate the preser-vation of digital information. *Longevity* has altered from a focus on extending the life of physical media to one on 'the life expectancy of the access system'. *Choice* (selection of material to be preserved) is no longer a decision made later in the life cycle of an item, but for digital materials has become 'an ongoing process intimately connected to the active use of the digital files'. *Integrity*, based on 'the authenticity, or truthfulness, of the information content of an item', has transformed from a primary emphasis on maintaining the physical medium, to developing procedures that allow us to be assured that no changes have been made: 'ultimately, the digital world fundamentally transforms traditional preser-vation principles from guaranteeing the physical integrity of the object to specifying the creation of the object whose intellectual integrity is its primary characteristic'. In the digital world, *access* to the artifact is clearly no longer suffi-cient; what is required, suggests Conway, is access to 'a high quality, high value, well-protected, and fully integrated digital product' (Conway, 2000, p.27).

The changing paradigms and definitions also entail major shifts in the concep-tualization of preservation. Cloonan (2001) refers to the 'paradox of preservation: 'it is impossible to keep things the same forever. To conserve, preserve, or restore is to alter' (Cloonan, 2001, p.235). Preservation implies alteration. But, if we seek to keep a digital object unchanged, we are in effect requiring that the technology on which it was developed to operate is also maintained. Over time this raises increasing problems. We reduce access, therefore, to digital materials we are attempting to maintain by preserving them. An illustration of the problem is provided by Thibodeau, Moore and Baru:

many users would not be pleased if, in order to access digital objects that had been preserved across the last 30 years, they had to learn to use the PL1 programming language or Model 204 database software (Thibodeau, Moore and Baru, 1999).

One implication of this paradox is that we should accept some degree of change in digital materials as we preserve them over time. The real issue is: how much change should we accept?

Transformations are also apparent in how information professionals define preservation. Definitions by professional associations show some appreciation that something more than preserving the object is required (Cloonan, 2001, pp.235–237). The Society of American Archivists, for example, maintains that

> preservation of digital information is not so much about protecting physical objects as about specifying the creation and maintenance of intangible electronic files whose intellectual integrity is their primary characteristic (Society of American Archivists, 1997).

In a 2002 survey of records managers and archivists who deal with electronic records, Cloonan and Sanett posed the questions: 'What is the meaning of *preservation*? Does the meaning change when it is applied to electronic rather than paper-based records?' (Cloonan and Sanett, 2002, p.73). They noted that:

> It is clear that professionals are revising their definitions of preservation from a once-and-forever approach for paper-based materials to an all-the-time approach for digital materials. Preservation must now accommodate both media and access systems . . . while we once tended to think about preserving materials for a particular period of time – for example, permanent/durable paper was expected to last for five hundred years – we now think about retaining digital media for a period of continuing value (Cloonan and Sanett, 2002, p.93).

Interviewees expressed dissatisfaction with the term *digital preservation*, suggesting that other terms such as *long-term retention* are more suitable (Cloonan and Sanett, 2002, p.74). This survey indicates that information professionals 'now think about maximizing "useful life" or preserving digital documents "forever" through emulation or forward migration, but without the emphasis on a specific number of years' (Cloonan and Sanett, 2002, pp.86–87). Definitions of preservation provided by survey respondents, Cloonan and Sanett conclude, overall 'demonstrate a shift taking place from defining preservation as a once-and-forever approach for paper-based materials, to an all-the-time approach for digital materials' (Cloonan and Sanett, 2002, p.85). This shift implies an acceptance that preservation may even begin before a record has been created.

Preservation definitions in the digital world

What, then, are viable definitions of preservation in a digital world? What concepts do these definitions need to accommodate? What difficulties do we encounter in trying to develop definitions that will assist us in our attempts to preserve digital materials?

The first point to note is the dynamic nature of the field. We must be prepared to change our paradigms and the definitions that we develop from them. In a discussion of how archivists' thinking can better inform digital preservation, Gilliland-Swetland comments that

> the paradigms of any of the information professions come up short when compared with the scope of the issues continuously emerging in the digital environment. An overarching dynamic paradigm – that adopts, adapts, develops, and sheds principles and practices of the constituent information communities as necessary – needs to be created (Gilliland-Swetland, 2000, p.v).

Another important concept that our definitions need to accommodate is that of information being preserved, independent of the media in which it resides. This is now well accepted; indeed, old preservation paradigm practices were, in recent decades, well acquainted with it through microfilming programs. It is no longer a fact that the original has 'more integrity and veracity than a copy' (Cloonan, 2001, pp.236–237); instead, in the digital world, we need to look further to define what attributes of the digital object we wish to maintain over time.

Definitions should also accommodate the social and organizational aspects of digital preservation, the 'public policy, economic, political, social or educational perspective' in Cloonan's words (Cloonan, 2001, p.238). Old paradigm definitions certainly recognized that there was more to preservation than the technical aspects – the IFLA Principles suggest it also encompasses 'managerial and financial considerations, . . . staffing levels [and] policies' (Adcock, 1998, p.5) – but definitions of digital preservation need to go considerably further. They must be extended because of yet another factor, the need to start preserving digital materials almost from the moment of their creation – and, some suggest, even before they are created.

Preservation, in the pre-digital paradigm, was usually applied retrospectively. Conservation procedures were applied to artifacts only after the artifact, or the information contained in or on it, had been deemed to be of significance and therefore worth preserving for use in the future. For example, books printed before 1800 are typically considered to be significant because they are the product of handcraft production techniques and, therefore, no two items are identical; and some artifacts are preserved because they attain iconic status – an Australian example is the veneration of relics of the nineteenth-century folk hero, Ned Kelly. We could also rely on benign neglect, where lack of action did not usually harm the item (assuming certain factors were in play, such as low use) and did not significantly affect the likelihood of its survival. This concept no longer works for digital materials. The 3.5-inch diskette, very common until recently, provides a good example. Information on it is likely to become unreadable for many reasons: the diskette may be stored in conditions too humid or too hot, the drives to read it may be superseded by newer technology and no longer be available, the driver software for that drive may no longer be found. After a period of time, the diskette becomes unusable. Active preservation needs to start close to the time of creation if there is to be any certainty that the digital information will be accessible in the future.

To this list we can add other concepts. One is that for digital materials 'their preservation must be an integral element of the initial design of systems and

projects' (Ross, 2000, p.13). However, this is not usually the case. Another is that digital materials exist in a bewilderingly large number of formats – there is still little standardization. And yet another, this one possibly the most signifi-cant to accommodate, is that the preservation of digital materials is much more than the preservation of information content or physical carrier alone:

> it is about preserving the intellectual integrity of information objects, including capturing information about the various contexts within which information is created, organized, and used; organic relationships with other information objects; and characteristics that provide meaning and evidential value (Gilliland-Swetland, 2000, p.29).

Preserving the original bit-stream is only one part of the problem: equally important is the requirement to preserve 'the means of interpreting, reading and utilizing the bit stream' (Deegan and Tanner, 2002).

The difficulties of definition are not helped by disciplinary differences: there are, for instance, differences in the way terms are used by archivists and librar-ians, although they are drawing closer in the digital environment, where 'the integrity and authenticity of digital objects is of mutual concern to both profes-sions' (Cloonan and Sanett, 2000, p.210). (Note that *integrity* and *authenticity* are terms deriving from the archival profession and were, until recently, not usually associated with the work of librarians.) However, these differences pale in comparison with the significantly different definitions used by the IT industry.

How IT professionals think about the long-term storage of digital data is a question that assumes some importance for digital preservation, because of the heavy reliance that information professionals place on their skills and services. There are abundant signs that the mindset of IT professionals is significantly different when they think about preservation. Definitions of *archive, archiving* and *archival storage* give us some indication of their concerns. A selection of IT dictionaries from the shelves of the National Library of Australia's Reference Collection in April 2003 and an internet search indicated that these terms were used in two ways:

1. The process of moving data to a different kind of storage medium: for example, '*archive* The process of moving data stored on an online, direct access device to an offline storage medium because its frequency of use and time-liness permit a delayed access to the data' (Sochat and Williams, 1992, p.16)
2. The process of backing up data for long-term storage: for example, '*archive* v To backup or make copies for long-term storage' (Wyatt, 1990, p.27).

Few of these definitions display any interest or concern with the reasons why long-term storage might be required, although one notable exception was located: '*archiving* Long term storage of information on electronic media. Infor-mation is archived for legal, security or historical reasons, rather than for regular processing or retrieval' (Gunton, 1993, p.11). Perhaps the mindset of IT profes-sionals is better indicated by this excerpt: 'You detect data that's not needed online and move it an off-shore store. When someone wants to use it, go find the off-line media and restore the data' (Faulds and Challinor, 1998, p.280).

There is no indication in these definitions of the period of time that *long-term* refers to, yet this is a crucial point for those who are concerned with

preservation. My employer, an Australian university, in a discussion of long-term storage facilities, suggests access 'for a number of years', or 'a considerable time (years)' (Message on my.csu, Subject line: Information Update – DIT Archiving Project', 11 May 2002). While it is perhaps not especially helpful to define *long-term* in terms of a specific number of months or years, some awareness of the problems is required, such as that evident in the NSF-DELOS Working Group's report *Invest to Save* (NSF-DELOS Working Group on Digital Archiving and Preservation, 2003, p.2) where the OAIS (Open Archival Information System) definition of *long-term* is noted:

> A period of time long enough for there to be concern about the impacts of changing technologies, including support for new media and data formats, and of a changing user community, on the information being held in a repository.

What, then, are the definitions currently being used? Definitions have, of course, changed as we come to know more about how to preserve digital objects. The example of time – how long we want to preserve material for – illustrates this point. *Long-term*, initially incorporating elements of old-paradigm thinking of indefinitely, or as long as possible – as in 'digital preservation means retaining digital image collections in a usable and interpretable form for the long term' (Kenney and Rieger, 2000, p.135) – is now more commonly defined in the preservation community in terms derived from the archival community, as the period during which the information remains of continuing *value*. Such a definition is more helpful than the commonly encountered phrase 'over time' – as in 'ensuring the integrity of information over time (Gilliland-Swetland, 2000, p.22), and 'digital preservation [is] the processes and activities which stabilize and protect reformatted and "born digital" authentic electronic materials in forms which are retrievable, readable, and usable over time' (Cloonan and Sanett, 2002, p.95). These issues and concepts are covered in two of the most comprehensive of the recent publications on digital preservation, the influential *Preservation Management of Digital Materials: A Handbook* (Jones and Beagrie, 2001) and the UNESCO *Guidelines for the Preservation of Digital Heritage* (UNESCO, 2003). Selected definitions from these two sources are presented in Figure 1.2.

A new term is gaining currency with the establishment of the Digital Curation Centre in 2004, although it is too early to know whether it will become the standard term. *Curation* is defined as

> the actions needed to maintain digital research data and other digital materials over their entire life-cycle and over time for current and future generations of users. Implicit in this definition are the processes of digital archiving and preservation but it also includes all the processes needed for good data creation and management, and the capacity to add value to data to generate new sources of information and knowledge . . . ; it is the key to reproducibility and re-use . . . Digital curation . . . is about maintaining and adding value to, a trusted body of digital information for current and future (Digital Curation Centre, 2004).

These definitions assist us by providing useful starting points for an extended discussion of digital preservation. In particular, they address some significant questions that we need guidance on:

Preservation Management of Digital Materials (Jones and Beagrie, 2001)	Guidelines for the Preservation of Digital Heritage (UNESCO, 2003)
Access . . . continued, ongoing usability of a digital resource, retaining all qualities of authenticity, accuracy and functionality deemed to be essential for the purposes the digital material was created and/or acquired for (p.9)	**Accessibility** The ability to access the essential, authentic meaning or purpose of a digital object (p.161). Digital materials cannot be said to be preserved if access is lost. The purpose of preservation is to maintain the ability to present the essential elements of authentic digital materials (p.22)
Authenticity The digital material is what it purports to be. In the case of electronic records, it refers to the trustworthiness of the electronic record as a record. In the case of "born digital" and digitized materials, it refers to the fact that whatever is being cited is the same as it was when it was first created unless the accompanying metadata indicates any changes. Confidence in the authenticity of digital materials over time is particularly crucial owing to the ease with which alterations can be made (p.9)	**Authenticity** Quality of genuineness and trustworthiness of some digital materials, as being what they purport to be, either as an original object or as a reliable copy derived by fully documented processes from an original (p.161)
	Digital heritage Those digital materials that are valued sufficiently to be retained for future access and use (p.161)
Digital Materials A broad term encompassing digital surrogates created as a result of converting analogue materials to digital form (digitization), and "born digital" for which there has never been and is never intended to be an analogue equivalent, and digital records (p.1)	**Digital materials** is generally used here as a preferred term covering items of digital heritage at a general level. In some places, *digital object* or *digital resource* have also been used. These terms have been used interchangeably and generically (p.21)
Digital Preservation Refers to the series of managed activities necessary to ensure continued access to digital materials for as long as necessary. Digital preservation is defined very broadly for the purposes of this study and refers to all of the actions required to maintain access to digital materials beyond the limits of media failure or technological change . . . (p.10)	**Digital preservation** The processes of maintaining accessibility of digital objects over time (p.161) . . . is used to describe the processes involved in maintaining information and other kinds of heritage that exist in a digital form. In these Guidelines, it does *not* refer to the use of digital imaging or capture techniques to make copies of non-digital items, even if that is done for preservation purposes . . . (p.21)
	Information Packages . . . Preservation depends on maintaining digital objects **and** any information and tools that would be needed in order to access and understand them. Together, these can be considered to form an *information package* that must be managed either as a single object or as a virtual package (with the object and associated information tools linked but stored separately) (p.40)
	Preservation program The set of arrangements, and those responsible for them, that are put in place to manage digital materials for ongoing accessibility (p.162). . . . is used to refer to any set of coherent arrangements aimed at preserving digital objects. (p.21)

Figure 1.2 Selected Definitions (From Jones and Beagrie, 2001; UNESCO, 2003)

- What exactly are we trying to preserve?
- How long are we preserving them for?
- What strategies and actions do we need to apply when we preserve them?

What exactly are we trying to preserve?

One of UNESCO's thematic areas is culture, and, within that, heritage. Therefore the UNESCO *Guidelines* are primarily concerned with digital *heritage*, 'those digital materials that are valued sufficiently to be retained for future access and use'. Although this statement is general and does not assist us to decide precisely what it is we want to preserve, it does introduce the essential concept of selection, of deciding value – in this case, that digital material on which high value is placed. This is the subject of Chapter 4.

More specific in the UNESCO *Guidelines* and in *Preservation Management of Digital Materials: A Handbook* are the definitions of digital materials – the specific digital items, objects or resources that we are concerned with. Both publications use *digital materials,* suggesting a high level of consensus; this term will, therefore, be adopted in this book, despite the suggestion of pre-digital paradigm thinking in the physicality of the word *materials,* as things with a physical presence.

Both sets of definitions categorically state that they are not concerned with the use of digitizing of analogue materials as a preservation technique. Jones and Beagrie's handbook 'specifically excludes the potential use of digital technology to preserve the original artifacts through digitisation', and the UNESCO *Guidelines* are equally adamant, stating that digital preservation 'does *not* refer to the use of digital imaging or capture techniques to make copies of non-digital items, even if that is done for preservation purposes'. Why such statements are thought to be worth making so firmly is explained by a strongly-held perception prevalent in the information professions that digitizing of analogue materials, often photographs or paper-based material, is sufficient for preservation purposes. Such attitudes have been noted earlier in this chapter: the Parish Map Project (Read, 1999) created digital content from original paper artifacts, and descriptions of such projects are very commonly found in the literature. Not all information professionals seem to be aware of this distinction and of its consequences. One exception is Sassoon, who fervently argues that the lack of understanding about just what is happening when photographs are digitized, about 'from where photographic meaning emanates' (Sassoon, 1998, p.5), results in the loss of crucial information and raises serious ethical issues about the destruction of information as a consequence of digitization.

In terms of how they are preserved, though, the definitions in these two sources make no distinction between 'born digital' materials and digital materials created by digitizing analogue materials. This is acknowledged in Jones and Beagrie's definition of *digital materials,* which covers both 'digital surrogates created as a result of converting analogue materials to digital form (digitisation), and "born digital" for which there has never been and is never intended to be an analogue equivalent, and digital records' (Jones and Beagrie, 2001, p.1).

But it is not simply the bit-stream that we are seeking to preserve, as these definitions make clear. In order to ensure access in the future to digital materials, we also need to take account of other attributes of the digital materials. The UNESCO *Guidelines* indicate this in the definition of *information packages.*

Guidelines for the Preservation of Digital Heritage (UNESCO, 2003)

Conceptual objects Digital objects as humans interact with them in a human-understandable form (p.161)

Essential elements The elements, characteristics and attributes of a given digital object that must be preserved in order to re-present its essential meaning or purpose. Also called *significant properties* by some researchers (pp.161–162)

Logical objects Digital objects as computer encoding, underlying conceptual objects (p.162)

Physical objects Digital objects as physical phenomena that record the logical encoding, such as polarity states in magnetic media, or reflectivity states in optical media (p.162)

Figure 1.3 Selected Definitions (From UNESCO, 2003)

In addition to the bit-stream, which is typically 'not understandable or re-presentable' by itself, 'any information and tools that would be needed in order to access and understand' the digital materials must also be preserved (UNESCO, 2003, p.40).

The definitions are also very specific about the need to maintain other attributes of digital materials. To ensure that digital materials remain usable in the future, access to them is required – and not simply access, but access to 'all qualities of authenticity, accuracy and functionality' (Jones and Beagrie, 2001, p.9). This, in turn, requires definitions of *authenticity*, well expressed by the UNESCO *Guidelines* as the 'quality of genuineness and trustworthiness of some digital materials, as being what they purport to be, either as an original object or as a reliable copy derived by fully documented processes from an original' (UNESCO, 2003, p.161). (Note the emphasis on the significance of full documentation to ensure authenticity: this has important implications for digital preservation, noted further in Chapter 5.) Four further definitions in the UNESCO *Guidelines* clarify and emphasize these requirements (see Figure 1.3). Digital materials can be considered as physical objects, logical objects, or conceptual objects. The *physical object* is the artifact (for example, the diskette, the CD, or the magnetic tape whose physical characteristics store in or on it the bit-stream – that is, the *logical object*). These are given sense when they are used by humans and are labeled *conceptual objects*: 'what we deal with in the real world' (Thibodeau, 2002, p.8). *Essential elements* (or significant properties) of digital materials, when taken together, enable us to re-present the materials in the manner in which they were originally intended; that is, to preserve them. These concepts are noted further in the UNESCO *Guidelines* (see, for example, UNESCO, 2003, p.36) and elsewhere (Thibodeau, 2002, p.6–13).

How long are we preserving them for?

Although the definitions in the UNESCO *Guidelines* are not very helpful in providing guidance about the length of time we preserve digital materials, Jones and Beagrie assist us with their articulation of long-term, medium-term and short-term preservation. *Long-term preservation* aims to provide indefinite access to digital materials, or at least to the information contained in them. Continued

access to digital materials for a defined time (but not indefinitely) is *medium-term preservation*: here, the time period is long enough to encompass changes in technology. *Short-term preservation* is, in part, defined by changes in technology: access to digital materials is maintained until technological changes make it inaccessible, or for a period during which the material is likely to be in use but which is relatively short (Jones and Beagrie, 2001, p.10). Such definitions provide helpful ways of thinking about digital preservation programmes: for example, about resource allocation, the long-term resource implications of embarking on long-term preservation being ongoing and therefore large.

What strategies and actions do we need to apply when we preserve them?

The definitions in these two sources make us aware, in a general sense, of the components of a digital preservation programme. In order to achieve the aim of a digital preservation programme – 'maintaining accessibility of digital objects over time' (UNESCO, 2003, p.21), or 'to ensure continued access to digital materials for as long as necessary' – various processes forming a 'series of managed activities' (Jones and Beagrie, 2001, p.10) are required. They need to form 'a set of coherent arrangements' (UNESCO, 2003, p.21). These are noted in Chapters 7 to 10.

Conclusion

This chapter has introduced some of the key concepts that are reshaping preservation practice in the digital environment. It has noted the need for new ways of thinking about preservation and has posed three key questions that need to be considered when we think about the preservation of digital materials:

- What exactly are we trying to preserve?
- How long are we preserving them for?
- What strategies and actions do we need to apply when we preserve them?

These questions and other themes introduced in Chapter 1 are explored in the rest of this book.

Chapter 2

Why do we Preserve?
Who Should do it?

Introduction

> *Society, of course, has a vital interest in preserving materials that document issues, concerns, ideas, discourse and events ... The ability of a culture to survive into the future depends on the richness and acuity of its members' sense of history (Task Force on Archiving of Digital Information, 1996, p.1)*

Preservation is commonly perceived to be the responsibility of large, well-resourced institutions such as national libraries and archives, state libraries, and some university libraries. This perception is no longer valid in the digital age. It may once have been legitimate, in the days when conservation laboratories were considered a necessary requirement for a successful preservation programme, and when computer installations were expensive and few in number, but the reality is now very different. Documentary materials in digital form are now being created at all levels of society. Digital preservation must come within the responsibilities of almost every creator and every user of digital information, not just those of librarians and archivists.

This chapter investigates the questions:

- Why should digital materials be preserved?
- Who has responsibility for their preservation?
- How significant is the problem of digital preservation?

While the continuing roles of those institutions traditionally identified as responsible for preservation – libraries, archives and museums – are noted, attention is paid to the roles of the much wider range of stakeholders now required for effective digital preservation.

Why preserve digital materials?

The reasons for preserving knowledge are variously described in terms of duties, obligations, and benefits. Preservation is based on the notion that, because man learns from the past, 'evidence of the past therefore has considerable significance to the human race and is worth saving' (Harvey, 1993, p.6). Not only is preservation worth doing; it is also, some suggest, a duty. Agresto, former head of the United States National Endowment for the Humanities, suggested that 'we have a human obligation *not to forget*' (cited in Harvey, 1993, p.7). The importance of preservation for a healthy society is frequently noted, one example being Agresto again, who considered that preservation is essential for the well-being of democracies which depend 'on knowledge and the diffusion of knowledge' and on 'knowledge shared' (Harvey, 1993, p.7). (Many commentators seem unaware that democracy is not the only possible foundation of a viable society, but we leave aside here the question of the role of preservation in societies not based on democratic principles. There is considerable evidence that those in power in democracies are just as likely to suppress or destroy evidence that does not suit their political agenda as are those in power in societies based on other political systems.)

It is also often contended that nothing less than 'the ability of a culture to survive into the future' depends on the preservation of knowledge (Task Force on Archiving of Digital Information, 1996, p.1). The cultural and political imperatives that have led to preservation have been explored in such books as Lowenthal's *The Past is a Foreign Country* (Lowenthal, 1985) and Taylor's *Cultural Selection* (Taylor, 1996), which persuade us that preservation is not simply the concern of a limited number of cultural heritage institutions and professions, but has dimensions that have significant impact, both limiting and sustaining, on most aspects of society. Economic reasons for preservation are noted by others attuned to the current pragmatic political environment. Brindley, the British Library's Chief Executive, notes that there are 'sound economic reasons' for preserving the 'digital assets' that are resulting from large investments in digitizing projects (Brindley, 2000, p.125). There is, in fact, no single reason why we preserve knowledge. Preservation, suggests Cloonan, 'has a life force fueled by many (often disparate) sources' (Cloonan, 2001, p.231).

None of these reasons change when we consider the preservation of knowledge encoded in digital materials, but the rhetoric alters to emphasize economic rationales. Preserving digital materials is essential 'if mankind is not to waste the institutional and societal investment already made in digital resources' (B. Smith, 2002, p.135); 'the emerging knowledge economy cannot survive and will not lead to democratic outcomes without a provision for the archiving function' (Waters, 1996, p.4). Recordkeeping and accountability reasons are also commonly given: 'we expect that this [digital] content will remain accessible to allow us to validate claims, trace what we have done, or pass a record to future generations' (NSF-DELOS Working Group on Digital Archiving and Preservation, 2003, p.[i]). The NSF-DELOS Working Group on Digital Archiving and Preservation specifies five conditions, any one of which, if it exists, is sufficient to provide a benefit to society:

- If unique information objects that are vulnerable and sensitive and therefore subject to risks can be *preserved and protected*;

- If preservation ensures long-term *accessibility* for researchers and the public;
- If preservation fosters the *accountability* of governments and organisations;
- If there is an economic or societal advantage in *re-using information*, or
- If there is a *legal requirement* to keep it (NSF-DELOS Working Group on Digital Archiving and Preservation, 2003, p.3).

The report of this Working Group provides examples and further discussion. It provides, for instance, the example of repositories of scientific data supporting the trends towards 'data-driven science' to illustrate the condition of ensuring long-term accessibility for researchers, and the economic benefits are noted in relation to reduction of costs through re-use of stored data (NSF-DELOS Working Group on Digital Archiving and Preservation, 2003, p.5).

There is also a widespread appreciation that the preservation scene is changing in significant ways. Lyman and Kahle (of Internet Archive fame) note that recordkeeping, which, combined with archival preservation, is the basis of historical memory, was greatly facilitated by print, and institutions such as universities, publishers and museums collect, organize and preserve 'the historical memory that gives culture continuity and depth'. But this is changing:

> What are, and will be, the social contexts and institutions for preserving digital documents? Indeed, what new kinds of institutions are possible in cyberspace, and what technologies will support them? What kind of new social contexts and institutions should be invented for cyberspace? (Lyman and Kahle, 1998).

The very aims of preservation are also being questioned – 'What are we preserving? For whom? And why?' (NSF-DELOS Working Group on Digital Archiving and Preservation, 2003, p.2) – and the expanded number of stake-holders in the digital age means that different interests must be considered.

Professional imperatives

What do these changes mean for libraries and archives? Has the basis on which their practice is founded altered?

At one level, there have been few changes. In the traditional view, libraries are, according to Marcum, then President of the Council on Library and Information Resources, 'society's stewards of cultural and intellectual resources' (Kenney and Stam, 2002, p.v). Preservation is nothing less than the 'core business' of libraries whose collections are maintained for use into the future (Webb, 2000b). For libraries and archives, preservation is about protecting 'information of enduring value for access by present and future generations' (Hedstrom, 1998, p.189) and 'documentation of human activity' (Conway, 1996, p.3). One typical view of the preservation role of libraries is Gorman's statement:

> Libraries have a duty to preserve and make available all the records of humankind. That is a unique burden. No other group of people has ever been as successful in preserving the records of the past and no other group of people has that mission today . . . Let there be no mistake: if we librarians do not rise to the occasion, successive generations will

know less and have access to less for the first time in human history. This is not a challenge from which we can shrink or a mission in which we can fail (Gorman, 1997).

The arguments for preservation being a core activity in libraries are traditionally articulated as maintaining the collection for access for a period of time (which varies according to the type of library and the number of years material is required to remain accessible), as making good sense economically by allowing items to be used longer before they wear out, and the 'just in case' argument: 'It cannot easily be predicted what will be of interest to researchers in the future. Preserving current collections is the best way to serve future users' (Adcock, 1998, p.8).

Similarly, there has been no fundamental change in the way that archivists consider preservation. Archivists' secure understanding of their preservation responsibilities is unaltered. They have typically placed the physical care of their collections at least on a par with, if not at a higher level of importance than, the provision of access to those collections. This 'physical defence of archives' was indeed considered paramount by the British archivist Sir Hilary Jenkinson, who formulated this statement in 1922:

> The duties of the Archivist . . . are primary and secondary. In the first place he has to take all possible precautions for the safeguarding of his Archives and for their custody . . . *Subject to the discharge of these duties* he has in the second place to provide to the best of his ability for the needs of historians and other research workers. But *the position of primary and secondary must not be reversed* (Jenkinson, 1965, p.15).

There is ample evidence in the literature of their profession to support the generalization that archivists have thought more thoroughly about their professional practice and have articulated it more clearly than have librarians. Gilliland-Swetland examines how archival principles provide powerful ways of thinking about the preservation of digital materials. 'Implementing the archival perspective in the digital environment', she suggests, encompasses

- Working with information creators to identify requirements for the long-term management of information;
- Identifying the roles and responsibilities of those who create, manage, provide access to, and preserve information
- Ensuring the creation and preservation of reliable and authentic materials;
- Understanding that information can be dynamic in terms of form, accumulation, value attribution, and primary and secondary use; . . .
- Identifying evidence in materials and addressing the evidential needs of materials and their users through archival appraisal, description, and preservation activities (Gilliland-Swetland, 2000, p.21).

Nor should we forget the specific legal reasons for preservation. In the case of archives these reasons are often connected to administrative and political accountability. For some types of libraries, statutory responsibilities require preservation to be their core business. National libraries, for example, have the role of collecting, and safeguarding access to, information published in their

country. In Australia, the National Library of Australia has 'a statutory responsibility to collect and preserve significant Australian publications regardless of their format' and has 'a special responsibility for collecting and preserving the published output of Commonwealth government agencies', including online publications (Gatenby, 2002a).

These are the traditional preservation responsibilities of libraries and archives, but they are changing rapidly. Commentators agree that the need for preservation will remain, and most suggest that it will become even more urgent; they also agree that the roles of these institutions will be different. Webb, for instance, considers that these roles will require 'flexibility, a willingness to change, proactively seeking a useful role that draws on the expertise and challenges we already have, while developing whatever new expertise and perspectives will be needed'. Preservationists will need to be willing to listen and learn, and to 'form new alliances and partnerships' (Webb, 2000b).

The preceding sections are reiterated and summarized cogently by Smith:

> Society has always created objects and records describing its activities, and it has consciously preserved them in a permanent way . . . Cultural institutions are recognised custodians of this collective memory: archives, librar[ies] and museums play a vital role in organizing, preserving and providing access to the cultural, intellectual and historical resources of society. They have established formal preservation programs for traditional materials and they understand how to safeguard both the contextual circumstances and the authenticity and integrity of the objects and information placed in their care . . . It is now evident that the computer has changed forever the way information is created, managed, archives and accessed, and that digital information is now an integral part of our cultural and intellectual heritage. However the institutions that have traditionally been responsible for preserving information now face major technical, organizational, resource, and legal challenges in taking on the preservation of digital holdings (B. Smith, 2002, pp.133–134).

Other stakeholders

The new challenges of digital preservation require new participants: we are seeing 'the privatisation of preservation' (Burrows, 2000, p.143). Stakeholders other than those who participated in the old preservation paradigm, whose legal and moral rights must be considered, are becoming significant players. Others are starting to participate as it becomes increasingly evident that the cultural heritage institutions traditionally charged with preservation responsibility cannot continue to carry this responsibility in the digital age without widening their range of partners in the endeavour. Digital preservation 'also affects information on long-term genetic research, monitoring global environmental change, locating nuclear waste sites, establishing property rights, storing and authenticating electronic criminal evidence, etc' (B. Smith, 2002, p.135); it is also 'a consumer problem':

> Individuals are storing an increasing portion of their social and personal memory on digital media with the mistaken belief that this will ensure

that those memories will always be available to them for consultation. Today no one is able to provide such guarantees (B. Smith, 2002, p.135).

While some of the digital output of individuals is being stored in their own computing environments, a very large amount of it exists publicly on the web.

Not only are new kinds of stakeholders claiming an interest or claiming control, but higher levels of collaboration among stakeholders are seen as necessary for digital preservation to be effective. Localized solutions are not perceived as likely to be the most effective; the problem is large enough 'to warrant a world-wide effort' (B. Smith, 2002, p.136) and the preservation of digital material will become 'essentially a distributed process' where 'traditional demarcations do not apply' and one for which 'an interdisciplinary approach is necessary' (Shenton, 2000, p.164). Collaboration is considered more and more as the only way in which viable and sustainable solutions can be developed, as the problems are well beyond the scope of even the largest and most well-resourced single institution. (UNESCO, 2003, Chapter 11 explores collaboration in more detail, and Chapter 9 of this book provides examples of collaborative activities).

Who, then, are these new stakeholders? What are their preservation roles likely to be in an increasingly digital environment? An early expression of this was made by the Task Force on Archiving of Digital Information, whose influential 1996 report set much of the digital preservation agenda for the rest of the decade. The report suggested that 'intense interactions among the parties with stakes in digital information are providing the opportunity and stimulus for new stakeholders to emerge and add value, and for the relationships and division of labor among existing stakeholders to assume new forms'. It proposed two principles, the first that information creators, providers and owners 'have initial responsibility for archiving their digital information objects and thereby assuming the long-term preservation of these objects' and the second that where this mechanism fails or becomes unworkable, 'certified digital archives have the right and duty' to preserve digital materials (Task Force on Archiving of Digital Information, 1996, pp.19–20). The implications of these principles are still being worked through today.

Information providers, creators and owners, and certified digital archives are new stakeholders, but there are many others. Hodge and Frangakis note that other stakeholders identified in the literature include disciplines, commercial services, government agencies, passionate individuals, rights holders, beneficiaries, funding agencies, and users (Hodge and Frangakis, 2004, p.15); they add trusted third parties to that list (Hodge and Frangakis, 2004, p.20). UNESCO's Charter on the Preservation of the Digital Heritage lists 'hardware and software developers, creators, publishers, producers, and distributors of digital materials as well as other private sector partners' in addition to 'libraries, archives, museums and other public heritage organizations' (UNESCO, 2004, Article 10). Lyman and Kahle suggest that many different communities must 'learn to work together if the problem of digital preservation and archiving is to be solved – computer scientists, librarians and scholars, and policy makers' (Lyman and Kahle, 1998). Some of these communities were communicating in the old preservation paradigm, one example being the collaboration of scholars and librarians to identify the core literature in specific discipline areas for microfilming and scanning projects (see Gwinn, 1993 for example in agriculture). The extent

and nature of collaborative activity, however, will need to intensify. Howell, an Australian preservation manager, indicates other stakeholders: 'managers of digital archives, representatives of the public interest and public policy, and actual and potential users of digital information'. One major challenge, he suggests, is to meet the requirements of all stakeholders while still ensuring that preservation and access objectives are also met, especially for digital materials which may have commercial value (Howell, 2001, p.140). Another Australian articulation lists the stakeholders in the Australian digital preservation context as 'government bodies, the corporate and academic sectors, software vendors, creators and publishers, libraries and archives, networked information service providers and the digital material audience of present and future generations' (Kerry, 2001, p.13).

Some attention has been given to the role of scientists and scholars as stake-holders in digital preservation. The way in which scholars' work is being transformed, most notably in the sciences, but also in the social sciences and the humanities, has been investigated. The increasingly data-driven approaches to science that are currently in fashion use 'very large primary research data sets, particularly in the genomics and earth sciences' (Howell, 2001, p.133). This means that increasing attention is being given to the long-term preservation of digital scientific data (see, for example, National Research Council, 1995, ERPANET/CODATA Workshop, 2004; Hodge and Frangakis, 2004). The dissemination of scholarly output provides an example of the transformations of this 'new-model scholarship' (Smith, 2003). No longer do scholars rely solely on formal print publication mechanisms for transmitting their research. Instead, more and more emphasis is placed on other mechanisms: pre-print archives in high-energy physics and in mathematics, e-repositories (often university-based), the development of web sites and internet discussion lists that are based around communities of scholars, all of which have preservation implications.

A useful illustration of the major changes that will be required is in the keeping of personal correspondence. Its value as a source of historical information has long been recognized. The extensive use of e-mail has diminished the likelihood that personal correspondence will remain accessible to future historians. Lukesh asks: 'Where will our understandings of today and, more critically, the next century be, if this rich source of information is no longer available?' as scientists, scholars, historians and many others increasingly use e-mail (Lukesh, 1999). Pre-digital paradigm preservation habits mean that scholars, scientists and other creators of e-mails retain the expectation that librarians and archivists will continue to collect and maintain materials ascertained to be of long-term value, usually well after the time of creation of the materials. But with e-mail (and in fact all digital materials) this cannot occur because the digital materials will quickly become inaccessible. (Reasons for this are explained in Chapter 3.) With digital materials, suggests Smith, 'the critical dependency of preservation on good stewardship begins with the act of creation, and the creator has a decisive role in the longevity of the digital object' (Smith, 2003, pp.2–3). For most creators of digital materials this is a new role.

Publishers are another stakeholder group whose responsibilities and roles change as more of their output is distributed in digital form. Some national libraries are developing cooperative arrangements with publishers to ensure that preservation responsibilities for digital publications are understood and shared. One example is the agreement between Elsevier Science and the Koninklijke

Bibliotheek (the National Library of the Netherlands) through which the Library receives digital copies of all journals on Elsevier's ScienceDirect web platform. The National Library of Australia and the Australian Publishers' Association are developing and trialing a *Code of Practice for Providing Long-Term Access to Australian Online Publications*. This code 'outlines the conditions and responsibilities that each partner agrees to observe in order to ensure Australian online publications remain available for use into the future' (Phillips, 2002).

Some express doubts about the interest and willingness of for-profit organizations to participate in digital preservation initiatives. Search engine companies, for instance, 'are not in the business of long-term archiving of the web or even a portion of it, nor should they be expected to take on this responsibility'. The entertainment industry is increasingly digital, and its products, audio and video, have a well-established place as 'critical resources for research, historical documentaries, and cultural coherence resources'. Even given the prevailing political ethos, it is impossible to envisage a situation where market forces will be sufficient to ensure the preservation of this digital material. The opposite may be true: 'in some cases market forces work against long-term preservation by locking customers into proprietary formats and systems' (Workshop on Research Challenges in Digital Archiving and Long-term Preservation, 2003, pp.x–xi).

An Australian example illustrates some of the issues and the difficulties in finding viable solutions. Pockley's search for a suitable home for his digital compilation *The Flight of Ducks* is described in his evolving online report *Killing the Duck to Keep the Quack* (Pockley, 1995-). This case study makes it clear that some traditional cultural heritage institutions lack knowledge of the issues. Some 'are unlikely to be able to bear the costs and complexities of moving digital content into the future'; others will 'deliberately or inadvertently, through a simple failure to act, render the information irretrievable'; and for some it is 'easier to ignore the existence of digital work or to treat it as somehow less worthy of collection and preservation' (Pockley, 1995-, Section 4. *Death in Custody*). Three different custodial environments illustrate three sets of problems. RMIT University did not accept custodial responsibility for online research during the development of the work, which was submitted as a doctoral thesis at this university, and it had no infrastructure to support long-term access. Political and ethical issues also intervened, as some members of the University's Ethics Committee suspected it might be culturally offensive. The National Library of Australia accepted the site for PANDORA, but has been unable to capture the password-protected area, which contains restricted material, so that the compilation is not preserved in its entirety. Cinemedia, a Melbourne-based organisation established in 1997 to cater for the screen-culture needs in the state of Victoria, next hosted the compilation. However, this arrangement was not fully satisfactory: Cinemedia retained control of all material and had the right to remove the whole or parts at any time, and lacked an infrastructure for preservation of online work (Pockley, 1995-).

The extent of the preservation problem

It is useful to have some understanding of how substantial the preservation problem is, although estimates must remain very inexact. We know something of its parameters for the traditional artifacts, mainly paper-based, that make up

the collections of libraries and archives. Studies of paper deterioration have been carried out since the 1950s, after Barrow's influential study *Deterioration of Book Stock: Causes and Remedies: Two Studies on the Permanence of Book Paper* (Barrow, 1959) raised alarm within the library community. Later studies refined these conclusions. Although the evidence allows only general statements to be made, it is commonly thought that paper embrittlement affects in the order of 30 per cent of the collections of large research libraries in the United States. Studies for Australia suggest a lower rate. (This is explained in more detail in Harvey, 1993, pp.9–10). Nor is the problem of deterioration of the kinds of artifacts typically found in traditional collections limited to paper. All materials deteriorate. Photographs, nitrate film, and cellulose acetate film are some examples.

However, our primary interest in this book is digital materials. What is the extent of the preservation problem for these? The geometrical increase in the volume of digital materials (Webb, 2000b) means that there is much more digital content worth preserving, and it follows that this quantity is also increasing geometrically, but our ability to manage and preserve them is far outpaced by this growth rate (Workshop on Research Challenges in Digital Archiving and Long-term Preservation, 2003, pp.2–4). It is suggested the last 25 years have been a 'scenario of data loss and poor records that has dogged our progress' so if this is not reversed, 'the human record of the early 21st century may be unreadable' (Deegan and Tanner, 2002).

Such rhetoric is commonly found in the literature, but it is lamentably short on supporting specifics and evidence. Alarmist descriptions abound: there will be 'a digital black hole . . . truly a digital dark age from which information may never reappear' (Deegan and Tanner, 2002) if we do not address the problem, and we will become an amnesiac society. (An early use of this evocative term in relation to digital materials was by Sturges (1990), still worth reading today.) Although we may be 'the best documented era in history' much of this has been lost, according to some: 'the first email message, chat group session, and web site' (Vogt-O'Connor, 1999).

There are regrettably few documented examples of digital data loss. Usually the literature notes only general categories of digital material that are, or are thought to be, at risk. One of these comes from the US federal government, for whom, O'Mahony notes, it was the norm, when web sites or internet files were changed, to overwrite the old information. He concludes that 'the public is now experiencing losses of government information, on a scale similar to that of the catastrophic fire of 1921 [in which the 1890 census records were destroyed], on what seems to be a regular basis' (O'Mahony, 1998, p.108). Another example is of business records in electronic form. A study of the companies that were relocated after the World Trade Centre bombing in 1993 found that 40 per cent ceased trading, a major reason being the loss of key business records in electronic form, and '43 per cent of companies which lose their data close down' (cited in Ross and Gow, 1999, p.iii). Some of the documented examples are about data recovery, in the sense that data thought to have become inaccessible were able to be recovered, or thought to have been lost were only mislaid. Ross and Gow note four case studies of data recovery: the Challenger Space Shuttle Tapes, Hurricane Marilyn (Virgin Islands September 1995), video image recovery from damaged 8mm recorders (from a crashed fighter plane), and German unification and the recovery of electronic records from East Germany (Ross and Gow, 1999, pp.39–42). Another documented example is of the Functional Requirements

for Evidence in Recordkeeping project administered by the University of Pittsburgh. 'Due to a technical glitch at the School the web site with the working files of this project was destroyed, but since the web site has not been updated since 1996 when the Project ended individuals interested in the project and use if the site can access it through the Internet Archive' (Cox, 2000?).

From the literature it is only possible to conclude, as do Jones and Beagrie, that the evidence of digital data loss is, overall, anecdotal. Jones and Beagrie note, for the United Kingdom, that, while the evidence is 'as yet only largely anecdotal . . . it is certain that many potentially valuable digital materials have already been lost', and cite the conclusion of the Catriona II project that, although digital resources were being created by Scottish universities, they were largely inaccessible (Jones and Beagrie, 2001, p.18). What is especially disturbing is that all the evidence of loss comes from large institutions, which might be expected to have the knowledge, resources to maintain access to these materials (Tibbo, 2003, pp.14–15).

How much data have we lost?

Can we quantify the extent of the preservation problem for digital materials? Why would we want to do this? We need to document some specific examples to supplement the handful of case studies (many of them anecdotal) that are currently all that can be found. Some of these examples are probably present in unpublished reports or business cases, but the publicly-accessible literature contains little. Beagrie suggests that 'statistics on current losses are difficult to compile. Wider overviews are rare' (Beagrie, 2004, pp.1–2). If we cannot produce specific examples, we lay ourselves open to the charge of being alarmist. A useful question to pose, then, is this: Is the problem of digital preservation as great as we have assumed?

One commonly-applied criterion for measuring the quality of a piece of research or scientific investigation is to ascertain that it has referred to (and preferably has built on) what has already been investigated; a literature review is the usual way in which the results of this investigation is presented. Another criterion is the presence of a clear statement of the problem to be investigated. In other words, we expect a clear understanding of the nature and extent of the problem to be demonstrated. Applying these criteria to the preservation of digital information would call for, at the least, a literature search to ascertain, as accurately as possible, just how large the problem is. We need answers to these questions: How much digital information has been lost and how much has been compromised? To what extent has the data been compromised? Is the problem of digital preservation as great as we have assumed? We assume that there is a problem, and many statements, including those in this book, have been based on the assumption that there is a problem. Phrases such as 'data losses through poor management of digital data' (Beagrie and Greenstein, 1998, Preface) and 'there is general consensus that digital preservation is both an imperative and a challenge' (Lavoie, 2003, p.2) are readily found – but little else.

It is valid, therefore, to ask how large the problem is – it may even be crucial to the future of digital preservation, for instance to secure resources. An inability to answer this question could lead to scepticism about whether the problem is as great as claimed and to conjecture that we may have been needlessly

alarmed into believing the issue is more urgent than it really is. An attempt to answer these questions is especially valid in the context of the history of the preservation of documentary heritage. Two examples – brittle books and nitrate film – come to mind. In both of these the initial concerns were undoubtedly well-meaning and were based on the best information available at that time, but the assumptions on which action was taken have been established as faulty to varying extents, with serious consequences. The preceding section in this chapter noted the extent of the preservation problem for paper-based material. This concern precipitated expenditure of large amounts of money by the US National Endowment for the Humanities on its Brittle Books Program, which has micro-filmed about one million books since it began in 1988. But was this money well spent? There is now some evidence to suggest that the rate at which paper becomes brittle is not as high as the earlier studies, on which the Brittle Books Program was based, suggested. This has led to some strident critiques (the most notable among them that of Baker (2001)). Similarly, early projections about the rate at which cellulose nitrate film would deteriorate resulted in large-scale refor-matting of these films to cellulose acetate stock, but there is now considerable concern about the stability of the new 'archival' carriers (ANICA, 2002).

The examples of brittle books and nitrate film might suggest that we urge caution in the case of digital information. This is an excellent reason to put some effort at an early stage into attempting to quantify the extent of digital informa-tion loss or compromise, or, at the very least, to document some specific examples to supplement the few studies. The desirability of more documented examples and case studies has been recognized for some years. For example, Ross and Gow concluded that 'information about data loss, recovery, and risk is very difficult to acquire . . . more case studies about data loss and rescue need to be collected' (Ross and Gow, 1999, p.vi) and James noted that 'documented examples of historically significant data loss are rare' (James, 2001).

The term *data loss* used here also includes data that is compromised: it is degraded to the extent that its quality is affected. (The phrases *loss of data integrity* or *loss of data authenticity* might also be used.) The data may still be accessible, but we have no clear idea of what they mean, what software was used to create them, and so on.

The question 'How much digital information has been lost and how much has been compromised?' is difficult to answer – maybe impossible to answer. Although studies of the kind of data which should be preserved are readily available, such as scientific data (National Research Council, 1995), historical data (Higgs, 1998) and statistical data (Royal Statistical Society and UK Data Archive, 2002), no general estimates of quantity based on solid evidence (as distinct from conjecture) have been located, and few specific examples or care-fully documented case studies appear to exist. The same examples are trotted out, even where they are no longer in the 'lost or compromised' category: the BBC's Domesday Project, NASA data, the Viking Mars mission, the Combat Area Casualty file containing prisoner of war and missing in action information for the Vietnam war, the first e-mail, the first web site, as described in more detail below.

It is doubtful that we will be able to accurately quantify the extent of loss. If we could, the answer would be inextricably bound up with the issue of selec-tion for preservation. Are we assuming that we need to preserve most, perhaps even all, digital materials, rather than be selective? Do we have unrealistic

expectations about the quantity of information (and not just digital information) that we want to preserve? As a crude (and unlikely) example, if we assume that all e-mails need to be kept, then the loss of any becomes a problem. One argument is that anything significant is likely to be maintained anyway, so should we be concerned about the rest? Some of the examples which follow assume that the *first* (e-mail, web site, and so on) is worth preserving – but is this necessarily the case? It is, often, a view developed in hindsight. Betts tells us that Ray Tomlinson, principal engineer at BBN Technologies in Cambridge, Massachusetts did not save the first network e-mail ever sent in 1972 because 'it just didn't seem worth saving . . . Even if backup tapes did exist, they might not be readable. They were just mag tapes, and after seven or eight years, the oxide starts falling off, especially from tapes of that era' (Betts, 1999). Selection is noted in more detail in Chapter 4.

Specific examples, although few in number, provide an indication of how great the problem of loss or compromise of digital materials may be. The most often quoted, indeed overused, examples are those cited in the 1996 report of the Task Force on Archiving of Digital Information. Because they have been reported very widely since, they warrant quoting at some length. The report notes the case of the US Census of 1960.

> As it compiled the decennial census in the early sixties, the Census Bureau retained records for its own use in what it regarded as "permanent" storage. In 1976, the National Archives identified seven series of aggregated data from the 1960 Census as having long-term historical value. A large portion of the selected records, however, resided on tapes that the Bureau could read only with a UNIVAC type-II-A tape drive. By the mid-seventies, that particular tape drive was long obsolete, and the Census Bureau faced a significant engineering challenge in preserving the data from the UNIVAC type II-A tapes. By 1979, the Bureau had successfully copied onto industry-standard tapes nearly all the data judged then to have long-term value.

The report notes the effect of this well-publicized 'loss':

> the data rescue effort was a signal event that helped move the Committee on the Records of Government six years later to proclaim that "the United States is in danger of losing its memory." The Committee did not bother to describe the actual details of the migration of the 1960 census records. Nor did it analyze the effects on the integrity of the constitutionally-mandated census of the nearly 10 000 (of approximately 1.5 million) records of aggregated data that the rescue effort did not successfully recover. Instead, it chose to register its warning on the dangers of machine obsolescence in apocryphal terms. With more than a little hyperbole, it wrote that "when the computer tapes containing the raw data from the 1960 federal census came to the attention of NARS [the National Archives and Records Service], there were only two machines in the world capable of reading those tapes: one in Japan, and the other already deposited in the Smithsonian as a relic . . . Other examples . . . equally illustrate how readily we can lose our heritage in electronic form when the custodian makes no plan for

long-term retention in a changing technical environment. In 1964, the first electronic email message was sent either from the Massachusetts Institute of Technology, the Carnegie Institute of Technology or Cambridge University. The message does not survive, however, and so there is no documentary record to determine which group sent the path-breaking message. Satellite observations of Brazil in the 1970s, crucial for establishing a time-line of changes in the Amazon basin, are also lost on the now obsolete tapes to which they were written (Task Force on Archiving of Digital Information, 1996, pp.2–3).

Rothenberg reminds us of some examples noted in a 1990 US House of Representatives report:

> hundreds of reels of tape from the Department of Health and Human Services; files from the National Commission on Marijuana and Drug Abuse, the Public Land Law Review Commission, the President's Commission on School Finance, and the National Commission on Consumer Finance; the Combat Area Casualty file containing POW and MIA information for the Vietnam war; herbicide information needed to analyze the impact of Agent Orange; and many others (Rothenberg, 1999b, pp.1–2).

He reiterates the paucity of specific examples and offers a reason:

> To date there appear to be few documented cases of unequivocal loss, but this may simply reflect the fact that documents or data that are recognized as important while they are still retrievable are the ones most likely to be preserved (Rothenberg, 1999b, p.2).

Another example frequently cited is the BBC Domesday Project. This project captured the national imagination in the UK and resulted in a multi-media version of the Domesday Book on videodisc, produced to mark the 900th anniversary of the original. It became inaccessible in the late 1980s as the hardware platform for which is was developed, the BBC microcomputer, became obsolete. The data has since been restored using emulation techniques (*Digital Domesday Book Unlocked*, 2002; CAMiLEON, 2002?; Mellor, 2003). This project is also noted in Chapter 7.

Cook's 1995 call to action gives some Canadian examples of data loss where recordkeeping practices were ignored in the move to online recordkeeping. Cook noted that 'the National Archives of Canada ... found not only that 30 out of 100 randomly chosen policy documents could not be found in the government's paper records, but also that no system was in place to safeguard the contents of the electronic system'. Ontario Hydro's nuclear power plant failed to keep adequate electronic or paper records of its construction and operation (Cook, 1995).

Some disciplines and industries have investigated their own practices and here the evidence is somewhat firmer. One of these is archaeology in the United Kingdom. The growth in computer use and the increase in digital data sets used by archaeologists resulted in the establishment of the Archaeology Data Service, part of the AHDS (Arts and Humanities Data Service), whose web site provides

studies. One such study is of the Newham Museum Archaeological Service archives, described here as an indication both of the extent of data loss and of the reasons why data is lost (Dunning, 2001). The Newham Museum Archaeological Service closed suddenly in 1998. Data on the hard disks of its computers were transferred onto floppy disks and were presented to the Archaeology Data Service (ADS) in the hope that the data could be retrieved. There were 239 disks with a total of 6350 files containing graphics, text and data in a variety of formats. Twenty-five files were corrupted and 12 were unrecoverable. However, the lack of documentation made much that was recovered unusable for archaeological purposes because the data made no sense. This case study teaches us that

> The loss of data from the Newham Archive is as much to do with poor project planning as it is to do with preservation . . . Preserving and documenting data should not be an additional chore at the end of a project, but an on-going process that is integrated into the creation of the data (Dunning, 2001).

Scientific data have been the focus of many studies. One is *Preserving Scientific Data on Our Physical Universe* (National Research Council, 1995), which indicates what scientific data were then available from United States scientific observation and what they have been and might be used for. It includes some comments about what has survived. Space physics data are among these. This area of research has generated about 50 gigabytes of data per year over the last 30 years and much of this was 'archived' by sending the tapes, also sometimes relevant documentation, to the NSSDC (National Space Science Data Center). However, 'there are many data at the NSSDC that most scientists would find difficult to use with only the information originally supplied' (National Research Council, 1995, p.21). This report also notes the Landsat data, a large part of which resided 'on tapes that cannot be read by any existing hardware. Recent data-rescue efforts have been successful in getting older data into accessible form, but these efforts are time-consuming and costly' (National Research Council, 1995). Humphrey gives examples of the research data generated by research funded by the Social Sciences and Humanities Research Council of Canada. Of a set of 150 studies from 1977 to 1980, only datasets from three could be located in 1998 (Humphrey, 2003).

Other examples come from a range of areas. For electronic journals, Warner notes 'the irony of the demise' of an archive established to archive electronic journals due to lack of funding. The CICNet Journal Archive archived electronic journals from 1991 to 1997 but, according to Warner, has now vanished (Warner, 2002, quoting Wiggins, 2001). Warner also notes 'the response to a query from Science Direct [Elsevier's web platform] was that at least 2% of its electronic journal content is missing' (Warner, 2002). Commercial data recovery companies provide snapshots. The web site of Authentec International provides six case studies of loss of data, much of which were subsequently recovered: for example, 15 per cent of the data on two diskettes chewed by a dog were not recoverable, and for a laptop computer damaged in the cargo hold of a plane 36 out of 112 bad sectors of its hard drive were unrecoverable (Authentec International, 2003). dataVault, citing research from CBL, Gartner Research, Meta Group, and SunGard Data Systems, reports that 94 per cent of all PC users surveyed experienced 'at least one significant data loss, on average, once a year', that fewer than one per cent

of companies perform daily data backups, and only 20 per cent of those that back up their data store backups offsite (Global Data Vault Inc., 2005). Although the web site of Ontrack Services does not provide specific examples of data loss, it does indicate the high costs of data recovery and the causes of data loss (Ontrack Data Recovery, 2004). While studies of document persistence on the web (such as Koehler, 2004) are primarily studies of access to data, they also throw some light on how much data is lost. Smith examined the longevity of a number of Australian winery web sites and concluded that, although a high percentage of them were still accessible, there was a significant loss of data within the sites (Smith, 2004). That the Electronic Literature Organization has mounted a project to identify threatened and endangered electronic literature and promote its protection (Electronic Literature Organization, 2005) is another example of action motivated by the assumption that digital materials have been lost, or are, at the very least, are threatened with loss.

Current state of awareness of the digital preservation problem

One cause of data loss is lack of awareness about the need for proactive thinking and interventionist action if we hope to preserve digital materials. What is the current state of awareness of the problem?

Wheatley describes the lack of understanding by IT industry vendors as demonstrated during the BBC Domesday Project. Commercial vendors offered to assist this digital preservation project:

> [one] offered us a special polymer that they guaranteed would preserve a CD-ROM for 100 years. They were unable to answer how we would preserve a CD-ROM player for that length of time.

Wheatley concludes that 'the myth that long-lived media equals long-lived preservation is still worryingly popular' (Abbott, 2003, p.10).

The general consensus is that levels of awareness of digital preservation are not keeping pace with the expansion in digital resource creation. There is general awareness of the problem but not much beyond that, except in a few isolated discipline areas, such as geoscience, where considerable specialist expertise is to be found. This is related to a continuing lack of appreciation by information professionals that preservation – of any materials at all – should be a central professional concern. Marcum, in describing the awareness of preservation in American academic libraries over the last two decades, notes little change, apart from the increasing specialization of preservation activities:

> Preservation treatments are increasingly sophisticated and effective, yet preservation as a core activity of libraries remains less visible than others such as cataloging and users surveys (Marcum, in Kenney and Stam, 2002, p.v).

Views of the current situation, especially in regard to digital preservation, corroborate Marcum's statement. Lukesh notes 'the apparent hole in the literature'

on the subject which seems, she suggests, 'not to have risen to a level of importance for historians, biographers, librarians and archivists' (Lukesh, 1999). It remains too often the concern of only a small number of information professionals, as Brindley, the British Library's Chief Executive, pointed out during her keynote address to a digital preservation conference in 2000:

> digital preservation is quite clearly not attention grabbing enough . . . to have yet brought seriously on board authors, publishers and other digital content creators, funding agencies, senior administrators, hardware and software manufacturers, and so on. Take a look at the conference attendance list if you do not believe me (Brindley, 2000, p.127).

Others are more sanguine. The level of awareness is increasing, for instance among scholars, 'who were "keen to do the right thing" but frequently lacked the clear guidance and institutional backing' to give them confidence about what they should do. It continues to be low among funding agencies and senior administrators who set policy and strategic directions. More guidance is needed for a wide range of people with varying levels of awareness about and expertise of digital preservation (Jones and Beagrie, 2001, p.3). Staff members of US college and research libraries are aware of the issues in general terms, but lack specific knowledge about how to address it. Their levels of awareness form a spectrum; at one end are 'those who are only beginning to appreciate the impact of digital preservation at the local level', and at the other are 'those who are taking concrete, if tentative, steps to meet the challenge' (Kenney and Stam, 2002, p.9).

These low levels of awareness pose a continuing threat (NSF-DELOS Working Group on Digital Archiving and Preservation, 2003, p.i). This point is specifically noted in Articles 3 and 4 of the UNESCO *Charter on the Preservation of the Digital Heritage.* 'Attitudinal change has fallen behind technological change' with the consequence that 'the threat to the economic, social, intellectual and cultural potential of the heritage – the building blocks of the future – has not been grasped' (UNESCO, 2004, Article 3). To address this threat 'awareness-raising and advocacy . . . alerting policy makers and sensitizing the general public to both the potential of the digital media and the practicalities of preservation' are urgent (UNESCO, 2004, Article 4).

In an Australian example discussing digital preservation at the Australian Centre for the Moving Image, Pockley notes, in relation to preservation metadata, that

> our stakeholders [individuals and industry] do not understand the need for authoritative metadata; have deeply entrenched paper-based or industry work practices; are uncertain about the 'ownership' of information; are not used to working and thinking in an electronic environment.

Collaboration is slow because institutions 'have failed to raise understanding beyond a conceptual level' (Pockley, 2002). Although this example relates specifically to creating metadata, it certainly applies to other aspects of digital preservation.

Conclusion

This chapter has dwelt on the question of who should take responsibility for digital preservation. As well as the organizations who have traditionally been concerned with preservation (libraries, archives, museums), the preservation of digital materials must involve many other stakeholders. Their input is required to 'decide what is kept, negotiate rights management, locate and manage the resources and develop the procedures and policies' (Kerry, 2001, p.17). How this is to be done is not yet clear. This chapter has also considered the question of how much digital material we have lost. Although the parameters of loss are very unclear, there is little doubt that the amount of digital materials that we are unable to access, or able to access only after considerable effort and expense, is significant and will continue to increase unless action is taken. Our current ability to do this is hampered by the widespread lack of awareness of the problem. The next chapter looks more closely at why there is a problem by considering the nature of digital materials.

Chapter 3

Why There's a Problem:
Digital Artifacts and Digital Objects

Introduction

Old bit streams never die – they just become unreadable (Rothenberg, 1999b, p.2)

On the surface, digital technology appears to offer few preservation problems. Bits and bytes are easy to copy, so there should be no problems in developing an unending chain of copies into the future, and having copies all over the world in case of disaster. However, we already know that the reality is not so simple and that there are very significant technical and management problems. The two main factors leading to inaccessibility of digital information: changing technology platforms and media instability, are relentless, with the potential to render digital information useless (Webb, 2000b).

Why are digital materials different? What are the modes of digital death? The answers to these questions (posed in Jones and Beagrie, 2001, p.19 and Wiggins, 2001) provide a helpful framework for understanding why digital preservation poses major challenges. In essence there are three sets of challenges:

- those relating to the nature of the media that are used to store digital materials;
- those resulting from the technologies required to create, store and access digital materials
- those characterized in this book as challenges to the integrity of digital materials.

The issues are complex and are interrelated (Rothenberg, 1999a, p.1).

Rothenberg's influential statement about the issues is worth quoting at length, as it neatly describes the range of issues and their close relationship:

It is now generally recognized that the physical lifetimes of digital storage media are often surprisingly short, requiring information to be 'refreshed' by copying it onto new media with disturbing frequency. Moreover, most digital documents and artifacts exist only in encoded form, requiring specific software to bring their bit streams to life and make them truly usable; as these programs (or the hardware/software environments in which they run) become obsolete, the digital documents that depend on them become unreadable – held hostage to their own encoding. This problem is paradoxical, given the fact that digital documents can be copied perfectly, which is often naively taken to mean that they are eternal ... In addition to the technical aspects of this problem, there are administrative, procedural, organizational, and policy issues surrounding the management of digital material. Digital documents are significantly different from traditional paper documents in ways that have significant implications for the means by which they are generated, captured, transmitted, stored, maintained, accessed, and managed ... [mandating] new approaches to accessioning and saving digital documents to avoid their loss. These approaches raise nontechnical issues concerning jurisdiction, funding, responsibility for successive phases of the digital document life cycle, and the development of policies requiring adherence to standard techniques and practices to prevent the loss of digital information. However, few of these nontechnical issues can be meaningfully addressed in the absence of a sound, accepted technical solution to the digital longevity problem (Rothenberg, 1999a, p.2).

Current trends in information management and delivery militate against the effective preservation of digital materials. The sheer number of digital materials now in existence threatens to overwhelm and the rate at which they are being created is increasing (as noted in Chapter 1). The ownership of intellectual property rights in digital materials is often complex (consider, for instance, a film with scriptwriters, actors, directors and many other interests) and these rights need to be negotiated before libraries and archives can legally preserve some digital materials. New formats continue to proliferate. Many libraries are focusing their attention more on short-term goals with the consequence that collection maintenance over the longer term is not adequately resourced (Webb, 2000b).

This chapter is primarily concerned with the reasons why digital materials are difficult to maintain access to into the future – that is, to preserve. It examines the causes of deterioration of the media, noting both structural and manufacturing causes and those relating to the storage and handling of the media. It considers the reasons for technological obsolescence and its consequences, such as the loss of functionality of access devices, manipulation and presentation capabilities, and contextual information. This chapter does not include strategies and techniques used to address the deterioration of digital materials – that is the focus of Chapters 6, 7 and 8 – but they are mentioned in passing. Case Study 1, in the Appendix, examines digital storage at the National Film and Sound Archive and illustrates the topic of media longevity.

Modes of digital death

Jones and Beagrie compare the challenges involved in the preservation of digital materials – 'maintaining access to digital materials over time' – with preservation of paper-based materials. First, they note the implications of the technology-related challenges – the dependence on machinery for playback of digital materials and the speed at which this technology changes – which call for more immediate preservation action than paper-based materials, for which a period of inaction is not usually harmful. They point out that preservation of digital materials cannot be sporadic: 'a continual programme of active management is needed from the design and creation stage', and this, in turn, results in changing roles of stakeholders and in different kinds of inter- and intra-institutional collaboration. Secondly, the issues resulting from 'the fragility of the media' are noted and, thirdly, the challenges of 'ensuring the continued integrity, authenticity, and history' of digital materials, which are a consequence of the ease of their alteration. Jones and Beagrie also describe some of the implications arising from the nature of digital materials: if proactive preservation is not implemented at an early stage in the life of the digital materials, they will be lost or unusable in a short period of time. This has significant implications for allocation of preservation resources (Jones and Beagrie, 2001, p.19).

An Australian statement of the challenges of digital preservation amplifies Jones and Beagrie's statement. The National Library of Australia's Digital Preservation Policy (NLA, 2002) suggests that the challenges fall into three categories: technology-related challenges, media-related issues, and the challenges of ensuring integrity and authenticity. The technology-related challenges include 'rapid changes in the availability of hardware, software and other technology required for access'. The media-related issues are 'widespread use of relatively unstable media' and 'the diverse and frequently changing range of file formats and standards'. The challenges of ensuring integrity and authenticity include 'uncertainty about the significant properties that must be maintained for different digital resources' and 'new models of "ownership" that impose property and other rights-based constraints'. The National Library of Australia's policy also pays attention to some of the more general issues that have an impact on the preservation of digital materials, such as their large quantity and rapid growth-rate, the 'recurrent, critical and demanding nature of the threats to accessibility', and uncertainty about viable strategies and techniques to apply. Other challenges and uncertainties are the resource implications ('the high costs of taking action', 'administrative complexities in ensuring timely and cost-effective action is taken over very long periods of time') and the roles of many stakeholders, which are, as yet, ill-defined.

Examples to illustrate these challenges are readily located (some in Chapter 2). Ontrack Data Recovery, a large US-based data recovery company, suggests that hardware and system problems provide by far the largest number of reasons for customers to approach them (56 per cent), followed by human error (26 per cent). Software corruption or program problems, computer viruses and natural disasters are the other reasons listed (Ontrack, 2003). Hedstrom and Montgomery's 1998 survey of Research Libraries Group members requested details of current storage medium and format, the date at which the earliest digital materials were written to their current storage medium, and whether

they held digital materials that could not be accessed. Their survey reported that the oldest digital materials were written to their current carrier in the late 1970s, although most carriers were only one to three years old. Fifteen of the 36 institutions responding to the survey could not access some digital materials they held because they lacked 'the operational and/or technical capacity to mount, read, and access' them. This was especially the case with floppy disks and open-reel nine-track tape, and to a lesser degree with 'CD-ROMs, magneto-optical disks, DDS DAT tape, 3480 cartridges, and various audio and video formats' (Hedstrom and Montgomery, 1999, pp.11–12).

Figure 3.1 lists the threats to digital continuity ('continuity of production, continuity of survival, continuity of access') identified in the UNESCO *Guidelines*. While not all of these threats are specific to digital materials, the list serves as a useful reminder of the magnitude of the challenge that we face in preserving digital materials.

- The carriers used to store these digital materials are usually unstable and deteriorate within a few years or decades at most
- Use of digital materials depends on means of access that work in particular ways: often complex combinations of tools including hardware and software, which typically become obsolete within a few years and are replaced with new tools that work differently
- Materials may be lost in the event of disasters such as fire, flood, equipment failure, or virus or direct attack that disables stored data and operating systems
- Access barriers such as password protection, encryption, security devices, or hard-coded access paths may prevent ongoing access beyond the very limited circumstances for which they were designed
- The value of the material may not be recognised before it is lost or changed
- No one may take responsibility for the material even though its value is recognised
- Those taking responsibility may not have adequate knowledge or facilities
- There may be insufficient resources available to sustain preservation action over the required period
- It may not be possible to negotiate legal permissions needed for preservation
- There may not be the time or skills available to respond quickly enough to a sudden and large change in technology
- The digital materials may be well protected but so poorly identified and described that potential users cannot find them
- So much contextual information may be lost that the materials themselves are unintelligible or not trusted even when they can be accessed
- Critical aspects of functionality, such as formatting of documents or the rules by which databases operate, may not be recognised and may be discarded or damaged in preservation processing.

Figure 3.1 Threats to Digital Continuity (From UNESCO, 2003, p.32)

Digital artifacts

The term *digital artifact* is here used to mean the carrier, or medium, on which digital data is recorded. Common examples are diskettes, CDs and magnetic tapes. The key issue with keeping digital artifacts can be concisely stated:

> digital materials are especially vulnerable to loss and destruction because they are stored on fragile magnetic and optical media that deteriorate rapidly and that can fail suddenly from exposure to heat, humidity, airborne contaminants, or faulty reading and writing devices (Hedstrom and Montgomery, 1999, p.1).

Digital artifacts are Thibodeau's *physical objects*, 'simply an inscription of signs on a medium' whose preservation is necessary but not sufficient for effective preservation of digital materials (Thibodeau, 2002, pp.6–7).

Rothenberg brought the issues associated with the short life-span of digital artifacts to public attention in his 1995 article in *Scientific American* (Rothenberg, 1995, expanded in Rothenberg, 1999b). He pointed out that the physical lifetimes of digital artifacts are 'often surprisingly short' (Rothenberg, 1999a, p.2) but that the actual life-span was irrelevant because it usually exceeded the length of time during which the media could be read. This is a consequence of the rapid obsolescence of hardware and software in a computing environment driven by rapid decreases in storage density and computing costs, and rapid increases in computer speeds. His conservative estimates (Rothenberg, 1995) were:

Magnetic tape	1 year	equipment obsolescence 5 years
Videotape	1–2 years	equipment obsolescence 5 years
Magnetic disk	5–10 years	equipment obsolescence 5 years
Optical disk	30 years	equipment obsolescence 10 years.

A more recent comparison of data carriers is provided in the UNESCO *Guidelines*, noted in Figure 3.2.

Carrier	Current storage capacities per unit	Speed of increase in capacity	Expected usable life of single unit	Other comments
Magnetic disk (eg hard disk)	up to 200 gigabytes	doubling every 12–18 months	around 5 years	generally fixed media
Magnetic tape	up to 200 gigabytes	doubling every 12–18 months	around 5 years	portable media suitable for backup
Optical disk (CD, DVD)	up to 4 gigabytes	slow because not used for very large archives or backups	wide range from say, 5 years for low quality products to several decades for high quality products	portable media. unit costs low; low-cost consumer equipment widely available

Figure 3.2 Comparison of Data Carriers (From UNESCO, 2003, p.117)

Current advertising in the popular press suggests differently. The readers of popular computing magazines or the computer supplements of daily newspapers are still likely to believe that their digital data will be safe and accessible in the future if it is recorded onto 'archival' quality CD. But the reality is otherwise. 'The short lifetimes of eight-inch floppy disks, tape cartridges and reels, hard-sectored disks, and seven-track tapes ... demonstrate', Rothenberg suggests, 'how quickly storage formats become inaccessible' (Rothenberg, 1999a, p.7). One implication of this short life-span is that digital information must be refreshed 'with disturbing frequency' (Rothenberg, 1999a, p.2).

The large quantities of materials that are to be preserved exacerbate the challenges. Bradley provides an estimate of the quantity of sound recordings on analogue magnetic tapes that are considered to be of long-term value. These analogue tapes have been, or very likely will be, transferred to a digital medium. It is estimated that there are at least 20 million hours of tapes in European broadcast archives, and perhaps 100 million hours in broadcast collections internationally. There is likely to be as much again in universities and research institutions (Bradley, 2003). Bradley has described in detail the ways in which sound archivists have had to come to terms with both the quantity of digital materials and changing technologies, providing the example from the National Library of Australia, which over five years moved from analogue tapes to a digital mass storage system for preservation of its sound recordings (Bradley, 2003).

Howell suggests six factors that contribute to the rapid deterioration of digital artifacts: manufacturing quality of the medium; how heavily the medium is used; how carefully it is handled; the temperature and humidity levels at which it is stored; the quality of its storage environment; and the quality of the equipment used to access the medium (Howell, 2001, p.139). These are worth examining in more detail.

The manufacturing quality of the medium is a key factor simply because all materials deteriorate. In the words of David Bearman, it is 'a fact of physics', a fact that we must accept as a major limitation on digital preservation, and the 'outside boundary beyond which we cannot rationally plan to retain the information without transforming the medium' (Bearman, 1998, p.24). (We can, however, attempt to influence manufacturers so that they improve the quality of their product to meet archival and preservation requirements). Knowledge of the physical and chemical makeup of digital artifacts and of the processes of their deterioration is helpful in making decisions about migration. One of the keys to prolonging the life of digital artifacts is the provision of storage conditions that will slow down the rate of deterioration.

Howell makes the point that many digital artifacts are 'rotating technologies' (Howell, 2001, p.138). They have moving parts and are, therefore, subject to wear, which can damage the media. For example, even a small rearrangement of the magnetized particles on a magnetic tape, perhaps caused by accidental physical contact with a part of the playback equipment, can result in loss of data; this is often sufficient to corrupt the whole file. The maintenance of the recording and playback equipment to a high standard minimizes the likelihood of this occurring. Similarly, inappropriate handling of digital artifacts can result in physical contact with the part of the media that records the data. An example is touching the surface of a CD-ROM and leaving an oily residue which can corrupt the files stored on it.

One of the significant changes from the pre-digital preservation paradigm is the realization that digital artifacts have little or no artifactual value. This point is explored in the 2001 report of the Task Force on the Artifact in Library Collections. Artifacts are valued in library and archives collections because their physical form demonstrates 'the *originality, faithfulness* (or authenticity), *fixity,* and *stability* of the content' (Task Force on the Artifact in Library Collections, 2001, p.vi); the artifact is significant for research purposes because it provides this evidence. When the information is reformatted, as in microfilming a book printed on brittle paper or copying digital data from an obsolete format to a current one, these evidentiary qualities are lost. Because deterioration of digital materials is, as already noted, 'a fact of physics', which makes migration a fact of digital preservation life, the artifact itself cannot demonstrate qualities such as originality, authenticity or fixity. Other mechanisms are required to demonstrate these evidentiary qualities. This is a major change from firmly entrenched pre-digital paradigm thinking, and we are only slowly changing our professional mindsets to accommodate the necessary changes in practice.

The following examples of magnetic tape and optical disks illustrate many of the factors that contribute to the deterioration of digital artifacts. Other media types in current use, such as magneto-optical disks and hard disks, and emerging media types, such as HD-ROSETTA etched metal disks, could have been noted. However, the general principles that are identified for the two media types described also apply to these.

Magnetic media

This section is based on the writings of Van Bogart (1995), Ross and Gow (1999), and the International Association of Sound and Audiovisual Archives Technical Committee (2004), which can be referred to for more detailed information.

Magnetic tapes have been used for digital data storage from the 1960s. Magnetic media (tape in reels and in housings such as cassettes and cartridges, and disks) are in common use today because they are versatile and cheap, and can provide higher data densities than other media. They are available in a large number of formats: the IASA guidelines for digital audio objects provide the specifications of 23 common data tape formats (International Association of Sound and Audiovisual Archives Technical Committee, 2004, p.58), but the number is higher, especially if formats not in current use are also counted.

Magnetic tapes store information in the alignment of magnetic particles suspended within a polymer binder, which sticks the magnetic information-carrying layer to a substrate and provides a smooth surface to assist the tape to run through playback equipment smoothly. Protection of this structure determines the longevity of the tape. If humidity levels are too high, the binder softens or becomes brittle through hydrolysis, resulting in the 'sticky tape' phenomenon where the binder sticks to the equipment's tape heads. Data loss from dropout is one result of 'sticky tape'. The magnetic particles, which store data in the direction of the magnetism in them, vary in their magnetically stability. The substrate is usually made of chemically stable polyester film (Mylar, polyethylene terephthalate, or PET). Mechanical problems affect the substrate, such as stresses on the tape caused by fluctuations in temperature and humidity levels in storage areas, which result in mistracking during playback. The substrate can also be stretched if the tape is not appropriately stressed when it is wound or

rewound. Other factors that affect data loss include the quality and maintenance of tape recording and playback devices.

The longevity of magnetic tape can be improved by attending to its care and handling. Appropriate storage is essential for minimizing deterioration through binder hydrolysis, which is a result of excessive moisture content of the tape. The rate of hydrolysis can be reduced by lowering humidity levels and temperatures in tape storage areas. Magnetic pigments also degrade more slowly at lower temperatures. Also important is that temperature and humidity levels are kept constant and stable. Storage at temperatures that are too high (above 23°C, suggests Van Bogart) increases dropout because the tightness of the tape packing is increased; this, in turn, increases tape distortion. Increased tape-pack stresses also occur as the tape absorbs moisture and expands at relative humidity levels greater than about 70 per cent. Temperature and relative humidity levels that are too high also promote fungal growth. Attention should also be paid to maintaining good air quality, and to reducing dust and debris. Conditioning (acclimatization) is also required if tape is stored in an environment that differs from that in which it is used. (Further information about the care and handling of magnetic media is available in Chapter 7 and in Van Bogart, 1995.)

An indication of the life expectancy of some common data tapes is provided in Figure 3.3. The important point to note here is the effect of different relative humidity (RH) and temperature levels on the life expectancy of digital artifacts.

A study carried out for the U.S. National Archives and Records Administration (NARA) examined the stability and life expectancy of three high-density magnetic tape types. All three 'demonstrated an impressive ability to deliver reliable data'. Their projected life expectancies were determined to be well outside NARA's requirements. However, a word of caution was sounded: all products suffered some failure during the study. The report notes: 'As good as the technology is today, failures can and do occur' (Arkival Technology Corporation, 2002, p.4).

Manufacturers of digital media have concerns that differ from those concerned with digital preservation. Manufacturers are primarily motivated by producing quantity at the lowest cost in high-volume, consumer-driven markets, and by providing new, improved products on a regular basis. The rate of change is rapid: the IASA guidelines for digital audio objects note that 'all of the main data tape formats have development roadmaps projecting upgrades every 18 months to 2 years' (International Association of Sound and Audiovisual Archives Technical Committee, 2004, pp.54–55).

Medium	25% RH 10°C	30% RH 15°C	40% RH 20°C	50% RH 25°C	50% RH 28°C
D3 magnetic tape	50 years	25 years	15 years	3 years	1 year
DLT magnetic tape cartridge	75 years	40 years	15 years	3 years	1 year
CD/DVD	75 years	40 years	20 years	10 years	2 years
CD-ROM	30 years	15 years	3 years	9 months	3 months

Figure 3.3 Sample Generic Figures for Lifetimes of Media
(From Jones and Beagrie, 2001, Figure 7)

Optical disks

This section is based on the work Saffady (1993), Lieberman (1995), Byers (2003), Ross and Gow (1999), and the International Association of Sound and Audiovisual Archives Technical Committee (2004), which can be referred to for more detailed information.

The term optical disk is applied to a large number of media which share the characteristic of using laser light to record and retrieve bits from a data layer. Optical disks became available at the end of the 1970s, so we have over three decades of practical experience to draw upon. The IASA *Guidelines on the Production and Preservation of Digital Audio Objects* note 12 commercially available CD and DVD disk types with storage capacities ranging from 650 megabytes to 9.4 gigabytes (International Association of Sound and Audiovisual Archives Technical Committee, 2004, p.42).

All optical disks are structured in basically the same way, but differ to some extent in the way the data is recorded (Lieberman, 1995; Saffady, 1993). Read-only optical disks are produced by a laser which burns pits into a coating on a master disk. From this, another master is produced which is then used to stamp the disks on a plastic base or substrate. The substrate is coated with a thin layer of metal, and is then covered with a protective polymer layer. Recordable optical disks are of two types: record-once (CD-R, DVD-R), and rewritable (CD-RW, DVD-RW). These use different methods for recording data on the disk. Record-once disks use a dye process, in which the laser light alters the reflectivity of the dye layer so that it is read as either reflective or non-reflective. Different kinds of dyes are used: cyanine (blue); phtalocyanine green); and azo (dark blue). Rewritable optical disks use a phase change (crystallization) process where the recording material (metal alloy film) is heated. Their archival qualities are not clear: 'no trustworthy analysis of the medium or long-term reliability has been undertaken' (International Association of Sound and Audiovisual Archives Technical Committee, 2004, pp.65–66). (Byers provides more detail about the structures of optical disks (2003, pp.5–12).)

The part of an optical disk that is most susceptible to deterioration is the metal reflecting layer, because the metal (usually aluminium in CD-ROM and CD-RW disks) is vulnerable to oxidization. Oxidization causes corrosion which obscures the distinction between pit and surface (that is, between 0 and 1, as digital data is stored) and data loss occurs. Metals or alloys less likely to oxidize (platinum or gold, for instance) are sometimes used, but their manufacturing costs are higher. The polymer base supporting the metal substrate may not be impermeable and may encourage oxidization by allowing oxygen to reach the substrate. This polymer base may also promote oxidization in small areas where rough spots or other defects do not provide full protection. Another cause of oxidization is failure of the protective polymer coating. It has also been reported that the ink used to print onto the disk causes the polymer coating to break down, leading to oxidization of the metal layer. For CD-R and DVD-R dye-based disks the density of the dye layer, the dye type, and the amount of exposure to light have an effect on life expectancy and error rates (Kunej, 2004, Slattery *et al.*, 2004).

As with magnetic tapes, the longevity of optical disks can be extended by improvements in manufacturing quality and attention to appropriate storage and handling. Although the temporary unreadability caused by fingerprints on

a CD-ROM is common knowledge, it is commonly assumed that optical disks are less vulnerable to damage caused by poor handling than are magnetic tapes. This is not the case: all digital artifacts need careful handling, and optical disks are no exception. The protective coating on a CD is thin and care must be taken to ensure that it does not break down. Storage at extremes of temperature and humidity can affect the physical structures: for example, because plastic substrates can absorb moisture, with oxidization of the metal layer following as a consequence, high humidity conditions should be avoided. For the same reasons should be storage areas in which temperature and humidity fluctuates, resulting in condensation, should be avoided. (Storage and handling are covered in Chapter 7.)

Early studies of optical disk longevity, such as that done at NARA in 1992, suggested that CD-ROMs would last for three to five years. Consequently NARA did not consider CD-ROM to be an acceptable medium for archival storage, although it was acceptable for use as a transfer medium for permanent records (Harvey, 1995). A 1992 report on accelerated aging studies of CDs, carried out by 3M with input from the National Media Laboratory, suggested 'a 25-year warranty that assures 100 year life-time at room temperature': that is, the lower estimate takes account of 'general storage fluctuation, as long as it's non-condensing', with 100 years as the lifetime in high quality storage conditions (Arps, 1993, pp.102–103). Saffady in 1993 summarized manufacturers' lifetime estimates for read/write optical disks, which ranged from 10 years to 100 years (Saffady, 1993, Table 5). Today we are much less sanguine: as noted in Figure 3.3, the periods can be significantly shorter (as little as 3 months) depending on storage conditions and there are other factors to be taken into account. Studies of the life expectancies of optical disks continue, and will need to continue, especially as new types of disk become available and enter into common use (Byers, 2003, p.13).

As has already been noted in the section on magnetic tape, there is a clear link between manufacturing quality of optical disks and their longevity. CD deterioration and its connection with manufacturing quality were recognized very early in their existence (Day, 1989). For reasons that include constantly changing production processes and narrow profit margins, the quality of blank CD-R and DVD-R can change from batch to batch and 'at best . . . can be described as variable' (International Association of Sound and Audiovisual Archives Technical Committee, 2004, p.67). When using optical disks in a preservation setting – for interim archival use, *not* for long-term storage – it is essential to monitor the quality of new disks before use. This applies equally to blank disks of any reliable brand.

A future for digital artifacts?

The implication of estimates of the longevity of digital artifacts is obvious: the limiting factor for digital preservation is not the lifetime of the media, but the obsolescence of the recording and playback technology, and changing standards. Australian examples illustrate this point. In 1990 the State Library of South Australia produced a videodisk containing about 54 000 images in PAL TV format. The images were played back using a videodisk player and display monitor controlled by a Macintosh computer; the computer hosted a database of image information which was displayed on its own monitor. In 1996 videodisk

images were digitized to produce JPEG files with an average file size of approximately 50 kilobytes. The image quality of these was adequate for web display but not for publication or detailed examination. Call number information was added to the images and these modified JPEG images were uploaded to a web server and linked to bibliographic records in the Library's catalogue. The videodisk continued in service until November 1997. Until recently the JPEG videodisk images were rescanned on demand where customers required high-quality digital images. The State Library of South Australia has recently begun a project to systematically rescan the remaining photographs which do not yet have a high-quality master. The images are now scanned as uncompressed TIFF files, at least 3000 pixels along longer dimension and file size at least six megabytes for greyscale and 18 megabytes for colour. The TIFF files are stored on the Library's 5.6 terabyte RAID mass storage system and on CD-ROMs stored off-site. A backup system for the RAID storage will be implemented, and the CD-ROM backup process may then be discarded. At Geoscience Australia the experience has been that many of the earlier media types used, such as high-density reel-based magnetic tapes, are unstable, with a life of 10 to 15 years, and the lack of standardization of storage formats for geospatial data has increased the difficulty of reading data archived 20 or more years ago. Although Geoscience Australia has developed techniques for recovering data from deteriorated magnetic tapes, the life of tapes is still a limiting factor, and they are forced to refresh their archival data much more frequently than they would like (Tresize, 2002).

It is, nevertheless, worth continuing to improve the ability of digital artifacts to store greater quantities of digital data securely for longer periods of time. Although it is well recognized that equipment and software obsolescence, rather than the longevity of digital artifacts, is the limiting factor, it is worthwhile committing research and resources to improving digital artifacts. For example, improvements offer potential reductions in storage costs if storage density is increased, and if the vulnerability of digital storage media to changes in temperature and humidity is reduced. Perhaps more importantly, improvements in media should reduce the frequency with which copying the data (refreshing or migrating it) must be carried out (Hedstrom, 1998, p.197). In addition, the appearance of new kinds of digital storage media and changes, sometimes subtle, in manufacturing techniques or in materials, can affect the length of life of some digital media significantly (NSF-DELOS Working Group on Digital Archiving and Preservation, 2003, p.10). Ongoing research into digital media is needed.

Until we succeed in improving digital media, we need interim responses to the challenges presented by deteriorating digital artifacts. One such response is proposed by Howell, who notes that 'it is pragmatic to keep crucial pieces of hardware and operating software tucked away from the IT department's upgrading programmes, for a few years at least' and provides an example from the State Library of New South Wales, where a 5½-inch floppy disk drive was maintained to provide access to legal deposit material in that format (Howell, 2001, p.142).

Harvey concluded in 1995 that 'there are at present too many unknowns to commit digital data to currently-available artefacts for anything other than short-term storage' (Harvey, 1995). This is still the case today. If we choose to preserve digital artifacts, then we do so in the knowledge that the measures we can take to do so are, as yet, short-term expedients.

Digital objects – more than digital artifacts

At the start of this chapter three sets of challenges for the preservation of digital materials were listed. The first set, the challenges relating to the nature of media that are used to store digital materials, is described above. This section examines the second and third sets: the challenges arising from the technologies required to create, store and access digital materials; and the challenges to the integrity of digital materials.

In the preceding sections the term *digital artifacts* has been used; this section uses the term *digital objects*. The distinction between these two terms is helpful in understanding the reasons why digital materials are difficult to preserve. The digital artifact is the physical storage medium, plus the bit-stream recorded on it. The digital object is more than that: it is the bit-stream, plus everything else that is needed to make sense of the bit-stream. For example, a digital object is likely to include information about the format of the data preserved in the bit-stream. The distinction noted in Chapter 1, between *physical objects* and *logical objects* – the terms used by the UNESCO *Guidelines* (2003) and by Thibodeau (2002) – is the key. *Physical objects* (our digital artifacts) are simply 'an inscription of signs on a medium' (Thibodeau, 2002, p.6) and have no concern with any meaning that is represented by the data in the bit-stream. *Logical objects* (our digital objects) are

> processable units ... according to the logic of some application software. The rules that govern the logical object are independent of how the data are written on a physical medium ... A logical unit is a unit recognized by some application software. This recognition is typically based on data type [for example, ASCII or other more complex formats] ... to preserve digital information as logical objects, we have to know the requirements for correct processing of each object's data type and what software can perform correct processing (Thibodeau, 2002, p.7).

To preserve the digital object, then, we need to preserve not merely the bit-stream, but also the means to process that bit-stream: the access devices that let us read the bit-stream from the digital media on which it is stored; the software that allows us to manipulate and present the information represented by the data carried by the bit-stream; the documentation so that we can understand the data formats used and the software; and the contextual information that is essential to ensure the integrity and authenticity of the information. Ross lists the main factors that 'can render resources non-interpretable' as degradation of the media, loss of functionality of access devices, loss of manipulation capabilities, loss of presentation capabilities, weak links in the documentation chain, and loss of contextual information (Ross, 2000, p.12). His terms are used hereafter in this chapter. As the UNESCO *Guidelines for the Preservation of Digital Heritage* bluntly put it, 'Digital materials cannot be said to be preserved if access is lost' (UNESCO, 2003, p.22).

Loss of functionality of access devices

The short life-spans of digital media are not the only reason that digital preservation remains a challenge. Another is what is commonly referred to as techno-

logical obsolescence, where 'the playback devices necessary to retrieve information from the media become obsolete or . . . the software that translates digital information from machine- to human-readable form is no longer available' (Hedstrom and Montgomery, 1999, p.1). Even if the digital media on which the bit-stream is stored remains in usable condition and the bit-stream stored on it is intact, the almost certain likelihood is that the drive, software driver or computer will no longer be available to access it.

Australia academic Tara Brabazon describes this situation vividly:

> I still own my first laptop computer, bought in 1991. It is an Olivetti M316. It functions, although the battery no longer does. It has a 40 MB hard drive, which is not large enough to install a current version of Windows 98, let alone the ability to use the Windows environment to prepare documents. That is probably quite fortunate, as the 'F' key does not work, and most of the letters on the keyboard have been scratched off through excessive use. There is no possibility or space for a modem connection. It does, however, have an expansion slot that is filled with the full-card for my Hewlett Packard flat-bed scanner of the same period. It only scans in black and white, and in enormous TIF files, rather than JPEG or GIF. I actually maintained this computer, existing alongside my Sharp PC-M200, until February this year, because I needed the scanning technology and had not yet bought a scanner for my new computer. Once this hardware was bought, the Olivetti computer and scanner became redundant and were 'taken over' by my father, who is teaching himself to use computers through Winders [*sic*] 3.1 and Word 5. He is managing the technology very well, placing marked stickers over the keys without letters. The 'F' is still causing problems.
>
> Between my current computer and the Olivetti, I owned an X-Press 420. The hard drive on this computer had a 'meltdown' in April 1998, and five of the keys – the F (there is a trend here), G, S, L and O – did not work. This computer was still 'living' in my house for the years after it was replaced. I would not throw it away, even though it could not be switched on . . . I had a profound hatred for this machine . . . Even though I felt this computer was the digital equivalent of Damien, son of Satan, I could not throw something that had cost me $5570 into the weekly garbage. . . . Burglars robbed my house last December . . . they took the obsolete computer that will not even power up for them (Brabazon, 2000, p.156).

Brabazon does not mention another kind of technological obsolescence: the obsolescence of digital storage media, where the media are no longer manufactured and cannot be purchased, drives to access the media are no longer produced, and software needed to control the drives (in the form of device drivers) and to read the data in the formats recorded on the media is no longer written (Rothenberg, 1999a, p.7).

The understanding of the general public (as presented by journalists) about digital preservation still has a long way to go. A 2001 newspaper article noted the sale by Booker Prize-winning Australian author, Peter Carey, of his papers and his laptop computer to the State Library of Victoria:

> The State Library Foundation has bought the laptop as part of a package of Carey papers that effectively tells the inside story of the creation of [the novel] True History of the Kelly Gang ... The laptop will feature in a Peter Carey section of a permanent exhibition ... [it] contains at least a dozen drafts of the novel. Umpteen e-mails (Sullivan, 2001).

The implication in this article is that keeping the computer itself is sufficient to preserve its contents. We are now much more aware of the naivety of this approach. Different strategies are needed.

The information professions have little or no control over this rapid rate of technological obsolescence, which is driven by the constantly changing economic demands of the information technology marketplace. Conway, writing about digitizing, informs us that digital project managers 'ultimately ... have no control over the evolution of the imaging marketplace' (Conway, 2000). And Rothenberg alludes to another reason, the influence of those working in the computer industry, who have 'become inured to the fact that every new generation of software and hardware technology entails the loss of information, as documents are translated between incompatible formats' (Rothenberg, 1999a, p.4).

Loss of manipulation and presentation capabilities

The crux of the problem of preserving digital materials is that they are 'inherently software-dependent' (Rothenberg, 1999a, p.8). The bit-stream can represent any of a very wide range of content and formats – often text or data, but also images, audio and video, 'animated graphics, and any other form or format, current or future, single or combined in a hypermedia lattice of pointers whose formats themselves may be arbitrarily complex and idiosyncratic' (Rothenberg, 1999a, p.8). This data requires software to interpret it, to turn it into information:

> This point cannot be overstated: in a very real sense, digital documents exist only by virtue of software that understands how to access and display them; they come into existence only by virtue of running this software (Rothenberg, 1999a, p.8).

Meaning is preserved only by preserving 'the ability to reconstruct streams of bits in a meaningful way that computers and humans can interpret, use, repurpose, and understand at any arbitrary point in the future' (Workshop on Research Challenges in Digital Archiving and Long-term Preservation, 2003, p.6). But software is becoming increasingly complex and becomes obsolete rapidly.

Besser divides the preservation challenges of this dependence on software into the viewing problem, the scrambling problem and the translation problem (Besser, 2000). Without appropriate software, the digital file cannot be displayed appropriately on the screen, so that 'all we will be able to see is gibberish'. Besser uses the example of files created in WordStar, once common word-processing software, which cannot be viewed using today's versions of Microsoft Word. The scrambling problem comprises the complications that result from the use of compression techniques to reduce the size of digital files so that they can be stored and transmitted more economically. These add further complexity to the encoding of files, adding another layer of coding to be recognized and allowed for. The use of lossy data compression techniques discard data, which cannot be recreated. Besser's translation problem refers to the

inability of applications software to read files created for use in its own earlier versions: 'in fact', he notes, despite the bit-stream being identical, 'the very reason for converting the file is because we are unable to successfully sustain that application's environment over time' (Besser, 2000).

Besser also notes what he calls the inter-relation problem. In the digital world material is typically inter-related to other material, a common example being web materials that often contain sections hyperlinked to other web-based materials. This raises an important question: what are the boundaries of a web page? That is, where does one stop preserving? Is it sufficient to preserve only the main web page and not the links to other web sites? (Besser, 2000). Chapter 4 explores this further.

Weak links in the documentation chain and loss of contextual information

Description is the key to converting a digital artifact to a digital object – description of three aspects: the bit-stream itself; the systems required to access the bit-stream; and the context in which the bit-stream was created and has been maintained.

From a museum curator's point of view, objects that have become separated from information about them are worthless, their value being 'little more than an aesthetic or curio value' (Hebditch, 1998, p.viii). Not only must this information about the objects be actively generated and recorded, 'the systems that exist to maintain this knowledge and to transfer it to the future' must also be maintained, for without them the objects become valueless (Hebditch, 1998, p.viii). Museum objects and digital objects have many parallels, not the least of which is the need for documentation about them to remain available so that their meaning continues to be apparent in the future.

As the report of the NSF-DELOS Working Group on Digital Archiving and Preservation puts it, 'There are two problems related to the preservation of digital entities that need generic solutions – interpretability and trustworthiness' (2003, p.iv). Interpretability is maintained by preserving the means to access the bit-stream and make sense of it, or preserving information about it that allows us to recreate the means. This requires preserving documentation about the data formats used and about the software.

An unbroken documentation chain is considered an essential requirement for determining whether a digital object can be trusted. 'Trustworthiness' of the digital object is based on its authenticity and its integrity, that it is what it purports to be, and that it is complete and has not been altered or corrupted (Ross, 2002, p.7). Authenticity and integrity are considered to be 'core requirements' that demand special attention if preserved digital objects are to be trusted. The ease with which digital objects can be altered adds complexity to these requirements, as do some preservation strategies, such as migration and normalization (see Chapter 8) which 'involve transformations of the original bitstream' (NSF-DELOS Working Group on Digital Archiving and Preservation, 2003, p.6). If we cannot be sure of the authenticity and integrity of a digital object, we may not be able to use it effectively. For example, the value of a record of a business transaction in digital form is compromised if it cannot be established that it has not been altered in any way. Figure 3.4 lists the threats to data integrity identified in the UNESCO *Guidelines*.

- 'Natural' generation of errors that arise in digital storage systems
- Breakdown of carriers. Most carrier media have a reasonably short useable life before deteriorating to the point of unreliability for data storage
- Malicious attack, which may come from system hackers, viruses, staff or outside intruders interacting with the storage system
- Collateral damage from malicious acts such as terrorist attacks, acts of war or civil unrest affecting buildings or power supplies
- Inadvertent acts by staff or visitors such as turning off power, throwing out disks or tapes, or reformatting storage devices
- 'Natural' disasters such as fire, flood, or building collapse
- Business failure.

Figure 3.4 Threats to Data Integrity (From UNESCO, 2003, p.113)

The challenge is to demonstrate the authenticity and integrity of digital objects. This is where the documentation about the object becomes significant, as 'authenticity is best protected by ... documentation that maintains the clear identity of the material' (UNESCO, 2003, p.24). For instance, if it can be established that a digital object has always been kept in the custody of an archive in which every change to it has been recorded (an example is changes resulting from migration of the bit-stream – the dates at which migration occurred, to which media, and so on), then we can be more secure about its integrity. Jones and Beagrie give further examples: scholars need confidence that the references they cite will remain stable, and materials used as evidence in legal situations need to demonstrate authenticity (Jones and Beagrie, 2001, p.25). Ross poses the questions 'What are the requirements of authenticity and integrity functionality and what can be done to ensure that they are present in digital objects or in the systems that maintain them?' He suggests that

> underpinning authenticity and integrity and their preservation over time are the concepts of fixity, stabilisation, trust, and the requirements of custodians and users ... an authentic digital object is one whose genuineness can be assumed on the basis of one or more of the following: mode, form, state of transmission, and manner of preservation and custody (Ross, 2002, p.7).

Many of the concepts that are applied to ensure authenticity and integrity of preserved digital objects come from research and thinking among the record-keeping community, such as the outcomes of the Functional Requirements for Evidence in Recordkeeping Project at the University of Pittsburgh, and InterPARES (see Chapter 5). Gilliland-Swetland reminds us that 'the value of an individual record is derived in part from the sequence of records within which it is located' and that 'it can be difficult to understand an individual record without understanding its historical, legal, procedural, and documentary context' (Gilliland-Swetland, 2000, pp.16,18).

It is also necessary to preserve documentation about other aspects of digital objects in order to ensure their preservation, so that they can be understood in

the future. Chapter 2 noted the example of recovery of digital data from the Newham Museum Archaeological Service archives, where the lack of documentation meant that much of what was recovered was unusable for archaeological purposes, because the data made no sense without documentation. Gavan McCarthy, Director of the Australian Science and Technology Heritage Centre at the University of Melbourne, provides another example – that of databases produced by the State Electricity of Victoria in Australia. When the State Electricity Commission privatized its power generation in the 1990s, its assets were surveyed and it was discovered that about 237 databases or digital information systems had been created. These were analysed to determine 'which ones had adequate documentation associated with them, or the information within them was intuitive, or implicit enough so that you could understand it' and which were, therefore, worthwhile preserving. McCarthy observes that 'of that 237, I think seven fulfilled those requirements. Only seven.' In many cases 'we couldn't even figure out what the data was about. There was nobody around who could explain it.' (Quotes come from an interview with McCarthy in 2004.) Chapter 6 explores these issues in more detail.

Conclusion

This chapter notes three modes of digital death: instability of storage media, obsolescence of storage and access technologies, and challenges to the integrity of digital materials. The rapid obsolescence of hardware and software is, to a large extent, a result of today's prevailing market-driven ethos, whose highly competitive nature means that 'product obsolescence is often key to corporate survival in a competitive capitalist democracy' (Kuny, 1998). Digital preservation requires that means of addressing rapid obsolescence must be established. (Some of these means are noted in Chapters 6, 7 and 8.) However, rapid obsolescence is not the only threat to the preservation of digital materials imposed by the prevailing market-driven ethos. Another consequence of this ethos is that commercial imperatives seldom coincide with cultural heritage imperatives. Creators of digital materials and other stakeholders may lose interest in their digital output (a business might close down, or a web site might cease to be maintained) with consequences for the future of these materials. Other threats include lack of awareness of stakeholders about digital preservation issues, a shortage of the skill sets needed to preserve digital materials, lack of internationally agreed approaches, a shortage of practical models on which to base preservation practice, and a lack of ongoing funding to address digital preservation issues. These issues are noted further in the rest of the book.

Chapter 4

Selection for Preservation – The Critical Decision

Introduction

Selection in the digital world is not a choice made once and for all near the end of an item's life cycle, but rather is an ongoing process intimately connected to the active use of the digital files (Conway, 2000)

Based on our knowledge of the past, two things can be said definitively about future library collections: not all recorded information will survive, and we will never be able to predict accurately which information will be in demand by scholars in the future (Smith, 1999, p.2)

There are dangers in assuming that current value assessments are a completely reliable guide to future values ... it is probably better to err on the side of collecting more material rather than less, if the preservation programme can manage it (UNESCO, 2003, pp.75–76)

Librarians have long acknowledged their responsibility for preserving documents for future use, and have developed criteria and processes for identifying the documents to which they will devote resources to ensure their preservation. The recordkeeping professions, particularly archivists, have also acknowledged this responsibility and have developed a considerable body of theory and practice about appraisal. However, these criteria, processes, theory and practice have been developed and applied to documents in collections that are primarily paper-based collections. They do not automatically translate to digital materials, and need to be revisited and modified to ensure that they can be applied effectively to digital materials.

Conway notes the 'transformation in preservation principles' that should be the basis of managing resources in preservation programmes. One of these principles is *choice*. He notes that

> Choice is selection . . . Choice involves defining value, recognizing it in something, and then deciding to address its preservation needs in the way most appropriate to that value . . . Selection is perhaps the most difficult of undertakings precisely because it is static and conceived by practitioners as either divorced from present use or completely driven by demand (Conway, 2000).

Conway makes one point that is the key to why selection must be reconsidered as we move from old to new preservation paradigms. For digital materials, selection decisions are 'not a choice made once and for all near the end of an item's life cycle, but rather . . . an ongoing process intimately connected to the active use of the digital files' (Conway, 2000). The digital mortgage that is the consequence of the selection decisions also needs to be considered: 'Program costs don't cease when the Web site disappears' (Vogt-O'Connor, 2000).

This chapter considers the important role that selection plays in responsible professional practice of librarians and recordkeepers. It notes selection criteria traditionally applied in library practice and appraisal criteria traditionally used by archives, and then indicates why these selection criteria, developed for physical artifacts, do not translate well when applied to digital materials. It considers what additional factors need to be considered to develop effective selection policies and practices for digital materials, such as the role of intellectual property ownership, the importance of preserving context, and the place of stakeholder input. Emerging frameworks for selecting digital documents are discussed, incorporating some new selection criteria and revised weightings for established criteria. PANDORA, the National Library of Australia's web archiving initiative, is examined in Case Study 2 (in the Appendix). This case study illustrates the topic of selection.

Selection for preservation, cultural heritage, and professional practice

Institutions such as libraries, archives and museums have traditionally considered one of their primary roles to be preservation, ensuring that the cultural heritage of the societies they are a part of is available for use by future generations as well as by current users. Preservation is one of the core business activities of these institutions, and they have developed preservation systems and technologies to provide continuing access to cultural heritage materials (NSF-DELOS Working Group on Digital Archiving and Preservation, 2003, p.4). This preservation role has, however, always been one in which major conceptual challenges are embedded. For whom are we preserving? Who exactly are the future users? Because the resources available to cultural heritage institutions (libraries, archives and museums) are seldom sufficient for the preservation of all materials, some selection is required. What are the implications of selecting one item or category of material over another one? How might this selection shape the ways that future generations think about us? Such selection decisions have been the matter of considerable debate, sometimes charged with political and polemical emotion, and they are not easy ones to make. 'Every choice to preserve is at the expense of something else' (UNESCO, 2003, p.73).

Selection decisions – what should we preserve?, for how long?, who takes responsibility? – are essential in managing collections of heritage materials. They are necessary because 'there are usually more things – more information, more records, more publications, more data – than we have the means to keep' (UNESCO, 2003, p.73). The networked environment has exacerbated this situation. In the pre-digital print environment the business of publishing provided (and continues to provide) some filtering, some quality assurance of the product, through mechanisms such as publishers' readers who make decisions based on quality, relevance to a defined public, and saleability. As noted in Chapter 1, increasing quantities of information are being produced digitally, and it is easier for individuals and organizations to make available to the public – to publish – without any intervening quality assurance measures. The ease of mounting information on web sites has meant significant increase in the amount of information readily available, but it has also meant significant variability of its quality. The inevitable result has been an even stronger requirement to select materials for preservation purposes in the face of insufficient budgets, expertise and facilities. 'Digital preservation will be expensive', the Cedars Project reminds us in response to the question 'why do we need to select?': 'Of one fact we can be sure: digital preservation will require more resources than preserving print material' (Russell, 1999). And, unlike non-digital material such as paper-based artifacts, where there is a 'comfort zone' (Jones and Beagrie, 2001, p.30) in which to make selection decisions before the materials deteriorate, the time frame in which decisions about whether or not to preserve digital materials is very short.

Selection decisions for cultural heritage materials – and this increasingly includes digital materials – have been the focus of considerable debate. The issues have been articulated most clearly by the recordkeeping professions. Cook summarizes many of them. Archives, he suggests, are:

> a source of memory about the past, about history, heritage, and culture, about personal roots and family connections, about who we are as human beings and about glimpses into our common humanity through recorded information in all media, much more than they are about narrow accountabilities or administrative continuity (Cook, 2000, p.5).

But there are many dangers:

> Memory is notoriously selective – in individuals, in societies, and, yes, in archives. With memory comes forgetting. With memory comes the inevitable privileging of certain records and records creators, and the marginalizing or silencing of others (Cook, 2000, p.5).

Views such as the ones Cook articulates are not the only response to selection emanating from the recordkeeping profession. A more traditional view is based on a clear distinction between the activities of records managers and the work of archivists. Records managers select records for retention based on 'risk avoidance, market opportunities, or desires to avoid embarrassment or accountability' but this approach 'inevitably will privilege the needs of business or government in terms of the issues that get addressed, the allocation of resources, and the long-term survival of records' (Cook, 2000, p.8). The records that survive into

the future will reflect the concerns of administrators, rather than the full range of human experience. Recordkeepers, suggests Cook,

> need as a profession to remind [themselves] continually of the fate of records left to White House presidents and Soviet commissars, South African apartheid police forces and Canadian peacekeepers in Somalia, rogue Queensland politicians and the American Internal Revenue Service (Cook, 2000, p.8).

However, in the need to select, the selectors must inevitably bring to their decisions their own beliefs and values. They move from a strictly objective custodial role to 'becoming themselves creators of social memory through the active formation of the archival heritage' (Cook, 2000, p.5). Responsible selection practice in preservation must aim to minimize bias in the value judgments that are inevitably contained in the decisions about what to select for preservation. Selection disenfranchises some groups, as our experiences with non-digital collections have shown; an example is that history has moved from being that of significant individuals (usually men) to a wider view based on the records of other groups such as women, the poor, and indigenous cultures. Brabazon has argued that digitization 'is actually and actively reinforcing the social exclusions of the analogue world' because of the digital divide between the information rich, information poor (Brabazon, 2000, p.154) and that even more of the memory of socially excluded groups will dissipate in 'the ephemeral winds of cyberspace' (Brabazon, 2000, p.155).

Should we save everything? Current thinking is that we cannot, because we lack sufficient resources. But there are other reasons why the answer to this question is no. Burrows provides the example of academic libraries, whose collections are, he maintains, 'a product of the rational and scientific "master narrative" of the Enlightenment'. This has been challenged by 'the new humanities and social sciences' which increasingly demand that libraries collect more of 'what used to be dismissed as ephemeral and "popular"'. Added to this is 'our pervasive faith in the power of technology to solve every problem' which leads us to believe that everything could – and should – be preserved (Burrows, 2000, p.146).

Whether or not this view is realistic and technologically feasible, the current state of development of digital preservation is that we still have to pose the question of what really matters. Burrows points to our current predicament:

> We face a real danger of being caught between two contradictory imperatives: the universalist, Alexandrian demands of cultural relativism, and the limitations imposed by technology, cost and organizational structures. Cultural relativism and postmodernism make it increasingly difficult to reach any consensus on defining 'what really matter', while insufficient funding and inadequate technology make it very difficult to achieve the goal of archiving everything (Burrows, 2000, p.148).

He suggests four selection scenarios. The first is 'picking the low-hanging fruit', that is preserving what is easiest to preserve (this metaphor is used in UNESCO, 2003, p.79). This may be unsatisfactory because what is easiest to preserve is unlikely to be what is of particular value. The second is to let the marketplace

decide. In this approach, the definition of value is likely to be linked to commercial considerations rather than to long-term societal value. The third is to base selection decisions on the type of material, but Burrows suggests that this scenario raises more questions than it answers: 'are websites more important to preserve than Usenet postings?' The fourth is to select on the basis of the most endangered material (Burrows, 2000, p.148). None of these are, however, completely satisfactory as a basis for making realistic decisions that are professionally responsible, although some of them have been applied to digital materials on a small-scale basis, so that we can develop expertise and scalable strategies and practices for digital preservation.

Where might we look for guidance on these issues? This chapter suggests that selection criteria based on library practice and applied to non-digital materials are insufficient, and that more appropriate guidance is to be found in appraisal theory and practice derived from the recordkeeping discipline. Archivists, notes Burrows, 'have already done considerable work in rethinking selection criteria for the retention of records in a digital environment' (Burrows, 2000, p.149). However, all matrices of selection criteria, regardless of their disciplinary origins, share common problems. One problem is the difficulty of determining value. Current assessments of value are not always a useful indicator of future value: the UNESCO *Guidelines for the Preservation of Digital Heritage* (UNESCO, 2003, pp.75–76) provide the example of remote sensing data from earlier decades, which is now being used to assess environmental damage. Another problem is determining how much to preserve. There is a growing perception that we need to keep more, rather than less, of the digital environment, partly because we have the technology to do so (such as that used by the Internet Archive) and partly because our abilities to interrogate and get new meanings from digital data are increasing as new tools such as data visualization and data mining software are developed (Kerry, 2001, p.11, quoting Ross, 2000, p.12). There is also an increasing perception that generalized selection criteria are not appropriate, and that sectoral differences should be further investigated and selection decisions made on this basis (Kerry, 2001, p.16).

Selection criteria traditionally used by libraries

Libraries, with their long history of preserving documentary heritage, are still more attuned to making preservation decisions about the artifacts (the physical objects) in their collections than about the less tangible digital materials. Many of the policies developed for the selection of artifacts also apply to digital materials. Certainly the key issues remain the same: on what basis do we select? What are the implications for current and future users? Who might the users of the future be? Who decides how much should be kept? Who keeps it? (Much of the rest of this chapter is based on Harvey, 2003).

The most important principle that guides most library selection practice is current user need. Many of the policies developed for selection by libraries are aimed at meeting the needs of their user communities. (National libraries are a significant exception to this in their use of legal deposit mechanisms to acquire comprehensive national documentary resources collections.) Secondary principles, such as decisions to develop particular subject areas where user needs are of lower priority, may modify these policies. However, selection guidelines

based on meeting current user needs do not automatically apply to selecting material for preserving in the future.

Criteria that have been developed by libraries to select artifacts for preservation vary little. The characteristics of artifacts which these criteria address are age, evidential value, aesthetic value, scarcity, associational value, market value, and exhibition value (Task Force on the Artifact in Library Collections, 2001, pp.9,11). There are some other perspectives on these criteria; for instance, the fact that an artifact is an original and not a copy may be strongly associated with its evidential value and its exhibition value. Selection criteria are sometimes described in other terms. For example, the criterion of evidential value is variously described as 'manufacturing or evidential value' (Pacey, 1991, p.189), 'rarity in terms of informational content' (Lyall, 1993, pp.72–74) and 'scientific or research significance' (*(Significance)*, 2001, p.11). More examples are given in Harvey, 2003, Table 1.

Occasionally additional criteria are used: examples include 'fragility or condition' (Pacey, 1991, p.189) and whether the artifact is 'held in community esteem' (*(Significance)* 2001, p.11). In recent years the practicalities of preservation are appearing more frequently, among them the management plan ('is there a plan which reflects the significance of the documentary heritage?' (Edmondson, 2002, pp.22–23)) and assessment of physical condition ('is its survival in danger?' (Edmondson, 2002, pp.22–23)); 'is this item in danger of being lost?' (Harris, 2000, pp.206–224)). Constraints to preservation resulting from intellectual property issues have also made an appearance, as in Harris's 'are there any constraints caused by copyright laws?' (Harris, 2000, pp.206–224).

To summarize, traditional library selection practices for preservation are based on the preservation of *items* (or artifacts) in their original formats, according to five key criteria: evidential value, aesthetic value, market value, associational value, and exhibition value. Additional criteria are often also used, although there is less consistency in their application: physical condition, resources available, use, and an ill-defined, but nonetheless well-represented, category of social significance (is the item 'held in community esteem'?).

Although this summary sounds straightforward and its criteria clear cut, in practice many problems arise with their interpretation, most of which relate to the difficulty of determining what value is. 'What were the grounds for detecting in favor of one object and against another? How can libraries cope with the fact that the value of the artifact is never quite the same to different researchers?' Artifacts are 'cultural variables' that 'are viewed and used in a given culture at a particular moment' (Task Force on the Artifact in Library Collections, 2001, p.12). Ayres asks a question about Australian literature to illustrate this point: 'to ask how well Australian archives represent Australian literature is to ask questions about what Australian literature *is*'. Is there an Australian literary canon? 'Interrogations of canonicity have raised important questions about 'high' versus 'popular' literature, gender and cultural biases, aesthetic versus political concerns, notions of "Australianness", and literature as cultural and economic production' (Ayres, 2001, p.33). Libraries haven't always got this right – in fact it is impossible to get it right, given 'the context of changing perceptions of value and the fluid dynamics of intellectual inquiry' (Task Force on the Artifact in Library Collections, 2001, p.5). As an example, consider the changing status as research materials of Australian romance novels, a genre which has been 'banish[ed] . . . from the cultural record of the nation' (Flesch, 1996, p.190;

2004). Other problems arise when determining if and when a surrogate is just as suitable as the original artifact. Copies of artifacts lose some of their information each time they are copied – a microfilm can never capture some of the information that resides in the physical structure of a book. This is known as generational loss.

Libraries have tested many approaches to selection for preservation. For some of these the aim has been to reduce the amount of intellectual input into the selection process, or to expend that effort only once so that others do not have to duplicate it. The 'great collections' approach was based on selecting artifacts whose content was valuable intellectually and which were physically fragile, but this is labour-intensive. Similar approaches involved the determination by a bibliographer or panel of experts of the core literature in a field, but this, too, is labour-intensive and requires a high level of bibliographic control in the field. User-driven selection occurs when an item requested by a user is in poor physical condition and is treated when attention is called to it (Cox, 2002, pp.97–98). Smith (1999, pp.9–11) provides more details of these approaches.

None of these approaches is considered to be entirely appropriate to the selection of artifacts for preservation. The same reservations apply to their application in the digital environment.

Appraisal criteria traditionally used by archives

The archival community has well-developed theory and a set of practices for selection, known as *appraisal*. This is well worth investigating for its suitability in a digital context. Appraisal practice is significantly more developed than library selection practice, so it is feasible that the deeper theoretical basis of appraisal can inform our thinking about what digital materials are worth preserving.

Appraisal lies at the core of archival practice. It is traditionally defined as

> the process of evaluating records to determine which are to be retained as archives, which are to be kept for specified periods and which are to be destroyed (Ellis, 1993, p.461).

Traditional appraisal of archival materials applies criteria similar to those used in library selection. *Archival value* encompasses several narrower values: administrative (usefulness for the conduct of business), fiscal (usefulness for financial business), legal (worth for conduct of legal business), intrinsic (the inherent nature of the material, its significance as artefact), evidential (its value as evidence of the record creator's origins, functions and activities), and informational (usefulness for more general research purposes because of the record's information content) (Tibbo, 2003, pp.29–30). What most strongly distinguishes archival appraisal practice from library selection practice is a stronger recognition of, and emphasis on, the importance of context. Cox suggests that 'from an archival perspective, context is crucial to understanding information or evidence (in any form)' (Cox, 2002, p.53). The emphasis placed on *context* is the key difference between library practice and archival practice in selection.

The value of archival theory and practice for developing effective practice in the digital environment is noted by Gilliland-Swetland:

> The archival perspective brings an evidence-based approach to the management of recorded knowledge. It is fundamentally concerned with the organizational and personal processes and contexts through which records and knowledge are created as well as the ways in which records individually and collectively reflect those processes. This perspective distinguishes the archival community from other communities of information professionals that manage decontextualized information (Gilliland-Swetland, 2000, p.2).

This evidence-based approach with its emphasis on context is likely to be more helpful in developing effective selection criteria for digital materials than is selection practice based on the traditional library criteria. Digital materials can be more effectively handled by considering them, at least in part, as records. For example, like records, digital materials need to have preservation decisions made about them at a point closer to their creation, whereas in library practice decisions of this kind can be made many decades after the item's production. Library-based practice has already concluded that documentation and metadata for digital materials, both of which provide contextual information, are requirements for their effective preservation. Closer investigation of appraisal concepts is likely to provide further guidance.

The Archives Association of Ontario's brief statement about appraisal (Archives Association of Ontario, 2001) poses six questions:

1. What is the administrative, evidential or informational value of the records to the organization?
2. Do the records meet the terms of your mandate and acquisition policy?
3. Are the records primary or unique?
4. Is the information in the records duplicated in another set of records?
5. Can the records be properly preserved?
6. Can the records be made available?

Two of these (questions 5 and 6) are concerned with practicalities: are the resources (technical, financial, and human) available to preserve the records? Are access restrictions so rigid that the records cannot be made available to users in a realistic and timely way? The first question is at the core of appraisal. By linking the administrative, evidential and informational value of the records to an organization, it clearly suggests the context aspect: the context – the organization – is defined. Cox further indicates that 'a record is a specific entity. It is transaction oriented. It is evidence of activity (transaction) and that evidence can only be preserved if we maintain content, structure, and context' (Cox, 2001, p.6).

How might we interpret this for application to materials that are not records of transactions, such as the kinds of materials, including digital materials, usually handled by libraries? Cox assists us: 'Structure is the record form. Context is the linkage of one record to other records. Content is the information, but content without structure and context cannot be information that is reliable' (Cox, 2001, p.6). We need to identify the equivalents of content, structure, and context for digital materials that are not records. However, the reality is not as straightforward as this. Appraisal, notes Piggott, 'is not free of bias and subjectivity; its results reflect the cultural and other values of the time'. He describes the 'great trinity mystery':

- apart from some exceptional cases, it is beyond our resources and power to keep all records; which is a pity, because
- beyond their original use, all records conceivable have their uses; we've come to expect unexpected uses and yet
- it is almost impossible to accurately predict future use, and when we try, the passage of time can cause serious havoc with appraisal judgments (Piggott, 2001).

Appraisal theory and practice are themselves being continually reappraised. For example, the development of the macro-appraisal concept is one attempt to refine decisions made about value. It

> is nothing more than deciding (what records to create and) how long they should be kept or deciding what archival records to collect, *by first* mapping the territory; *by first* identifying and analyzing the theoretical documentary universe ... Only *after* that intensive research based examination of societal or business functions ... should you do 'micro-appraisal' by identifying the key records (Piggott, 2001).

This approach, it is suggested, helps cope with greater quantities of records. 'All of the traditional appraisal values now come into play plus the secondary factors such as existence of control records, costs, and preservation' (Piggott, 2001). The definition of appraisal is being reconsidered to accommodate digital records, so that appraisal decisions are made at or near the time that records are created. The ISO standard *Records Management – Guidelines,* which is based on an earlier Australian Standard for Records Management, does not define appraisal but notes that capture is the 'the process of determining that a record should be made and kept ... It involves deciding *which documents are captured*, which in turn implies decisions about who may have access to those documents and generally how long they are to be retained' (AS ISO 15489.2, 2002, 4.3.2 – the italics have been added).

Why traditional selection criteria do not apply to digital materials

Some argue that there is no difference between selection for preservation of digital materials and selection of non-digital materials, that the 'selection of digital heritage is conceptually the same as selection for non-digital materials': the same principles and practices, based on existing policies and procedures, apply, although they 'may need some adjustment' (UNESCO, 2003, p.73). This may be too simplistic a view. It could be argued that the different emphases required are so great that the concepts are altered significantly. For instance, the increased emphasis we must place on whether we have the technical capability to preserve digital materials means that the practicalities become more important, whereas in the past the information content of most materials in the collections of libraries and archives would not be altered if no actions were taken.

What are the differences that affect selection decisions? As noted in previous chapters, digital materials are more vulnerable than material in traditional

formats, such as paper. One of the major differences is the cost of maintaining these more vulnerable materials. While major resourcing issues are attached to any decisions we make about which materials we will retain, the issues are greater for digital materials (the digital mortgage noted earlier in this chapter). For example, the cost of preparing a digital object for preservation could be significantly higher than the cost of preparing a book for addition to a library's collection, and (assuming a fixed budget) fewer objects can therefore be processed (Weinberger, 2000, p.65).

Another difference is that preservation strategies and techniques developed in a pre-digital era do not always apply in the digital environment: in Cloonan's words, 'digital objects force us to preserve them on their own terms' (Cloonan, 2001, p.237). For example, selection decisions made about digital materials probably need to take into account whether or not the equipment to read them is available; this is not typically the case for non-digital materials. We need to develop appropriate preservation strategies and techniques for the digital environment.

A third difference is the requirement that conscious preservation decisions need to be made about digital materials early in their existence. Burrows compares the pre-digital environment with today:

> In the pre-digital era, selection necessarily preceded preservation. Once a book or journal had been acquired, a decision could be made about its long-term retention. The mere act of placing it in a library was often seen as a sufficient method of preservation in itself. In the digital era things are very different. 'Digital records don't just survive by accident', observes Margaret Hedstrom. As a result, a lack of preservation is tantamount to de-selection (Burrows, 2000, p.152).

As the UNESCO *Guidelines* succinctly state, 'it may not be possible to wait for evidence of enduring value to emerge before making selection decisions' (UNESCO, 2003, p.74).

More differences between digital and non-digital materials that need to be considered when developing selection criteria are listed in the UNESCO *Guidelines* (UNESCO, 2003, p.74). For digital materials the quantities to be assessed may be significantly greater, and their quality may be more variable as, unlike print-based publications, they do not always go through a quality assurance process imposed by their publisher. We also face the challenges posed by new genres being developed, especially those that incorporate linked resources. There is too the question of exactly which attributes of digital materials should be preserved (noted in more detail in Chapter 5. Yet another issue is the difficulty of determining ownership of intellectual property rights for some digital materials.

Any effective process and criteria for selection of digital materials for preservation must take account of these differences.

IPR, context, stakeholders, and the continuum approach

Viable selection criteria for digital materials need to take account of many factors that differentiate them from non-digital materials. Intellectual property rights

assume greater importance, legal deposit for digital materials is slowly becoming a reality, and there is a need to preserve much more contextual information than is thought necessary for most non-digital materials. Stakeholders potentially play a much greater role. A continuum approach, borrowed from recordkeeping theory, shows promise in assisting us to develop effective selection principles.

Intellectual property rights and legal deposit

There are already well-established legal frameworks for preservation of traditional (usually non-digital) material that enters the collections of libraries. These include provisions in copyright law and legal deposit legislation. For instance, copyright laws are likely to include a provision that an item can be copied without specific approval from the copyright owner if the copies made are for preservation purposes. No similar blanket provisions apply to digital materials. For them 'the legal framework is in a state of flux as it attempts to accommodate new information society paradigms and practices' (Jones and Beagrie, 2001, p.32). Copying digital material for preservation purposes – the very basis of the digital preservation strategies of refreshing, migration, and emulation – can infringe intellectual property rights as they currently stand for some material (Muir, 2004a, pp.76–77). Some countries have recognized this in their copyright legislation, as in the United States' Digital Millennium Copyright Act (1998) and in a 1997 amendment to the Canadian Copyright Act, which allow digital materials to be copied if their format has become obsolete (Muir, 2004b, p.72). For Australia, the Copyright Amendment (Digital Agenda) Act 2000, which came into effect in March 2001, allows digital copying of material held in libraries and archives for preservation purposes.

Some countries have data protection acts that may also present barriers to preservation (Jones and Beagrie, 2001, p.34). Commenting on trends in intellectual property rights, Beagrie notes that, as the economic value of intellectual property increases and investment in it expands, legislation becomes more restrictive: for example, copyright protection periods have been extended. He comments that 'the needs of memory institutions for legal exceptions to undertake archiving are often overlooked or not sufficiently understood' and are overridden by commercial imperatives to protect intellectual property (Beagrie, 2003, p.3). There are at present no simple solutions to this issue. Strategies include establishing a dialogue with intellectual property rights owners so that they are fully informed about the issues and about what is required to allow the preservation of digital materials (Jones and Beagrie, 2001, p.32).

Intellectual property rights issues may influence selection of digital materials for preservation. If the rights are so restrictive that there is no real possibility of access to the material being made available in the future, then it would probably be pointless to expend resources on its preservation (UNESCO, 2003, p.77).

Legal deposit legislation

One of the powerful tools that some libraries are able to use in the preservation of traditional documentary heritage materials is legal deposit legislative provisions, through which material comes automatically to a designated library, without the expenditure of considerable effort and resources to acquire that material. Digital materials are not covered by legal deposit legislation, which

predates the digital era, except in a handful of countries. Legal deposit is concep-
tually antithetical to selection: it implies that no selection is made, but that all
materials defined by the legislation are automatically provided to the deposit
library. Legal deposit is noted here, however, because it addresses one of
the issues faced in preserving digital materials: getting hold of them in the
first place.

Legal deposit legislation for digital materials is often considered as an
important step in a viable national preservation programme for digital materials.
Without it, preservation of digital materials is 'necessarily ad-hoc' (Kerry, 2001,
p.8). Countries that have enacted legislation covering all forms of digital publi-
cation include Denmark (1998), New Zealand (2003), and the United Kingdom
(2003). Other countries have legal deposit legislation that covers some digital
materials, usually static publications such as those issued on CD-ROM.

Without legal deposit legislation, there is some potential in negotiating less
comprehensive arrangements such as the National Library of Australia's *Volun-
tary Deposit Scheme for Physical Format Electronic Publications* (NLA, 1999?) and
its *Use of Australian CD-ROMs and Other Electronic Materials Acquired by Deposit*
(NLA, 2001). But these are more time-consuming and resource-intensive arrange-
ments and the National Library of Australia is keen to see legal deposit
legislation for digital materials enacted in Australia so that it can carry out more
effectively its role to preserve Australia's documentary heritage. Such legisla-
tion would enable the National Library of Australia to collect important online
publications without negotiating with the publisher, and consequently 'more
national resources of significance would be preserved and available for use in
the future, and more cost-efficient and effective work procedures would be
possible for both publishers and the Library' (Gatenby, 2002b).

Australia's neighbour, New Zealand, has enacted legislation in 2003 which
'provides for the deposit of physical format documents and for the copying
of Internet documents' and the National Library of New Zealand is developing
its procedures to handle the resulting acquisition of digital materials (Legal
deposit, 2003).

Context and community

The importance of preserving contextual information has already been noted in
earlier chapters. It is not, as noted in Chapter 1, simply the bit-stream that we
wish to preserve, but also the additional information and tools needed to access
and understand that bit-stream. Selection processes must take this into account.
If the contextual information is not available, then the digital materials are
unlikely to be selected. The UNESCO *Guidelines* suggest some specific instances:

> Where digital materials can only be understood by reference to a set of
> rules such as a record keeping system, database or data generation
> system, or other contextual information, selection processes must iden-
> tify the documentation that will also need to be preserved (UNESCO,
> 2003, p.76).

Preserving contextual information, challenging in itself, becomes more so when
the aims of preservation programmes are also taken into account. Every
programme is itself working within its own context. For national libraries that

context is the nation; for a business archive, the company that it is established to serve; for a university, its faculty and students. The community that the programme serves is likely to impose its own requirements. This directly affects the quantity and nature of digital materials that are selected for preservation: in the case of a national library it is a wide range, whereas for a university-based programme it will be narrower, perhaps restricted only to the intellectual output of its faculty and research students. The necessary influence of context on selection for preservation is exemplified in this recommendation of an Archaeological Data Service (ADS) study into the use of archaeological data in digital formats:

> strategies are needed to identify which datasets should receive the highest priority for preservation. Such strategies should be determined by the information needs of archaeologists and must be able to react to those projects that are most in danger of being lost (Condron *et al*, 1999, section 11.7).

As well as the nature and extent of material that is preserved, the community will also define what kind of contextual information is also collected and preserved. For some communities it may be sufficient to see only a passive rendition of the digital materials: a screen shot or other visual presentation; perhaps a PDF version is all that is required. For others, it will be necessary to retain sufficient contextual information to allow the digital materials to be searched or manipulated. Users need 'the option of interrogating old data to produce new results . . . Some programmes may even have to ensure users can run old simulations, play old computer games, or view digital art in ways that reproduce the original experience rather than a speeded up experience that later technologies may provide' (UNESCO, 2003, pp.77–78). For other communities, there must be enough contextual information of the right kind to demonstrate that the authenticity of the digital materials has not been compromised.

Selection criteria for determining digital materials to be preserved need to take account of this contextual information. Chapter 5 examines further the questions surrounding what attributes need to be preserved.

Stakeholder input

Chapter 2 noted that stakeholders would play a greater role in digital preservation than they played in the past in the preservation of non-digital materials. An example is the need to communicate with intellectual property rights owners so that they understand the preservation implications of the control they wish to exert over digital materials. The UNESCO *Guidelines* suggest that because producers of digital materials are 'well placed to understand why digital objects were brought into being, their essential "message", and the relationships between objects and their context' they are likely to play an important role in selection decisions. 'If that information is not captured from the producer it may be too difficult to reconstruct it later' (UNESCO, 2003, p.76).

Another example is the role of the individual in preserving popular culture. Where previously institutional collectors (libraries and archives) were unlikely to collect the more ephemeral materials that constitute popular culture, there were

myriad alternative sites where ephemeral material was stored, such as the family home [where we might expect to find] a light sabre, toy dalek, Duran Duran posters. [But] the digital era reduces the number of fan-based archivists. Subsequently forfeited is the spectrum of interests and ideologies that construct the popular memory of a culture (Brabazon, 2000, p.157).

Increasing engagement of some community sectors in the selection of digital materials for preservation is also envisaged. A summary of the key areas for research in digital preservation in Australia includes the statement that 'more work needs to be undertaken on a sectoral basis on establishing significance assessment policies . . . with clearly established priorities' (Kerry, 2001, p.16). Greater stakeholder input is being encouraged in many areas. For example, a 'stakeholder consultation approach' to appraisal is being introduced by the National Archives of Australia (Schwirtlich, 2002, pp.60–61). Peer review has been used to determine the value of retaining scientific data sets (National Research Council, 1995, p.34). A related idea is 'authority by community', a concept used by Janes in relation to the authoritativeness of web sites. Janes provides the example of the Internet Movie Database (www.imdb.com) which requests that errors and omissions be reported to the IMDB database managers, who will check and incorporate if relevant. Janes notes that 'we've grown used to the notion that a site's *content* could be dynamic; now it may well be that its *authority* is as well' (Janes, 2003, p.92). Another example is the Wiki (defined in perhaps its best-known manifestation, the Wikipedia – 'a free-content encyclopedia that anyone can edit' – as 'a website (or other hypertext documents collection) allowing users to add content, as on an internet forum, but also allows anyone to edit the content' (en.wikipedia.org/wiki/Main_Page). This suggests greater input into the selection process by users and other stakeholders. Members of communities have a stake in keeping digital files accessible. In universities, faculty members play an expanding role by participating in the establishment of their institutions' e-repositories (Smith, 2003, pp.13–14).

Discipline-based approaches, also present in the pre-digital preservation paradigm, are proving effective, as shown by examples such as the Astrophysics Data System (adswww.harvard.edu) and Bright SPARCS (www.asap.unimelb.edu.au/bsparcs/bsparcshome.htm). For scientific data, there appear to be significant differences in how appraisal criteria need to be applied in different disciplines, a contention that needs further investigation (Hodge and Frangakis, 2004, p.59).

Value of the continuum approach

The point has been made in this book several times already that selection decisions about which digital materials to preserve need to be made at an early stage in their existence. The continuum approach, developed for application in recordkeeping, shows promise in assisting us to develop effective selection principles. The continuum approach (explained in more detail in Upward, 2005) is essentially a way of thinking about the life of a record, from its creation onwards. It was conceived to get around the issues associated with the traditional split between records and archives. The recordkeeping community has been at the forefront in developing responses to digital preservation issues. For electronic

records, recordkeepers can no longer wait 'passively at the end of the life cycle for records to arrive at the archives when their creators no longer wanted them – or were dead' (Cook, 2002, p.2). Significant records must be identified early in their life so that management and preservation decisions that will ensure ongoing access to the critical aspects of those records, such as the information content and the attributes that determine their authenticity, are made right from the start. This, suggests Weinberger, 'will ease the selection of digital objects for preservation' (Weinberger, 2000, p.67). JISC (the UK Joint Information Systems Committee) has recognized the value of a continuum approach. It is supporting a 'life-cycle' approach to the management of digital resources (Beagrie, 2004).

Developing selection frameworks for preserving digital materials

The point that traditional library preservation paradigms do not transfer well to the digital environment has been made already. The critical reasons why they do not stem from the fact that issues such as media instability and technological obsolescence shorten the timeframe within which decisions about the future of digital materials must be made. The physical condition of artifacts drives many traditional preservation decisions (Gertz, 2000, p.98) but this factor is of little or no importance when applied to digital materials. In the past we have decided what to preserve by keeping everything that we can and waiting 'for the significant information to rise to the surface as time, people and events dictate its importance' (Howell, 2000, p.129). This approach has also been applied in the digital environment, the most notable example being the Internet Archive. There remains doubt about whether this approach is sustainable as the quantity of digital materials increases. The persistence of this approach avoids what is very likely to be the real issue: how to determine significance.

Most of the literature published to date about selecting digital materials is about the selection of analogue material for digitization, not about the selection of digital material for preservation. These are not the same. The principal reason for selecting material to digitize is usually to improve access to that material, which may still be subject to pre-digital preservation regimes, whereas selection for preservation is aimed at long-term retention of access to information that is already, and only, in digital form. Digitizing programmes are usually access-driven, with preservation as a by-product (Gertz, 1998). Despite those differences, criteria for selecting materials to digitize can provide useful advice for developing selection criteria for preservation. Many of the traditional selection criteria apply, although the emphasis is different: for example, greater prominence is given to user demand and intellectual property rights (Gertz, 2000, pp.98–99). Gertz has identified the criteria most frequently cited as:

- Does the item or collection have sufficient value to and demand from a current audience to justify digitization?
- Do we have the legal right to create a digital version?
- Do we have the legal right to disseminate it?
- Can the materials be digitized successfully?
- Do we have the infrastructure to carry out a digital project?

- Does or can digitization add something beyond simply creating a copy?
- Is the cost appropriate? (Gertz, 2000, p.104).

The Cedars Project Team report includes one of two especially helpful statements about selecting digital materials for preservation (Cedars Project Team, 2002). It defines a digital object's *Significant Properties* as 'the level of content and functionality retained'. These significant properties are not empirical; they require judgments to be made by organizations about how these significant properties apply to their user communities and to the organization's preservation responsibilities. The Cedars Project Team report provides an example: for a text in PDF, the decision is made that the text, not the format, is significant, so information about the PDF format does not need to be stored (Cedars Project Team, 2002, p.15). The report places high importance on negotiating intellectual property rights before any other preservation actions occur. It suggests that selection decisions for digital preservation must 'be pragmatic' and based on the 'estimated value of the material, the cost of storage and support mechanisms, and the production of metadata to support the material' (Cedars Project Team, 2002, p.53). Primary criteria are proposed:

- currently high use
- the type of material (typically commercially published scholarly works) that we would expect to preserve if it were published in traditional printed format
- tied to the long-term or cultural interests of the organisation (Cedars Project Team, 2002, section 4.5.1).

A typology of digital resources proposes additional criteria (Cedars Project Team, 2002, pp.109–110) including:

- Legal and IP issues: (for example, 'legal status – IP rights need to be negotiated for preservation purposes')
- Format issues (for example, 'some formats harder to preserve than others')
- Technical issues (for example, 'Technical capacity to preserve may be lacking in a library'; 'some technical environments may be easier to preserve than others').

The *Decision Tree for Selection of Digital Materials for Long-term Retention*, in the Digital Preservation Coalition's handbook on the preservation of digital materials (Jones and Beagrie, 2001, section 4), also assists. This decision tree first poses questions relating to selection *policy*: is there an institutional selection policy? Does the material fit into it? Is the material of long-term value? A second group of questions is about *legal and intellectual property issues*: have acceptable rights been negotiated? Can they be? *Technical* questions form a third group of questions: can you handle the file format, now and in the future? Can the material be transferred to a more manageable format? The existence of *documentation and metadata* form a fourth group: has sufficient been supplied?

To summarize: changes are required to the selection procedures developed for non-digital artifacts to accommodate digital materials. Some of the traditional factors assume greater importance, but new factors must also be considered for digital materials. The digital selection frameworks developed to date still place high priority on criteria for determining value, but do strongly emphasise other

criteria: the legal and intellectual property rights governing a resource, whether we have the technical ability to preserve it, the costs involved in preserving it, and the presence of appropriate documentation and metadata. Figure 4.1 summarizes these changes.

Towards a new decision-making framework

Weinberger poses three questions that need to be answered when selecting digital materials for long-term preservation:

- Do we want to preserve this digital object?
- May we (do we have the legal rights to) preserve this digital object?
- Can we (do we have the technical ability to) preserve this digital object? (Weinberger, 1999).

	Traditional Selection Criteria	Criteria Applied to Selection for Digitizing	CEDARS/DPC Decision Tree
Value	Evidential Aesthetic Market Associational Exhibition Informational	Sufficient value to current audience Does digitization add value?	Significant long-term value?
Physical condition	Threat to object Fragility		
Resources available	Management plan?	Is infrastructure available? Is cost appropriate?	
Use	Heavy use	Current demand	Currently high use
Social significance	Held in community esteem?		Tied to long-term interests of organization
Legal rights	Copyright	Rights to digitize Rights to disseminate	Legal status IP rights
Format issues		Can it be digitized successfully?	Type of material (can it be digitized successfully?)
Technical issues			Technical ability to preserve? Can file format be handled?
Policies			Selection policy?
Documentation			Sufficient available?

Figure 4.1 Selection Criteria Categorized

We need to expand upon this starting point. As already noted, increasingly non-traditional criteria, such as the legal and intellectual property rights governing a resource, whether we have the technical ability to preserve it, the costs involved in preserving it, and the presence of appropriate documentation and metadata, are becoming central to decision-making in selection of digital materials for preservation.

Many of these factors have been recognized for some time by the audio-visual archiving community and have been incorporated into their selection procedures. The process for determining what to migrate to digital format at the television archives of a German public service broadcaster, the Südwestrund-funk, Stuttgart, is typical. This organization operated a cautious policy on de-selection because their experience indicated that future requirements were not easy to predict. Nonetheless, it would be too expensive to transfer everything to digital format, so a more sophisticated prioritization schedule was developed. In addition to criteria based on content and form (documentary, magazine, spot) and so on) the 'archival worthiness' of the material is determined, based on the cataloguer's assessment. Also considered are broadcast rights (where these exist only for a limited time, the material is not selected), physical carrier condition (good; at risk because of brand, age, frequent use; showing signs of deterioration) and status of the copy (is it a copy, a copy where the original still exists, etc). This process is 'time-consuming, but nevertheless it is to be strongly recommended' (Lacken, 2001, p.25).

In Phase 1 of its investigations the InterPARES project addressed the question 'How do we select electronic records for preservation?'. It determined that records in digital format should be selected for long-term preservation on the basis of 'continuing value, authenticity, and feasibility of preservation'. The authenticity of records should be established using the InterPARES Benchmark Requirements for Assessing the Authenticity of Electronic Records. The feasibility of preservation should take into account 'current and anticipated capabilities and projected costs'. Appraisal of records in digital form should be carried out as early as possible, and ideally should be 'built into the design of record-keeping systems'. Assessment of authenticity and feasibility may be carried out later. Appraisal decisions should be monitored regularly to ensure that the information kept about the records is valid: the recommendation is to 'ensure that changes to records and their context have not negatively affected their identity or integrity nor the ability to preserve them' (US-InterPARES Project, 2002, pp.8–9).

This InterPARES statement refers to records, which are of diminished value if they not authentic. We can widen this discussion to include other kinds of digital materials as well. The UNESCO *Guidelines* consider the attributes that contribute to authenticity as 'the elements that give material its value ... the selection process should consider what those elements and characteristics are' (UNESCO, 2003, p.75). These vary according to the kinds of material. For example, for e-mail messages it may be decided that

> users of a large collection of electronic mail messages only need to see elements that can be characterised as 'content information', such as the name and address of the sender, subject, date and time, recipients, and the message, in a standardised structure with only the most simple of formatting (UNESCO, 2003, p.78).

For other materials where the structures are much less well-defined, different elements and characteristics will be considered of value.

Earlier in this chapter it was noted that we need to identify the equivalents of content, structure, and context for digital materials that are not records. Can this 'content, structure, and context' notion assist us to develop more precise preservation selection criteria for application to digital materials? To test this we might use three examples: videotapes maintained by a government-owned broadcasting company's library, web sites, and dissertations and theses in digital form. Note that these examples are described here only as a kind of 'proof of concept' to suggest that this approach will assist the development of viable selection criteria.

The first example is not strictly of digital material but some of the same principles apply. For videotapes maintained by a government-owned broadcasting company's library, the information content is significant, as much material of national heritage significance is produced by this broadcaster. Because the videotapes exist in a number of formats, technological obsolescence of recording and playback equipment is a major issue. Selection criteria should consider the 'obsolescence rating' for each format, such as *lower risk* for formats such as VHS, *vulnerable* for Digital Betacam (Sony), *threatened* for 1-inch Umatic, and *critically endangered* for 1-inch SMPTE (Ampex). For this material the structure (record form) becomes a crucial criterion for selection. The context in which these videotapes were created also becomes important to consider: the broadcasting company has a legal deposit obligation for some material it produces, and for other material it has negotiated rights with intellectual property owners.

For web sites (the second example) we need to document the structure (record form). This will be html, perhaps with Java applets, CGI, Cold Fusion and other related applications or add-ons. There is a need to preserve documentation about software. Some web sites may need to be retained for legal purposes.

For the third example, dissertations and theses in digital form, we need to document the structure (record form), which may be word-processing and/or imaging software. Contextual information to retain could include documentation that explains the reasons why and the conditions under which this material was created. These examples are summarized in Figure 4.2.

	Structure (record form)	Content (information)	Context (linkages)
Videotapes	VHS, Digital Betacam (Sony), 1-inch Umatic, 1-inch SMPTE (Ampex)	Significant national heritage content (e.g. documentaries)	Legal deposit regulations; intellectual property rights of other parties
Web sites	Html, Java applets, etc	Significant intellectual content	Legal requirements
Digital theses	Word-processing software, pdf	Significant intellectual content	Regulations under which submitted; value as a record of the university's activities

Figure 4.2 Content, Structure and Context of Some Digital Materials

Selection of materials for preservation is a fluid field, in which many variables are constantly being redefined and more thinking needs to be done. Digital materials add extra complications. Codification of these variables into frameworks that can be applied in practice is being attempted. One attempt is the appraisal toolkit for electronic records of the Public Records Office in the United Kingdom (Public Record Office, 2000).

How much to select?

The discussions about how much to select, and about the feasibility of selecting all digital materials for preservation (that is, applying little or no selection), have been largely carried out in relation to web archiving. In this context the opposing ends of the spectrum are the selective approach exemplified by the National Library of Australia's PANDORA, and the 'whole domain harvesting' approach of the Internet Archive. Both have their strong proponents, and for web sites the concept of targeted acquisitions supplemented by periodic trawls is gaining ground. The cases for and against selection in the digital preservation context are presented in this way:

> Advocates of a comprehensive approach argue that any information may turn out to have long-term value, and that the costs of detailed selection are greater than the costs of collecting and storing everything. Advocates of a more selective approach argue that it allows them to create collections of high value resources, with some assurance of technical quality and an opportunity to negotiate access rights with producers. There may well be a place for both approaches, as they are likely to produce quite different collections of digital heritage that are valued for different purposes (UNESCO, 2003, p.76).

Other advocates of a selective approach suggest that sampling may prove useful. Vogt-O'Connor, for example, includes sampling in her three approaches to selection. Statistical sampling methods avoid human judgment and bias, and have the merit of 'providing a non-editorial sketch of the whole', although material of enduring value will be missed. Traditional selection criteria, with their particular values and belief systems, can be applied. Or a combination can be applied: 'statistically sample everything, to an extent that is economically feasible . . . [then] select any items that fit the collecting statement of the archives and which are evaluated as having high value . . . [and finally] pray for technological help and funding from the government, individuals, and the organizations benefiting most from the new technologies, the software and hardware firms' (Vogt-O'Connor, 1999, p.23).

We must also be aware of the fact that notions of significance will vary over time. In a discussion of material of national significance, Lyall suggests, as do other writers about selection in the digital environment, that 'national significance cannot always be allocated to material at the time of its acquisition. The importance of an item or collection may change over time' (Lyall, 1993, p.74). Variation in significance over time becomes difficult to manage in the digital environment, because, as indicated above, it is necessary to select at the very start of the life of digital materials. Perhaps this argues for a greater emphasis

on sampling as a method to select a representative body of digital objects or collections.

Whatever point on the selection spectrum is chosen, and at whatever point on the timeline, a cautious approach is urged by the UNESCO *Guidelines* because 'a decision not to preserve is usually a final one for digital materials' (UNESCO, 2003, p.75). A triage system might be used, so that material definitely worth preserving and material definitely not worth preserving are identified, and interim preservation measures are applied to the rest until a definite decision about selection can be made.

Conclusion

While it is reasonably straightforward to identify the criteria traditionally used by libraries when they select for preservation, and to describe appraisal practice for archival material, they cannot be applied directly to the selection of digital materials for preservation. A combination of existing criteria, weighted differently, with new criteria is needed. As one example, Eastwood suggests that the cost of preservation of digital materials will become 'rather more determinative of the outcome of appraisal' than it was for traditional materials (Eastwood, 2003).

Further research into selection is needed, as it is into other parts of the life cycle of digital materials. Such investigation needs to take into account the high levels of human input currently required in selection decisions and their cost. By identifying selection processes that can be automated, it may be possible to reduce the level of resources needed for this aspect of digital preservation. The outcomes may well result in 'radically different approaches' (NSF-DELOS Working Group on Digital Archiving and Preservation, 2003, p.7).

It would be easy to become obsessed by the challenges of selection, but consider this:

> preservation . . . is a relative rather than an absolute concept because objects change over time as do our approaches to viewing or interpreting those objects (Cloonan, 2001, p.235).

So we should be reconciled to never getting it completely right for all time – and to the frequently changing concepts in the future. Nevertheless, it is our responsibility to rise to the challenges posed with some understanding of the consequences of ignoring them.

newman[1]. Other factors that affect data loss include the quality and maintenance of tape recording, and playback devices.

The longevity of magnetic tape can be improved by attending to its care and handling. Appropriate storage is essential for minimizing deterioration through binder hydrolysis, which is a result of excessive moisture content of the tape. The rate of hydrolysis can be reduced by lowering humidity levels and temperatures in tape storage areas. Magnetic pigments also degrade more slowly at lower temperatures. Also important is that temperature and humidity levels are kept constant and stable. Storage at temperatures that are too high (above 23°C, suggests Van Bogart) increases dropout because the tightness of the tape packing is increased; this, in turn, increases tape distortion. Increased tape-pack stresses also occur as the tape absorbs moisture and expands at relative humidity levels greater than about 70 per cent. Temperature and relative humidity levels that are too high also promote fungal growth. Attention should also be paid to maintaining good air quality, and to reducing dust and debris. Conditioning (acclimatization) is also required if tape is stored in an environment that differs from that in which it is used. (Further information about the care and handling of magnetic media is available in Chapter 7 and in Van Bogart, 1995.)

An indication of the life expectancy of some common data tapes is provided in Figure 5.3. The important point to note here is the effect of different relative humidity (RH) and temperature levels on the life expectancy of digital artifacts.

'A study carried out for the US National Archives and Records Administration (NARA) examined the stability and life expectancy of three high-density magnetic tape types. All three demonstrated an impressive ability to deliver reliable data'. Their projected life expectancies were determined to be well outside NARA's requirements. However, a word of caution was sounded: all products suffered some failure during the study. The report notes: 'As good as the technology is today, failures can and do occur' (Arkival Technology Corporation, 2002, p.4).

Manufacturers of digital media have concerns that differ from those concerned with digital preservation. Manufacturers are primarily motivated by producing quantity at the lowest cost in high-volume, consumer-driven markets, and by providing new, improved products on a regular basis. The rate of change is rapid: the IASA guidelines for digital audio objects note that 'all of the main data tape formats have development roadmaps projecting upgrades every 18 months to 2 years' (International Association of Sound and Audiovisual Archives Technical Committee, 2004, pp.54–55).

Medium	25% RH 10°C	30% RH 15°C	40% RH 20°C	50% RH 25°C	50% RH 28°C
D3 magnetic tape	50 years	25 years	15 years	3 years	1 year
DLT magnetic tape cartridge	75 years	40 years	15 years	3 years	1 year
CD/DVD	75 years	40 years	20 years	10 years	2 years
CD-ROM	30 years	15 years	3 years	9 months	3 months

Figure 5.3 Storage Life-expectancy Figures for Different Media
(From Arkival Technology Corp., 2002, Figure 2)

Chapter 5

What Attributes of Digital Materials Do We Preserve?

Introduction

> There is an inherent paradox in digital preservation. On the one hand, it aims
> to deliver the past to the future in an unaltered, authentic state. On the other
> hand, doing so inevitably requires some alteration (Thibodeau, 2002, p.28)

> What parts of digital objects do we need to keep into the future? Is it the
> 'essence' of a document? Should we be able to 'render' the 'digital original' in
> its native environment? (Van der Werf, 2002)

In 1915 the fossil remains of an ancient Pleistocene hominid were discovered in
the Piltdown quarries in Sussex, following the discovery of other fossil remains
from this quarry in the preceding three years. The discovery of this Piltdown
man transformed thinking about the evolution of mankind. However, in the
1950s it was clearly established that Piltdown man was 'a case of outright delib-
erate fraud', made up of fragments from a wide geographical and temporal
range of sources (Harter, 1999). There is a real possibility that we might see the
same issues arising with digital information as arose with Piltdown man, if
digital materials are reconstructed, interpreted and used for evidential purposes
without appropriate knowledge of their context, leading, at the very least, to
erroneous conclusions, and perhaps even to fraud.

A repeat of the Piltdown man saga is definitely a possibility, perhaps even a
probability – it may even have occurred already – in the digital context. The
characteristics of digital materials predispose them to such misinterpretation
and fraud. Preserving digital materials inevitably means altering them, because
the processes and techniques we apply require changes to be made. This raises
Thibodeau's 'inherent paradox', quoted at the head of this chapter. We need,
therefore, to determine the level of change that is acceptable, so that we can
claim to have preserved digital materials in a state that is close to the original.

We also need to have a clear idea about what level of loss of digital data is acceptable to us. We need to understand better the nature of the changes that we must make in order to preserve digital materials.

As well as gaining a deeper understanding of the changes that we make, we need to know more about exactly what it is we are trying to preserve. What characteristics, attributes, essential elements, significant properties – many terms are used – of digital materials do we seek to retain access to? What is the 'essence' of digital materials? Whereas this question was a simple one to answer in the non-digital context, where typically we sought to conserve and preserve the original artifact, for digital materials it is not so straightforward.

The example of e-mails, referred to in the previous chapter, is commonly used to illustrate this point. The essential elements of these are relatively easy to identify: the 'content information' (sender's name and address, subject, time, date, recipient(s), text of the message itself) and a simple standardized structure (UNESCO, 2003, p.78). But for other digital materials the essential elements are considerably less standardized, if they are standardized at all, so identifying what attributes of these we need to retain is difficult. The UNESCO *Guidelines* note, perhaps rather simplistically:

> some materials are much more difficult to characterise, and expectations about how they will be re-presented for use, especially to an open-ended community of potential users, may be so hard to define in advance that it becomes almost impossible (UNESCO, 2003, p.78).

A good example to illustrate this difficulty comes from the realm of the web. Some web sites do not have a clearly-defined audience, so it becomes more complex to determine what users of these sites might wish to see in the future. It is, therefore, harder to define those characteristics of web sites that it is essential to preserve. Many web sites are dynamic and interactive, with 'search and retrieval aspects intrinsically bound with content'. Therefore we need to preserve the functionality of the search and retrieval components, as well as the data that the functionality interacts with to generate the required output (Smith, 2003, p.1).

In order to determine the essential elements of digital materials we want to retain access to, we need to know in the future 'that they are what they purport to be', that they 'are complete and have not been altered or corrupted' (Ross, 2002, p.7). If we cannot ensure this, we will be victim to the frauds exemplified by Piltdown man. Considerable energy has been expended, particularly in the recordkeeping context, on determining what *authenticity* and *integrity* mean in the digital environment. If these characteristics cannot be established, then the genuineness of digital materials and our ability to use them for evidential purposes are devalued. How do we demonstrate that digital materials have not been altered? What actions do we have to take to establish authenticity and integrity and maintain them over time, so that the future user can be confident that the digital materials they are using retain their original meaning? (Ross, 2002, p.7).

Another concept that we need to know more about when we address the question 'what attributes of digital materials do we preserve?' is that of *acceptable loss*. It is unlikely, if not impossible, that we can preserve all of the attributes and functionality of digital materials, but we do not know much at all about

what levels of loss are acceptable to users. In the words of a statement about research needs in digital preservation,

> how can we measure what loss is acceptable? What tools can be developed to inform future users about the relationship between the original digital entity and what they receive in response to a query? (NSF-DELOS Working Group on Digital Archiving and Preservation, 2003, pp.19–20).

Current knowledge of the attributes of digital materials and of how important they are for users is insufficient to preserve digital materials effectively. We need to know more:

> If an object is preserved only to enhance access and use, some transformations might be desirable that would be prohibited if they transformed attributes deemed essential to the object . . . It would seem obvious that strategies, tactics and method for the preservation of digital objects ought to be informed by a rich understanding of their nature and the specific objectives for preserving them in digital form. The nature of digital objects defines what we need to preserve (Thibodeau, 1999).

This chapter examines some of these issues.

Digital materials, technology and data

Digital materials are the result of the mediation of information technology and data. That is, the digital object that is developed on a particular software and hardware platform can be viewed as it was originally conceived only on that particular platform. Viewing web sites illustrates this point. The software used to view them – the web browsers – are configurable by the user in relation to characteristics such as the font size and colour, unless the web site designer insists that the browser displays a site in a particular way. The experience of viewing that web site will be different for users who access that site using software and hardware that differs from that used to develop the site. Strictly speaking, observes Eastwood, 'it is not possible to preserve an electronic record. It is only possible to preserve the ability to reproduce an electronic record. It is always necessary to receive from storage the binary digits that make up the record and process them through some software for delivery or presentation' (Eastwood, 2002, p.77, citing Thibodeau, 2000).

This mediation aspect – the rendering or presentation (and re-presentation) of the digital files – is an important point to appreciate for digital preservation. Digital objects are not simply a bit-stream; rather, they are a combination of hardware, software and computer file. The bit-streams of computer files have to be processed technically before they make sense to a user:

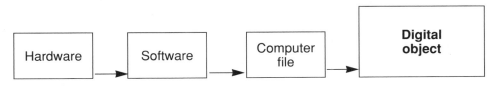

The computer file may look and behave differently from how it was origi-
nally intended to look and behave, if the hardware and software combination
differs. This difference may be so extreme that the authenticity of the digital
object is called into question (Digital Preservation Testbed, 2003, pp.13–14).
(These concepts have been considerably extended in the consideration of digital
objects as physical, logical or conceptual objects in Chapter 1.)

Some implications of this dependency of digital objects on software are listed
in the UNESCO *Guidelines*. Three different kinds of software dependency are
identified:

- digital objects that are simple and less dependent on specific software (plain
 text in ASCII files is an example)
- digital objects that depend on more complex software that is, however,
 generic (such as HTML)
- and digital objects that depend on software specific to a particular hard-
 ware platform or operating environment (such as spreadsheets and word
 processing software).

The example of web sites that incorporate search and retrieval functions indi-
cates that some digital objects contain executable files and software programs,
and others may contain combinations of all of the above. The extent to which
the digital object is dependent on software has a significant effect on the way
in which it can be preserved (UNESCO, 2003, p.124).

Furthermore, it is not possible to preserve originals of digital materials,
because migration is probably inevitable at some stage in the preservation
process, and migration involves technology. We are preserving copies of the
originals, 'preservation copies made according to the particular methods and
strategies that are appropriate or expedient' (Gilliland-Swetland, 2002, p.198).

Crucial to the development of digital preservation was the realization that
separating the technology from the data was the key. The technology (hardware
and software) was changing rapidly and would continue to do so. Earlier
thinking placed a high emphasis on preserving the ability to read computer files
in the software that was used to create them. Digital preservation solutions such
as museums of technology and emulation were proposed. Once it was acknowl-
edged that the digital file would have to be transferred from one medium to
another and that it could be viewed using a hardware/software combination
different from that with which it was created, the focus shifted from maintaining
access to obsolete software and hardware to determining which characteristics
or attributes of the digital file are essential to maintain access to in the future,
and how this can be achieved on current and future hardware/software combi-
nations. However, this change in thinking brought its own problems, as an early
statement about electronic records recognized:

> The content of a traditional record is recorded on a medium (storage
> device, like a piece of paper) and cannot be separated from this medium.
> The content of an electronic record is also recorded on a medium, but
> from time to time it has to be separated from the original device
> and transferred to other, and often different types of, storage devices
> whenever it is retrieved or when necessitated by technological obsoles-
> cence. Unlike traditional records, an electronic record is therefore not

permanently attached to a specific medium or storage device, so the opportunities for corruption grow. This presents additional problems in ensuring that the record's authenticity and reliability are maintained (International Council on Archives. Committee on Electronic Records, 1997, p.22).

The history of the response to digital preservation of the archives community in Australia illustrates this changing awareness and focus. Early responses to the issues of preserving electronic records, dating from around 1990, stemmed from pre-digital preservation attitudes, and tended towards the requirement that the artifacts themselves be preserved and kept accessible. Consequently emphasis was placed on maintaining hardware and on the longevity of media types such as disks and tapes. By the mid-1990s the thinking had changed and it was accepted, according to National Archives of Australia staff in May and June 2004, that 'the solution had something to do with software applications . . . the archives community generally hovered around this idea that somehow or other, if you could preserve the application, then you could preserve the data'. However, by the late 1990s the archives community recognized that the 'problem is a data problem, it's not a software application problem'. A new understanding of how software interacts with data was emerging:

> At the end of the day records are just data and data are just records, and in that process we came more to a clearer understanding of how software applications interact with data to produce records . . . That radically changed the possibilities of finding solutions, and we found the solution very quickly . . . We really started to give serious attention to this in the year 2000 and we had our basic approach worked out within a year. The basic idea [was] of normalizing materials into XML structures and ensuring that those XML structures have appropriate metadata kept with them, so that . . . the provenance and all the other authenticity issues about them could be re-established (Interviews with National Archives of Australia staff, May-June 2004).

Once we have realized that the key is to ensure the preservation of the data, regardless of the hardware and software platforms that the data will be processed on, then we need to pay a lot more attention to that data – to the attributes of the data to be preserved and the level of acceptable loss and alteration of the data.

As already noted, the process of preserving digital materials inevitably means that they are altered. While at one level digital preservation is a relatively simple matter of preserving the bit-stream, the result is meaningless unless the means to read and interpret that bit-stream are available, either by preserving them or developing software that makes them accessible. We might, for example, emulate a software application with a resulting loss of some functionality, affecting the ability of that software to fully interpret the data. What effect does this have on the authenticity of the digital object? Is some loss acceptable? If we can determine what attributes of that digital object are essential for us to understand it, then we can seek to preserve these attributes. For example, the colours presented on the screen may not be significant for text content, but it could be significant for understanding a web page. 'Document-like' digital

materials, typically in PDF, HTML, XML, or SGML file formats, 'embody data content, structure and presentation' (Van der Werf, 2002) and can be read using software other than that in which they were created. (In fact, this is the very characteristic of these file formats that makes them so useful for digital preservation purposes.) Other digital materials, typically educational software, games, and web animations, are 'executable' files, that is, they are in a format that is directly read by a computer as a program and is run ('executed'). These are usually in proprietary file formats, not re-usable in other contexts (Van der Werf, 2002). The determination of which attributes of digital objects are essential to maintain into the future has been addressed largely by the recordkeeping community in relation to establishing the requirements for authentic digital records (considered later in this chapter). Once these have been established, 'combinations of data, software and hardware that will re-present those elements as accurately as required' need to be maintained (UNESCO, 2003, pp.123–124).

An allied question is: What level of loss or alteration of data is acceptable? The UNESCO *Guidelines* suggest that decisions about this are likely to be required by digital preservation programs; as already noted, some 'loss of content, loss of the original "look and feel", or loss of some original functions' is likely. Further thinking about this question will assist in determining what the essential attributes of digital objects are (UNESCO, 2003, p.123).

The importance of preserving context

In addition to determining the essential attributes of digital materials and developing and applying techniques to maintain them over time, other information about digital materials must be identified and maintained over time, such as information about the context in which the data was created and existed. This concept is derived from recordkeeping theory and practice. Weber states: 'A good archive contains not only the end document, for instance the text of a document, but also documents which allow you to reconstruct the process which led to the agreement' (Kasteren, 2002, p.9, quoting Weber). Gilliland-Swetland points out the value that is placed on context in standard archival practice:

> When materials are generated by the activity of an individual or organization, an interdependent relationship exists between the materials and their creator. A complex web of relationships also exists between the materials and the historical, legal, and procedural contexts of their development as well as among all materials created by the same activity. The organic nature of records refers to all these interrelationships, and archival practices are designed to collectively document, capture, and exploit them. These practices recognize that the value of an individual record is derived in part from the sequence of records within which it is located. They also recognize that it can be difficult to understand an individual record without understanding its historical, legal, procedural, and documentary aspect (Gilliland-Swetland, 2000, pp.16,18).

She uses the example of a web page without its hyperlinks to illustrate this point: it 'may be less valuable to users because of its diminished evidential context'.

The requirement to trace the process of creation and change is doubly significant for digital materials, which, as we have seen, are altered in the process of preserving them. It is significant because the authenticity of digital objects – whether we believe that they are what they claim to be, our ability to trust them as accurate – depends on knowing how and when, and by whom, they have been altered. In other words, we need to preserve information about the context of the data (this is also noted in Chapter 4). For records (that is, records in the recordkeeping context, records as evidence of transactions) to be authentic, 'knowledge about the business context and about the interrelationship between records' is required. We should be able to identify 'why, when, where, by whom and so on they were created (or received) and used' as indicators of the record's trustworthiness. Put another way, 'it should be possible to position a record in the time and context in which it purports to originate' (Hofman, 2002, pp.18–19).

The OAIS reference model

The Open Archival Information System (OAIS) reference model brings together many of the concepts discussed so far in this chapter and points to others that are relevant to the question of which attributes of digital materials we are attempting to maintain into the future. This model was developed to provide a common framework for describing and comparing architectures and operations of digital archives. It is being adopted throughout the world as an important design schema for digital preservation systems. The digital preservation community is adopting the concepts and terminology embedded within it. The OAIS model is 'emerging as the first international standard in digital preservation' (Beagrie, 2003, p.5).

The OAIS reference model was developed by the Consultative Committee on Space Data (based at NASA in the USA) and is now an international standard – ISO 14721:2003. It is based on the concept of open standards, increasingly being recognized as a stable foundation for digital preservation activities. As Breeding explains, 'one of the most important digital preservation strategies involves taking advantage of open standards whenever appropriate and avoiding proprietary data formats when possible' (Breeding, 2002, p.48). The OAIS model has been used as the basis of digital preservation systems, such as those developed by OCLC, the Koninklijke Bibliotheek's e-Depot, and the CEDARS archiving demonstrator project, more details of which are provided in Chapter 9.

Part of the significance of the OAIS reference model lies in the establishment of a common language for discussion of digital preservation: its Foreword notes that it 'establishes a common framework of terms and concepts' to allow 'existing and future archives to be more meaningfully compared and contrasted' and to promote standardization (Consultative Committee for Space Data Systems, 2002, p.iii). For example, it defines *long term preservation*: 'long enough to be concerned with the impact of changing technologies, including support for new media and data formats, or with a changing user community. Long Term may extend indefinitely' (Consultative Committee for Space Data Systems, 2002, p.1–1). It makes a clear distinction between simple data storage and long-term preservation:

> A major purpose of this reference model is to facilitate a much wider understanding of what is required to preserve and access information

for the Long Term. To avoid confusion with simple 'bit storage' functions, the reference model defines an Open Archival Information System (OAIS) which performs a long-term information preservation and access function (Consultative Committee for Space Data Systems, 2002, p.2–1).

The significance of the OAIS reference model also lies in its articulation of the functional requirements of a digital archival system. It defines five functions:

- the Ingest function 'responsible for receiving information from producers and preparing it for storage and management within the archive'
- the Archival storage function which 'handles the storage, maintenance and retrieval of the AIPs [Archive Information Packages] held by the archive'
- the Data Management function which 'coordinates the Descriptive Information pertaining to the archive's AIPs, in addition to system information used in support of the archive's function'
- the Administration function which 'manages the day-to-day operation of the archive'
- the Access function which 'helps consumers to identify and obtain descriptions of relevant information in the archive, and delivers information from the archive to consumers'.

These five functions 'taken together ... identify the key processes endemic to most systems dedicated to preserving digital information' (Lavoie, 2000, pp.28–29). They have proved to be influential, one indication being the widespread adoption of the term *ingest* in digital preservation discussion.

Of greatest relevance to this chapter, however, is the OAIS concept of 'information package', explained as

> a conceptual container of two types of information called *Content Information* and *Preservation Description Information (PDI)*. The Content Information and PDI are viewed as being encapsulated and identifiable by the *Packaging Information*. The resulting package is viewed as being discoverable by virtue of the *Descriptive Information* (Consultative Committee for Space Data Systems, 2002, p.2–5).

In other words, a digital object consists of much more than just the content that we wish to preserve (the 'information which is the original target of preservation'). It also comprises information that tells us what we need in order to preserve it ('to ensure it is clearly identified, and to understand the environment in which the Content Information was created'), information about its attributes (such as file formats), and so on. What is this information? And why is it an essential component of the digital materials 'package' in relation to preservation? This information – metadata – is an essential part of the OAIS reference model and is increasingly considered vital to all digital preservation activities.

OAIS is not straightforward to comprehend. Beagrie suggests that it needs to be further developed to make it more accessible, for example by producing 'accessible guides to major concepts behind the standard' (Beagrie, 2003, p.7).

The role of metadata

Metadata ('structured information that describes, explains, locates, or otherwise makes it easier to retrieve, use, or manage an information resource' (NISO, 2004, p.1)) has captured the attention of many. A considerable amount of energy has been channeled into its development, and many words have been written about it. A subset of this activity is concerned with preservation metadata. Preservation metadata is now considered an integral part of the strategies required for long-term maintenance of and access to digital materials, although some (such as Chivers and Feather, 1998, and Lazinger, 2001) claim for it an even more dominant role, suggesting it to be almost synonymous with digital preservation. Day notes that metadata is an intrinsic part of the current key digital preservation strategies of emulation, migration, and encapsulation (Day, 2004, p.255). The UNESCO *Guidelines* reinforce the essential nature of preservation metadata, listing among their fundamental principles four relating to metadata:

17. Digital heritage materials must be uniquely identified, and described using appropriate metadata for resource discovery, management and preservation.
18. Taking the right action later depends on adequate documentation. It is easier to document the characteristics of digital resources close to their source than it is to build that documentation later.
19. Preservation programmes should use standardised metadata schemas as they become available, for interoperability between programmes.
20. The links between digital objects and their metadata must be securely maintained, and the metadata must be preserved (UNESCO, 2004, p.23).

The second of these principles is reinforced by the view of US experts that best practice for preservation metadata is to create it 'at the information creation stage' (Meeting of Experts on Digital Preservation, 2004).

The importance of metadata is corroborated by Australian digital preservation specialists interviewed in 2004. One was a self-confessed 'metaphile'. Another considered that intellectual control was the key to effective digital preservation:

> the only way to manage [digital preservation] is to have an intellectual control system that applies across all media, that is not media-specific ... building systems that are not technologically or system dependent, [where] the intellectual control system is a sort of conceptual system above whatever technology you use.

From his experience of '10 or 15 years of work' in the digital preservation environment, he claims that metadata works 'really really well, you know ... [If] you use that across all technologies or media or record types, then you don't ever have a problem finding anything'.

Preservation metadata – defined on the PADI web site as 'structured ways to describe and record information needed to manage the preservation of digital resources' – should not be confused with descriptive metadata, those based on schemas such as Dublin Core or AGLS (the Australian Government Locator Service). These have the primary aim of resource discovery, that is of enabling information resources to be identified and linked to users' requests, and are best considered as 'a set of signposts for digital surfers ... there to guide people to

resources' (Wilson, 2003, p.33, citing Tom Baker). By comparison, preservation metadata stores 'technical details on the format, structure and use of the digital content, the history of all actions performed on the resource including changes and decisions, the authenticity information such as technical features or custody history, and the responsibilities and rights information applicable to preservation actions' (Preservation metadata, 2003).

Preservation metadata consists of two types of metadata: *content information*, and *preservation description information* (to use the terms of the OAIS reference model). Content information consists of 'details about the technical nature of the object which tells the system how to re-present the data as specific data types and formats'. Preservation description information is 'other information needed for long-term management and use of the object, including identifiers and bibliographic details, information on ownership and rights, provenance, history, context including relationships to other objects, and validation information' (UNESCO, 2003, p.98). More specifically, preservation metadata

- Identifies the material for which a preservation programme has responsibility
- Communicates what is needed to maintain and protect data
- Communicates what is needed to re-present the intended object (or its defined essential elements) to a user when needed, regardless of changes in storage and access technologies
- Records the history and the effects of what happens to the object
- Documents the identity and integrity of the object as a basis for authenticity
- Allows a user and the preservation programme to understand the context of the object in storage and in use (UNESCO, 2003, p.97).

There are, as yet, no commonly accepted standards for preservation metadata, although several contenders are in development. Perhaps the best-known schemes to date include those of the OCLC/RLG Working Group, the National Library of New Zealand, and the National Library of Australia; another Australian scheme is the National Archives of Australia's recordkeeping metadata scheme. Early preservation metadata schemes were developed by NEDLIB and CEDARS, and the National Library of Australia.

The National Library of Australia's metadata scheme was grounded in that Library's experience with digital preservation, including the PANDORA web archiving project, and was issued in 1999 (Lupovici, 2001, pp.6–7; National Library of Australia, 1999b; Bradley and Woodyard, 2000). An exposure draft issued by the National Library of Australia in October 1999 outlined the information it believed was needed to manage the preservation of its digital collections. This scheme was informed by other schemes and models, such as the OAIS Reference Model, the NEDLIB project, and activities relating to projects at the Library of Congress, CEDARS, the National Archives of Australia, and the Research Libraries Group, none of which was considered to be fully satisfactory for the National Library of Australia's requirements at that time. The National Library of Australia model is 'meant to be a data output model, not a data input model'; that is, it defines 'the information we want out of a metadata system, not necessarily what should be entered, how it should be entered, by whom and at what time; nor does it concern itself with how the metadata should be associated with what it is describing' (National Library of Australia, 1999b). It consists of 25 elements:

1. Persistent Identifier	14. Quirks
2. Date of Creation	15. Archiving Decision (work)
3. Structural Type	16. Decision Reason (work)
4. Technical Infrastructure of Complex Object	17. Institution Responsible for Archiving Decision (work)
5. File Description	18. Archiving Decision (manifestation)
6. Known System Requirements	19. Decision Reason (manifestation)
7. Installation Requirements	20. Institution Responsible for Archiving Decision (manifestation)
8. Storage Information	21. Intention Type
9. Access Inhibitors	22. Institution with preservation responsibility
10. Finding and Searching Aids, and Access Facilitators	23. Process
11. Preservation Action Permission	24. Record Creator
12. Validation	25. Other.
13. Relationships	

Figure 5.1 Elements of the National Library of Australia Metadata Scheme

NEDLIB (the Networked European Deposit Library) published a metadata scheme in 2000, which was intended specifically to manage the preservation of digital materials received through national deposit. CEDARS immediately developed the NEDLIBS metadata scheme further to cover administrative, technical and legal information (Lupovici, 2001, pp.6–7). These and other schemes were analysed by a Working Group on Preservation Metadata convened by OCLC and the Research Libraries Group (RLG), with representatives from the RLG's international membership, including Australia. This Working Group released a recommended preservation metadata framework in 2002 (OCLC/RLG Working Group on Preservation Metadata, 2002). The framework is based on the OAIS reference model recommendations. Following its release OCLC and RLG convened the PREMIS Working Group to focus on how preservation metadata could be implemented in digital preservation systems. In 2004 PREMIS released a report on metadata practices and other digital preservation activities of respondents in 13 countries (OCLC/RLG PREMIS Working Group, 2004). Among other outcomes will be an implementable set of core preservation metadata elements and a data dictionary (Guenther, 2004; Caplan, 2004).

The National Library of New Zealand has been active in developing a metadata scheme for digital preservation as well as tools for extracting metadata automatically from digital materials. Its scheme is based on the OCLC/RLG metadata framework. Knight describes progress and expectations of the National Library of New Zealand's preservation metadata scheme (Knight, 2003, p.18). Its metadata standards framework is 'a work in progress which, when complete, will provide a comprehensive statement of the standards environment within the National Library'. The scheme has 18 elements describing the logical object, 13 elements to record the history of actions performed on the object, nine for

technical information about file types, and five to record the history of changes made to the preservation metadata (Searle and Thompson, 2003). A resource discovery metadata scheme was released in 2000, followed by a preservation metadata scheme in November 2002, which was revised in June 2003. A data model and its associated XML schema definitions, released in July 2003, describe how the metadata scheme can be implemented.

The metadata extraction tool developed by the National Library of New Zealand has attracted the attention of the international digital preservation community. It is designed to extract automatically preservation metadata from a range of file formats and output the extracted data in XML format so that it can be loaded into a preservation metadata repository. It is being developed to extract data from a number of common file formats, such as MS Word (various versions), WordPerfect, Open Office, MS Works, MS Excel, MS Powerpoint, TIFF, JPEG, WAV, MP3, HTML, PDF, GIF, and BMP. This tool 'is designed for use by the wider digital preservation community and it is hoped that any future development will be informed by that community', notes the National Library of New Zealand's web site, describing the strongly collaborative approach taken by the international preservation metadata community. This metadata extraction tool, as well as information about it, is available free from the National Library of New Zealand's web site. Its innovative nature and significance was acknowledged by its short-listing for the digital preservation award, introduced in 2004 as one of the Pilgrim Trust Conservation Awards.

The National Archives of Australia's recordkeeping metadata scheme is part of its 'e-permanence' initiative. It is designed to be used in conjunction with AGLS metadata, to uniquely identify records, authenticate them, document and preserve their content, context and structure over time, administer conditions of access and their disposal, track usage history and management, and simplify the transfer or migration of electronic records between computer systems (Robertson and Cunningham, 2000, p.196). Some of its elements are specific to preservation: no. 2, Rights Management, and no. 17, Preservation History (National Archives of Australia, 2001c).

Although implementing preservation metadata undoubtedly has the potential to improve digital preservation practice, its full potential will not be realized until there is widespread agreement on a standard set of elements. US experts concluded that 107 elements were needed in a preservation metadata scheme (Meeting of Experts on Digital Preservation, 2004), and the current lack of consensus is apparent even from the brief descriptions of preservation metadata schemes, above. There is potential for reducing the costs of developing preservation metadata schemes, as well as reducing the costs of creating metadata by using automated metadata creation software. Standardization also allows greater sharing of information, making it easier to move digital objects from one archive to another, and encourages the standardization of preservation processes (UNESCO, 2003, pp.92–93). Here, perhaps, is an analogy with the history of the MARC format in libraries: from a single format in the mid-1960s, it proliferated during the 1970s and 1980s, and only after several decades has it once again become a single internationally-adopted standard. The advantages of a limited number of standard schemes appear not to have yet been fully recognized by the preservation metadata community.

Preservation metadata schemes continue to evolve. There is still relatively little experience of the effective application of preservation metadata. The

NSF-DELOS Working Group on Digital Archiving and Preservation notes that there has been 'limited evaluation of the effectiveness or cost of metadata for managing digital entities over time' and suggests that research is needed, for example to demonstrate its value for specific purposes and to determine how much metadata is needed. Tools are needed to 'aid in the creation, authoring and management of metadata', such as those which automate, or partly automate, the creation of metadata; these are being developed, an example being the National Library of New Zealand's metadata extraction tool. Also required are tools that manage metadata schemes so that they are useful over time, such as those 'to track the provenance of metadata schema, for version control, and to allow users to navigate from current metadata schema and ontologies to those used when the digital entity was created'. The value of metadata could be assessed relative to the costs of 'extracting, creating and managing' it, to provide a better understanding of the 'minimum amount of metadata necessary for digital preservation' (NSF-DELOS Working Group on Digital Archiving and Preservation, 2003, p.19).

Persistent identifiers

Persistent identifiers are a form of metadata relating to digital materials on the web. The normal way of identifying web materials is to use a URL (Uniform Resource Locator). However, a URL points only to the one location of the material on the web, and, if the location of that material changes (for example, the material is moved from one domain name to another), the URL is altered and the material becomes inaccessible if the superceded URL is used. The persistence of URLs has been investigated in many studies (such as Koehler, 2004; Smith, 2004) and their tendency to change is widely recognized as an impediment to digital continuity.

Persistent identifiers have been developed to address this issue. Reliable identification of digital materials is essential for reliable long-term access and for ensuring their authenticity. Beagrie's survey of international preservation activities highlighted the need for persistent identifiers, not just for web material but also for 'the linking and citation of primary research and data sets' (Beagrie, 2003, p.7). Persistent identifiers are, of course, not new: formal identifier schemes such as ISBN, ISSN and ISMN have developed and been applied for many years in the pre-digital context. A persistent identifier is 'a name for a resource which will remain the same regardless of where the resource is located' (National Library of Australia, 2002b). If the material (or resource) is moved, the persistent identifier provides access to it in its new location, provided that the persistent identifier is 'maintained with the correct current associated location when the resource was moved' (Persistent identifiers, 2002). Persistent identifiers can be considered as a form of preservation metadata, in the sub-set of preservation description information already noted above (UNESCO, 2003, p.98).

Various kinds of persistent identifiers have been developed and implemented. The Uniform Resource Name (URN) is 'a standard, persistent and unique identifier for digital resources on the Internet' (National Library of Australia, 2002b). URNs rely on a resolver service to link the URN to the location (URL) of the web site on which the digital material is currently hosted. The Persistent Uniform Resource Locator (PURL) is similar to a URL, but links to the resolution service

rather than the actual location of the digital material on the web. An example (hypothetical) of a PURL is *http://purl.org.net/weibel/*, where *http://* is the protocol, *purl.org.net/* is the resolver address, and *weibel/* is the name. (This example is one of many given in answers to frequently asked questions about PURL (purl. oclc.org/docs/purl_faq.html#toc1.4).) PURLs were developed by OCLC as an interim system, awaiting the full implementation of URNs (National Library of Australia, 2002b). The Digital Object Identifier (DOI), an implementation of the URN concept, was initiated by the Association of American Publishers to 'assist the publishing community with electronic commerce and copyright management of digital objects published on the Internet' and allow 'the allocation of a unique digital identifier to commercial digital publications' (National Library of Australia, 2002b). It has achieved NISO standard status, as ANSI/ NISO Z39.84. DOIs can be applied to any kind of digital materials. The DOI system is managed by the International DOI Foundation, and DOIs are allocated by DOI Registration Agencies in the USA, Australasia, and Europe (International DOI Foundation, 2004?).

Other persistent identifiers have been developed, such as the Handle System (similar to URNs) and ARKs (Archival Resource Keys). Dack (2001) and the PADI web site (Persistent identifiers, 2002) provide further information about them.

Authenticity

As noted in Chapter 1, definitions of terms taken from the pre-digital preservation paradigm are not always appropriate when applied to digital preservation. Discussions about digital preservation are further confused by the difference in terminology among librarians, recordkeepers and other interested groups. 'Terms like provenance, archiving, context, records, etc. are used with slightly different meanings . . . any discussion about preservation is challenged by confusion of terminology' (Hofman, 2002, p.15). The term *authenticity* is one of these, and therefore we first need to establish what is meant by it

Authenticity is defined variously:

- the 'quality of genuineness and trustworthiness of some digital materials, as being what they purport to be, either as an original object or as a reliable copy derived by fully documented processes from an original' (UNESCO, 2003, p.161)
- 'the digital material is what it purports to be' (Jones and Beagrie, 2001, p.9)
- 'the degree of confidence a user can have that the object is the same as that expected based on a prior reference or that it is what it purports to be' (Authenticity, 1999)
- 'a document that is the same as that which a user expected based on a prior reference' (Kerry, 2001, p.7, citing the CEDARS Project).

Terms related to authenticity are:

- *integrity*, which for digital material is 'the state of being whole, uncorrupted and free of unauthorised and undocumented changes' (UNESCO, 2003, p.162)
- *essential elements* or *significant properties*, 'the elements, characteristics and attributes of a given digital object that must be preserved in order to represent its essential meaning or purpose' (UNESCO, 2003, pp.161–162); and

- *identity*, the attributes of a digital object that uniquely characterize and distinguish it from other digital objects (Duranti, 2003, p.2).

The UNESCO *Guidelines* get to the heart of the matter, stating succinctly that

> Authenticity derives from being able to trust both the *identity* of an object – that it is what it says it is, and has not been confused with some other object – and the *integrity* of the object – that it has not been changed in ways that change its meaning

and that 'evaluating, maintaining and providing evidence of continued authenticity are key responsibilities for most preservation programmes' (UNESCO, 2003, p.113).

Authenticity is valued in a number of different contexts for a variety of reasons. It is critical where digital materials are used as evidence. For records, the authenticity of the record is paramount: all who use it need to be able to trust that it is what it purports to be. Because 'regulated industries, financial institutions, hospitals and clinics, and public entities are legally obliged to keep records over decades for purposes of accountability, continuity of operations and organizational memory' their authenticity needs to be safeguarded (NSF-DELOS Working Group on Digital Archiving and Preservation, 2003, p.4). Scholars 'will need to feel confident that references they cite will stay the same over time', and for participants in the legal system, there needs to be an assurance that 'material can withstand legal evidential requirements' (Jones and Beagrie, 2001, p.25). The list goes on: heritage materials are valued because they are authentic; for scientific data, 'trust in their ongoing authenticity is critical, for without it they are of virtually no value' (UNESCO, 2003, p.112). It could even be said that the future of government is at stake: 'the likely success of e-government initiatives will depend on their ability to demonstrate to the citizen that digital records are maintained over time in systems that guarantee their authenticity and integrity' (NSF-DELOS Working Group on Digital Archiving and Preservation, 2003, p.4).

The high value placed on authenticity has a long history. The Athenian government considered that a key function of the library should be 'to serve as a repository of trustworthy copies', at least for the works of Aeschylus, Sophocles, and Euripides. Their plays were considered to be superior to those of their successors and revivals of these plays became the dramatic mainstay. However, according to Casson (2002) 'the actors in them took liberties with the text' to the extent that Lycurgus (leader of Athens from 338 to 325 BC) directed that

> Written versions of the tragedies of [Aeschylus, Sophocles, and Euripides] are to be preserved in the records office, and the city clerk is to read them, for purposes of comparison, to the actors playing the roles, and they are not to depart from them.

'In other words', notes Casson, 'an authoritative version of each play was to be kept on file, and the actors were to follow it, under penalty of law' (Casson, 2002, pp.29–30).

Authenticity of non-digital records has traditionally been assured by 'the need for creators to rely upon their own active records, the fixity of these records, a

documented unbroken chain of custody from the creators to the archivists, and the description of the archival record within a finding aid' (Gilliland-Swetland, 2005). Authenticity of non-digital materials was determined by considering provenance, integrity and context. Artifacts are of value because their originality, fidelity, fixity, and stability are preserved (Task Force on the Artifact in Library Collections, 2001, pp.10–11). For museum objects, provenance ('the chain of ownership and context of use of an object' (*(Significance)*, 2001, p.37) is especially important. An artwork that has a doubtful provenance is diminished in value (in this case financial); material from an archaeological site whose provenance has not been recorded is similarly reduced in irs reliability as evidence of past societies, and, therefore, in the uses to which it can be put. Integrity – an object's 'condition, intactness and integrity' – provides an object with authenticity in that it is complete and in original condition (*(Significance)*, 2001, p.43). These determinations of authenticity and integrity are very closely linked to context. We need to be sure that the context in which the object was produced, discovered, owned, and stored is recorded. But this is more difficult to ensure for digital materials, and their authenticity, therefore, is harder to establish and maintain.

Why is establishing and maintaining the authenticity of digital materials different from traditional materials? Why is it of such concern to those involved in digital preservation? As noted at the start of this chapter, preserving digital materials inevitably means altering them, because the processes and techniques we apply require changes to be made, changes that are easy to make. In the words of Jones and Beagrie (2001, p.9), 'confidence in the authenticity of digital materials over time is particularly crucial owing to the ease with which alterations can be made'. The threats to authenticity are intrinsic to the preservation processes for digital materials. These threats can be summarized as of three kinds:

1. 'the possibility of a multiplicity of versions of a particular document' (Authenticity 1999) resulting from 'confusion in identifying data, changes to identifiers, or failure to document the relationships between different versions or copies' (UNESCO, 2003, p.113)
2. changes caused by preservation processes, for example, the common practice of migrating information from one system or carrier to another may result in changes, as may adding metadata, creating new copies and other processes (UNESCO, 2003, p.113)
3. changes to the content of the material (UNESCO, 2003, p.113).

In addition there are, as noted in Chapters 2 and 3, threats that apply to all digital data – what the UNESCO *Guidelines* call 'the ongoing integrity of data' – and they affect authenticity. Among the threats are breakdown of carriers, malicious acts, such as attacks by hackers or viruses, terrorist attacks, war, civil unrest (especially as they compromise power supplies and the integrity of buildings), accidental acts by staff, and fires, floods and other natural disasters, and business failure (UNESCO, 2003, p.113).

Because authenticity is so highly valued, digital preservation programs need to take appropriate steps to ensure that it is not compromised for the materials in their custody. The strategies applied to ensure the authenticity of digital materials include unique identifiers, encapsulation techniques (the packaging together of the digital object, its metadata, and other associated data), digital

watermarking, digital signatures, encryption, digital time stamping, audit trails, controlled custody, and trusted repositories (Authenticity, 1999; NSF-DELOS Working Group on Digital Archiving and Preservation, 2003, p.6).

Significant properties

Ensuring authenticity does not require keeping the materials in their original form without change: this is, as noted, impossible for digital materials, and is indeed inimical to digital preservation processes. We need to identify the attributes of digital materials that we must preserve to ensure authenticity, and also the attributes we do not need to preserve, because 'preservation processes often require transforming the original bitstream' (NSF-DELOS Working Group on Digital Archiving and Preservation, 2003, p.17). This has been variously described as *essence, core activities, significant properties, essential elements*, and *performance*.

The term 'preservable essence' of digital materials comes from the CEDARS Project (Kerry, 2001, p.7) and has been widely adopted. At the National Archives of Australia it is used to refer to the essential characteristics of a record (Heslop, Davis and Wilson, 2002, p.13). It is noted further below in this chapter and also in Chapter 8.

Hofman discusses the term 'significant properties' in relation to records in digital form:

> One of the basic notions in a digital environment is the difference between what is shown on the screen and what is stored on the disk or medium. There isn't even always – nor does there have to be – a 1:1-relationship between them . . . It is the message or the intellectual content which the author or creator intended to convey that has to be preserved. That content has a context, form and structure and in some cases also behaviour (e.g. spreadsheets) . . . in general we want to preserve the intellectual expression (object, if you like), not the digital components of which it consists per se, because, if one thing is obvious in a digital world, it is that fact that these digital components will change over time . . . What we want to achieve . . . is that in the future we will still be able to see, read and understand the documents or other information entities that were once produced for a certain purpose and in a certain context. In trying to achieve this, we of course need to preserve these digital components, but, as information technology will evolve, these components have to be migrated or in some cases emulated to be usable on future hard- and software platforms. Therefore, one of the issues is to identify what the intellectual aspects are. The emerging notion of 'Significant Properties' seems to acknowledge this (Hofman, 2002, p.17).

Hedstrom and Lee define significant properties as 'those properties of digital objects that affect their quality, usability, rendering, and behaviour' (2002, p.218). Microfilming of paper documents preserve the significant properties of most of these documents, that is their information content. But what is the equivalent for digital materials, which are considerably more complex? Hedstrom and Lee (2002) attempted to provide an empirical model for assisting decision-making about which significant properties of digital materials need to be preserved.

The National Library of Australia's Digital Preservation Issues Group has also investigated significant properties, defining them in relation to four categories of desired functionality of digital objects that it wishes to preserve: 1) full dynamic/interactive functionality, 2) look/sound and feel, 3) intellectual content, and 4) description of what was (e.g. metadata for an object that no longer exists). Both the National Library's experience and that of Hedstrom and Lee suggest that further research is required to ascertain significant properties for specific types of digital materials in relation to their use by particular communities (Hedstrom and Lee, 2002, p.223).

The idea of access to digital materials being analogous to a performance is gaining currency. Thibodeau tells us:

> It is necessary to recognize that, strictly speaking, it is not possible to preserve an electronic record. It is only possible to preserve the ability to reproduce an electronic record. It is always necessary to retrieve from storage the binary digits that make up the record and process them through some software for delivery or presentation. Analogously, a musical score does not actually store music. It stores a symbolic notation which, when processed by a musician on a suitable instrument, can produce music. Presuming the process is the right process and it is executed correctly, it is the output of such processing that is the record, not the stored bits that are subject to processing (Thibodeau, 2000, p.1).

It is described in the UNESCO *Guidelines*. The idea is simple; the application of the same software and hardware to the same digital materials should create a 'presentation or performance' that is the same every time. For preserved digital materials, their essential elements are presented during a performance sometime in the future: 'copying data from carrier to carrier, and providing the right tools to recreate the intended performance will preserve continuity of access to most digital objects'. This apparently simple model is, however, rather more complex in practice:

> it may be hard to define the performance that must be re-presented; it is usually difficult to work out what tools are needed once the original ones have been lost; the tools themselves typically rely on other tools that also may have been superseded; and it may be difficult to find tools that will create the required performance in a reliable, cost-effective and timely way, especially in the context of many thousands, millions or more of digital objects. Despite such underlying complexities, the performance model helps in recognising what digital preservation programmes must aim for: the best means of re-presenting what users needs to access (UNESCO, 2003, p.36).

An Australian digital preservation specialist interviewed in 2004 noted the National Archives of Australia's view of performance and essence:

> issues like look and feel . . . are significantly less important, because we can demonstrate to you that if we show you the same Word document on a different operating system, it can actually look different. If we show it on a different machine which has different fonts installed, it will look

different. If I alter the page setup, or even on different machines with the same page setup, you'll get a different pagination, and if you've got an automatic footer with a page number in it, it will automatically change that pagination for you, and it won't be apparent to you that the pagination has changed. So a lot of that we have actually defined as being ephemeral or circumstantial aspects of the performance of the record in a particular situation . . . is not particularly relevant. I suppose if we got down to a very fine detail we might at certain points sort of say, well we have to say that because this record is a very important record and it matches let's say a hard copy record, then it really needs to be viewed with this sort of pagination and that sort of thing, but generally we don't get down to that level of detail and we would regard that as an extremely exceptional sort of thing to have to do. We've defined most of these essence characteristics, in practice we define them by defining the schema for the particular elements.

What this boils down to is that for the materials being preserved we need to understand the characteristics that they embody, and the minimum set of these characteristics that need to be maintained in order to recreate the materials in the future. As well as needing to preserve the physical object (the physical form that carries the bit-stream) it is necessary to preserve the logical object (the computer readable code) and the conceptual object ('the performance presented to a user' (UNESCO, 2003, p.36)) that is meaningful to the human user. However, we also need to envisage the digital object as 'bundles of *essential elements* that embody the message, purpose, or features for which the material was chosen for preservation' (UNESCO, 2003, p.36). Not all of the elements that make up a digital object are equally important in recreating the conceptual object.

It is also necessary to understand the needs of the community of users for whom digital materials are being preserved. 'Community' can be as closely defined as a specific organization or discipline group, or as extensive as 'the general public'. Their needs determine the kind of material selected for preservation and the levels of authenticity required. 'Essence', 'significant properties', or 'essential elements' of the materials selected are defined in relation to the community's requirements. For example, if the community is one where value is placed on the authenticity of records of transactions, that is their evidential value is high, then a lot of attention must be paid to maintaining the integrity of those records: ensuring that any alterations made to them are carried out only by authorized personnel and are appropriately documented, or that the records are preserved in an unalterable (read-only) form (UNESCO, 2003, p.77). However, some communities will not require that authenticity be proved to this extent. 'Ultimately, preservation programmes must decide how much to invest in ensuring that the authenticity of material in their care can be trusted, bearing in mind that object identity and data integrity are fundamental responsibilities' (UNESCO, 2003, p.114). An Australian example of a community's response to the challenges of authenticity can be seen in the Authenticated Electronic Editions project. This addresses the needs of textual editing scholars who require 'maintenance of the integrity of the core text while it is being proliferated, translated across platforms, manipulated, supplemented and analysed.' To achieve this, the project has developed JITM (Just In Time Markup) (Australian Scholarly Editions Centre, 2001).

The UNESCO *Guidelines* suggest some questions to be posed in deciding on essential elements to preserve:

- For whom should this material be kept? Do they have specific expectations about what they will be able to do with the material when it is re-presented?
- Why are the materials worth keeping? What gives them the value that warrants the trouble of preserving them? Is that value associated with evidence, information, artistic or aesthetic factors, significant innovation, historic or cultural association, what a user can make the material do or do with the material, culturally significant characteristics?
- Is the value tied to the way the material looks? (Would it be lost or significantly degraded if the material looked different?)
- Is the value tied to the way the object works? (Would it be lost if particular functions were removed? Or if particular functions happened at a different speed or required different keystrokes?)
- Is the value tied to the context of the material? (Would it be lost if links embedded in the material did not work? Or if a user could no longer see evidence that connected the material with its original context?)
- Is it possible to distinguish between elements within each of these areas? For example, would advertising banners be considered an essential part of the way the material looked? Would some navigation elements or display functions be needed but not others?
- If it is difficult to define what needs to be maintained, it may be easier to consider the impact of an element not being maintained, and to look for functions or elements that are definitely not needed.

Figure 5.2 Deciding on Essential Elements (From UNESCO, 2003, pp.78–79)

Further elaboration of the example of e-mails, used in the previous chapter and earlier in this chapter, serves to illustrate some points about preserving authenticity. Authenticity in this case ensures the trustworthiness of the e-mail as a record of a transaction. An authentic record is 'one that can be proven a) to be what it purports to be, b) to have been created or sent to the person purported to have created or sent it, and c) to have been created or sent at the time purported' (Millar, 2004, p.4). For an e-mail to be considered an authentic record, it must be demonstrated that it has not been changed or corrupted, and that it was created by a particular person. This is achieved by 'describing and preserving the original context of the records and by maintaining a chain of unbroken custody' (Digital Preservation Testbed, 2003, p.15). Changes are acceptable as long as they do not alter the original meaning of the e-mail. E-mails can be considered as consisting of five characteristics:

- context ('the environment in which the digital record is made')
- content ('the body of the record, regardless of structure, colour, position or font')
- structure ('the structure as it was originally made and reproduced on the screen')

- appearance ('the final presentation, what the records looks like when it appears on the screen')
- behaviour ('the interactive characteristics of a records; that which enables us to manipulate and use the record so that new and extra content is displayed') (Digital Preservation Testbed, 2003, pp.14–16).

For e-mails, however, it could well be decided that it is only the content information that users require – 'the name and address of the sender, subject, date and time, recipients, and the message, in a standardised structure with only the most simple of formatting' (UNESCO, 2003, p.77).

Clausen provides another example, of digital objects harvested from the web. He identifies five aspects of 'preservation evidence quality' – readability, comprehensibility, appearance, functionality, and 'look and feel' – and gives examples of how these might be applied to a range of digital objects commonly encountered on the web (Clausen, 2004, pp.8–10). A third example, provided by an Australian digital preservation specialist interviewed in 2004, was of the Perseus web site (www.perseus.tufts.edu). He commented that 'the way the site is laid out, the way things relate to each other, I would have thought was sufficiently significant to warrant preservation apart from the actual content'. The difficulty of one aspect of this decision was noted: 'quite how one generalizes from that into a wider set of principles is a harder thing to try to come to terms with'.

More research into authenticity and its requirements in the digital world is required, although establishing these will be no easy task, as the authors of a CLIR publication emphasize (*Authenticity in a Digital Environment*, 2000). In the opinion of the NSF-DELOS Working Group on Digital Archiving and Preservation, the digital preservation research agenda includes research into tools that allow future users of digital materials to determine whether they are authentic (NSF-DELOS Working Group on Digital Archiving and Preservation, 2003, p.vii). We need a working definition of authenticity, closer definition of significant properties and a clearer understanding of how these significant properties affect use and access of digital materials, knowledge of how much change is acceptable before the authenticity of digital materials is compromised, among other things (Kerry, 2001, p.7). We also need strong legislative, organizational, and policy frameworks for managing digital records, and stronger technical and operational standards (Millar, 2004, p.8).

Research into authenticity

Several research projects have been influential in determining requirements for digital materials to be considered as authentic. It is significant that these projects originate in the recordkeeping professions and, consequently, are principally concerned with electronic records. It is not clear how some of their conclusions might relate to other kinds of digital materials. There have not as yet been any similar projects that have focused on other kinds of digital materials.

Functional Requirements for Evidence in Recordkeeping Project (Pittsburgh)

One of the ironies of digital preservation is that the web site on which the reports of the Functional Requirements for Evidence in Recordkeeping Project were to

be found was an early victim. The project was administered by the University of Pittsburgh. The web site hosting the working files of this project was deleted; however, the site can be accessed through the Internet Archive (Cox, 2000?). The project (commonly referred to as the Pittsburgh Project) investigated during the early to mid 1990s the functional requirements necessary for electronic record-keeping systems to meet the needs of archivists better. However, its focus soon changed from system requirements to the requirements of electronic records to be considered as evidence. It developed a definition of what constituted an electronic record which placed high importance on metadata (Heazlewood, 2000, p.176).

InterPARES 1 and 2

The InterPARES (International Research on Permanent Authentic Records in Electronic Systems) project was based on an earlier project headed by Luciana Duranti at the University of British Columbia in the mid 1990s, which sought to establish the systems requirements for electronic recordkeeping. Its first phase, now referred to as InterPARES 1, ran from 1999 to 2001. Gilliland-Swetland (2002) provides a detailed description of InterPARES 1 and its outcomes. InterPARES 1 focused on the preservation of records that are no longer current and was mainly concerned with records generated in databases and document management systems. It asked 'What is required to prove the authenticity of electronic records?' and analysed case studies of electronic records systems to develop statements of requirements to create and maintain stable electronic records and for reproducing copies of preserved electronic records (US-InterPARES Project, 2002, p.5). Recommendations about authenticity include:

- Records should be created and maintained in a trusted recordkeeping system, and preserved via a trusted custodian, who is able to maintain them for the long term without alteration.
- The custodian of records should assess the authenticity of the records before transfer to the preserver . . . The assessment of authenticity needs to . . . establish the record's identity (the distinguishing characteristics of the record) and its integrity (the record's wholeness and soundness) [and] establish evidence that the records have not been inappropriately altered . . .
- Records creators . . . should [meet] . . . the following Benchmark Requirements in the creation, handling, and maintenance of active records:

Maintain expression of record attributes (especially those relating to identity and integrity), and evidence of the following:

- Effectively implemented, creator-defined access privileges.
- Protective procedures to prevent loss or corruption of records procedures and to prevent media and technology deterioration.
- Documentary forms of records (according to requirements of juridical systems or of creators).
- Specific rules for authentication of records (i.e., which records are authenticated, by whom, and how).
- Procedures that identify an authoritative record (when multiple copies exist).
- Procedures for removal and transfer of relevant documentation (involving removal of records from the electronic system) . . .

- The trusted custodian should be able to attest to the authenticity of copies of inactive or preserved electronic records by meeting the following Baseline Requirements:
 - Maintain controls over records transfer, maintenance, and reproduction.
 - Retain documentation of reproduction processes.
 - Capture, as part of archival description, any changes the records have undergone since they were first created (US-InterPARES Project, 2002, pp.7–8).

Other recommendations relating to preservation stress the importance of metadata, for instance, the need to 'maintain information about the original form of the record and the methods needed to translate between the stored digital components and the copy of the record presented for use'. Thorough documentation of the entire process of preservation is also recommended (US-InterPARES Project, 2002, pp.9–10).

InterPARES 2 was planned to run from 2002 to 2006. It is addressing issues of authenticity, reliability and accuracy of records, but differs from InterPARES 1 in that it examines these characteristics of records throughout their life-cycle, not just after they have been determined to be worthy of long-term retention, and in that it focuses on dynamic records, rather than those generated in databases and document management systems. It is also different because it examines records in the artistic and scientific domains.

Trusted digital repositories

InterPARES 1 defined the role of a trusted custodian in ensuring that authentic records are available. The concept of trusted digital repositories, the roles and responsibilities of which were articulated by the influential 1996 Task Force on Archiving of Digital Information, is similar. A number of 'trusted organizations' which have the capability of 'storing, migrating and providing access' to digital materials are crucial for effective digital preservation, and a process of certification is essential to ensure trust (Task Force on Archiving of Digital Information, 1996, p.37). However, it is only in recent years that the manner in which they might operate has become clearer. Trusted digital repositories would be 'national – and, increasingly, international – systems of digital repositories that are . . . responsible for the long-term access to the world's . . . heritage in digital form' (RLG/OCLC Working Group on Digital Archive Attributes, 2002, p.[i]). To reach this level of operation much needs to be done. The RLG/OCLC Working Group on Digital Archive Attributes listed the tasks as:

1. Develop a process for the certification of digital repositories.
2. Research and create tools to identify the significant attributes of digital materials that must be preserved.
3. Research and develop models for cooperative repository networks and services.
4. Develop systems for the unique, persistent identification of digital objects that expressly support long-term preservation.
5. Investigate and disseminate information about the complex relationship between digital preservation and intellectual property rights.

6. Determine the technical strategies that best provide for continuing access.
7. Define the minimal-level metadata required for long-term management and develop tools to automatically generate and/or extract as much of it as possible (RLG/OCLC Working Group on Digital Archive Attributes, 2002, p.[i]).

Because content creators and the owners and users of information need to be able to trust digital repositories, certification is a vital aspect of their establishment and operation. How certification might be achieved has been the subject of recent discussion. Not only is certification required, but auditing may also be required to monitor ongoing trustworthiness.

Conclusion

Chapter 1 notes that 'to ensure that digital materials remain usable in the future, access to them is required – and not simply access, but access to 'all qualities of authenticity, accuracy and functionality' (Jones and Beagrie, 2001, p.9). Authenticity of digital material needs to be defined in relation to users' requirements, and the elements of the materials that meet these requirements must also be clearly defined. It is also essential that we realize that some loss of elements and functionality is inevitable. Consequently the levels of acceptable loss must also be clearly described. An Australian digital preservation specialist interviewed in 2004 claimed that 'there's no absolute answer' to the question 'what kind of compromise should we accept?' He noted that in film archiving

> the whole field is fraught with compromise: when we see a Technicolor film of the 40s and 50s, we are actually watching an Eastmancolor copy usually, and the colour rendition has already changed, because Eastmancolor just has different spectral characteristics . . . So if you are going to give people the actual experience, how purist do you get? . . . there just are compromises in every direction.

Once we have defined what levels of loss are acceptable, we can focus on *how* to preserve the essential elements. The next chapter examines strategies and techniques for digital preservation.

Chapter 6

Overview of Digital Preservation Strategies

Introduction

There is as yet no viable long-term strategy to ensure that digital information will be readable into the future (Rothenberg, 1999b, p.v)

Maintaining access to digital resources over the long-term involves interdependent strategies for preservation in the short to medium term based on safeguarding storage media, content and documentation, and computer software and hardware; and strategies for long-term preservation to address the issues of software and hardware obsolescence (Jones and Beagrie, 2001, p.95)

High-level models for persistent repositories indicate that digital archiving and long-term preservation is best handled by separating archival storage of bits (storage management) from data management, logical representations, and higher level services that can be built on top of a persistent storage architecture (Workshop on Research Challenges in Digital Archiving and Long-term Preservation, 2003, p.xiv)

This chapter provides an overview of the range of principles, strategies and practices that we have available to us at present for digital preservation. It also examines the requirements for approaches that will remain viable and effective in the future. It attempts to put the approaches identified to date, both those in current use and those that are emerging, into a useful context so that they can be reflected on. Such reflection may point to clearer ways forward in the future.

A distinction is made between principles, strategies and practices. *Principles* are general ways of thinking, usually at the conceptual level; for example, it is a *principle* to use standards where they exist. *Strategies* are more concrete plans to achieve a particular long-term aim, as plans designed to achieve a particular long-term aim; an example of a *strategy* might be to limit the number

of standard file formats that are to be maintained. *Practices* are even more specific. A *practice* is what you need to do to implement and maintain a strategy, for example, the application of the necessary technology to maintain the standard file formats selected. Practices encompass technologies – the 'machinery and equipment based on the application of scientific knowledge for practical purposes' (as defined in the *Concise Oxford English Dictionary*). The terminology is used in different ways through the literature. For instance, ERPANET (the Electronic Resource Preservation and Access Network) uses the word *technology* inclusively to cover all hardware and software as well as methods and procedures: 'technology are all means that serve the purpose of preserving digital objects for as long as it [sic] is needed (ERPANET, 2003, p.2).

Others have developed typologies of the principles, strategies and practices. (*Typology* is used here in the sense of systematic grouping to help understanding of things being studied by identifying attributes or qualities among them that link them together.) These typologies range from limited lists with a small number of categories, such as that of Lim, Ramaiah and Pitt (2003), to more sophisticated versions, such as Rothenberg's typology (2003). These are examined in more detail later in this chapter.

Why might dwelling on these typologies help us to address digital preservation concerns? The UNESCO *Guidelines* suggest that strategies 'are still evolving' and that 'there is, as yet, no universally applicable and practical solution to the problem of technological obsolescence for digital materials' (UNESCO, 2003, pp.122,124–125). Alan Howell notes 16 strategies to ensure the long-term sustainability and accessibility of digital objects (Howell, 2004, pp.31–32). There are many ways of characterizing the range of strategies. For example, we can distinguish between *passive* approaches (such as improving digital storage media, improving storage and handling practices) or *active* approaches (such as refreshing, migration, emulation, encapsulation, normalization, and replication). Research and implementation work proceeds into all of these and more, for example, replication (the LOCKSS (Lots of Copies Keep Stuff Safe) Project), digital mass storage systems, and trusted repositories. The contention of this chapter is that, because such a wide range of approaches, strategies and practices is in use or development, determining their desirable characteristics could guide us to more rapid development of viable mechanisms to address the significant threat of loss of digital information. Developing such typologies could indeed heighten our understanding.

The UNESCO *Guidelines* identify some strategies that are likely to be viable in the long term: 'the use of standards for data encoding, structuring and description', emulation, and migration of data (UNESCO, 2003, pp.124–125). The *Guidelines* also note some principles that lie behind current approaches to preserving digital materials (UNESCO, 2003, section 17.11–12). Despite guidance such as this, the list of possible strategies remains long and bewildering (see Figure 6.1). From this a smaller number of strategies is likely to emerge.

This chapter first notes some of the history of the development of principles and strategies for digital preservation. It then notes strategies that are being applied. Finally, some existing typologies of approaches, strategies and practices are described, and a further typology is proposed.

Principle, Strategy, Practice	Also referred to in the literature as . . .
Analogue backups	Output to permanent paper or microfilm, page image techniques; Save page-images of artifacts
Backup and restore	
Bit-stream copying	
Canonicalization	Translate artifacts into standard or 'canonical' forms
Digital archaeology	Data recovery
Durable/persistent media	Improved storage media
Emulation	Technology emulation
Encapsulation	Creating a persistent object; Digital tablets
Improving handling and storage	
Mass storage	Digital mass storage systems
Media transfer	
Metadata	
Migration	Format migration; Normalization then migration; Software migration; Backwards compatibility and version migration
Persistent archives	
Persistent object preservation	
Policy development	Developing policy, specifications and procedures
Refreshing	Refreshing data; Medium refreshing
Replication	Replication; Redundancy; Keeping multiple copies
Standard data formats	Normalization; XML; Restricting the range of formats to be managed; Long term formats
Standards	Reliance on standards; Use of standards
Technology preservation	Preserve technology; Maintain old technology; Technology watch
Viewers	Viewers for obsolete formats
Virtual machines	Virtual machines; UVC (Universal Virtual Computer) approach
Other (not readily categorized)	Save source-code of rendering software (for future reverse-engineering); Extract and save core contents of artifacts; Software repositories; Web domain harvesting; Formalization (replace artifacts by formal descriptions of themselves); Data extraction and structuring

Figure 6.1 Digital Preservation Principles, Strategies and Practices

(From Kransch, 1998; Soete, 1997, p.7; Hendley, 1998, p.4; Bullock, 1999; Woodyard, 2000; Heazlewood, 2000, pp.180–184; Howell, 2000, pp.133–134; Van der Werf, 2002; Howell, 2001, pp.142–146; Strang, 2003; Walton, 2003, p.5; Lim, Ramaiah and Pitt, 2003, p.121; Digital Preservation Testbed, 2003, p.29; Rothenberg, 2003; UNESCO, 2003, pp.126–149; Smith, 2003, p.43; Beagrie, 2003, pp.15–16; Kenney *et al.*, 2003)

Historical overview

Chapter 1 explored the need for a new preservation paradigm in the digital world. It noted that the principles that lie behind preservation practice, and the preservation techniques themselves, need to change. Where pre-digital preservation paradigm practices are based on the preservation of artifacts, the new preservation paradigm requires different ways of thinking which are still not completely clear. Some are accepted and understood: for example, that there is a need to actively maintain digital information from the moment of its creation, and that there is likely to be greater emphasis on collaboration and support from a wider range of stakeholders.

It is perhaps inevitable that the path to these new ways of thinking should have its beginnings in elements of pre-digital preservation paradigm, such as the strong emphasis on techniques and processes based on artifacts and copying. This resulted in early digital preservation efforts focusing on the storage media (developing more durable media is an example) and on copying onto more durable storage media (the printing of digital objects to paper is perhaps an extreme example of this).

It is salutary to review the literature of digital preservation over the last decade and to see how thinking has changed. An awareness of this historical background helps us understand better the requirements for effective digital preservation strategies and practices. One can summarize from the sources used to construct Figure 6.1. Before 2000 the list of possible strategies and practices was short: migration, emulation, and technology preservation were the constants, with mention of refreshing, output to permanent paper or microfilm, and digital tablets. From about 2000 others are added. Migration, emulation, and technology preservation remain as the primary strategies and technologies. The list expands, however, to include encapsulation, digital archaeology, standardized file formats, printing to paper and writing to film, canonicalization, developing policy, keeping multiple copies, and developing preservation metadata. Currently the list, having expanded still further, also includes bit-stream copying, analogue backups, persistent object preservation, digital archaeology, reliance on standards, viewers, replacing artifacts by formal descriptions, data extraction and structuring, the Universal Virtual Computer approach, Web domain harvesting, mass storage systems, redundancy, software repositories, and technology watch. The list also includes the 'do nothing' strategy. There is a growing recognition in the literature that combinations of strategies and practices, rather than a single approach, will be required.

Pre-digital paradigm concepts may also have led to the focus of some current digital preservation activities on technical problems, without sufficient effort being directed to wider issues such as developing appropriate public policy. Research in digital preservation can be characterized along similar lines. Early research focused on two areas: 'preserving the bitstream' and 'extending the useful life of the entity on which information was recorded' (NSF-DELOS Working Group on Digital Archiving and Preservation, 2003, pp.10–11). Research into media has attempted to develop more durable media. Research directed at preserving the bit-stream has examined issues such as media migration. Much of this research has been concentrated on three strategies: 'normalization of digital content into a few common formats; migration of data

from obsolete to current computing platforms and applications; and emulation of obsolete platforms on current computing platforms' (NSF-DELOS Working Group on Digital Archiving and Preservation, 2003, p.12). There still appears to prevail a mindset that wills us to develop the killer application, a single technical solution (such as Rothenberg's championing of emulation, described below), although this way of thinking is weakening.

Two key realizations have allowed us to move towards a new preservation paradigm and to develop new approaches, strategies and practices. One is the concept of separating digital content from the technologies; the other is the need to embrace a wider range of stakeholders in digital preservation processes and to accommodate them in all-embracing policies and guidelines. These are examined in the rest of this chapter and in the two following chapters.

Who is doing what?

One way of thinking about the applicability and long-term viability of specific strategies and practices is to consider those that are actually being applied, and see if there are lessons to be learned from observing current practice. Digital preservation is a field in which, so far, there has been considerable invention but relatively little application.

In 1998 Hedstrom reported that methods being applied 'fall far short of what is required to preserve digital materials'. She noted that 'all preservation methods require trade-offs between what is desirable from the standpoint of functionality, dependability, and cost and what is possible and affordable' and this could be observed in the methods being applied: printing to paper or microfilm, with the loss of 'retrieval and reuse potential', and migration strategies, which by normalizing to a standardized data format often result in loss of information about document structures and relationships (Hedstrom, 1998, p.195). In 1999 Hedstrom and Montgomery reported the results of a survey of 54 Research Library Group members. Only 13 institutions had established digital preservation methods in place, the most common being 'transfer accessions to new media' (25), refresh (18), migrate (17), 'limit formats accessioned' (16) and 'standards for archival masters' (7) (Hedstrom and Montgomery, 1999, pp.14–15).

By 2003 Walton could observe that, although there was no consensus on the best method or methods,

> it is worth noting that the 4 major national archives which either have existing digital preservation programs . . . or are beginning one . . . have chosen to use a strategy which emphasizes preserving objects over preserving technologies: conversion to standard format (NA, NARA, NAA) or format migration (PRO) (Walton, 2003, p.7).

Also in 2003, Bryan's small survey of United States manuscript repositories, which sought to ascertain their practice in managing preservation of born-digital material, noted that of the nine respondents, four 'print electronic documents to paper and three migrate them to a server' (Bryan, 2003).

The European Commission-funded ERPANET Project provides case studies of the experiences of and approaches to digital preservation in a range of sectors

and institutions. These note some general strategies, for example, migration, and reducing the proliferation of formats. These case studies make observations about the pharmaceutical, publishing and telecommunications sectors. In the pharmaceutical industry, 'size and proliferation of formats are the main obstacles to the preservation of objects'. Migration to new data formats was carried out when necessary, PDF (Portable Data Format) had become the standard format for preservation purposes, and there was a general belief that digital preservation solutions should come from outside the industry. In the publishing industries 'PDF proved a very popular format alongside TIFF (Tagged Image File Format), XML (Extensible Markup Language), and SGML (Standardized General Markup Language) for distribution and preservation.' The telecommunication organizations relied on migration carried out when their business software was updated (Ross, Greenan and McKinney, 2003).

Two more extensive surveys published in 2004 provide firmer data. A survey of digital preservation practice in 21 natural science and scientific publishing organizations operating on an international level concluded that

> *Migration remains the preservation strategy of choice; it is still too soon for most archives to have undergone a significant technological change.* Other than the large data archives, which have existed for many years, archives have not yet faced large-scale technological changes. This means that migration remains the strategy for most of the materials of interest to libraries, archives, and publishers (Hodge and Frangakis, 2004, p.2 – italics as in the original).

The strategies used in this community were 'Transformation to a Preservation Format' (for example, ASCII and XML), migration, and 'Migration On-Request [where] the original version of the material is retained and when necessary, conversion tools are applied to convert the original to the format required by the user' – this had been tested but not applied (Hodge and Frangakis, 2004, pp.38–40).

An international survey of current digital preservation practice in national libraries, state libraries, university and research libraries and consortia, archives, museums, and other organizations from 13 countries was carried out under the auspices of OCLC and the Research Libraries Group and reported in 2004 (OCLC/RLG PREMIS Working Group, 2004). Of its 48 respondents, 92 per cent were implementing (or planned to implement) normalization, migration, or emulation, most indicating that they applied more than one strategy. The most popular strategies are bit-level preservation (refreshing), 85 per cent, then restricting submissions and normalization (both ways to limit the variety of formats that have to be managed), migration, and migration-on-demand, in that order. Ten per cent were using emulation (OCLC/RLG PREMIS Working Group, 2004, p.6). Other strategies included technology preservation, the UVC (Universal Virtual Computer), and a 'digital ontology, defined as a description of the structure of the digital entity' (OCLC/RLG PREMIS Working Group, 2004, p.36). Three conclusions from this survey are of interest. The first is that 'only one respondent in production checked a single strategy' (OCLC/RLG PREMIS Working Group, 2004, p.36), reinforcing the point made earlier that combinations of strategies and technologies are considered to be the most effective approach. The second is that 'because there is an assumption that there

will be additional technical options in the future', decisions about digital preservation are being made on a short-term basis (OCLC/RLG PREMIS Working Group, 2004, p.37). Finally, the report noted that 'less than a quarter of respondents had actual production experience in implementing active preservation strategies' (OCLC/RLG PREMIS Working Group, 2004, p.53). This is a significant point. It emphasizes that there is still not a lot of operational experience in digital preservation. This makes the experience of those who have applied digital preservation strategies and technologies in more than a test situation all the more important.

The Australian experience

The views of Australian digital preservation specialists noted in this book are derived from their extensive operational experience. In interviews of Australian digital preservation specialists during 2004 the question was posed 'What makes a good digital preservation strategy?' Their answers can assist us to determine the characteristics of viable preservation strategies and practices, and guide us to more rapid development of viable strategies to address the significant threat of the loss of digital information. Five themes emerged:

1) Societal and organizational missions
2) Knowing what you are preserving
3) Standards
4) Operational matters
5) Technical issues.

The first theme (societal and organizational missions) involves concepts such as assured funding, a sustainable supportive environment over time, knowing the context in which preservation occurs, and community will. A sustainable environment that supports digital preservation over time is essential, and this is related to funding: 'You need to have your long-term funding sorted out'. To be sustainable, digital preservation activities had to be built into 'normal operating activity' and a good understanding of the context was required: the example was provided of the need to understand the business drivers within a specific corporate context, where digital preservation was not seen as core business. To secure funding for digital preservation in this context, the preservation manager has 'to link it into the drivers in that particular sector'. To fully 'grapple with the problem . . . it's very short-term work that we're doing', there needs to be 'a reason . . . a will as a community to hang onto things'.

The second theme (knowing what you are preserving) was expressed in terms of the need to think clearly about exactly what it was that we are trying to preserve. For Australian preservation managers from the recordkeeping context this was expressed in terms of 'essence', 'the essential parts, the things about a record that we think are significant enough to be retained' which had to be defined in advance. These concepts were closely linked to the third theme (standards), which noted strategies such as metadata, data formats that remain accessible, normalization, and standard data formats. Most respondents commented on standards as an essential aspect of any preservation strategy: one noted that 'for starters you have to have very clearly defined standards and

that may include the diversity of standards for different types of material', and another suggested that 'it's doing it to the highest standard that is appropriate to what you're doing'. The importance of standards was emphasized by a member of the archives community who described why XML had been adopted. Its 'multiple attractions' included its stability as a standard ('it's actually got a very good track record. It's been in existence for . . . over 25 years now') and its widespread and increasing use. Metadata was noted as another area in which standards were essential. However, most attention was paid to standard data formats as a digital preservation strategy. A respondent from the archives community noted that 'the core of our strategy is to preserve records in data formats that are going to remain accessible over time. And what that means is that we actually convert . . . we call it normalization . . . the source records, which are usually in proprietary data formats into our archival data format, which is non-proprietary . . . it is our intention to always have non-proprietary data formats as our archival format. At the moment it's XML'.

A fourth group of points made during the interviews have been grouped together under the term operational aspects. These points can be summarized as: capture the material first, build digital preservation into normal operations, integrate digital preservation processes fully, keep data moving. There is a need to capture the data first: 'you can't preserve it unless you've got it. So that's trying to get the thing into the cycle of preservation in the first place'. The importance was stressed of ensuring that digital preservation was established as 'part of normal operating activity', so that it was considered as a mainstream activity and became part of the normal resourcing issues. Another respondent described this in terms of an integrated response: 'I would certainly use the word infrastructure . . . [a digital preservation strategy] is not something you can just put down in one line. It's a whole series of integrated responses'. Another theme was that data needed to be kept alive: 'the only strategy that will work is one where there are open, in a sense living, digital networks and systems that are extremely robust and have high levels of redundancy built into them i.e. there is duplication all over the place, there is distributed responsibility, there is distributed access.' Therefore 'the stuff has to be able to migrate . . . just to keep moving . . . so migration has to be part of the system. You know, there's no question about that.'

The fifth theme was technical issues. Although there was relatively little comment in these interviews about technical issues needing to be taken into account in effective digital preservation strategies, one that was noted was the importance of not relying on proprietary data formats or systems. A respondent noted this as 'having . . . control systems that are non-system-dependent . . . so that they exist independently . . . the objects themselves have got to be in a non-proprietary format.'

According to the Australian specialists interviewed, an effective digital preservation strategy has these characteristics:

- It should be part of a sustainable environment that supports digital preservation over time
- The context in which digital preservation operates, and therefore in which the strategy is placed, needs to be clearly understood
- A very far-reaching forward plan should exist for it
- It should be built into normal operating activities

- It should be based on clear definitions of what it is that we are trying to preserve, the 'essence' of a record
- It should be based on stable, widely used, and clearly defined standards, including a limited number of standard data formats where possible
- It requires sufficient management information metadata and preservation metadata
- It should recognize that digital preservation is an active process
- It should not be based on proprietary data formats or systems.

Criteria for effective strategies and practices

It is also worth noting what other commentators have decided to be the requirements for effective digital preservation strategies and practices. One way of doing this is to analyze responses to the threats to digital preservation. Respondents to a survey of RLG members in 1999 ranked the threats, in order of significance, as 'technology obsolescence, insufficient resources, insufficient planning; and physical condition of materials' (Hedstrom and Montgomery, 1999, p.19). This suggests that effective approaches to and strategies for digital preservation need to address these concerns, so our list of criteria could include the requirements that the approach or strategy should be independent of technology, that it must be adequately resourced, that it is planned in detail, and that attention is paid to improving the physical condition of media.

Jeff Rothenberg has commented extensively on some of the requirements. He encourages 'a sound technical approach' as the basis of any approach, recognizing that there are many inter-related issues that must also be addressed, such as 'technical, administrative, procedural, organizational, and policy issues' (Rothenberg, 1999b, p.6). He elaborates that 'any technical solution must be also able to cope with issues of corruption of information, privacy, authentication, validation, and preserving intellectual property rights' and 'must be feasible in terms of the societal and institutional responsibilities and the costs required to implement it' (Rothenberg, 1999b, p.9). His 'ideal approach' would be a single solution that is long-lived and can be 'applied uniformly, automatically, and in synchrony (for example, at every future refresh cycle) to all types of documents and all media, with minimal human intervention' (Rothenberg, 1999b, p.16):

> The long-term digital preservation problem calls for a long-lived solution that does not require continual heroic effort or repeated invention of new approaches . . . This approach must be extensible, since we cannot predict future changes, and it must not require labor-intensive translation or examination of individual documents. It must handle current and future documents of unknown type in a uniform way, while being capable of evolving as necessary. Furthermore, it should allow flexible choices and tradeoffs among priorities such as access, fidelity, and ease of document management (Rothenberg, 1999b, p.30).

This is a tall order. Implicit in Rothenberg's comments is the idea that there is a single technical solution – he is well-known as championing emulation as this single solution; but others do not agree. More recently, Lavoie and Dempsey have suggested that factors such as 'cost, user preferences, nature of the material,

whether it exists in multiple forms' need to be taken into account when ascertaining which preservation strategies are appropriate (Lavoie and Dempsey, 2004).

Thibodeau has identified four criteria by which to ascertain the best strategy:

- its *feasibility* (is there software and/or hardware capable of doing it?),
- its *sustainability* (can it be done into the future, or can an alternative future path can be identified?),
- its *practicality* (can it be applied within reasonable limits of difficulty and expense?), and
- its *appropriateness* (this criterion relating to the type of objects and why we are preserving them) (Thibodeau, 2002, pp.15–16).

To illustrate these he describes a spectrum of possibilities, ranging from 'preserving technology itself to preserving objects that were produced using information technology (IT)' (see Figure 6.3). The suitability of any strategy and practice, which Thibodeau calls 'methods', can be determined only with respect to the nature of the material being preserved. Computer games, for example, are much more likely to require methods that fall at the 'preserve technology' end of this spectrum, whereas e-mails fall at the 'preserve object' end. Some methods are general and some apply only to specific technologies, for example specific software and/or hardware, or specific data types. Therefore, the 'range of applicability is another basis for evaluating preservation methods' (Thibodeau, 2002, p.17).

Nor must we forget the requirements for authenticity, noted in Chapter 5, in digital preservation. Because 'an authentic digital object is one whose genuineness can be assumed on the basis of one or more of the following: mode, form, state of transmission, and manner of preservation and custody' (Ross, 2002, p.7), it follows that effective digital preservation strategies and technologies must ensure that these requirements are not forgotten. We should keep in mind Gilliland-Swetland's cautionary comments:

> Counterintuitively, perhaps, it is during the preservation of digital materials that evidential value is often most at risk of being compromised. Digital preservation techniques have moved beyond a concern for the longevity of digital media to a concern for the preservation of the information stored in those media during recurrent migration to new software and hardware. In the process, many of the intrinsic characteristics of information objects can disappear – data structures can be modified and presentation of the object on a computer screen can be altered (Gilliland-Swetland, 2000, pp.11–12).

ERPANET has produced a guide to assist with selecting digital preservation technologies in its erpaTool series (ERPANET, 2003). They provide a list of evaluation factors, reproduced here, with minor amendments, as Figure 6.2.

Finally, we need to note the effect of national information infrastructures on approaches and strategies for digital preservation. Effective approaches and strategies will work best if supported within these infrastructures. Also relevant here are the possibilities for cooperation: for example, Beagrie's 2002 survey of national digital preservation activities indicated that 'national libraries offered

	Factors	Remarks
General	Maturity	Is the technology fully developed and are there already systems in productive use?
	Experience	Are there already verifiable experiences in applying the technology for the preservation of similar objects?
	Spread	Is the technology widespread enough to guarantee that it will be supported by the manufacturers during the desired lifespan of the preservation system?
	Standardization; open specifications	Is the technology based on standards and are the specifications of all the critical elements laid open by the manufacturers or at least deposited with an independent and trusted third party and available there in case of the dissolution or downfall of the manufacturers?
	Reliability	Does the technology work reliably and can the reliability of the outcome easily be checked?
	Modularity and flexibility	Is it easily possible to add new components at low cost, to change or update them?
	Costs	It is important to include not only the price of system components, but all cost of implementing and maintaining the system. See for this purpose the *erpaTool* on *cost orientation*.
Objects	Legislation	Are the objects subject to specific legislation which asks for a specific form, format, storage medium, or accessibility? Such regulations are basic conditions for the selection of technologies.
	Characteristics	How can the main characteristics of the objects and their context be preserved without threatening authenticity and integrity? As conversion of digital objects for preservation is often difficult and costly, all selected technologies must be able to treat current and, as far as possible, also future objects. Consider also carefully what consequences a selected technology has regarding the creation or preparation of the objects for preservation.
	Preservation period	As digital systems only have a life span of about five to 10 years at highest and digital objects must be preserved for much longer periods, it is important that the system is able to efficiently export objects and their context data in standard formats in order to migrate them into a new system.
People	Skills	Does the selected technology need specific skills which must be available in-house? Are these skills already available or can they easily be acquired?
	Staff for maintenance	Is the appropriately skilled work force in the right number for the maintenance available?
	Experience	Is there sufficient experience with the technology for support in case of difficulties available? (in-house or easily accessible in the region)
Procedures	Workflow	Can the technology easily be implemented in the preservation workflow or can the workflow be adapted to the technology without major difficulties or loss of efficiency?
	Flexibility	Can the technology flexibly be implemented? Does it allow changes in the preservation procedures?
	Good practices	Are good practices in using the technology already established?
	Quality requirements	Can the technology meet the previously defined quality standards? However, automatic or semi-automatic techniques are difficult to be applied for heterogeneous collections, complex objects, and high quality requirements.

Figure 6.2 Factors to Consider when Selecting Digital Preservation Technologies (Modified from ERPANET, 2003, pp.4-5)

several recurring suggestions for international cooperation in developing effective strategies for long-term preservation' (Beagrie, 2003, p.6), and the example of a preservation technology watch was offered.

Typologies of principles, strategies and practices

Figure 6.1 provides an unclassified list of most of the principles, strategies and practices for digital preservation noted in recent literature. It is worth attempting to categorize these, to develop a typology (or typologies) to assist us to understand them better, so that we can develop viable mechanisms more rapidly to address the significant threat of the loss of digital information. Most of the literature lists, rather than categorizes, the strategies. Five publications, those of Jones and Beagrie (2001), Walton (2003), Thibodeau (2002), Rothenberg (2003) and the UNESCO *Guidelines* (2003), do more than simply list them and deserve further attention.

Jones and Beagrie's influential handbook *Preservation Management of Digital Materials* (2001) divides digital preservation strategies into primary and secondary strategies. Primary strategies are 'those which might be selected by an archiving repository for medium to long-term preservation of digital materials for which they have accepted responsibility'. Secondary strategies are 'those which might be employed in the short to medium term either by the repository with long-term preservation responsibility and/or by those with a more transient interest in the materials' (Jones and Beagrie, 2001, p.102). Primary preservation strategies are migration and emulation; secondary strategies are technology preservation, adherence to standards, backwards compatibility, encapsulation, permanent identifiers, converting to stable analogue format, and digital archaeology. Jones and Beagrie note that sometimes secondary strategies will be employed as a holding action, to defer the need for primary strategies to be applied. They consider that there are two dominant strategies, migration and emulation, and that the need to apply these can on occasion be 'deferred and/or simplified if appropriate preventive preservation procedures such as storage and maintenance . . . and selected secondary preservation strategies' are applied. They also note another strategy, 'converting to an analogue preservation format' and its significant limitations such as the loss of digital characteristics, and they characterize digital archaeology as 'a fallback position' (Jones and Beagrie, 2001, p.103). The need to apply more than one strategy is indicated:

> employing a judicious mix of secondary strategies . . . with responsible storage and maintenance decisions . . . has the potential significantly to reduce both risks of losing access to digital resources in the short-term and costs of preserving them in the long-term (Jones and Beagrie, 2001, p.103).

Walton suggests five categories:

1) Preserve old technology
2) Emulate old technology
3) Format migration

4) Standardize formats
5) Persistent object preservation (Walton, 2003, pp.5–7).

Walton discusses digital records within the context of the InterPARES Project's concern to establish the characteristics of authentic digital records. His five categories fall into two types: those concerned primarily with the technology, and those primarily with the data formats. The two categories of strategies that focus primarily on the technology are 'preserve old technology' and 'emulate old technology'. Both of these leave 'the digital components of the record exactly as received', concentrating instead on the technology (software, operating system, hardware) that is required to reproduce the digital object. Walton suggests that the merit of this approach is that authenticity is much more likely to be maintained, but it is impractical because 'it requires multiple solutions (that is, one for every distinct category of equipment being preserved) rather than a single one', and writing emulator software is labour-intensive and costly. There is also, for the first method, the major issue of technology obsolescence.

Walton's three categories that focus primarily on the data formats are 'format migration', 'standardize formats', and 'persistent object preservation'. Format migration attempts to ensure that the data remains 'live' by continually updating it so it 'can be reproduced using current technology'. Format standardization converts the data to a limited number of non-proprietary formats (for example, TIFF for images, XML for text) and there is thus no need to rely on one technology to read them, as many kinds of software can do this. Both of these categories minimize the need to rely on software and hardware that will become obsolete, but both require high levels of resources to manage ongoing migration projects or convert to standard formats. Walton's fifth category, 'persistent object preservation', attempts to separate data completely from the technology. 'All aspects of the record are abstracted, or represented by other data, to the highest possible degree in order to render them independent of any specific technology.' Digital materials are described in terms that are independent of software or hardware: an example is electronic records converted to XML and then encapsulated with metadata. Walton notes, however, that 'its operational viability remains to be demonstrated'. (All quotes in the preceding two paragraphs come from Walton, 2003, pp.5–7.)

Walton's approach is based on distinguishing between data preservation and maintaining the technology. Thibodeau extends this approach. He describes a 'preservation spectrum', which has at one end 'preserve technology', and at the other 'preserve objects'. He suggests principles to guide us in positioning 'candidate methods' across the spectrum:

- On the 'preserve technology' end of the spectrum, methods that attempt to keep data in specific logical or physical formats and to use technology originally associated with those formats to access the data and reproduce the objects
- In the middle of the spectrum, methods that migrate data formats as technology changes, enabling use of state-of-the-art technology for discovery, access, and reproduction
- On the 'preserve objects' end of the spectrum, methods that focus on preserving essential characteristics of objects that are defined explicitly and independently of specific hardware or software (Thibodeau, 2002).

But these are not sufficient: also to be taken into account is the suitability of a method for the material being preserved. Some methods are general, and others apply only to specific technologies. Thibodeau accordingly proposes that the method's suitability (which he designates as applicability) needs also to be taken account of. He has suggested a graph of preservation methods, reproduced here as Figure 6.3.

Rothenberg takes a different tack. His classification is based on the extent to which strategies and practices are complete. His 'overview of proposed approaches to preservation' (Rothenberg, 2003) has three categories: non-solutions, partial solutions, and potentially complete solutions. Non-solutions include 'do nothing' and digital archaeology. The longer list is of partial solutions:

> Save page-images of artifacts, Extract and save 'core contents' of arti-facts, Translate artifacts into standard or 'canonical' forms (without migration), Rely on 'viewer' programs to render obsolete formats in the future, Save metadata to help interpret saved bit streams ('assisted archaeology'), Save source-code of rendering software (for future reverse-engineering).

It is Rothenberg's potentially complete solutions that we should pay most attention to. It has only three entries, suggesting that there is still significant work to be done to develop a range of viable strategies and practices:

- Formalization (replace artifacts by formal descriptions of themselves)
- Migration (repeatedly convert artifacts into new artifacts)
- Emulation (run original rendering software on virtually recreated hardware) (Rothenberg, 2003).

The categorization in the UNESCO *Guidelines* (2003) is different again, being based in part on the length of time that the strategies are likely to provide a

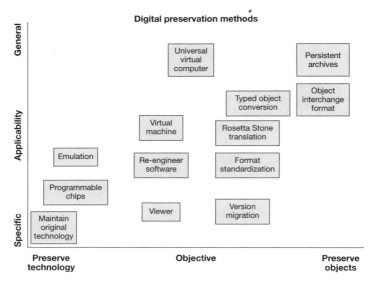

Figure 6.3 Digital Preservation Methods (From Thibodeau, 2002, p.19)

viable result, and in part on what stage of the preservation process the principal effort is needed:

'Investment' strategies (primarily involving investment of effort at the start):

- Use of standards
- Data extraction and structuring
- Encapsulation
- Restricting the range of formats to be managed
- 'UVC' (Universal Virtual Computer) approach

Short-term strategies (likely to work best over the short-term only):

- Technology preservation
- Backwards compatibility and version migration
- Migration (which may also work over longer periods)

Medium- to long-term strategies (likely to work over longer periods):

- (Migration)
- Viewers
- Emulation
- (UVC approach)

Alternative strategies:

- Non-digital approaches
- Data recovery
- Combinations (UNESCO, 2003, pp.126–127).

These *Guidelines* distinguish between general principles, and specific strategies and practices. For example, they suggest that the principles (which they label as 'strategies') for preserving digital materials include:

- Working with producers (creators and distributors) to apply standards
- Recognising that selection of material to be preserved is essential
- Placing the material in a safe place
- Using structured metadata and other documentation to control material, facilitate access and support preservation processes
- Protecting the integrity and identity of data
- Effectively managing preservation programs (UNESCO, 2003, p.37).

Nine further specific principles on which current strategies and practices are based are articulated in the UNESCO *Guidelines*. These can be grouped into four categories: conversion to analogue form, maintaining the original format, standardizing formats, and migration. *Conversion to analog form* involves converting data to a human readable form on a stable carrier such as paper, film or metal. *Maintaining the original format* is the most popular category, with four strategies: 'Making the data 'self-describing' and 'self-sustaining' by packaging it with metadata and with links to software that will continue to provide access for some time'; 'Maintaining the data in its original form ... and providing tools

that will re-present it . . . using the original software and hardware . . . or using new software that emulates the behaviour of the original software and/or hardware'; 'Maintaining the data and providing new presentation software (*viewers*) that will render an acceptable presentation of it for each new operating environment'; 'Providing specifications for emulating the original means of access on a theoretical intermediate computer platform, as a bridge to later emulation in a future operating environment'. *Standardising formats* includes either 'creating data in, or converting data to, a highly standardised form of encoding and/or document structure (or file format) that will continue to be widely recognised by computer systems for a long time', or 'converting the data to a format where the means of access will be easier to find'. *Migration* involves converting the data to new formats that can be read by each new technology; it also includes providing the ability for migration on demand 'by maintaining the data and recording enough information about it to allow a future user or manager to convert it to a then-readable form' (UNESCO, 2003, p.125). Finally, preservation programmes, these guidelines suggest, must be organizationally viable and financially sustainable, if they are to be effective and credible (UNESCO, 2003, pp.43–44).

This classification is noteworthy because of its emphasis on the combination of strategies and practices. In the absence of a single, universally applicable solution these guidelines support the application of multiple strategies in preservation programmes. These are likely to be based on the use of

> *standards* for data encoding, structuring and description that can be expected to remain recognisable for long periods; *emulation* of obsolete software or hardware in a new environment; and *migration* of data from one operating technology to another (UNESCO, 2003, pp.124–126).

The doubt expressed in the *Guidelines* as to the likelihood of a single solution ever being found is now generally shared. Whatever we might consider as mainstream approaches – the consensus is that these are migration, technology preservation, emulation, and perhaps persistent object preservation – they are not mutually exclusive, and will be deployed according to the kind of digital materials to which they are applied and their access requirements (Smith, 2003, p.43). Rothenberg is also aware of this, noting that

> For now, consider using multiple approaches in parallel: Digital archaeology (for records that are unlikely to be accessed), Page-image techniques (for simple records), Formal methods (when applicable and affordable), Standards (when available), Migration (when it needs to be done anyway, i.e. for active records; *or* as a stopgap), Emulation (if original behaviour is needed; *or* as a cheap backup, to preserve everything) (Rothenberg, 2003).

None of the typologies described here are complete. They do not, for instance, note the principle of redundancy (multiple copies at multiple locations), best exemplified by the LOCKSS Project. However, they allow us to identify some of the principles that are important and to make some judgments about the applicability and viability in the longer term of specific strategies and practices. For example, they help us distinguish more clearly between 'preserve

technology' and 'preserve objects' approaches, they encourage us to consider the nature of the digital object and the different requirements that each may have, with consequent different 'best' strategies and technologies for their preservation, and they suggest that the tools we have available to us at present should be applied in combination.

A typology of digital preservation?

The desirable principles, strategies and practices that we need to have in place for digital preservation activities to be viable and effective can, perhaps, be listed, although the changing nature of the field makes this task a challenging one. Such a list could include the aspects below, but it is essential to recognize that this list does not intend to be comprehensive:

1) Principles (general ways of thinking, usually at the conceptual level)

a) Separate archival storage of bits from the processes of representing and managing those bits
b) Actively maintain digital information continuously from the moment of its creation
c) Give high priority to cooperative activities, including collaboration with and support from a wide range of stakeholders
d) Combine strategies and technologies, rather than focus on a single solution
e) Apply the principle of redundancy
f) Ensure that digital preservation activities are part of a sustainable environment that supports digital preservation over time
g) Build digital preservation into normal operating activities.

2) Desirable strategies (plans designed to achieve a particular long-term aim)

a) Distinguish between medium- to long-term strategies (primary strategies) and short-term strategies (secondary strategies). (Short-term strategies focus on safeguarding storage media, content and documentation, and computer software and hardware; long-term strategies attempt to address software and hardware obsolescence.)
b) Strategies should be feasible in terms of institutional responsibilities and the costs required to implement them
c) Authenticity must be maintained, so strategies that emphasize preserving objects over preserving technologies are to be preferred
d) Prefer strategies that recognize the nature of different kinds of digital materials and the different requirements that each may have. (Clear definitions of what it is that we are trying to preserve are therefore needed.)
e) Adequate and appropriate management information metadata and preservation metadata are required
f) Strategies should not be based on proprietary data formats or systems, but rather on stable, widely used and clearly defined standards
g) Strategies should be designed around as limited a number of standard data formats as possible.

3) Desirable practices (the 'machinery and equipment based on the application of scientific knowledge for practical purposes')

a) Practices should have the characteristics of *feasibility* (is there software and/or hardware capable of doing it?); *sustainability* (can it be done into the future, or can an alternative future path can be identified?); *practicality* (can it be applied within reasonable limits of difficulty and expense?); *appropriateness* (this criterion relating to the type of objects and why we are preserving them)

b) Distinguish between practices that leave the digital components of the record exactly as received (e.g. Preserve old technology, Emulate old technology), and those that focus on the data formats (e.g. format migration, standardize formats, and persistent object preservation).

Conclusion

Lavoie and Dempsey have noted that digital preservation is 'a set of agreed outcomes' based on considerations such as the complexity of digital materials and the features that we collectively decide should be preserved. These considerations, they suggest, require that

> the choice of preservation strategy will need to reflect a consensus of all stakeholders associated with the archived digital materials. Achieving such a consensus is difficult, and in some circumstances, impossible (Lavoie and Dempsey, 2004).

How, then, are we to determine which strategies are best if we do not have this consensus to guide us? Lavoie and Dempsey continue:

> A second-best solution is for the digital repository to articulate clearly what outcomes can be expected from the preservation process. These outcomes should in turn be understood and validated by stakeholders. Communication between the repository and stakeholders, either to promote consensus on preservation outcomes, or for the repository to disclose and explain its preservation policies, mitigates the risk that the repository's commitments are misaligned with stakeholder expectations (Lavoie and Dempsey, 2004).

Clear communication with stakeholders is the key while we are in a rapidly evolving environment where there is little agreement about preferred strategies and practices, and where new approaches are being developed and trialed.

The following two chapters are based on Thibodeau's typology (Figure 6.3), to which is added some aspects of Rothenberg's typology (noted above). They describe specific principles, strategies and practices: Chapter 7 examines approaches based on preserving the technology, and Chapter 8 examines approaches based on preserving the digital object.

Chapter 7

'Preserve Technology' Approaches: Tried and Tested Methods

Introduction

The need to preserve digital materials runs counter to the market ethos of the computing industry, which requires high turn-over of hardware and software in order to survive financially. This outlook necessitates rapid changes in formats and functionality and an unwillingness to support 'obsolete' technology, all of which make it harder and harder to preserve access to digital materials (Heazlewood, 2002)

There is, as yet, no universally applicable and practical solution to the problem of technological obsolescence for digital materials (UNESCO, 2003, p.124)

The previous chapter presented a long and bewildering list of possible strategies that are available or under consideration for digital preservation (listed in Figure 6.1). It noted that they 'are still evolving' and that 'no universally applicable and practical solution' is available (UNESCO, 2003, pp.122,124). Chapter 6 also noted some of the characteristics of digital preservation strategies and practices and described some of the typologies proposed for their categorization. Chapters 7 and 8 take as their basis Thibodeau's typology, described in Chapter 6, add to it some parts of Rothenberg's typology, also described in Chapter 6, and use the result to describe specific principles, strategies and practices. The result is three categories:

1) 'Non-solutions' (examined in this chapter)
2) 'Preserve Technology' approaches (examined in this chapter)
3) 'Preserve Objects' approaches (examined in Chapter 8).

'Non-solutions' (the term used by Rothenberg (2003)) are:

- Do nothing
- Storage and handling practices
- Durable/persistent digital media
- Analogue backups
- Policy development
- Standards
- Digital archaeology.

The list of 'Preserve Technology' approaches (the term used by Thibodeau (2002)) is much shorter:

- Technology preservation
- Emulation.

The reader of this chapter and the next should keep firmly in mind that 'Preserve Technology' and 'Preserve Objects', as noted in Chapter 6, are the two ends of a spectrum of possibilities, not discrete points on that spectrum. There are many points in between these two poles. The reader should also keep in mind that there are other ways of grouping the possible approaches. The grouping used in Chapters 7 and 8 represents the current state of evolution of digital preservation strategies and practices, which *will* change. For instance, many of the approaches described in this chapter – technology preservation, adherence to standards, converting to stable analogue format, digital archaeology – are what Jones and Beagrie refer to as secondary strategies, 'those which might be employed in the short to medium term either by the repository with long-term preservation responsibility and/or by those with a more transient interest in the materials' (Jones and Beagrie, 2001, p.102). These strategies are, in a sense, holding actions, buying time for digital materials while longer-term strategies are developed, and practices that keep digital materials viable are implemented. But, as Jones and Beagrie make clear, these strategies and practices do not address the real issues of technology obsolescence; they only put off the need to make decisions.

This chapter draws heavily upon two key sources: *Preservation Management of Digital Materials: A Handbook* by Maggie Jones and Neil Beagrie (2001), and the UNESCO *Guidelines for the Preservation of Digital Heritage* (2003). The reader may wish to update these by referring to PADI, the web portal maintained by the National Library of Australia with the support of the Council on Library and Information Resources, the Digital Preservation Coalition and ERPANET. PADI, which describes itself as 'a subject gateway to digital preservation resources', is an essential source for definitions and explanations of, and further references for, the strategies and practices covered in Chapters 7 and 8.

'Non-solutions'

'Non-solutions' is one of three categories suggested by Rothenberg (2003) in his overview of preservation approaches, the others being 'partial solutions', and 'potentially complete solutions'. This categorization is useful because it emphasizes that some of the practices promoted as viable digital preservation techniques, both in the past and at present, are not likely to achieve the aims

of most digital preservation activities – that is, an assurance of long-term access to authentic digital materials. Rothenberg's examples of non-solutions are 'do nothing' and digital archaeology. Leaving aside 'do nothing' for the moment, these non-solutions are strategies and practices that are useful in the toolbox of approaches to digital preservation, or are essential parts of the infrastructure required for successful digital preservation, but they do not provide outcomes that result in preserved digital materials over time.

Of the six non-solutions noted in this chapter, the first (*do nothing*) is not a realistic option. Unlike non-digital materials, for which the principle of benign neglect can have validity, digital materials require active intervention right from the moment of their creation, if they are to survive. This is noted in more detail in Chapter 1. Two of the non-solutions (*storage and handling practices*, and *durable/persistent media*) provide a breathing space, extending the life of digital storage media and, thereby, ensuring that the digital materials remain in good condition for longer. This potentially provides sufficient time to develop and implement strategies and practices that are viable over the long term. Storage and handling practices focus on environmental control, handling, building design, and security, although we note here only the first two. The durable/persistent media non-solution is based on the premise that developing improved storage media – media that will last longer, store more, and remain accessible for longer than current media – will provide greater economies and efficiencies by reducing the frequency of copying and the number of media items that are handled. However, both of these approaches are non-solutions because they focus on the media, avoiding the real issue of technological obsolescence. Proposing them as anything more than an interim solution is a classic example of the inappropriate application of pre-digital paradigm preservation thinking to digital materials.

Another of the non-solutions, *analogue backups*, has the problem of negating the advantages of being digital, such as improved retrieval of the information content, ease of dissemination, and so on. (There is, of course, the possibility of converting back to digital form material that has been copied to analogue form, although this is obviously expensive and not likely to occur.) This approach is also referred to as analogue copying, output to permanent paper or microfilm, and sometimes as page image techniques and saving page-images of artifacts, although these last two can also refer to making digital page images, such as PDF files. This approach, too, is an example of the inappropriate application of pre-digital paradigm preservation thinking to digital materials. Two more approaches included in the category of non-solutions (*policy development*, and *standards*) are in fact principles, following the definition and use of this term in Chapter 6, rather than strategies or practices. Attending to these provides a more favourable environment for successful digital preservation. Policy development is a prerequisite for digital preservation. Standards are also a prerequisite in that their development and application provides the same benefits for digital preservation as they do for any cooperative endeavour. Standards are considered in another context, that of standard data formats, in Chapter 8.

The final non-solution, *digital archaeology* (also known as data recovery) is commonly recognized to be 'not precisely a preservation strategy' (Jones and Beagrie, 2001, p.103) but, rather, a fall-back position. It encompasses actions taken to recover digital data that has become inaccessible using normal techniques, but where the value of the data warrants the time-consuming and expensive techniques of the data recovery specialist.

Do nothing

A discussion of the *do nothing* approach need not detain us long. As noted earlier in this chapter and in more detail in previous chapters, especially Chapter 1, it is not an option for digital materials. Doing nothing reduces to nil, in a very short period of time, the possibility of preserving digital materials. One familiar example is failure to monitor and respond to the deterioration of digital media (for example, a floppy disk) and the consequent inaccessibility of any data it might carry.

Storage and handling practices

Some of the reasons for media deterioration were noted in Chapter 3. This section notes techniques that are currently recommended as good practice for the storage and handling of media, in order to prolong the length of time that the data on them remains accessible. Application of these techniques assumes that the hardware and software required for these media is still available. (The sections 'Technology preservation' and 'Emulation' later in this chapter consider what is necessary to support this assumption.)

Why is paying attention to the care and handing of digital media a good preservation strategy? The principal reason is that it reduces risk. 'Responsible storage and maintenance decisions' have 'the potential significantly to reduce both risks of losing access to digital resources in the short-term and costs of preserving them in the long-term' (Jones and Beagrie, 2001, p.103). They include this approach in their list of secondary strategies, that is, strategies that are short-term but, nonetheless, are worth committing resources to. Storing digital media in appropriate environmental conditions (this term refers to temperature, relative humidity, light and clean air levels) extends the time the media will last. It also protects them to some extent against accidental damage, as does appropriate handling. Of course, the need for attention to the storage and handling of digital media is not unique to them: it is fundamental to the preservation of other materials too.

The National Library of Australia's 1999 *Draft Research Agenda for the Preservation of Physical Format Digital Publications* lists 'what we already know', based on experience at the National Library of Australia and other institutions. One of its statements is particularly relevant to this section – that 'magnetic media such as floppy disks have a relatively short useable life span, so we have to slow down the rate of deterioration and/or move what we want to preserve to a more stable carrier'. The comment is made that 'we know quite a lot about the conditions of storage and handling that will maximise the useful life' of these media (National Library of Australia, 1999a). Optimum environmental conditions for the storage of digital media are well documented. Figure 7.1 summarizes the recommendations for magnetic tape, CD-ROM, and DVDs.

The life expectancy of digital storage media is determined by a number of factors. For optical disks, for example, it is a combination of the 'manufacturing quality, condition of the disk before recording, quality of the disk recording, handling and maintenance, [and] environmental conditions' (Byers, 2003, p.12). Similar statements can be made about other media types. For all of these media one essential factor is to provide the optimum storage conditions, with temperature and relative humidity within the recommended ranges, and with as little

Media	Access storage (allows immediate access and playback)		Long-term storage (preserves the media as long as possible)	
	Temperature (°C)	Relative Humidity (%)	Temperature (°C)	Relative Humidity (%)
Magnetic tape cassettes 12.7mm[1]	18 to 24	45 to 55	18 to 22	35 to 45
Magnetic tape cartridges[1]	10 to 45	20 to 80	18 to 22	35 to 45
Magnetic tape 4 & 8mm helical scan[1]	5 to 45	20 to 80	5 to 32	20 to 60
Magnetic tape[3]	Room ambient (15 to 23), maximum variation 4°	Room ambient (25–75), maximum variation 20%	As low as 5°, maximum variation 4°	As low as 20%, maximum variation 10%
CD-ROM[1]	10 to 50	10 to 80	18 to 22	35 to 45
CD-ROM & DVD[2]			4 to 20	20 to 50

[1] Jones and Beagrie, 2001, p.100, from BS 4783
[2] Byers, 2003, p.vi
[3] Based on Van Bogart, 1995, p.18.

Figure 7.1 Environmental Storage Conditions for Some Digital Media

fluctuation as possible. Light levels are usually controlled; Byers notes that this is less of an issue for CD-ROMs and DVDs, but is important for CD-Rs that use dye-based technology, because light levels affect the rate at which the dye layer (the layer where the data is recorded) degrades (Byers, 2003, p.17). Another factor for media in long-term storage is the need to acclimatize the media if it is removed from this storage to room temperature for access (playback) purposes. Long-term storage areas are typically kept at much lower temperatures and relative humidity levels: for instance, Byers' 'consensus of several reliable sources on the prudent care of CDs and DVDs' (2003, p.1) recommends long-term storage levels as 18°C and 40% RH, but 'a lower temperature and RH ... for extended-term storage' (2003, p.vi).

Careful handling of digital media also prolongs their life. For CDs and DVDs, for instance, careful handling minimizes the possibility of data loss resulting from scratching the data layer. Jones and Beagrie recommend that written guidelines and procedures for handling be produced (2001, p.101). For CDs and DVDs these procedures could include statements about handling the disks by their outer edge, returning them to storage cases straight after use, marking or labeling disks in a non-harmful way, not attempting to bend the disks, and cleaning them as seldom as possible, and then using approved methods only (Byers, 2003, pp.vi,19,25–26).

Figure 7.2 is a summary of recommendations about the storage and handling of digital media derived from several sources. It is not an exhaustive list.

Storage areas	Keep free of smoke, dust, dirt and other contaminants Store magnetic media away from strong magnetic fields Keep cool, dry, dust-free, stable and secure Minimize light levels, especially direct sunlight Prohibit smoking and eating in the storage area Minimize the threat from natural disasters Provide enclosures for media to afford additional protection Store in appropriate conditions any non-digital accompanying materials such as operating instructions and codebooks
Monitoring	Monitor environmental conditions on a regular basis Monitor media condition on a systematic basis
Handling practices	Handle with care Minimize the handling and use of archival media Establish guidelines and procedures for acclimatizing media if moving them from significantly different storage conditions Do not place labels on optical disks and/or mark using a pen or pencil Follow recommended guidelines for labeling and marking Document the contents of the media, when created, and their frequency of use
Quality of media and equipment	Choose digital media with preservation in mind: 'all digital media are not created equal' (Howell, 2001, p.144) Use high quality equipment Keep access devices well maintained and clean
Disasters	Prepare for accidents

Figure 7.2 Storage and Handling of Digital Media
(From Howell, 2001, p.144; Jones and Beagrie, 2001, pp.100,133;
National Library of Australia, 2000?; Ross and Gow, 1999, p.43)

Durable/persistent digital media

Encouraging the manufacture and use of durable/persistent media is based on the idea that by using storage media that last longer and store more, the number of times copying of data is required and the number of media items to be handled is reduced, thereby producing economies through efficiencies. This approach is a non-solution because it does not address technological obsolescence. It does, however, have a place among the practices used in digital preservation in that it buys time while other strategies and practices that will make long-term preservation viable are developed and implemented. Zwaneveld provides the example of CD-R disks and notes that 'an estimated 320 million units of CD-R disks will be produced in 1999', but that half of the manufacturers of this media are producing disks that will fail within five years (Zwaneveld, 2000, p.2). One of the reasons for this is the economics of the media production industry; another

is that the media are 'constantly evolving' and production processes are in a state of 'almost constant evolution' (Jones and Beagrie, 2001, p.129).

Despite the limited use of these strategies and practices aimed at increasing the life and efficiency of digital media, they are useful tools. The lifespan of digital storage media is well enough known for us to be aware of the risks we take when we commit digital materials to these media for preservation purposes. This awareness should make us wary of some of the claims made by the media manufacturers, which 'tend to reflect the exuberance of scientists compounded by the hype of their marketing teams' (Ross and Gow, 1999, p.iii). Attention to the selection of high quality media for preservation purposes (gold CDs perhaps) 'may reduce the need for refreshing, and help diminish losses from media deterioration', but that is all it does. It has 'no impact on any other potential source of loss' (Kenney et al., 2003). We need to keep in mind that relying on strategies and practices that focus on media storage have 'the potential for endangering content by providing a false sense of security' (Kenney et al., 2003). We should also keep in mind that there is still a considerable lack of awareness about the real issues of digital preservation. An indication of this lack is the BBC Domesday Project, where IT industry vendors offered solutions based on extending the life of CD-ROMs for 100 years. As noted in Chapter 2, 'the myth that long-lived media equals long-lived preservation is still worryingly popular' (Abbott, 2003, p.10).

Despite the likelihood that 'even modest improvements which produce storage media with larger per unit storage capacities and greater tolerance to variations in temperature and humidity will lower preservation' (Hedstrom, 1998, p.197), it is doubtful that there will be sufficient benefit to warrant serious attention. There is, perhaps, an analogy with the efforts made by the library and publishing industries, archivists, and authors to influence the manufacture of paper so that it was less acidic and longer lasting (Harvey, 1993, pp.192–194) but the benefits in that case were significant. For digital materials, the outcome of this way of thinking (which is perhaps pre-digital preservation paradigm thinking) is considerably less productive.

Analogue backups

Making analogue backups is a non-solution in the sense that it preserves only part of the digital materials and loses what Rothenberg refers to as 'their core digital attributes', including their machine-readability, interactive abilities, and other aspects of their functionality (Rothenberg, 1999a, p.9). This approach is most commonly discussed in terms of making copies of the textual and image information content of the digital material by printing them to paper or trans-ferring them to microfilm. Early attempts to preserve digital materials often focused on copying them from relatively unstable digital storage media to formats known through extensive experience to be stable, such as paper and microfilm. Hedstrom remarked in 1998 that it was 'probably the most commonly used preservation strategy' because, lacking 'more robust and cost-effective migration strategies' at that time, copying to more stable formats, even if they were analogue, offered advantages as a method 'of last resort' (Hedstrom, 1998, p.194). Although it has largely been discounted as a viable preservation approach, it may on occasion still be useful. An Australian digital preservation specialist interviewed in 2004 commented:

when we first started thinking about preserving web sites, and capturing them was at that stage seen to be too difficult, I considered for a time just at least printing out all the web pages that we could identify . . . on good colour printers and storing them as representations of at least what was on the Web in 1996 . . . [but] I thought that was inappropriate as a form of preservation . . . because it had to be digital. Well in fact now I really rue that decision because at least we would have had at least some record of what was happening in 1996 on the Web.

More specifically, making analogue backups or copies is defined as 'converting certain valuable digital resources to a stable analogue medium' (Jones and Beagrie, 2001, p.109), thus 'shifting the preservation burden to an analogue copy in place of the digital object' (UNESCO, 2003, p.146). The stable analogue media suggested are paper (usually 'permanent' paper), microfilm (silver halide or produced to preservation standards), and HD Rosetta, explained as nickel plates onto which document images are micro-engraved using an ion beam by HD-Rosetta technology; viewing with optical magnifiers is required (UNESCO, 2003, p.146; Norsam Technologies, 2001).

Making analogue backups is useful as a preservation practice for a limited number of categories of materials. For this material, it preserves the information content in a form free from the threat of technological obsolescence because it either does not need equipment to access it (as in paper) or requires only relatively simple non-digital equipment (such as a microfilm reader). These analogue formats are likely to remain accessible for some hundreds of years if they are produced to preservation standards (such as the standards defined for 'permanent' paper or archival-quality microfilm) and stored in appropriate conditions. This approach provides a 'simpler preservation alternative, as analogue materials may be preserved for the long-term using traditional preservation methods' (UNESCO, 2003, p.146). However, the advantages of making analogue copies are countered by some significant limitations. Jones and Beagrie consider that making analogue copies is not a digital preservation strategy because it does not preserve the digital characteristics of the materials it is applied to, but is, rather, a way of preserving the information content of digital materials and is only applicable to small-scale operations (Jones and Beagrie, 2001, p.103). The major limitation is that analogue copies do not possess the digital qualities of the original materials. For instance, there is a loss of functionality, such as the ability to carry out calculations in spreadsheets or to search the digital data, which may be an issue for some digital materials but not for others (UNESCO, 2003, pp.146–147). The ability to share digital materials readily is reduced, as is the potential for 'lossless transferability' (Kenney *et al.*, 2003) and storage efficiency.

Making analogue copies is best considered as 'a pragmatic interim strategy' applicable only to a limited category of digital materials for which loss of functionality is less important, 'pending the development of more appropriate digital preservation strategies' (Jones and Beagrie, 2001, p.109). The UNESCO *Guidelines* suggest that it 'may be required as a last resort where no other strategy is available and such limited accessibility is better than no accessibility at all' (UNESCO, 2003, p.147). It is likely to be used only where the full functionality of the digital materials being copied is not considered to be important to preserve, such as 'textual, image or data type documents that require no functionality above "flat" display' (UNESCO, 2003, p.147).

Two examples are provided in the UNESCO *Guidelines*. The first is printing out to paper of a database in an obsolete proprietary format which cannot be extracted or migrated; the database is retained in its digital version to allow for the possibility that it can be accessed at a later date. The second example is the creation of COM (Computer Output Microfilm) of digital image masters created during a digitization programme as a backup for preservation purposes (UNESCO, 2003, p.146). If analogue copies are made for preservation purposes, two conditions should be adhered to. The analogue formats should be produced to archival standards and housed in archival conditions. The original digital objects should, where possible, be retained to allow for the possibility of access mechanisms becoming available in the future (UNESCO, 2003, p.147). It is possible that storing analogue formats in archival conditions over long periods of time may not be feasible on technical and/or financial grounds, so these factors should be considered. To summarize:

> Text and monochromatic still images are the most amenable to this kind of transfer. Given the cost and limitations of analog backups, and their relevance to only certain classes of documents, the technique only makes sense for documents whose contents merit the highest level of redundancy and protection from loss (Kenney *et al.*, 2003).

Policy development

Developing a digital preservation policy is suggested by Howell as a prerequisite to digital preservation (Howell, 2001, p.142). This is best thought of as a general principle relating to most, if not all, aspects of managing an information service, and is not addressed further here.

Standards

Standards in the context of non-solutions relates to a principle, rather than a strategy or practice, if we apply our Chapter 6 definitions. Attention to the use of standards provides a more favourable environment in which digital preservation can be successful: their widespread use can be considered a prerequisite for effective preservation. The increase in standards development for digital preservation indicates, it is suggested, 'a certain maturation of the field' (Hodge and Frangakis, 2004, p.48), and is of considerable importance because it promotes collaboration and interoperability among organizations. Adelstein describes the current state of ISO standards development for preservation of digital materials, which focus on media quality, storage, and handling (Adelstein, 2003). The use of standard data formats is not, however, a non-solution and is noted in Chapter 8.

One principle that lies behind the promotion of standards that are stable and have been widely adopted is that there is an increased likelihood that they will be supported and will remain viable over a longer period. This is not always the case with proprietary standards or standards designed for use only with specific software and/or hardware. If standards are open source (that is non-proprietary), so much the better, for this reduces the risk of obsolescence if there is a large user base willing to ensure that the standards are maintained. Jones and Beagrie suggest that the widespread adoption of open standards 'thus can defer inaccessibility of digital resources due to technological obsolescence' (Jones

and Beagrie, 2001, p.107). Other advantages that are perceived to accrue from standardization are that costs will be reduced because there are fewer and less complex variations to deal with: for example, economies of scale could be achieved when migrating data (Jones and Beagrie, 2001, p.107). The UNESCO *Guidelines* add that the use for widely available standards 'is more likely to allow re-interpretation of the data or re-construction of tools in the future, if necessary' but notes that use of standards is an 'investment' strategy, that is, it involves investment of effort at the start of the process (UNESCO, 2003, pp.127–128) so there are resourcing implications. Rothenberg sounds a word of caution: 'standards are not enough' and are 'not realistic in the foreseeable future' because 'using successive, evolving standards would require translation, but translation between standards is rarely reversible without loss, so this cannot reconstruct an original artifact' (Rothenberg, 2003).

Digital archaeology

Digital archaeology, often referred to as data recovery, denotes a set of techniques that are applied as a last resort, and is therefore not a solution in any sense. The term applies to 'methods and procedures to rescue content from damaged media or from obsolete or damaged hardware and software environments' and involves 'specialized techniques to recover bitstreams from media that has been rendered unreadable, either due to physical damage or hardware failure' and is 'explicitly an emergency recovery strategy' (Kenney *et al.*, 2003). Special facilities, equipment and expertise are required and it is usually carried out by specialized data recovery companies whose expertise has established that it is possible to recover data from a wide range of media types. The recovery of the data does not necessarily lead to recovery of the ability to understand that data, although it is a necessary pre-condition for it (see Dunning, 2001 for an example).

The UNESCO *Guidelines* caution us against relying on digital archaeology and remind us that it is 'a very unreliable and high-risk substitute' for a current and active preservation programme (UNESCO, 2003, p.148). For one thing, it is very expensive and most materials would not justify the costs of recovering them. But more important, it is not reliable; there is no guarantee that digital materials can be recovered, and, even if the data is recovered, there is no certainty that it will be intelligible (Jones and Beagrie, 2001, p.110; UNESCO, 2003, pp.148–149).

Ross and Gow's 1999 study *Digital Archaeology: Rescuing Neglected and Damaged Data Resources* suggests that data recovery should be unnecessary if 'good disaster planning' is in place, but this very rarely is the case. They note that (and this is the sting in the tail) 'with sufficient resources much material that most of us would expect to be lost can be recovered' (Ross and Gow, 1999, p.iii). Their detailed report is essential reading for further information about digital archaeology and its techniques.

'Preserve technology' approaches

Approaches located at the 'preserve technology' end of the digital preservation spectrum are those that attempt to keep data in specific logical or physical formats and use technology originally associated with those formats to access

the data and reproduce the objects (Thibodeau, 2002). That is, there is as little change as possible, preferably none, to both the digital materials (which remain exactly as received) and the software, operating system, and hardware that these materials were originally developed to be rendered on. Strategies and practices at the extremes of the 'preserve technology' end of the spectrum allow ideally no change at all. A little further along the spectrum is emulation of old technology, where change is allowed but the original conditions are maintained as far as possible.

Of the two approaches noted in this 'preserve technology' category, one – emulation – is commonly considered as viable for long-term preservation, but the other – maintain original technology – is not. The UNESCO *Guidelines* take the view that technology preservation is a short-term strategy ('likely to work best over the short-term only') and classifies emulation as medium- to long-term, 'likely to work over longer periods' (UNESCO, 2003, p.126).

Technology preservation

The 'preserve technology' approach to digital preservation is also referred to by other terms which, taken together, define its scope: preserve technology; maintain old technology; maintain museums of working computing equipment, software and documentation; and the related strategy 'technology watch'. This approach, which 'exudes a certain technological bravado' (Rothenberg, 1999a, p.12), requires that obsolete hardware and software are maintained in working condition so that the digital materials retained by an institution can be accessed. It has a long history, being perhaps the most immediately obvious approach to take when obsolescence is imminent, but our experience with this approach has shown us that it is an expensive – ultimately too expensive – approach. This experience has also indicated that, given the large number of formats, hardware and software that become obsolete (a number that is increasing over time), it is not a viable option for anything but the short term. It is also an approach that most, if not all, institutions that undertake digital preservation have applied, and has an important role as a first line of defence:

> it is the most basic, and in some ways the most important first step in preserving access if no other strategy is in place. If the hardware and software required for access are discarded before other strategies are available, it may be effectively impossible to provide later access without expensive and uncertain data recovery work (UNESCO, 2003, p.135).

One example of technology preservation is maintaining old disk drives, as in the State Library of New South Wales where a 5½ inch floppy disk drive was maintained so that material on these disks that had been lodged under legal deposit legislation could be copied to a more current medium (Howell, 2001, p.142).

Technology preservation is considered as useful only in the short term, 'ultimately a dead end' because obsolete technology cannot be maintained in a functional condition indefinitely. At best it can 'extend the window of access for obsolete media and file formats' but if it is attempted it is heavily resource-intensive (Kenney *et al.*, 2003). The experience of preserving technology in audiovisual archives over many decades provides clear evidence of this. Edmondson (2004) provides a starting point for further investigation on this point.

Technology preservation is perceived to have many positives. Authenticity is preserved, both of the digital materials (which are unaltered), and of the technology and software platforms that render them (which are also not changed). Thus the 'functionality, look and feel of the original' (Jones and Beagrie, 2001, p.106) are retained. Preserving the technology provides the benefit of buying time, by delaying the need to apply practices that will ensure long-term preservation. An additional benefit may be that the documentation for the software and hardware preserved is likely to be of future use when implementing other strategies (UNESCO, 2003, pp.135–136).

But there are many less positive factors in technology preservation. It becomes more and more expensive as replacement parts for hardware and the expertise to maintain it become scarce: 'technical support will inevitably disappear within a relatively short timeframe' (Jones and Beagrie, 2001, p.106). This effect may, however, be ameliorated by sharing expertise, equipment and parts among a number of organizations (UNESCO, 2003, p.136). The access it allows to obsolescent and obsolete digital materials is extended, but only for a short period, according to the UNESCO *Guidelines* only for a period 'as narrow as five to ten years from the time the original format is superseded' (UNESCO, 2003, p.135). To be effective this approach requires access to documentation, such as manuals, for the software and hardware, which also needs to be procured and managed.

To work effectively, this 'preserve technology' approach has specific requirements, which are articulated in the UNESCO *Guidelines*. It requires that the hardware and software that will be needed to provide access is actively identified and its move towards obsolescence monitored (This is discussed in the 'Technology watch' section below.) Active and continuing arrangements to maintain hardware and to license software should be put in place. The expertise needed to maintain equipment and software should ideally not reside in one person but should be shared (UNESCO, 2003, p.136).

It is worth reiterating that technology preservation is useful in the toolkit of approaches and practices for digital preservation, but, in doing so, it must also be noted that it can be no more than an interim strategy because of its limitations. The UNESCO *Guidelines* go further by suggesting that it should be 'a matter of principle' that 'if the required access software is available, it should be sought and retained at least until another strategy has been put in place'. Technology preservation is best considered as 'an initial strategy for all preservation programmes, in the absence of longer term strategies or while they are being developed' and may have specific application to maintaining software that is used to support other strategies (UNESCO, 2003, p.136).

Museums of computing have been established, such as the Computer History Museum (www.computerhistory.org), but these are established principally for museum purposes and maintaining working computers is unlikely to be their primary intention. Some envisage that a widespread industry will develop, 'the equivalent of Kinko's where they'll have every ancient computer available', whose customers will drop in to read and copy their old data files (Peter Schwartz quoted in Hafner, 2004).

Technology watch

A strategy related to technology preservation is *technology watch*. Because the process of technology obsolescence is rapid, and storage media and file formats

change equally rapidly, there is a need to monitor the rate of change so that access to digital materials in danger of being lost because of this obsolescence can be maintained. This process of technology watch acts as a trigger to action, by ensuring that equipment is maintained until another preservation practice is applied to at-risk material, or by migrating to a more stable storage medium (Bennett, 1997, p.6). The process is simply described:

1) identify at risk technology in a collection
2) monitor its rate of obsolescence at regular intervals
3) take action when a technology is in danger of no longer being supported.

At the international level, Bennett proposes a survey of organizations to develop base-line data, updated regularly by consultations with a group of 'Wise Practitioners' to forecast technology trends (Bennett, 1997, p.27). At the institutional level, a first step is likely to be a survey of digital materials present in a collection to identify the formats, media, and software requirements present. A risk assessment approach from which a plan of action is developed may be useful (Jones and Beagrie, 2001, pp.132,134). This initial identification process is assisted if the storage media and software and hardware requirements are noted in the catalogue records of a collection, but this is not always the case. When a survey of digital materials in the collections of the State Library of Victoria was carried out in 2003, it was initially assumed that the Library's catalogue could be used to identify relevant material. In the event, the initial simple searches of the catalogue identified only about 3000 items from a total of about 12 000 items, which were located by carrying out complex searches and shelf checks. Learning from this experience, and to track the size and the nature of its growing digital collection, the State Library of Victoria now puts a digital flag into a specified field of its catalogue records. The National Library of Australia developed a list of hardware and software as a basis for flagging changes in technology (Woodyard, 1999). Identification will be considerably assisted in the future if the metadata records for all current additions to the collection contain this data, so that identifying material at risk from technology obsolescence is straightforward. A list of hardware and software available in an organization should also be maintained and used to plan for their replacement (Jones and Beagrie, 2001, p.134).

The Digital Preservation Coalition publishes a series of Technology Watch Reports, available from its web site (www.dpconline.org/graphics/reports). An example is its report on mass archival storage systems, based on experience at the British Library, published in February 2005.

Emulation

The battle lines were drawn in the 1990s between migration and emulation as the preservation strategy most likely to succeed. In the event neither has dominated, as we learn to place less trust in a single-strategy salvation and to develop ways of working and thinking that accommodate several approaches simultaneously.

Emulation is based on the principle of 'simplify[ing] digital preservation by eliminating the need to keep old hardware working' (Thibodeau, 2002, p.19). Emulation and emulators are variously described and defined. In terms of preservation, emulation is 'a means of overcoming technological obsolescence

of hardware and software by developing techniques for imitating obsolete systems on future generations of computers' (Jones and Beagrie, 2001, p.105). Emulation is the ability of a program or device to imitate another program or device, using software 'that makes one technology behave as another' (UNESCO, 2003, p.144). It 'combines software and hardware to reproduce in all essential characteristics the performance of another computer of a different design, allowing programs or media designed for a particular environment to operate in a different, usually newer environment'. Emulators, 'programs that translate code and instructions from one computing environment so it can be properly executed in another', are required (Kenney *et al.*, 2003).

Emulation is a well-established principle in the computing industry. Emultion can be of operating systems (for example, VirtualPC, which allows PC software to be run on an Apple Macintosh), of hardware platforms (for example, Kaypro or Apple II machines can be emulated on a PC), and of software applications (for example, arcade games emulated through the MAME project). One emulator in common use is built into the Apple Macintosh operating system and enables this computer to run software developed for earlier Apple computers. Printers are often designed to emulate Hewlett-Packard printers: here, notes the *Webopedia* definition (www.webopedia.com), 'emulation tricks the device into believing it [is] really some other device'. Terminal emulation is also common, so that a PC, for example, can be used as a terminal connected to a larger computer; these were once very common in mainframe computer environments. Although emulation is often associated with computer games, such as emulators that allow Sony PlayStation games to be played on a PC, it is an essential part of computing in all areas. The web is a fruitful source of information about emulators (e.g. www.directory.net/Computers/Emulators).

Both hardware emulation and software emulation have been experimented with to determine their feasibility for preserving digital materials. The aim is to make 'future technologies behave like the original environment of a preserved digital object, so that the original object could be presented in its original form from the original data stream' (UNESCO, 2003, p.144). Emulation of hardware has the attraction of being applicable to a wide range and large amounts of digital materials, because it 'would allow a range of systems and digital objects to operate, thus solving the problem for a very wide range of digital objects' (UNESCO, 2003, p.144). The same widespread applicability applies to emulation of operating systems. Emulation of software applications is less in favour, because it is more limited in its use and the effort and level of skill required to develop a complex piece of emulator software that can be used for only a small number of digital materials may be too high for this to be an option in most preservation situations.

Emulation has been investigated in several major projects, most notably, the CAMiLEON (Creative Archiving at Michigan and Leeds) project which investigated emulation, testing available emulators and constructing an emulator for the BBC Domesday Project. Among its conclusions was that 'emulation is not necessarily superior to migration for preserving the original look and feel of complex digital objects'. (The project's web site (www.si.umich.edu/CAMILEON) provides more information.) However, more research was needed, as this was a study of limited scope (Hedstrom and Lampe, 2001). Project NEDLIB (Networked European Deposit Library) ran from 1998 to 2000 and was based at the Koninklijke Bibliotheek in The Hague. One of its activities was to

conduct an experiment using commercial emulation tools to investigate the feasibility of emulation for digital preservation. This experiment, conducted by Rothenberg, was limited in its scope. It concluded that emulation should work in principle, but that further investigation is required to demonstrate that it can also work in practice (Rothenberg, 2000). The project's web site (www.kb.nl/coop/nedlib) gives more information.

Jeff Rothenberg's name is firmly linked with emulation as a digital preservation strategy. He has been a strong proponent of emulation as the only digital strategy that is likely to be effective. His argument is that the only way to make sure that digital materials are preserved in their native form (so that they are experienced appropriately by future users) and are not corrupted is to run software that interprets the bit-stream correctly. Because software can behave differently in different contexts, we should not expect software developed in the future to reproduce the behaviour of obsolete software. To ensure the appropriate behaviour of digital materials it is necessary to run the original software used to view the document in its native form.

Rothenberg points out that all digital materials depend on software, and in particular many new kinds of digital materials are 'inherently digital' and 'cannot be meaningfully represented as page images' (Rothenberg, 2003). This means that preservation strategies such as saving page images are of little use for the preservation of much digital material. Emulation, according to Rothenberg, is the only preservation approach that has multiple advantages and capabilities, among them preserving executable digital objects (objects in which software programs are embedded), providing a 'single, consistent way' of preserving all kinds of digital materials, reducing the effort expended in preserving individual artifacts (except for copying the bit-stream onto new media), and minimizing the need to understand record formats. Despite his strong advocacy of emulation, Rothenberg suggests that a mixed strategy approach is most feasible, with emulation used 'if original behavior is needed; *or* as a cheap backup, to preserve everything' (Rothenberg, 2003).

Other authorities also suggest that emulation has potential. Jones and Beagrie consider it to be one of only two primary strategies (those suitable for medium to long-term preservation of digital materials), the other being migration (Jones and Beagrie, 2001, p.103). They suggest that it has the advantage over other methods of recreating the look and feel and functionality of the original digital material, as well as the potential for avoiding the high costs associated with repeated migration. Emulation, by their judgement, has good prospects for preserving complex digital materials (Jones and Beagrie, 2001, p.105). The UNESCO *Guidelines* note that emulation is already well established and understood in computing, that many emulators already exist for a variety of hardware and software platforms, and that it has the potential to 'allow a range of digital objects to be recreated with full functionality, including software objects, using the original, untransformed data stream in combination with original preserved software' (UNESCO, 2003, p.145).

Not all share Rothenberg's enthusiasm, among them Granger (2000). The arguments against emulation form a list as long as the arguments in its favour (Jones and Beagrie, 2001, p.105; UNESCO, 2003, p.145). Chief among them is that emulation has not been sufficiently tested in practice. Also high on the list of disadvantages is the high cost of developing emulators, which may be greater than the costs of repeated migration, because it requires high levels of

expertise to write complex software. There is some scepticism about the ability of emulation to do all that is claimed, and it may not be possible to emulate fully all of the functionality of the original, nor all of its look and feel. The lack of adequate documentation of hardware and software may frustrate emulation attempts. Copyright issues associated with ownership of software code may impede emulator development. Users may have problems in interacting with 'archaic applications operating under emulation', and the need either to migrate the emulators themselves or emulate the emulators raises the interesting spectre of 'layers upon layers of emulators' (UNESCO, 2003, p.145).

If emulation is to be attempted, then the requirements are many and varied. Appropriate expertise is, of course, essential. Documentation of the systems to be emulated needs to be comprehensive and accurate. The emulation software should be written in open source code, using a 'standard programming language with good prospects for longevity and future compatibility' (UNESCO, 2003, p.145) and following best industry practice, including thorough documentation.

Probably the most widely reported emulation project carried out for preservation purposes to date is the BBC Domesday Project. Abbott (2003), Darlington, Finney and Pearce (2003), Mellor (2003), National Archives (U.K.) (2004?) are just some of the reports on this project; the CAMiLEON web site (www.si.umich.edu/CAMILEON/domesday/domesday.html) is also a useful source. The original Domesday Project, undertaken from 1984 to 1986, surveyed the UK to celebrate the 900th birthday of the Domesday Book. It cost about ?2.5 million and involved about one million school children from 14 000 British schools. The resulting images and text were recorded on two 12-inch videodisks that were accessed using a LV-ROM (LaserVision Read Only memory) player attached to a BBC Master computer with additional software and hardware (Abbott, 2003, p.7). As part of its activities the CAMiLEON Project developed an emulation of the original Domesday system hardware.

The process of developing this emulation involved migrating the data files from the videodisks to current media, and developing software that emulates the BBC Master computer and the laserdisk player (Mellor, 2003). Image files were re-digitized from the original one-inch analogue videotapes (Darlington, Finney and Pearce, 2003). The need to avoid the obsolescence of the emulation software was kept in mind: ideally, the software should not be limited to operation on any specific operating system or type of computer so that it will be easier to run on future computers. In the end, however, the BBC Domesday emulator that was developed runs only on the Windows operating system (Mellor, 2003, p.8).

Significant lessons were learned from the BBC Domesday Project. This emulation project was hampered by lack of documentation and software to test the emulation, but was fortunate to have available a working original system, albeit a fragile one. This was important because it allowed the developers to 'compare with and validate the migrated system', which has special significance in a multimedia system 'where the look-and-feel and user interaction is important' (Darlington, Finney and Pearce, 2003). Wheatley, one of the team who worked on this project, summarizes the issues:

> Most of the really difficult problems we faced were due to the long time gap between the creation of Domesday and its preservation. If we had conducted the rescue 10 years earlier it would have been far easier. The

timeliness of preservation work is a crucial issue that Domesday really underlines. Would we be able to rescue Domesday if we left it another 10 years? I'm sure we could, but it would be at far greater expense (Abbott, 2003, p.10).

Emulation is likely to play a significant role as a major preservation strategy. It has been sufficiently well tested to show promise. What is now required to exploit that promise is the allocation of significant resources, probably through collaborative action, to develop a range of emulators. Emulation is unlikely to be the 'magic bullet' (Lynch, 2004), the single solution to digital preservation, as it is sometimes promoted. Nor is it likely to replace migration as a primary digital preservation strategy, because emulators will themselves need to be migrated. Holdsworth and Wheatley remind us that emulation should not be over-sold as the answer to all digital preservation issues. It is just part of the armoury necessary for defending our digital heritage against the ravages of time in a world where innovation (and hence change) is highly prized (Holdsworth and Wheatley, 2001).

We can envisage that emulation will be used increasingly as more emulators are developed, in specific situations, such as for complex digital materials or for those which contain executable software that will only run on specific hardware, or for digital materials that need to be viewed in their original environment. These, of course, presuppose that suitable emulators are already available or that the expertise is available to develop them (UNESCO, 2003, p.145).

The Universal Virtual Computer

An extension of emulation is the Universal Virtual Computer. This program is

> constructed independently of any existing hardware or software, so that it is independent, too, of time. It would simulate the basic architecture that every computer has had since the beginning: memory, a sequence of registers, and rules for how to move information among them. Computer users could create and save digital files using the application software of their choice; when a file was saved, though, it would also be backed up in a way that could be read by the universal computer (Tristram, 2002, quoting Raymond Lorie).

The Universal Virtual Computer is general and basic, and its simplicity ensures that it will be 'relatively easy to write an emulator for [it] in the future on the real machine being used at that time' (Lorie, 2002, p.1). The Universal Virtual Computer has been developed by the Koninklijke Bibliotheek and IBM as a proof-of-concept prototype that 'successfully demonstrated that the concepts are quite sound, can be applied to the archiving of PDF documents, and can be implemented' (Lorie, 2002, p.2). More recently the Koninklijke Bibliotheek and IBM have developed and implemented a UVC tool for images in JPEG format (Van Wijngaarden and Oltmans, 2004). The significance of such a virtual computer is that it provides a single platform, with the potential for minimizing the amount of effort required to handle diverse combinations of hardware and software. However, the Universal Virtual Computer approach is still experimental. If it becomes more widespread, it represents a strategy that requires

considerable investment at the beginning of the preservation process (UNESCO, 2003, pp.133–134).

Conclusion

This chapter has described a number of strategies and practices currently applied or being tested for digital preservation. They are all focused on the principle that alteration of digital materials must be kept to the minimum and that the technology (hardware and software) to access these materials is kept operational or is emulated. Of the range of strategies and practices noted here, some are interim measures and only one – emulation – is generally considered to be viable for the long-term preservation of digital materials. The next chapter considers a range of approaches from the other end of the preservation spectrum: 'preserve objects'.

Chapter 8
'Preserve Objects' Approaches: New Frontiers?

Introduction

Migration has been the only serious candidate thus far for preservation of large scale archives (Granger, 2000)

Migration is essentially an approach based on wishful thinking (Rothenberg, 1999a, p.15)

Handling file formats is an essential part of a long-term archive ... most file formats fall out of fashion within a few decades, and unless action is taken at an early stage, many archived files will be incomprehensible blocks of bits (Clausen, 2004).

Let us return briefly to the beginning of the previous chapter and its derivation, from the work of Thibodeau and Rothenberg, of three categories of preservation strategies and practices:

1) 'Non-solutions'
2) 'Preserve Technology' approaches
3) 'Preserve Objects' approaches.

This chapter looks into the third of these groupings, the 'Preserve Objects' approaches which are at the opposite end of Thibodeau's spectrum (see Figure 6.3) from 'Preserve Technology' approaches. Like Chapter 7, it relies heavily on two key sources: *Preservation Management of Digital Materials: A Handbook* by Maggie Jones and Neil Beagrie (Jones and Beagrie, 2001), and the UNESCO *Guidelines for the Preservation of Digital Heritage* (UNESCO, 2003). The Appendix contains several case studies relevant to this chapter. Case Study 1 examines digital storage at the National Film and Sound Archive and illustrates the topic of migration. Case Study 3, which notes digital preservation activities at the

National Archives of Australia, illustrates the topics of normalizing and XML. VERS (Victorian Electronic Records Strategy) is the subject of Case Study 4, and illustrates the topic of encapsulation. Case Study 5 describes migration at the Australian government Department of Family and Community Services.

'Preserve Objects' approaches

The 'preserve objects' approach attempts to preserve the essential characteristics of digital materials without reliance on specific hardware or software. That is, the digital materials may be altered, although it is preferable if they are not, but only to the extent that is required to make them able to be rendered by current and future technology (hardware and software), without compromising the 'essence' or essential elements (discussed in Chapter 5) of that material. These essential elements are 'defined explicitly and independently of specific hardware or software' (Thibodeau, 2002). The 'preserve objects' approach can be contrasted with the other end of the spectrum, the 'preserve technology' approach, where, as stated in Chapter 7, as little change as possible – preferably none – occurs to both the digital materials and the software, operating system, and hardware that these materials were originally developed to be rendered on. The strategies and techniques encompassed by the 'preserve technology' approach attempt to keep data in specific logical or physical formats and to use technology originally associated with those formats to access the data and reproduce the objects (Thibodeau, 2002). There are other positions along the spectrum between these two poles; for example, in the middle are 'methods that migrate data formats as technology changes, enabling use of state-of-the-art technology for discovery, access, and reproduction' (Thibodeau, 2002).

This chapter is concerned with the range of strategies and practices that seek to accommodate changes in technology without compromising the digital materials themselves or the ability to render their essential elements accurately and meaningfully. These strategies and practices are grouped for the purposes of this chapter as:

- those based on copying the bit-stream (backup and restore, bit-stream copying, refreshing, replication, mass digital storage systems)
- those centered around data formats (standard data formats, Universal Preservation Format)
- migration, which requires the bit-stream to be copied, and for which significant knowledge about data formats is required (including migration on demand and the use of viewers)
- encapsulation, which is based on packaging the digital object with metadata and other associated information.

Only one of these groups of strategies and practices – migration – has been implemented to any great extent. Jones and Beagrie consider migration to be a primary strategy: one 'which might be selected . . . for medium to long-term preservation of digital materials' (Jones and Beagrie, 2001, p.102). Other strategies described in this chapter, such as standardizing data formats and encapsulation, are secondary strategies – 'those which might be employed in the short to medium term either by the repository with long-term preservation responsibility and/or by those with a more transient interest in the materials'

(Jones and Beagrie, 2001, p.102) – which may precede, 'substantially defer the need for', or strengthen primary strategies. Some strategies noted in this chapter are investment strategies, in terms of the UNESCO *Guidelines'* classification of digital preservation strategies (UNESCO, 2003, pp.126–149); they primarily involve 'investment of effort at the start'. Encapsulation and restricting the range of formats to be managed fall into this category. Other strategies noted (backwards compatibility and version migration, and migration) in this chapter are short-term strategies, those 'likely to work best over the short-term only'. One (the use of viewers) can be characterized as a medium- to long-term strategy 'likely to work over longer periods'. Two of the strategies and practices included in this chapter are noted as 'current front-runners as long-term strategies' and that have been shown to work over short periods of time (UNESCO, 2003, pp.124–126). These are using standards, especially standards for data structuring, and migration. These strategies and practices in general support the principles suggested in the UNESCO *Guidelines*.

Bit-stream copying, refreshing, and replication

Some definitions are called for. *Bit-stream copying*, sometimes referred to as *backup and restore*, is the process of making an exact duplicate of a digital object. *Refreshing* is the copying of data onto new media. *Replication*, also known as *redundancy*, refers to keeping multiple copies. All of these processes involve making copies, but each differs significantly from the other.

Bit-stream copying

Bit-stream copying is 'the process of making an exact duplicate of a digital object' (Kenney *et al.*, 2003). Procedures for bit-stream copying are well understood. They are commonly practised as *backup and restore*, that is, backing up (copying) computer files on a regular basis and restoring them if the data in the primary source (the files from which the backup copy or copies are made) are corrupted or destroyed. Regular backup routines are a key component of the operation of any computing facility. In making copies of the bit-stream, well-established techniques that ensure that the data is copied accurately are applied, such as check-sums and digests (Howell, 2001, p.144). The backup files are often stored at sites away from the main site of operation, which offers additional security in the event that one site is affected by disaster. This is usually referred to as remote storage.

 Although it is necessary for all digital preservation strategies, bit-stream copying is not a long-term strategy because it does not address the key factors that cause digital deterioration, mainly obsolescence of hardware and software. It is effective as a risk management technique to minimize the possibility of data loss through failure of hardware, media deterioration, sabotage, natural disasters or other events. It should be considered as 'the minimum maintenance strategy for even the most lightly valued, ephemeral data' (Kenney *et al.*, 2003).

Refreshing

Refreshing is a refinement of bit-stream copying. Whereas bit-stream copying is carried out so that a backup copy exists in case there is a problem with the

primary source files, refreshing takes a longer-term view. It is typically carried out in order to copy data 'from one long-term storage medium to another of the same type' (Kenney *et al.*, 2003), for example, from a DAT tape that is becoming unstable to a new DAT tape. The bit-stream is not altered. As with bit-stream copying, refreshing is 'a necessary component of any successful digital preservation program' but does not address issues of obsolescence (Kenney *et al.*, 2003).

Replication

Keeping multiple copies – replication – is a long-established preservation technique in libraries, valued for its 'built-in high redundancy and protections against loss of information through vandalism, theft and disaster' (Howell, 2001, p.143). For example, a copy of a book may be kept in secure environment-controlled storage as a preservation copy, with other copies available for use. Kenney *et al.* (2003) distinguish among several uses of the term *replication*: as bit-stream copying, as refreshing, and, in the sense that it is used here, as a 'consortial form' of copying of digital materials. This is demonstrated in the LOCKSS project, where 'the intention is to enhance the longevity of digital documents while maintaining their authenticity and integrity through copying and the use of multiple storage locations' (Kenney *et al.*, 2003). The progenitors of LOCKSS, as reported by Howell (2001, p.143), describe replication as a fault-tolerant paradigm which works by acquiring copies, distributing them around the world so that some can readily be located but others are hard to find, and lending or replicating copies when others need access. Replication of digital materials had been noted as a feasible preservation strategy before it was implemented in the LOCKSS project. Exon suggested that mirror sites around the world would store selected digital information according to international agreement, so that 'when the tides of history turn against previously stable and peaceful areas of the world, their history can be saved elsewhere, just like the Elgin marbles' (Exon, 1995).

LOCKSS was developed for the preservation of e-journals. It is based on open source software that harvests, stores, and copies digital content using standard desktop computers and ensures accuracy of the digital material through peer-to-peer polling. It is inexpensive because it does not require costly hardware, the software is free, and, as claimed on the LOCKSS web site, very little technical administration is required. In 2004 more than 80 libraries and 50 publishers were using the LOCKSS software, and further development was taking place through collaborative research to expand its capabilities.

The LOCKSS web site (lockss.stanford.edu) provides a detailed summary of how the system works. An inexpensive personal computer running LOCKSS software collects specified e-journal content, for which the publisher's permission to collect has been secured, using a web crawler. It compares continually the content collected with the same content that has been collected by others in the network and ensures that the content is identical. It also allows access to this content by authorized users and provides administrative functions. In order to allow the LOCKSS crawler software access to their content, publishers need to give permission to the LOCKSS system. The basis of the preservation function of LOCKSS is the continual checking of digital content against other copies and the repairing of discrepancies identified by comparing copies through polling. The LOCKSS web site provides more details:

At intervals appliances [the name given to the personal computers with LOCKSS software] take part in polls, voting on the digest of some part of the content they have in common. If the content in one appliance is damaged or incomplete that appliance will lose the poll, and it can repair the content from other appliances. This cooperation between the appliances avoids the need to back them up individually. It also provides unambiguous reassurance that the system is performing its function and that the correct content will be available to readers when they try to access it. The more organizations that preserve given content, the stronger the guarantee they each get of continued access.

LOCKSS is also promoting a range of related projects to investigate preservation of other kinds of e-publications, for example humanities e-journals, government documents, newspapers, electronic theses and dissertations, web sites, and materials in special collections. In November 2004 the LOCKSS project announced that it has successfully demonstrated 'transparent format migration of preserved web content' (Rosenthal *et al.*, 2005).

Other information is readily available to supplement the operational and technical detail given on the LOCKSS web site, such as an early paper describing the concept and reporting on its test phase (Reich and Rosenthal, 2000) and a fuller description of production-scale activities (Reich, 2002).

Standard data formats

Understanding file formats is a necessary precondition for the effective use of many digital preservation techniques. In order to access and display digital content it is necessary to decipher the bit-stream, to learn what the information in that bit-stream represents. This is the role that file formats play. They define how to interpret the bits in the bit-stream. File formats are

> a crucial layer, indeed a hinge between the bits in storage and their meaningful interpretation . . . one of the core issues of any digital preservation approach, and file format obsolescence is a major challenge for anybody wanting to preserve digital files (ERPATraining, 2004, p.1).

File formats would not pose so great a challenge to digital preservation if there were fewer of them and they were more accessible. The wide range of standards and formats that need to be handled is illustrated in the following examples. A survey of the National Library of Australia's collections in 1996 identified 134 CDs and 721 floppy disks, of which 172 were 5½-inch and 549 were 3½-inch disks. As well as PC and Macintosh, other operating systems were required to access these disks: Apple II (various varieties), BBC, Commodore 64 or 128, Apricot PC, Microbee 64, and 'unknown'. A significant number of the disks were over five years old (Woodyard and Webb, 1997). Analysis of the data on a sample of 64 disks, chosen to represent variables such as operating system, software, disk size, and age, identified many problems, including lack of appropriate hardware or software, disk errors, and illegal characters in file names. Of the 64, 37 per cent were not accessible at all. Of the 40 disks that could be copied, 55 per cent produced functional files after copying, 12 per cent were not

functional after copying and 33 per cent were probably largely functional but the National Library of Australia did not have the software needed to test this (Woodyard, 1998). In a survey of RLG member institutions in the same year, 'at least' 24 different storage formats were identified. Of the 36 institutions with digital holdings, 24 maintained these in six or more different formats, with 10 or more different formats in 13 institutions. The most common file formats were image files, text files with mark-up, and ASCII files, with word-processing files, audio, video, and spreadsheets also well represented (Hedstrom and Montgomery, 1999, pp.9–10).

Another example illustrating the range of standards and file formats that need to be handled in everyday use comes from a proposal for a DOMS (Digital Objects Management System) at an Australian university:

Open system/ Internet standards	Metadata standards	File formats
DOI HTTP/HTML Z39.50 Java XML Resource Description Framework (RDF) MIME	MARC21 Dublin Core EAD IMS SCORM ONIX	*Image formats:* PNG, PSD, TIFF, GIF, JPEG, BMP, and other common graphic file types *Audio formats:* AU, AIFF, WAV, RealAudio, Audio CD and other common audio file types *Video formats:* MPEG, QuickTime, RealVideo, AVI and other common video file types *Web file types:* HTML, PHP, ASP, DHTML, XML, Java Script, CCS, JSP, CFM, SGML and other common web file types *Multimedia formats:* Shockwave, QuickTime, Director, Authorware, Flash, VB application, IPix, etc *Databases:* Oracle, MS Access, FileMaker Pro *Desktop application source formats:* MS Word, MS Excel, MS PowerPoint, MS Project, MS Visio, Adobe Pagemaker, Adobe Illustrator *Publishing formats:* PostScript, PDF, TIFF *Other common file types:* TXT, EXE, ZIP, RTF, CSV, DOT, etc.

Figure 8.1 Standards and Formats in a Digital Objects Management System (From McKnight and Livingston, 2003, p.9)

In one week's crawl of Danish web sites by the Danish Royal Library in 2003, the following formats were identified from a total of 688 029 documents:

- document-like formats: 3
- image formats: 6
- sound formats: 3
- video formats: 3
- configuration and metadata formats: 2
- program formats: 2
- unknown format: 1.

Of the total, 66.78 per cent were text files in HTML format, 19.17 per cent were image files in GIF format, and 10.12 per cent were image files in JPEG format; that is, 96 per cent were in HTML, GIF, or JPEG formats (Clausen, 2004, p.5).

The problem posed by the multiplicity of formats (one estimate is more than 15 000 (Clausen, 2004, p.4)) is compounded by their nature. Many formats are proprietary, that is, they are the property of an owner who, for commercial reasons, is not willing to provide access to documentation about them, and who may require a fee to be paid for their use. Because one of the essential requirements of nearly all digital preservation strategies and techniques is a thorough understanding of file formats, the lack of access to full documentation about proprietary formats presents a major barrier. By comparison, the documentation for open formats, those that are in the public domain, is much more accessible. Consequently open formats are considered much more favourably for use in digital preservation applications than proprietary formats. To illustrate this point, consider that Microsoft Office documents (such as Word and Excel files) can be preserved as PostScript, PDF, DSSL, RTF, ASCII, SGML, TIF, CGM, or PNG files, each of which have different file format specifications. Of these, PostScript, PDF, and RTF are proprietary file formats (Moehle, 2004).

A report on the preservation of E-Prints (digital duplicates of academic research papers that are made available to improve access to these papers) commissioned by JISC in the UK devotes six of its 16 recommendations to file formats:

1. Recognise the preservation risks of file formats
2. Adopt open, standards-based file formats
3. Investigate the use of XML formats to describe data and metadata
4. Plan for migrating rare and obsolete file formats
5. Maintain file format information
6. Include file format identification functionality in E-Print repository software (James *et al.*, 2003, pp.8–9).

Four main responses to the issues posed by the proliferation and complexity of file formats can be identified: file format registries, standardizing file formats, restricting the range of file formats handled in digital preservation systems, and developing archival file formats such as PDF/A.

File format registries

One response to the issues presented by file formats that is gathering momentum is the establishment of file format registries (also called repositories or depositories). Although these have existed for some time in the computer science arena, it is only recently that registries have been established for digital preservation purposes. These registries exist to provide detailed and reliable information about file formats, the key to many digital preservation activities. In their influential case study of file formats, Lawrence *et al.* note that the risks associated with migration, such as the differences between the source and target formats, are quantifiable, so the risks of migration can be managed (Lawrence *et al.*, 2000, pp.12–13). The kinds of file format problems that can arise as a result of migration are illustrated in the report of the Representation and Rendering Project at the University of Leeds. For example, format migration difficulties, where

migrating an object created in version 1 of Macromedia Freehand to versions 5 and 9 resulted in different letter spacing, word spacing and kerning, although the drawing part of the object remained intact; objects migrated from MacDraw to Illustrator were unreadable (University of Leeds, 2003, pp.6–9).

Risks of this kind are minimized if file formats specifications are available. The experiments reported by Lawrence *et al.* found that 'the most difficult aspect of this project was the acquisition of complete and reliable file format specifications' (Lawrence *et al.*, 2000, p.13). Their study concluded that information about file formats that is publicly available is vulnerable because it relies on the efforts of interested individuals. They concluded that 'there is a pressing need to establish reliable, sustained repositories of file format specifications, documentation, and related software', to support migration (Lawrence *et al.*, 2000, p.13). The Representation and Rendering Project reached the same conclusions: accessible file formats information falls 'far short of what is required to successfully tackle the problems of data obsolescence' and the accuracy of most of what was available is 'mediocre at best' (University of Leeds, 2003, p.42). It specifically recommended that, because file format information available on the web is vulnerable, it should, as a matter of urgency, be captured and preserved in a file format registry.

There are now a number of file format registries for digital preservation, and research to develop tools to apply them to the automation of digital preservation is under way. Christensen, for example, describes how a format registry can be used as part of the automated processes of running a web archive, by such things as matching up the best viewer with a specific file format so that it is rendered as accurately as possible. He provides the example of HTML files rendered by Notepad, which are intelligible but 'far from perfect' (Christensen, 2004).

PRONOM is one file format registry set up specifically to support digital preservation. It has been developed by the National Archives (UK) to provide and manage information about file formats and about the software applications used to render these formats. It was originally developed as an in-house tool to support the National Archives' digital preservation activities, but is now accessible on the web. PRONOM makes publicly available specifications of software and the file formats that each piece of software can read and write, and records 'the degree to which the content remains unchanged by different products, and the support lifetime of products used to create, view or update electronic records'. This is a response to the short life cycle of software and to the fact that older file formats are not necessarily supported by later versions of software, or, if they are, only with alteration of formatting or content, a situation inimical to the faithful reproduction of electronic records. PRONOM also provides information about software vendors and product support providers. It plans in the future to provide more detailed information about individual file formats. (This section is based on the PRONOM web site (www.nationalarchives. gov.uk/pronom).)

Another file format registry developed to support digital preservation is the Global Digital Format Registry (hul.harvard.edu/gdfr/), set up to be 'inclusive in coverage, detailed in representation, rigorous in validity, public in discovery and delivery, and sustainable over archival time-spans'. It aims to minimize the duplication of effort that occurs with the maintenance of multiple local format registries. Established in 2002, it has developed 'use cases', which are available on the Registry's web site, to identify some potential situations where a format

repository would be used. These include assessing the risk associated with a digital format, collection audit, validating the ingest of a digital object with a new format, monitoring for technology obsolescence, identifying rendering conditions for a digital object, determining the appropriate migration path for a digital object, determining the format of a given digital object, and identifying the migration pathway for a format (Abrams and Seaman, 2003).

Other file format registries used to support digital preservation include *Wotsit's Format: The Programmer's Resource* (www.wotsit.org) and *My File Formats* (www.myfileformats.com). These have mostly been established and maintained by computer scientists or enthusiasts rather than by those involved in digital preservation.

The file format registry response to file format issues attempts to deal with all file formats, making no distinction among them. Other responses are based on restricting the range of file formats, both those in which files are created and those which digital archives agree to manage and preserve.

Standardizing file formats

If 'good' file formats are used for creating digital materials, the difficulties of preserving these digital materials will be minimized. This is the thinking that lies behind the digital preservation approach centred on encouraging document creation in those file formats that are most likely to be sustainable over the long term. Investigations into the effectiveness of different formats for this purpose are ongoing. For example, in its search for ways to ensure sustained accessibility to authentic archival records in the long term the Digital Preservation Testbed at the Nationaal Archief of the Netherlands investigated the sustainability of different record types (text documents, e-mails, spreadsheets, databases) in different file formats – MS Word or WordPerfect for text documents, Outlook, Eudora, Novell GroupWise, Hotmail, and Kmail for e-mails, MS Excel and Lotus for spreadsheets, and MS Access and Oracle for databases. Together these account for more than 90 per cent of Dutch Government records (Slats, 2004).

What are the characteristics of 'good' file formats? They are the formats that are most likely to be viable for longer periods and are most likely to be open source and widely available and supported. Clausen tells us that most file formats 'fall out of fashion within a few decades' (Clausen, 2004, p.23) and suggests a list of criteria by which we can predict the ongoing viability of a file format. These include:

- *Openness* criteria: for example, open, publicly available specification for the format; specification is in the public domain; not encrypted
- *Portability* criteria: for example, independent of hardware; independent of operating system; independent of other software; independent of particular institutions, groups, or events; widespread current use; containing little built-in functionality
- *Quality* criteria: for example, low space cost; highly encompassing; robustness; simplicity; highly tested; loss-free (Clausen, 2004, pp.11–12).

Using standard file formats is not a long-term digital preservation strategy. It does not address the obsolescence of file formats, but merely slows down the rate at which it occurs. It is based on the assumption that, for popular file

formats, obsolescence and compatibility problems will be addressed because of the large number of users, who will require that software to handle and render this format be upgraded to be usable in new operating systems and on new hardware platforms. However, this strategy has a limited lifespan: it is suggested that 'reliance on standards may lessen the immediate threat to a digital document from obsolescence, but it is no more a permanent preservation solution than the use of gold CDs or stone tablets' (Kenney *et al.*, 2003).

Identifying and applying standard file formats is common practice. One example is the use of TIFF (Tagged Image File Format) to create preservation master images in many digitization programs. TIFF is used in this context because it is open and stable, and has a large user base (UNESCO, 2003, p.127). Creating digital materials in standard formats can be encouraged in situations where some creators of the material can be influenced, for example, in-house digitizing programs. Format standardization is suitable for use in situations where the file formats can accommodate all or most of the characteristics of the digital materials. Consider a document created in a current version of a standard office word-processor, which, when converted to ASCII, will lose formatting. While this may not be considered an important loss for some kinds of materials, it may be significant for others. In this case another file format that retains formatting, such as PDF, could be considered.

A point in favour of the strategy of selecting and applying standard file formats is that it is likely to slow the rate at which file formats become obsolete. If widely used and supported file formats, or basic formats such as ASCII, are selected, then the software available to encode, decode and render these formats is likely to be available for longer periods of time than those for less popular formats. This strategy is not suitable for materials where there would be a loss of characteristics that are essential for its understanding if a particular file format is selected (UNESCO, 2003, p.128).

Not all commentators are convinced that this strategy has merit. Rothenberg argues that

> to force digital documents into current standard forms (even if this sacrifices some of their functionality) and then translate them, when current standards become obsolete, into whatever standards supplant the obsolete ones ... is analogous to translating Homer into modern English by way of every intervening language that has existed during the past 2,500 years. The fact that scholars do not do this (but instead find the earliest original they can, which they then translate directly into the current vernacular) is indicative of the fact that something is always lost in translation (Rothenberg, 1999a, p.11).

He concedes, however, that 'converting digital documents into standard forms, and migrating to new standards if necessary, may be a useful interim approach while a true long-term solution is being developed' (Rothenberg, 1999a, p.12).

Restricting the range of file formats

A strategy related to restricting the range of file formats in which files are created is for the digital archive to restrict the range of file formats that it agrees to receive and manage. The archive may convert material it receives into these

formats. This process is 'a formalized implementation of reliance on standards' in which 'all digital objects of a particular type (e.g., color images, structured text) are converted into a single chosen file format that is thought to embody the best overall compromise amongst characteristics such as functionality, longevity, and preservability' (Kenney *et al.*, 2003). This practice has a long history in data archives. One example frequently cited is the UK Archaeology Data Service (ads.ahds.ac.uk), which prescribes the range of formats in which it will accept material.

This strategy is most suitable where the digital archive is responsible for digital materials that are uniform in structure and content. The archive may be able to influence the creation of these materials. For example, a government archives may specify and encourage, or enforce, that records created by its agencies are in the only standard formats that it will accept. Requirements for the successful operation of this strategy include clear submission guidelines, effective data conversion processes (if data conversion is needed), and quality control checking to a high standard (UNESCO, 2003, p.132–133). Clausen proposes this strategy for web archiving. He recommends that the file formats harvested and added to the web archive should be constantly monitored so that action can be taken when new formats become widespread and old formats fall out of favour. He also suggests that the files received should be retained in their original format as well as in the converted and migrated versions 'to allow for higher-quality conversion or emulation at a later stage' (Clausen, 2004, pp.23–24).

The use of stable, open file formats has the same advantages as noted in the previous section. The file formats selected will adhere to the characteristics, noted above, of openness, portability, and quality. In particular, the strategy has the potential to use the resources available for digital preservation in the most efficient way. This will ensure that resource requirements, such as specific software and expertise are minimized, and that the need for customized attention during migration processes is lessened. It is most suitable for materials for which content retention is essential but formatting and other characteristics are less significant. While this strategy 'reduces the range of problems needing to be managed' (UNESCO, 2003, p.132), it has the major disadvantage of not accommodating 'new varieties of digital expression' (Hedstrom, 1998, p.195).

Developing archival file formats

The fourth response to the issues posed by the proliferation and complexity of file formats is the development of file formats with characteristics that will ensure their sustainability. One of these is PDF/A.

Although PDF (Portable Document Format) is a proprietary file format, it has been developed as a format suitable for archival use. PDF, which reproduces the visual appearance of the digital material, is in widespread use. Because it allows the physical appearance as well as the content of digital materials to be reproduced, it is considered to be especially well suited for situations where authenticity is required. However, PDF is not an archival format. Although it is a proprietary format, Adobe (its owners) have published its specifications, but are under no obligation to continue to do so. Some features of PDF, such as allowing parts of the document (such as fonts) to be defined outside the format, are incompatible with long-term sustainability or authenticity. In order to ensure the sustainability of PDF over long periods of time, an International

Joint Working Group was established under the auspices of the International Organization for Standardization to prepare an archival version of the PDF format. A draft standard for PDF/A, ISO 19005–1 *Document Management: Electronic Document File Format for Long-Term Preservation – Part I: Use of PDF 1.4* (PDF/A-1), was circulated for comment late in 2003. The PDF/A standard aims to define a format that will ensure that PDF documents can be rendered consistently and predictably in the future. As an ISO Standard, PDF/A is more likely to be supported by publicly funded archival institutions than the proprietary PDF format. It is anticipated that the PDF/A standard will be finalized in 2005 (Sullivan, 2004). Differences between PDF and the draft PDF/A specifications include audio and video content being forbidden in PDF/A, Javascript and executable file launches are forbidden, requiring all fonts to be embedded in PDF/A, the definition of colours in a device-independent way, and the forbidding of encryption (LeFurgy, 2003).

The idea of a platform-independent format that would address the issues posed by the wide range and rapid obsolescence of file formats for digital media, especially video formats, was promoted in the mid to late 1990s by US radio station WGBH. A Universal Preservation Format especially suitable for media file types (particularly video) was advocated. This wraps the content in 'self-describing' metadata that includes the technical specifications required to build software to view the content. However, there has been little recent activity. More information is available on the Universal Preservation Format web site (info.wgbh.org/upf/index.html).

XML

XML (eXtensible Markup Language) is being actively investigated as an archival data format. XML is non-proprietary, being based on ISO8879–1986 (a standard for SGML, the Standard Generalized Markup Language), and is considered to promise long-term sustainability. XML is not, strictly speaking, a file format; rather, it is a set of rules to describe data and documents, a mark-up language in the same sense that HTML, in common use for web-based documents, is. XML was specifically designed to be used regardless of the hardware platform and is supported by many open software applications.

One principal reason for XML's favourable consideration as an archival format is its stability and longevity. It has been used since the 1980s and there is a considerable amount of knowledge about it in the IT industry. The National Archives of Australia has adopted XML because 'even if the IT industry replaces XML with another data format in the future, we will still be able to create our own XML tools for as long as we wish because all the information needed to construct XML tools is publicly available' (Heslop, Davis and Wilson, 2002, p.18). The National Archives of Australia is converting digital records in proprietary data formats into equivalent formats in XML. It has defined a number of XML schema for common formats (for instance JPEG and PNG) and these are available on its web site. It has developed open source tools that convert digital materials in some proprietary formats into XML.

The process of using XML for digital preservation usually starts with 'analysing and tagging data so that the functions, relationships and structure of specific elements can be described', a process known as normalization (UNESCO, 2003, p.129). The UNESCO *Guidelines* provide three examples: a large-scale

project to apply XML tags to e-mails at the San Diego Supercomputer Center, XML tagging of e-mails and other common record formats by the National Archives of Australia, and XML representation of database tables by the VERS project at the Public Record Office Victoria of Australia (UNESCO, 2003, p.129).

Another example is the use of XML as the basis of the DiVA (Digitala Vetenskapliga Arkivet) publishing system developed and used by a number of Scandinavian universities to establish and maintain electronic documents. In DiVA all metadata and contents of documents are converted to an XML-based format, which is an essential part of this system's long-term preservation strategy. Templates to convert documents created in word processors such as Word and Open Office to this format are provided (Müller, 2004). XML was recommended as the basis of an archive to store content originating as publisher SGML or XML files; the reasons included that there is a wide range of tools available for XML (Inera Inc., 2001). XML was investigated in the Dutch Digital Preservation Testbed study From Digital Volatility to Digital Permanence: Preserving Email (Digital Preservation Testbed, 2003) where, in a comparison with migration and emulation, it was found to be the most suitable preservation strategy for e-mails.

One of the issues currently perceived with the XML approach is that it is based on close definition of elements of the data structures: the 'essence' (see Chapter 5) has to be defined in advance. While this works well for simple data structures such as e-mails, it is not easy to see how all of the characteristics and behaviours of more complex kinds of materials can be captured and sustained. It is, therefore, likely to be applied primarily to 'structured or semi-structured data or documents for which retention of content, semantics and relationships is more important than any particular display characteristics' (UNESCO, 2003, p.130). In other words, XML allows content to be reproduced, but is less accurate in representing the original formatting and layout of the document: it 'is not a one-size-fits-all solution' (Aschenbrenner, 2004). However, as such documents constitute a very high proportion of the kinds of digital materials in some contexts, such as recordkeeping environments, this approach is likely to be fruitful.

XML is at the heart of the persistent archives approach, as described by Thibodeau (2002). This approach is based on describing the essential characteristics of objects in a way that is independent of any specific hardware or software. Thibodeau describes it thus:

> In effect, tags delimit atomic preservation units in physical storage ... Every tag is linked to one or more higher-level constructs, such as data models, data element definitions, document type definitions, and style sheets ... research has shown that XML is currently the best method for tagging and articulating requirements at the information level and, to some extent, at the knowledge level (Thibodeau, 2002).

The persistent archives approach is still experimental.

Migration

We first need to establish what *migration* refers to in the context of digital preservation. Is it format migration, software migration, or version migration? In its simplest definition migration is:

to copy data, or convert data, from one technology to another, whether hardware or software, preserving the essential characteristics of the data (Kenney *et al.*, 2003).

A longer definition that is commonly encountered (for example in its use by Howell (2001, p.14) and Kenney *et al.*, (2003)) is that migration is

> a set of organized tasks designed to achieve the periodic transfer of digital materials from one hardware/software configuration to another, or from one generation of computer technology to a subsequent generation.

The first use of this definition appears to have been by the Task Force on Archiving of Digital Information (1996).

The term migration is sometimes used in the same sense as refreshing (defined earlier as 'the copying of data onto new media'), but it is considerably more than that. Unlike refreshing, which is carried out because of concerns about obsolescence of the physical carrier, migration is additionally concerned with obsolescence of data formats and attempts to ensure that file formats remain readable. It is included in this chapter, rather than in Chapter 7, because it is based on ensuring that the digital materials remain accessible in the current technology, and are modified as and when this technology changes. Kenney *et al.* (2003) tell us more:

> The purpose of migration is to preserve the integrity of digital objects and to retain the ability for clients to retrieve, display, and otherwise use them in the face of constantly changing technology ... Migration includes refreshing as a means of digital preservation but differs from it in the sense that it is not always possible to make an exact digital copy or replica of a data base or other information object as hardware and software change and still maintain the compatibility of the object with the new generation of technology. Migration theoretically goes beyond addressing viability by including the conversion of data to avoid obsolescence not only of the physical storage medium, but of the encoding and format of the data (Kenney *et al.*, 2003, quoting in part from Task Force on Archiving of Digital Information, 1996, pp.ii,5).

Migration has many varieties. Thibodeau, for example, notes simple version migration, format standardization, typed object model conversion, Rosetta Stones translation, and object interchange format (Thibodeau, 2002, p.23). The most commonly used migration process is *simple version migration*: migration 'within the same family of products or data types', for example versions of WordPerfect (.wpd files) or Excel (.xls files). He notes that software vendors provide this kind of migration and there is, therefore, the likelihood that support will be discontinued when such products are withdrawn (Thibodeau, 2002, p.23). Another migration process is *format standardization*, noted elsewhere in this chapter as a prerequisite or favourable pre-condition for successful migration over time (Thibodeau, 2002, p.23).

Wheatley discusses in more detail the different kinds of migration and offers an extended example taken from his work on the Domesday Project (Wheatley, 2001). He notes that migration has to date been concerned mainly with relatively simple digital material and that maintaining access to this material has largely

occurred by applying format migration. What happens, he asks, with complex digital material? The definition in the Task Force on Archiving of Digital Information 1996 report (noted above) indicates 'a set of organised tasks' and Wheatley defines these tasks in terms of the preservation techniques currently available. He identifies these as:

- *Minimum preservation* – preserving a copy of the bit-stream (noted in this chapter as *bit-stream copying* and *refreshing*)
- *Minimum migration* – migration that uses simple manual or automated techniques to improve human viewing; for example, removing all characters except common ASCII characters from a word-processed file, resulting in a text file that is easy to access but no longer has any formatting or structural information
- *Preservation migration*, broken down into
 - *Basic preservation migration* – recording screen shots of the software in use; for example, a snapshot of the screen display on the obsolete platform
 - *Annotated preservation migration* – basic preservation migration, with the addition of textual descriptions describing the original material's function and look and feel
 - *Complex preservation migration* – annotated preservation migration with the addition of descriptive information about the original material; for example, video sequences captured to record key processes such as running the application, scrolling through content
- *Recreation* – recoding the digital material by hand; for example, retyping the text in a current application and adding formatting to match the original
- *Human conversion migration* – migration with elements of the original incorporated into the final migrated material; for example, text and image data from the original is incorporated into the migrated object
- *Automatic conversion migration* – uses software tools to interpret digital material and modify it into a new form; for example, a file from obsolete word-processing software is output as a current Word document. Wheatley notes this as 'a good example of a traditional view of migration'.

Wheatley illustrates each of these tasks with examples from the digital materials which were the test cases in the CAMiLEON Project. He examines the advantages and disadvantages of each and the possible situations where each is best applied. For instance, he suggests that the minimum migration approach has the advantages of simplicity and ease of execution, and although all functionality is lost it provides a 'cheap and reliable way of getting to a substantial amount of the intellectual content'. It has potential for application as a 'useful stop gap measure' as long as the original bit-stream and documentation are also maintained. He concludes:

> Although much recent work has gone a long way to establish the terminology that provides a common language for the discussion of preservation issues, the description of *migration* terms in particular has remained relatively confused. To continue progress in the development of practical preservation strategies we should not be afraid to introduce new and more specific language or to redefine ambiguous terms of old (Wheatley, 2001).

No matter how it is defined, migration has been, with emulation, the principal preservation technique applied to date. It has a long history. Granger notes that it 'has been the only serious candidate thus far for preservation of large scale archives' (Granger, 2000), and there is considerable expertise on the part of data administrators and computer scientists in migration.

The literature of digital preservation includes some substantial studies of migration. One is the report *Preserving the Whole: A Two-Track Approach to Rescuing Social Science Data and Metadata* (Green, Dionne and Dennis, 1999), a detailed case study of preserving data in obsolete column binary format, and its associated documentation. This case study is based on the experience of the data archiving community, in particular that of Yale University Library's management of social science numeric data since 1972. It identified that the best strategy for data in column binary format was to convert it to ASCII, because this format is software independent and also preserved the original content. This approach did, however, require 'a file-by-file migration strategy' that is time-consuming for large numbers of files (Green, Dionne and Dennis, 1999, p.24). One conclusion of this study was that the existence of detailed documentation about the obsolete column binary format meant that there were many options available to migrate this format to others and also to read data in it (Green, Dionne and Dennis, 1999, p.[vi]).

A Dutch study of migration investigated the issues of large-scale migration, in the order of 100 terabytes (Van Diessen and Van Rijnsoever, 2002). This quantity of data poses major resource issues:

> Let's say you want to migrate all this information to an optical storage medium. Current optical storage media have a capacity of around 5 GigaBytes and a write speed of around 4 MegaBytes/second. A quick calculation shows that a complete migration to optical storage would take at least 290 days (100 TeraBytes/4 MegaBytes per second)! (Van Diessen and Van Rijnsoever, 2002, p.v).

This report developed 'medium migration indicators' which, when applied in conjunction with 'changes in the system architecture or load characteristics', can be used to ascertain when migration needs to be carried out. The report also notes the actions required to manage media migration effectively in an electronic deposit system (Van Diessen and Van Rijnsoever, 2002).

The National Library of Australia has long experience of migration. In 1998 it surveyed some of its material stored on disk and reported on the practical aspects of migrating floppy disks to CD-R (Woodyard, 1998). The aim was to migrate Australian publications that existed on floppy disks to CD-R. The data on a sample of disks, chosen to represent variables such as operating system, software, disk size, and age, was transferred to a network drive, downloaded to the hard drive of a PC containing disk writing software, and then written to CD-R. This study identified problems such as lack of the appropriate hardware or software, disk errors picked up by disk scan software, and illegal characters in file names. This trial highlighted the need to take further actions, including copying existing floppy disk publications selected for preservation to CD-R as soon as possible, establishing ongoing copying procedures for floppy disks, developing guidelines for selecting material to be preserved, and continuing trials of other forms of migration. The National Library of Australia has also

investigated digital materials in its manuscript collections. Here some issues assume greater significance – for example, the material is often old by the time it reaches the Library, and there may be a need to maintain authenticity of features such as layout (crucial to the understanding of poetry and some other literary works) (Woodyard, 2001). The Library established a Migration Strategy Group to develop further understanding of the issues and to draw up strategies for migration. One of its activities was a migration of PANDORA files to identify 'dead and depreciated HTML tags in the archive, which may not be recognised by later browsers' (Webb, 2000c) and to see what the issues were in migrating to a later version of HTML. The outcome has suggested that there are likely to be scalability issues if this is carried out on a large scale (for example, 127 dead HTML tags were found). Software used by data recovery companies to determine older file formats and write translation tables has been purchased and used in the Library's migration exercises. The National Library has recognized that these methods of migration are not a guarantee of preservation, but considers that they are necessary steps to increasing the period during which digital information remains accessible.

Migration, as suggested above, is the preferred preservation strategy for most digital archives. It is favoured for the reasons already noted: the long history of its use, and our experience with it, at least for some kinds of materials and formats. There is some optimism that it will become simpler to apply as automated techniques are developed (Jones and Beagrie, 2001, p.102).

However, the list of arguments against migration is long. Rothenberg, whose view is that migration is 'essentially an approach based on wishful thinking' (Rothenberg, 1999a, p.15), trenchantly summarizes these when he characterizes migration as 'labor-intensive, time-consuming, expensive, error-prone, and fraught with the danger of losing or corrupting information' (Rothenberg, 1999a, p.13). Migration needs to occur on a regular basis throughout the life of the materials, each time different in that it requires analysis of data structures, rules to be developed to control the transformation from one data format to another, programs to be written, and quality control procedures (UNESCO, 2003, p.139). Migration, therefore, has significant ongoing costs associated with it. It is unlikely to benefit from increases in computing power, Rothenberg suggests, because it is 'highly dependent on the particular characteristics of individual document formats'. He also considers it unlikely that automated migration techniques will assist; in fact, he encourages us to consider them 'with great suspicion because of their potential for silently corrupting entire corpora of digital documents by performing inadvertently destructive conversions on them' (Rothenberg, 1999a, p.15). Complex materials are not, at present, considered to be migratable because the loss of functionality and compromising of integrity and other attributes of the materials will be outside acceptable ranges (Beagrie, 2001, p.104). Finally, Hedstrom notes that despite our long experience with migration, we have no reliable data about the costs it will incur (Hedstrom, 1998, p.198).

Version migration is worth noting in more detail. The backwards compatibility of software can be used to migrate digital materials: most applications can read older file formats created in earlier versions of that software. Relying on this for migration means depending on software vendors to develop and maintain their products' ability to read earlier formats, and experience shows that this is not often the case (University of Leeds, 2003, p.4). Jones and Beagrie note that, although backwards compatibility is offered by an increasing number of vendors,

'its continued availability is dependent on market forces which are notoriously volatile [and] it may therefore cease to be available with little or no warning' (Jones and Beagrie, 2001, pp.107–108). The UNESCO *Guidelines* distinguish between backwards compatibility and version migration: for the former, 'the presentation may be limited to temporary viewing'; by comparison, version migration 'permanently converts documents into a format that can be presented by the current version of the software' (UNESCO, 2003, p.137). Common examples are word processing software and web browsers, which can usually interpret and display material created in earlier versions of that software or in earlier versions of HTML. The National Archives (UK) has decided that

> In the case of passive systems, we are quite convinced that migration is the only way to go. However, we intend to use migration sparingly; our view is that we should only migrate a system when it becomes absolutely necessary; that is to say when it cannot be run on future generations of software or hardware. To take the example of Microsoft Word, we would only migrate documents written in Word version 1 if it ever became impossible to read them on the latest version of Word (Thomas, 2004).

For migration to be successful certain requirements should be met. These include (based on Jones and Beagrie, 2001, p.104 and UNESCO, 2003, p.139):

- Written policies and guidelines
- Rigorous documentation of the procedures that were followed
- Strict quality control procedures, applied during the development stages and also after migration
- Retention of copies of the original material if some essential elements may be lost in migration
- Testing the migration process before it is fully implemented.

Migration is best applied to less complex digital materials 'where the essential elements to be preserved are reasonably straightforward and do not depend on the look and feel of the material, and do not involve executable files' and to collections of materials that are in uniform formats, such as collections of audio or digital image materials, especially if these formats are not proprietary (UNESCO, 2003, pp.139–140).

Some thought has been given to the functions that migration software should be required to perform. It should

- Read the source file and analyze the differences between it and the target format
- Identify and report the degree of risk if a mismatch occurs
- Accurately convert the source file(s) to target specifications
- Work on single files and large collections
- Provide a record of its conversions (Lawrence *et al.*, 2000, p.13).

The aim of migration is to ensure that when it occurs, usually in response to specific triggers such as software upgrade or installation of new software, there is little or no loss in content or context (Jones and Beagrie, 2001, p.103). While some commentators envisage an increasing role for migration, especially for

migration of simple data objects and for migration on demand (Wheatley, 2001), others suggest a diminished role as we move towards open standards and formats, and towards software with built-in format conversion functions (Dollar, quoted in Wheatley, 2001). Experimentation with migration continues, such as the 'on-access' format migration experiments by LOCKSS in relation to web content (Rosenthal *et al.*, 2005).

Viewers and migration on request

Migration on request – that is, migration that is triggered by a request to access the digital material – has been promoted principally by the CAMiLEON Project. The CAMiLEON Project (noted in more detail in Chapter 7) investigated migration and in the process came up with the concept of migration on request. Migration on request differs from other migration techniques because of the point at which the migration is applied. Migration is usually carried out when certain conditions apply, such as impending obsolescence of a data format or a new software installation, whereas migration on request occurs when a user wishes to access digital material. This material is maintained in its original bit-stream, along with a migration tool (a conversion utility, or viewer) which is able to run on the current computing platform. Viewers are in common use; Microsoft, for example, provides free viewers that allow people to view, but not edit, documents produced in its Office software. This migration tool is maintained, perhaps through emulation techniques, so that it can always run on the current platform (Wheatley, 2001).

This approach, which Clausen calls 'conversion on demand' (Clausen, 2004, p.16), has two main advantages (albeit conjectural because migration on demand is still at proof-of-concept stage) over standard migration approaches. First, it reduces the possibility of cumulative errors (loss of functions or of content) typically introduced during each migration, so that loss of essential properties of the digital material and of the attributes which contribute to its authenticity are minimized. Second, it has the potential to reduce the costs incurred in regular migration. Because the migration is performed on demand when users request material, mass migration, with its significant resource demands, is avoided. Against these advantages must be set some potential risks. One is that it may not be possible to develop viewers or software tools that work for complex materials. Another is that not all elements of the material will be re-presented satisfactorily by the viewers. And, of course, viewers and other software tools needed for migration on demand will themselves need to be migrated (UNESCO, 2003, p.143).

Migration on demand needs further investigation before it can be added to the digital preservation toolbox. If it moves from its experimental status, it is likely to be of most use for digital materials for which there is low demand and for which the cost of regular migration is high.

Encapsulation

The concept of encapsulation has been on the digital preservation agenda for over a decade. Encapsulation is a technique of 'grouping together a digital resource and whatever is necessary to maintain access to it ... [including]

metadata, software viewers, and discrete files forming the digital resource' (Jones and Beagrie, 2001, p.108). In some cases, rather than including the actual software that reads the data in the bundle, metadata that points to the software at another location, or to the software's specifications is included. Encapsulation is widely used: for example data, metadata and software is often 'wrapped' in XML metadata, thus providing the data 'in a way that can be understood by a wide range of technologies' (UNESCO, 2003, p.131). This is the approach that has been taken in the VERS Project. The OAIS reference model's AIPs (Archival Information Packages), described in Chapter 5, are another example of encapsulation.

Encapsulation is a prerequisite for emulation. For emulation, according to Rothenberg, the information that needs to be encapsulated is of three kinds:

- 'the document and its software environment' – file(s) representing the original bit stream of the document, plus file(s) representing the original executable bit stream of the application program, plus file(s) representing the bit streams of the operating system
- 'a specification for an emulator for the document's original computing platform' or a copy of or pointer to an emulator specification developed elsewhere
- 'explanatory material, labeling information, annotations, metadata about the document and its history, and documentation for the software and (emulated) hardware included in the encapsulation' (Rothenberg, 1999a, pp.17–18).

The advantages that Jones and Beagrie perceive encapsulation has to offer as a digital preservation strategy are based on the way it groups together relevant information, as 'all supporting information required for access is maintained as one entity' (Jones and Beagrie, 2001, p.108). Some skepticism is, however, evident in the statement that 'ostensibly, the grouping process lessens the likelihood that any critical component necessary to decode and render a digital object will be lost' (Kenney et al., 2003). In theory, everything that is necessary to access the digital object, along with the digital object itself, is maintained into the future, but this is a risky approach to take because

> the only test of an encapsulated specification is at the point it is used to implement a rendering tool. The risk of missing vital information in the specification seems to invalidate this approach (University of Leeds, 2003, p.39).

Encapsulation by itself is not considered a viable digital preservation technique because it 'does not really address the basic problem of technological change' (UNESCO, 2003, p.131). The software encapsulated will still become obsolete. It is a key part of emulation, and is best considered as a strategy that is either a part of or a prerequisite for other digital preservation approaches. The UNESCO *Guidelines* suggest that encapsulation is best considered as 'a basic good practice for all objects', one that 'may facilitate other strategies' (UNESCO, 2003, p.132).

Digital mass storage systems

Digital preservation activities require reliable techniques for storing large quantities of data. 'Storing digital objects leads, if nothing else, to large byte-counts',

note Linden *et al.*, who point out that individuals now routinely deal with giga-bytes of data for their personal archiving requirements (Linden *et al.*, 2005, p.3). Although digital mass storage systems can be considered as basic to computer system management and, therefore, outside the scope of this book, they are included here because one of the fundamental routines of digital preservation is the archiving of large amounts of data. The digital preservation community has needed to learn about computer systems management as it develops. Concepts and practices such as ensuring security of computer systems, redun-dancy, RAID, total cost of ownership, are all part of the knowledge required to develop and maintain digital mass storage systems that will provide secure, long-term storage of both the digital materials and associated metadata.

A digital mass storage system can be simple or very complex, depending on what is required of it. At its most basic, it is little more than 'a straightforward storage and back up system for a single type of file format, its derivative copies and related metadata', available for purchase off the shelf (International Association of Sound and Audiovisual Archives Technical Committee, 2004, p.49). The feasibility of a relatively inexpensive 'personal' digital mass storage system for small institutions has been noted: these are technically feasible, but 'their practical implementation . . . is obstructed by the high initial investment and annual running costs – mainly in the provision of software' (Schüller, 2000). At its most complex, a digital mass storage system is 'a comprehensive, fully automated system designed to store, manage, maintain, distribute and preserve an array of complex digital heritage objects and their related metadata' (Inter-national Association of Sound and Audiovisual Archives Technical Committee, 2004, p.49). Typically it requires a high financial outlay on hardware, software, and ongoing financial investment in running, upgrading, and maintenance. Although the costs of hardware and storage continue to decrease, the costs of the software needed to run a digital mass storage system, such as database management software and integrity checking software, do not decrease.

Technical specifications for digital mass storage systems are available. The International Association of Sound and Audiovisual Archives' *Guidelines on the Production and Preservation of Digital Audio Objects* (2004, pp.49–50) provide brief descriptions of the specifications of a number of large-scale systems, such as the National Library of Australia's Digital Object Storage System, and systems at the National Library of Norway, Südwestrundfunk (a German public broad-casting corporation), and ScreenSound Australia (now the National Film and Sound Archive), along with more detailed technical discussion. The Digital Preservation Coalition has published a Technology Watch Report on mass archival storage systems, based on experience at the British Library, which includes specifications and notes lessons learned in the process (Linden *et al.*, 2005). Calls for tender and similar documents available on the web are a further source of technical specifications.

As well as the technical requirements, digital mass storage systems require well-defined management processes, including

- allocating 'unambiguous responsibility for managing data storage and protection'
- appropriate technical infrastructure to do the job
- system capabilities such as:
 - sufficient storage capacity

- demonstrated reliability
- ability to manage redundant storage ('as digital media has a small, but significant failure rate, redundant copies of files at every stage are a necessity')
- error checking
- means of storing metadata and of reliably linking metadata (International Association of Sound and Audiovisual Archives Technical Committee, 2004, pp.51–52).

Commercial data archiving services exist. One such is dataVault, whose services provide small businesses with 'a reliable data protection service'. Its secure server is located in a 'state of the art data center facility' which features extensive security features such as fire suppression system, backup power supply, environmental control, surveillance, and 'full systems redundancy [Redundant IBM RAID 5 servers], including redundant network connections from Tier One providers (Global Data Vault Inc., 2005). dataVault provides a web-based facility for backing up data and monitors these backups and advises clients if errors occur But can commercial services such as dataVault be considered as 'trusted digital repositories', in the sense that these are described in Chapter 5? The dataVault web site describes how the files it stores are compressed and restored on the fly. But digital preservationists would do well to be wary of such practices and raise questions about them. What are the implications of this for authenticity, for instance?

Conclusion: combining principles, strategies and practices

How do all of the various principles, strategies and practices noted in this chapter and the two previous chapters fit together? The key lies in their effective combination. There is, as yet, no single recommended combination, but we can identify some that seem likely to rise to the top of what on the surface seems a muddy pond. Collections of digital materials that consist of only a single simple data format, or a very limited range of formats, can conceivably be made sustainable by applying one strategy or technique. Diverse collections require a range of solutions. As well as addressing better the range of attributes that need to be preserved, there are 'potential benefits of redundancy in pursuing more than one strategy: even with good planning, a single strategy may fail leaving the programme with no means of access' (UNESCO, 2003, p.149). Combinations already in use are:

- Standard formats and migration: for example, TIFF is often chosen as a standard file format for collections of images to prepare for migration in the future
- Encapsulation and emulation go together, as noted in the section above
- Standard data formats (PDF), viewers and migration (of data and metadata encoded in XML) are combined in the VERS strategy.

Chapter 9

Digital Preservation Initiatives and Collaborations

Introduction

Preservation is a problem domain that demands collaborative action (Ross, 2004)

How can we begin to describe the wide variety and large number of digital preservation initiatives? What is a useful starting point to reflect on digital preservation activities in a way that will allow us to benefit from the experience of these initiatives?

One approach is to locate and apply existing typologies, but in the rapidly changing landscape of digital preservation these are likely to be outdated by the time they become public. This chapter first considers the theme of collaboration that is strikingly apparent in many digital preservation initiatives. It then notes some ways in which these initiatives have been categorized and describes a number of digital preservation activities in those categories, which are structured first around geographical considerations – international, regional, national or sectoral – and then subdivided into *services* (projects actually attempting digital preservation) and *alliances* (collaborations to develop approaches to digital preservation). Only a selection of initiatives and collaborations is covered here. Their description is intended to illustrate the range and nature of current digital preservation activities, not to provide a comprehensive list.

Collaboration

One characteristic of the digital preservation agenda is that collaboration is firmly embedded in it and has been so from the earliest days of its compilation.

Partnerships have always been important in the digital preservation community. From the very beginning it was apparent that no one

organization – whether library, government or academic – could adequately archive, preserve and continue to provide access to the digital material, even with stringent selection criteria (Hodge and Frangakis, 2004, p.63).

Certainly collaborative activities are more and more evident at all levels, and collaboration is seen increasingly as one of the keys to effective confrontation of what seem at times to be overwhelming threats posed to digital preservation. A report of a recent workshop notes that 'one key theme running throughout the day was the need for active collaboration at every level and across sectoral and geographic boundaries. Speaker after speaker illustrated how this collaboration was essential' (Digital Preservation Coalition, 2004). The topic of Article 11 of the UNESCO *Charter on the Preservation of the Digital Heritage* (UNESCO, 2004) is 'Partnerships and cooperation' and the UNESCO *Guidelines* devote a whole chapter to collaboration (UNESCO, 2003, chapter 11, 'Working Together'). Increasing collaboration at local, national, regional and international levels can be readily observed, and the rest of this chapter describes some examples of collaboration.

The reasons for the prominence of collaborative action in digital preservation are to be found in large part in the scale of the issues and uncertainty surrounding how to address them. Because digital preservation is expensive and resources are scarce, collaborative activities 'can enhance the productive capacity of a limited supply of digital preservation funds, by building shared resources, eliminating redundancies, and exploiting economies of scale' (Lavoie and Dempsey, 2004). The issues are similar across different kinds of organizations (such as libraries and archives) and different sectors (for example, different business sectors) so 'it makes sense to capitalise on the potential benefits of pooling expertise and experience'; there may also be political pressure to collaborate (Jones and Beagrie, 2001, p.38).

Another compelling reason to collaborate is the uncertainty about where the responsibility for preserving digital materials lies. There are many stakeholders (noted in Chapter 2), none of whom can realistically expect to develop workable, scalable solutions on their own. Authors are encouraged to collaborate in archiving their own works in university-based digital repositories, for example. Journal publishers are collaborating with libraries or library-based organizations such as JSTOR and LOCKSS to provide continuing access to their publications. Morris sees promise in 'the way that organisations from different parts of the information chain are beginning to work together to address some of the problems' (Morris, 2002, p.130), but cautions that

> the only way we can hope to find reasonable and scholarship-friendly solutions is to work together. We have to make sure that there is close communication between the plethora of initiatives in different parts of the world, so that none of us wastes time and money re-inventing the wheel . . . And we need to make sure that all the members of the information chain – information creators, information users, and all the intermediaries in between – are involved in the discussions and in creating the solutions (Morris, 2002, p.132).

However, as the UNESCO *Guidelines* put it, 'Collaboration costs' (UNESCO, 2003, p.64). Collaboration has the potential to sidetrack the main outcome by

diverting attention from local objectives. Considerable effort has to be put into ensuring that 'unambiguous agreements able to be accepted by all parties' are reached (Jones and Beagrie, 2001, p.39). Despite these and other concerns, it is acknowledged that the benefits outweigh the disadvantages. The *Guidelines* identify the benefits of collaboration as:

- Access to a wider range of expertise
- Shared development costs
- Access to tools and systems that might otherwise be unavailable
- Shared learning opportunities
- Increased coverage of preserved materials
- Better planning to reduce wasted effort
- Encouragement for other influential stakeholders to take preservation seriously
- Shared influence on agreements with producers
- Shared influence on research and development of standards and practices
- Attraction of resources and other support for well-coordinated programmes at a regional, national or sectoral level (UNESCO, 2003, pp.64–65).

Two studies of collaborative activities have come down strongly in favour of their benefits, both actual and potential. Case studies carried out by ERPANET indicate that, in the broadcasting sector, 'strong sectoral cooperation leads to increased confidence and in turn, increased activity and development of common knowledge and understanding' and suggest that this collaboration will result in the 'development of more robust and financially viable tools and solutions' (Ross, Greenan and McKinney, 2003, p.8). One major finding of Hodge and Frangakis's study of providing permanent access to scientific information in digital form was that developing partnerships is of increasing importance. The stakeholders in this arena have increasingly realized that 'partnerships are the only way to ensure that digital information will be preserved.' As well as providing the possibility of preserving most, if not all, significant scientific digital information, partnerships offer benefits such as 'providing some measure of redundancy, sustainability and sharing of the cost for preservation' (Hodge and Frangakis, 2004, p.3).

An Australian example is the National Library of Australia's strong commitment to international collaboration. In his 2002 survey of digital preservation activities, Beagrie observed that the National Library of Australia 'believes that international collaboration at many levels is essential in digital preservation' (Beagrie, 2003, p.18) and noted the Library's commitment to many international collaborations, including PADI with its international advisory group, a Memorandum of Understanding with the Digital Preservation Coalition, the Safekeeping Initiative with CLIR, the National Library's role in the Conference of Directors of National Libraries, whose action plan includes aspects of digital preservation, and its participation in working groups such as the OCLC/RLG working groups on preservation metadata and on digital archive attributes (Beagrie, 2003, p.19).

Typologies of digital preservation initiatives

Collaboration takes many forms. At one level of categorization the distinction is made between *internal* collaboration (cooperation among sections in a large

organization) and *external* collaboration (cooperation with other organizations) (Jones and Beagrie, 2001, pp.38–39). Beyond this, though, existing typologies are not particularly helpful in suggesting ways to group activities that acknowledge adequately the variety and extent of these increasingly fruitful collaborative activities. One typology takes an evolutionary approach by suggesting that collaboration comes at the end of a chain of activities: first *acknowledging* that digital preservation is of concern at a local level, next *acting* by initiating a project, then *consolidation* by moving from projects to programmes, *institutionalizing* the activities to incorporate the larger environments, and finally *externalizing* the activities by 'embracing inter-institutional collaboration and dependency' (Nancy Y. McGovern, in a presentation at the DPC Forum, London, 23 June 2004). Another typology is based on the nature of the organizations that carry out digital preservation: *'enterprise-based* preservation services' include research libraries, academic disciplines, and publishers; and *'community-based* preservation services' include JSTOR and The Internet Archive (Smith, 2003).

The UNESCO *Guidelines*, which, as noted above, devote a whole chapter to cooperation, suggest four ways in which digital preservation collaborations can be categorized. In the *centralized distributed* model one partner takes the main role and other partners contribute in specifically defined ways. While this model offers some cost sharing, develops expertise among partners, and may offer economies of scale, it does not necessarily encourage ownership by lesser partners. This model is 'probably good for beginning programmes seeking to collaborate with large, advanced programmes'. *More equally distributed* models, with several partners who have similar responsibilities and commitments, may have issues of leadership and consultation may become time-consuming. This model is 'probably suitable where there are a number of players willing to share responsibility but none wanting to lead a programme'. *Very highly distributed collaborations* have a number of participants who largely take responsibility for their own activities. This model 'may be a useful starting point for a preservation programme, raising awareness and allowing some steps to be taken' and does not require high costs to participate. *Standalone* arrangements, curiously, are noted in the UNESCO *Guidelines* as the fourth model of collaborative activities. They allow the development of 'expertise, strategies and systems' before collaborative partners are sought (UNESCO, 2003, p.67). The UNESCO *Guidelines* also provide useful information about how to make collaborations work effectively and how to set them up (UNESCO, 2003, pp.66,68).

The typology applied in this chapter is loosely based around geographical considerations – international, regional, national or sectoral – and subdivided into *services* and *alliances*. These categories, based on geography and the nature of the collaboration, at times require arbitrary distinctions to be made. Although some of these programmes are categorized in this chapter as national, or local, and so on, such is the collaborative nature of digital preservation activities that their lessons are typically made available to a wider audience and are keenly scrutinized. Despite its imperfections this typology is applied because it accommodates most current digital preservation activities. Initiatives and programmes that have been described elsewhere in this book are only referred to briefly in this chapter.

Among other useful lists of digital preservation activities is the *Directory of Digital Preservation Repositories and Services in the UK* (Simpson, 2004b). This lists digital preservation service providers and repositories in the United Kingdom offering digital storage services who are considered to have a commitment to

	Services	Alliances
International	The Internet Archive International Internet Preservation Consortium JSTOR DSpace LOCKSS OceanStore	UNESCO RLG PADI OCLC CAMiLEON
Regional	NEDLIB	ERPANET Digital Record- keeping Initiative
National	Koninklijke Bibliotheek's e-Depot National Archives (UK) Digital Archive Digital Curation Centre AHDS UK Web Archiving Consortium	Digital Preservation Coalition NDIIPP Digital Preservation Testbed
Sectoral	PARADISEC CEDARS	JISC

Figure 9.1 Initiatives and Collaborations Described in this Chapter

long-term digital preservation, this latter criterion excluding some commercial data storage services. The UNESCO *Guidelines* provide another listing focusing on collaborative activities (UNESCO, 2003, pp.68–69). The online *erpaDirectory* provides evaluations of digital preservation projects (www.erpanet.org).

International initiatives and collaborations

International in this chapter is applied to two types of programme. The first type are either those digital preservation initiatives or collaborations that were established from their inception to be available or applicable to participants from any country, or those whose concern is with digital materials from anywhere in the world, without any geographical limitation, such as country or state, or sectoral limitation, such as research libraries. The second type are those initiatives or collaborations that were initially established with a geographical or sectoral limitation, but have since become available to the international community. The international services considered here are The Internet Archive, the International Internet Preservation Consortium, JSTOR, DSpace, LOCKSS, and OceanStore, and the international collaborations noted are those of UNESCO, RLG, PADI, OCLC, and CAMiLEON.

International services

The Internet Archive (www.archive.org)

The Internet Archive, established in 1996 by Brewster Kahle, is a non-profit organization based in San Francisco whose aim is to provide permanent access

to digital materials, primarily those on the web. Its web site (on 4 January 2005) describes its aims as 'working to prevent the Internet – a new medium with major historical significance – and other "born-digital" materials from disappearing into the past' and promoting the ideals of 'open and free access to literature and other writings' which have 'long been considered essential to education and to the maintenance of an open society.' The Internet Archive is funded by donations from individuals and philanthropic organizations (among them the Hewlett Foundation, the Sloan Foundation, the Kahle/Austin Foundation, and the National Science Foundation) and by contract work it undertakes for bodies such as the Library of Congress, the national archives of the US and Britain, and the Bibliothèque nationale de France.

The Internet Archive contained over 400 terabytes at November 2004, the result of web crawls of all publicly accessible material on the web every two months plus, from 1999, targeted web crawls, some commissioned by specific organizations. This has resulted in several collections of web sites:

- The UK Central Government Web Archive: selected UK Government websites from 2003, collected for the National Archives (UK)
- Election 2002 Web Archive: almost 4000 web sites relating to the 2002 US elections, collected for the Library of Congress
- September 11th: archived web sites relating to the events of 11 September 2001 in the US, collected for the Library of Congress
- Election 2000: web sites relating to the US elections held in 2000, commissioned by the Library of Congress
- Web Pioneers: web sites illustrating the early years of the internet.

The Internet Archive is not, as is popularly believed, a complete depiction of the web. It does not capture password-protected sites, dynamically-generated content, and other material. It justifies its inclusive approach of archiving the entire publicly-available web by arguing that the cost of selection is greater and riskier than capturing all. The thorny question of intellectual property rights is addressed by collecting all publicly available material, but responding to requests for privacy and blocking access if a site's owner requests this.

Technically, the Internet Archive is based on a large number of personal computers with IDE hard disks. The data is stored on DLT tapes and hard drives in ARC file format, a format being promoted as a standard for archiving internet material by Alexa Internet, who supplies the Archive with its web crawls. (Specifications for the ARC file format are available at pages.alexa.com/company/arcformat.html.) Copies of the collections are maintained at several sites, currently in Egypt and Holland. The data is migrated as appropriate. To counter data format obsolescence the Archive intends to collect appropriate software and emulators. The Internet Archive has until recently been primarily interested in capturing and storing web sites, but is now turning its attention to providing access. The Wayback Machine, launched in 2001, provides access to archived versions of web pages.

The Internet Archive is active in research and development, for example to develop better web crawlers and better user middleware. It actively seeks collaboration, such as in the International Internet Preservation Consortium (netpreserve.org), formed in 2003 (described below), and in the Open Access Text Archive, a collaboration with libraries from many countries, which is

putting digitized books into open-access archives. In December 2004 over 27 000 books were available, with another 50 000 expected in the first quarter of 2005; the goal is one million books.

The Internet Archive has influenced digital preservation by demonstrating that large quantities of web materials can be archived over time. (This section is based on Lyman and Kahle (1998), Smith (2003) and the Internet Archive's web site (www.archive.org).)

The International Internet Preservation Consortium (netpreserve.org)

The International Internet Preservation Consortium (IIPC) was formed in 2003, initially for three years. Its members are the national libraries of Australia, Canada, Denmark, Finland, Iceland, Italy, Norway, and Sweden, the British Library, the Library of Congress, and the Internet Archive, with overall coordination by the Bibliothèque nationale de France. The goals of the consortium are:

- To enable the collection of a rich body of Internet content from around the world to be preserved in a way that it can be archived, secured and accessed over time
- To foster the development and use of common tools, techniques and standards that enable the creation of international archives
- To encourage and support national libraries everywhere to address Internet archiving and preservation (netpreserve.org).

It has six working groups: Framework, Researchers Requirements, Access Tools, Metrics and Testbed, Deep Web, and Content Management. To date it has provided two reports available on the Consortium's web site: one that presents a taxonomy of the challenges that web crawlers encounter when trying to copy content for web archiving, and another that classifies the conditions encountered on web sites (such as static HTML documents, forms, JavaScript) and describes the issues that arise in harvesting these. The IIPC is developing software tools for web archiving and this has resulted in products such as Heretrix (an archive quality web crawler) and DeepArc (software that extracts database content to XML flat files). The aim is to develop a toolkit of web archiving software that is open source and easy to install. If it achieves this aim, our ability to archive web content will be considerably enhanced. (This section is based on information from the International Internet Preservation Consortium's web site (netpreserve.org) and from comments made during the Archiving Web Resources International Conference, Canberra, 9–11 November 2004.)

JSTOR (www.jstor.org)

JSTOR, a non-profit organization based in the US, was established in 1994, initially to address the problems libraries faced in providing storage space for long runs of scholarly journals. It now has two aims: to develop a trusted archive of important scholarly journals, and to provide access to these journals as widely as possible. Today, users of JSTOR from many countries can search and retrieve high resolution images of journal issues and pages: 2 224 participants in November 2004, of whom 909 were located outside the US in 86 countries. JSTOR's content covers scholarly journals with a focus on the humanities and

social sciences: 457 titles and 16.6 million pages in November 2004 (statistics at 23 November 2004 come from the JSTOR web site).

Each journal title is digitized from its first issue as a 600dpi TIFF image and a text file for searching purposes. JSTOR's preservation strategies focus on stable standard formats, data backup, and redundancy (Heterick, 2002, pp.114–116). JSTOR is extending its activities into born-digital materials as one partner in the Electronic-Archiving Initiative (or E-Archive). This seeks to preserve the publishers' versions (the source files) of e-journals, because these often contain material that is not presented in the online versions, for example high resolution image files. To date planning and discussions with publishers and libraries have occurred, a working prototype archive has been developed, a production-level archive is now in development, and verification and normalization procedures are being developed.

JSTOR's significance for digital preservation lies mainly in its business model, which provides benefits to all of its stakeholders – publishers, libraries, and users. It is subscription-based, and charges an initial one-off fee to all subscribers, which supports the costs incurred in digitizing journals and managing the resulting files. This business model, Smith suggests, 'promises to be sustainable over time' (Smith, 2003, p.21). (This section is based on Heterick (2002), Smith (2003) a presentation by Eileen Gifford Fenton at the DPC Forum, London, 23 June 2004, and the JSTOR web site (www.jstor.org).)

DSpace (www.dspace.org)

DSpace began life as a sectoral initiative, as an institutional repository for the material produced by staff of MIT (Massachusetts Institute of Technology). At an early stage in its development DSpace was made available to other institutions and has been adopted around the world. DSpace is an institutional repository 'designed to enable the capture, distribution and preservation of the intellectual output of MIT' but always 'with a view to its adoption by, and federation with, other institutions' (Greenan, 2003, p.8). Developed jointly by MIT Libraries and Hewlett-Packard, it was trialled within MIT from February 2002 and launched in September 2002. The benefits of using DSpace, according to its publicity, include its making content quickly and widely available, and its indexing capabilities; preservation benefits include

- 'Long–term preservation for a variety of digital formats including text, audio, video, images, datasets, and more
- A long-term stable URL that can be used in a citation to link to items in DSpace' (*DSpace Communications Kit*, 2003).

A significant characteristic of DSpace is that it is an open source system. The source code for DSpace was made available under an Open Source licence in November 2002. These licences are promoted by the OpenArchives Initiative, whose aims are to develop protocols and interoperability standards and tools to promote interoperability among multiple repositories (see www.openarchives.org). Since November 2002 it has been downloaded by several thousand institutions, more than 1500 in 2003 alone (Greenan, 2003, p.8).

DSpace distinguishes between 'bit preservation' and 'functional preservation'. Bit preservation

ensures that a file remains exactly the same over time – not a single bit is changed – while the physical media evolve around it. Functional preservation goes further: the file *does* change over time so that the material continues to be immediately usable in the same way it was originally while the digital formats (and physical media) evolve over time (*DSpace FAQ*, 2003).

DSpace recognizes that faculty will create digital materials in a wide variety of formats to suit their own aims, and that repositories must, therefore, handle these formats. It accepts all forms of digital materials and defines three levels of preservation for file formats – supported, known, or unsupported. Bit-level preservation is carried out for all three levels. Supported file formats (those that are open and 'archival', such as TIFF, SGML, XML, AIFF, and PDF) are functionally preserved using format migration or emulation techniques. Known file formats (popular proprietary formats such as Microsoft Word and Powerpoint, Lotus 1–2-3, and WordPerfect) will rely on the likelihood that third party format migration tools will be developed for them. Unsupported file formats (those about which little is known, such as unique software programs) will not have any functional preservation applied. DSpace developers are working on procedures for uploading processes which will convert unsupported or known formats to supported ones, and is also developing its capability to carry out regular format migrations. DSpace assigns to material submitted 'a unique identifier, stores provenance information, maintains an auditable history and record of changes to the archive [and] provides persistent storage' (Sullivan *et al.*, 2004).

MIT also encourages collaboration among DSpace participants. An early collaboration was the DSpace@Cambridge Project (www.lib.cam.ac.uk/dspace) from 2003. As well as implementing a repository at Cambridge University, this collaboration is intended to act as a UK model. In 2003 the DSpace Federation was established, of which all institutions that have implemented DSpace are members. The intention of the DSpace Federation is to share 'technical innovation, content, and services' and 'to promote interoperability among institutional repositories to support distributed services, virtual communities, virtual collections, and cataloging'. This will happen through activities such as sharing in the development and maintenance of the DSpace source code, and promoting the DSpace service and interoperability of archival repositories.

In Australia, DSpace is implemented at the ANU (Australian National University), Canberra (dspace.anu.edu.au). In 2004 ANU tested DSpace as a platform for its digital repository, and was trialling a Google DSpace search facility. DSpace is also being trialled at the University of Melbourne to ascertain its suitability for maintaining and accessing resources located in the University of Melbourne's Percy Grainger Museum (Sullivan *et al,*. 2004).

DSpace's influence in digital preservation is growing because it provides a framework in which academic libraries and archives can develop strategies and practices in a collaborative international environment. (This section is based on Barton and Walker (2003), Greenan (2003), Smith (2003), Sullivan *et al.* (2004) and the DSpace web site (www.dspace.org).)

LOCKSS (lockss.stanford.edu)

The LOCKSS (Lots Of Copies Keep Stuff Safe) project is noted in detail in Chapter 8. It is based on the well-established preservation principle of

redundancy (keeping multiple copies as a safeguard against loss). LOCKSS is significant in digital preservation terms because it established the feasibility of replication and peer-to-peer polling using standard personal computers.

OceanStore (oceanstore.cs.berkeley.edu)

The peer-to-peer concept demonstrated in LOCKSS is also the basis of OceanStore, whose web site describes it as a

> global persistent data store designed to scale to billions of users. It provides a consistent, highly-available, and durable storage utility atop an infrastructure comprised of untrusted servers.

OceanStore's features include data protection through redundancy and through its cryptographic techniques. Any computer can join the OceanStore infrastructure, and users subscribing only to a single OceanStore service provider can access other OceanStore servers. Data is cached in OceanStore 'promiscuously: any server may create a local replica of any data object'. This offers benefits such as faster access. OceanStore claims that it can offer 'durability which exceeds today's best by orders of magnitude' because digital material is stored on 'hundreds or thousands of servers' and so can be readily reconstructed. 'Only a global-scale disaster', they claim, 'could disable enough machines to destroy the archived object'. Pond, a prototype of OceanStore, is being developed. (This section is based on information available on the OceanStore web site (oceanstore.cs.berkeley.edu).)

International alliances

The examples of digital preservation services noted above are all based on collaboration to a significant extent. Some international collaborations are different in that they are intended primarily to educate, inform, and lobby, rather than to establish services that carry out preservation of digital materials.

UNESCO (www.unesco.org)

UNESCO (the United Nations Educational, Scientific and Cultural Organization) has assumed a prominent role in promoting digital preservation. Its general conference in 2001 adopted a resolution which drew attention to the need to safeguard endangered digital heritage. A discussion paper prepared by ECPA (the European Commission on Preservation and Access) (de Lusenet, 2002) and further consultation, including five regional expert meetings in Canberra, Managua (Nicaragua), Addis Ababa (Ethiopia), Riga (Latvia), and Budapest (Hungary) in 2002 and 2003, resulted in the 2004 *Charter on the Preservation of the Digital Heritage* (UNESCO, 2004). This statement of principles is for advocacy and public policy purposes. Its 12 articles describe the value of digital resources and their vulnerability, note that it is vital that these resources remain accessible, and stress the need for action. They also note the importance of taking a life cycle approach, affirm the need to consult stakeholders and to define criteria for selection, emphasize the importance of appropriate legal and policy frameworks, stress the need for cooperation, and note the responsibility of UNESCO (UNESCO, 2004, pp.14–17).

In conjunction with the *Charter on the Preservation of the Digital Heritage*, UNESCO contracted the National Library of Australia to develop guidelines for digital preservation. These *Guidelines for the Preservation of Digital Heritage* (UNESCO, 2003) were made available via the UNESCO web site in 2003. They were the product of a wide international consultation process with all levels of interest groups, from governments to individual experts. The preface to the *Guidelines* states that their intention is to introduce 'general and technical guidelines for the preservation and continuing accessibility of the ever growing digital heritage of the world' and that they are intended to complement the *Charter on the Preservation of the Digital Heritage*. They are best seen as 'a guide to the questions that programme managers need to find answers to' and do not claim to address 'every technical and practical question that will arise in managing digital preservation programmes', relying rather on establishing and stating principles that can be applied (UNESCO, 2003, pp.7,11). The UNESCO *Guidelines* have already proved valuable to the digital preservation community for their comprehensive approach and statement of principles, as the frequent reference to them throughout this book attests.

RLG (www.rlg.org)

RLG, founded as the Research Libraries Group in 1974, is a not-for-profit alliance of libraries, archives, museums, and historical societies with strong research collections. RLG was established to provide a mechanism for collaborative action on the problems facing research collections. Preservation has always been a major interest of RLG, demonstrated most recently by its significant digital preservation activities, particularly in advocacy and raising awareness and in standards development. RLG's advocacy and awareness-raising activities include publication since 1997 of the electronic journal *RLG DigiNews*. Perhaps its most influential activity in digital preservation has been its participation, with the Commission on Preservation and Access, in the Task Force on Archiving of Digital Information. The report of this Task Force in 1996 (Task Force on Archiving of Digital Information, 1996) laid the foundations for much subsequent work in digital preservation. RLG surveyed the digital preservation needs of its members in 1998 (Hedstrom and Montgomery, 1999).

RLG's role in standards development is similarly significant. It participated in 1998 in the development of the OAIS Reference Model. It has participated in working groups, including:

- RLG-OCLC Working Group on Digital Archive Attributes, whose final report was *Trusted Digital Repositories: Attributes and Responsibilities* (RLG/OCLC Working Group on Digital Archive Attributes, 2002)
- OCLC-RLG Preservation Metadata Working Group, which produced *A Metadata Framework to Support the Preservation of Digital Objects* (OCLC/RLG Working Group on Preservation Metadata, 2002)
- Preservation Metadata: Implementation Strategies (PREMIS) Working Group, another joint RLG-OCLC working group, reported in 2004: *Implementing Preservation Strategies for Digital Materials: Current Practice and Emerging Trends in the Cultural Heritage Community* (OCLC/RLG PREMIS Working Group, 2004).

Other RLG collaborations include a 'fruitful working relationship and strategic partnership' with JISC since 1999 (Dale, 2004, p.20). RLG staff have also been on the advisory groups of many collaborative digital preservation activities, such as CEDARS and CAMiLEON. RLG is a founding member of the DPC and has worked with the National Library of Australia on PADI. (This section is based on Dale (2004) and on the RLG web site (www.rlg.org).)

PADI *(www.nla.gov.au/padi)*

PADI (Preserving Access to Digital Information) describes itself as 'a subject gateway to digital preservation resources' and is considered by many as *the* essential starting point for digital preservation matters. It was established in 1997 by the National Library of Australia to share information about digital preservation and support activities in Australia and worldwide. PADI demonstrates the collaborative aspects that characterize many digital preservation activities: it is developed in cooperation with CLIR (the Council on Library and Information Resources) and the UK-based Digital Preservation Coalition, and has an international advisory group. PADI is described in more detail as Case Study 6 in the Appendix of this book.

OCLC *(www.oclc.org)*

The activities of OCLC in digital preservation sit uneasily with the distinction between services and alliances that is made in this chapter. OCLC has been active in both arenas. Some of its collaborative activities with RLG are referred to above.

OCLC was founded, as the Ohio College Library Center, in 1967, primarily to offer cataloguing services to US libraries. Now renamed Online Computer Library Center, it offers a very wide range of services, including digitization and preservation services, to an international clientele. In addition to the collaborations with RLG already noted, OCLC's digital preservation activities include a Registry of Digital Masters working group (again with RLG), and participation on the board of METS (Metadata Encoding Transmission Standard), which may become an important industry standard for digital archives. It is also a partner in the DLF Format Registry working group, formed in January 2003 by OCLC, the DLF (Digital Library Federation), and international stakeholders such as JISC, NARA, the National Archives (UK) and JSTOR, which is investigating a registry of data formats to support digital preservation.

In addition to these collaborations, OCLC has maintained since 2003 a digital archive. This general purpose OAIS-compliant digital repository accepts materials using OCLC's web-archiving toolset or its batch ingest service. OCLC's digital archive can handle multiple file formats. It links with Connexion (another OCLC service) and offers automatic metadata retrieval with its web harvester service. Its current bit-preservation techniques include circulating backups (onsite and offsite) and media migration, and it is developing processes that will probably combine migration and emulation. (This section is based on Bellinger *et al.* (2004) and OCLC's web site (www.oclc.org).)

CAMiLEON *(www.si.umich.edu/CAMILEON)*

CAMiLEON (Creative Archiving at Michigan and Leeds), described in Chapter 7, is noted here because it is a significant example of an international digital

preservation collaboration, in this case a research collaboration. From 1999 to 2003 the University of Michigan (in the US) and the University of Leeds (in the UK) combined forces to develop and evaluate a range of techniques for long-term preservation of digital materials. CAMiLEON's reports and other publications, available on its web site, remain valuable source material. Rushbridge considers its influence to have been in its high-profile activities, especially the BBC Domesday project (see Chapter 7), and its proof-of-concept of migration on request. CAMiLEON, he suggests, 'has given leadership, attracted public attention, advanced both theory and practice, and highlighted many of the issues involved in digital preservation today' (Rushbridge, 2004a, p.35).

Regional initiatives and collaborations

The term *regional* is applied here to those digital preservation initiatives or collaborations established to apply to, or be available for, participants from a region greater than a single nation, for example, in the European Union. As with some of the international initiatives and collaborations noted above, the initial intention may have been for it to apply to a narrow geographical region or sectoral limitation, but it may have since become more widely available within a region. The regional service considered here is NEDLIB, and the regional alliances noted are ERPANET and the Digital Recordkeeping Initiative.

Regional services

NEDLIB (www.kb.nl/coop/nedlib)

NEDLIB (the Networked European Deposit Library) was a European Commission-funded research project that was launched at the start of 1998 and ended in January 2001. NEDLIB, a collaborative project of national libraries, a national archive, IT organizations and publishers led by the Koninklijke Bibliotheek (National Library of the Netherlands), explored the technical and managerial issues of building a networked European deposit library. NEDLIB's web site hosts the publications and reports resulting from its activities, which include Jeff Rothenberg's report *An Experiment in Using Emulation to Preserve Digital Publications* (Rothenberg, 2000). Its outcomes include a proof-of-concept demonstrator of a deposit system for electronic publications, and guidelines for best practice. Its results have been further developed by the Koninklijke Bibliotheek and IBM-Netherlands in implementing the Koninklijke Bibliotheek's electronic deposit system, e-Depot (described below). The significance of NEDLIB lies in the background work it has done to develop and implement a fully functioning electronic deposit system. (This section is based on Beagrie (2003) and the NEDLIB web site (www.kb.nl/coop/nedlib).)

Regional alliances

ERPANET (www.erpanet.org)

ERPANET (the Electronic Resource Preservation and Access Network) was funded by the European Commission and the Swiss Government from 2001 to 2004 to 'enhance the preservation of cultural and scientific digital objects through

raising awareness, providing access to experience, sharing policies and strategies, and improving services' (ERPANET brochure, 2004). This collaboration is led by HATII (Humanities Advanced Technology and Information Institute) at the University of Glasgow, in partnership with the Schweizerisches Bundesarchiv (Switzerland), ISTBAL at the Università di Urbino (Italy), and the Nationaal Archief van Nederland.

ERPANET has produced a remarkable variety of products and services, aimed at identifying quality sources of information and making their results widely available. They include thematic workshops, training activities, studies of digital preservation activities, assessments of selected publications about digital preservation, an e-repository, 'tools' that provide structured advice to aspects of digital preservation activities, an online discussion forum, and an advisory service. For example (these come from Ross, 2004), it assesses significant literature on digital curation and preservation selected from a broad range of publications, analyses these, and provides a commentary on them. Its thematic workshops and seminars have covered a wide range of topics, for instance OAIS, digital preservation policies, web archiving, metadata, appraisal of scientific data, file formats for preservation, and persistent identifiers. One outcome has been the conclusion that 'the community at large is hungry for practical case studies and reports of real world experiences', so ERPANET has been conducting case studies in a wide range of sectors, including publishing, pharmaceutical, and government; completed case studies are available on the ERPANET web site. These case studies have led to the awareness that most organizations 'are hesitant in their digital preservation activities', often because of a lack of awareness, and are 'waiting for external developments that they can adopt, or off-the-shelf solutions they can implement' (Ross, Greenan and McKinney, 2003, p.8).

At the heart of ERPANET is its collaborative nature. It depends on synergy with many European and international agencies – national libraries, universities, other digital preservation collaborative activities – and with professionals (Ross, 2004). At the end of 2004 strategies for continuing ERPANET's key functions beyond the period of its EU funding were being explored. (This section is based on Ross, Greenan and McKinney (2003), Ross (2004) and the ERPANET web site (www.erpanet.org).)

Digital Recordkeeping Initiative

The Digital Recordkeeping Initiative, launched in May 2004, has as its members the government archives of Australia and New Zealand: National Archives of Australia, Public Record Office Victoria, State Records New South Wales, Archives New Zealand, Queensland State Archives, Archives Office of Tasmania, State Records South Australia, State Records Office of Western Australia, Territory Records Office of the ACT, and Northern Territory Archives Service. It was formed to develop a collaborative regional Australasian approach to the development, articulation and implementation of a common set of strategies for enabling the making, keeping and using of 'born digital' records. Collaborative work will include determining how to support government agencies to create and manage full and accurate digital records, how to ensure that authentic, reliable and usable digital records are preserved, and how to make these records accessible. A press release about the Digital Recordkeeping Initiative is on the National Archives of Australia's web site (www.naa.gov.au/publications/media_releases/digital.html).

National initiatives and collaborations

The term *national* refers here to a single country. While the intention may have been to develop a service or alliance within only one country, the availability (as with some of the international and regional initiatives and collaborations noted above) may have since expanded. The national services considered here are the Koninklijke Bibliotheek's e-Depot, the UK National Archives Digital Archive, the Digital Curation Centre, the AHDS, and the UK Web Archiving Consortium. National alliances noted are the Digital Preservation Coalition, the NDIIPP, and the Digital Preservation Testbed.

National services

KB's e-Depot (www.kb.nl/dnp/e-depot/e-depot.html)

The Koninklijke Bibliotheek is responsible for the Dutch legal deposit library, encompassing electronic publications. The Bibliotheek, in partnership with IBM, has developed and implemented a digital archiving system for electronic publications by Dutch publishers. Implemented in December 2002, the e-Depot was fully operational by March 2003. Publishers such as Elsevier Science and Kluwer Academic are participants. By April 2004 more than two million electronic publications had been included in the e-Depot, and it was estimated that by the end of 2004 about 5 terabytes would be held, consisting of 3 terabytes of online journal publications and 2 terabytes of other electronic publications.

The e-Depot is based on IBM's Digital Information and Archiving System (DIAS), which is based on the OAIS Reference Model (ISO 14721:2002) and is constructed as much as possible from off-the-shelf components. The e-Depot is designed to meet 'large-scale and high-quality storage requirements and [to support] digital preservation functionality' (*The KB e-Depot*, 2004). The Library has developed workflows for processes such as accepting materials, generating identifier numbers, searching and retrieving publications, and for authentication. The e-Depot handles two kinds of digital content: offline media such as CD-ROMs, and online media such as electronic articles. Offline media are handled by copying files and the software needed to execute the files to a Reference Workstation. A snapshot of the entire workstation, including its operating system, is then generated into an image which is loaded into the e-Depot. The result is accessed by retrieving the image from the e-Depot and installing it onto a Reference Workstation. Online media are submitted accompanied by publishers' metadata, and after checking and validating the content and metadata are linked and the resulting package is then processed. The process is fully automatic.

The e-Depot's preservation subsystem uses metadata to manage long-term access to the digital materials. Information about file formats and software required to view a stored document is stored. The system indicates when obsolescence is expected so that action can be taken to convert or migrate materials. Currently all e-publishing formats are accepted, although preferred formats may be specified in the future.

The Koninklijke Bibliotheek has been active in digital preservation research. One of the projects in which it collaborated was NEDLIB, described above. Other projects include collaboration with IBM, as on the Universal Virtual Computer

(see Chapter 7). The Bibliotheek participates in international working groups such as PREMIS (noted above) and the Digital Repository Certification Task Force, and is active in other digital preservation collaborations. Some of these activities have been adopted elsewhere; for example, Deutsche Bibliothek's KOPAL (Kooperativer Aufbau eines Langzeitarchivs Digitaler Informationen), a long-term archive for digital materials, is based on DIAS. (This section is based on Steenbakkers (2002, 2004a, 2004b), the brochure *The KB e-Depot* (2004) and the e-Depot web site (www.kb.nl/dnp/e-depot/e-depot.html).)

National Archives (UK) Digital Archive
(www.nationalarchives.gov.uk/preservation/digitalarchive)

The National Archives (UK) launched its Digital Archive in April 2003 to store, preserve and provide access to government electronic records. It complies with the UK Government's e-government interoperability requirements and uses open source software, including XML and Java, whenever possible. The tape-based system is designed to handle a wide range of electronic records: documents, e-mails, audio and video files, databases, and web sites. Java-based accession software ensures the creation of metadata and its linking to the appropriate files, carries out quality checks, identifies file formats, scans for viruses, and so on. Further technical details are provided on the National Archives' web site.

The significance of the Digital Archive has already been acknowledged in winning the 2004 Pilgrim Trust Preservation Award for its innovation in the preservation of digital material. Rushbridge considers that the Digital Archive

> is likely to have a positive impact among other British institutions. The success of a large-scale, high-profile archive such as this is likely to encourage others to begin their own archiving projects and it may be that such organisations will base their ideas upon those implemented here. This is not without merit: as this essential work needed to be performed for legal reasons the techniques implemented quite rightly prioritise security over innovation (Rushbridge, 2004a, p.34).

(This section is based on Brown (2003), Rushbridge (2004a) and the National Archives' web site (www.nationalarchives.gov.uk/preservation/digitalarchive).)

Digital Curation Centre (www.dcc.ac.uk/)

Funding of £1.3 million a year for three years was announced in February 2004 to establish a Digital Curation Centre in the UK. The funding, provided by JISC and the eScience Core Programme of the UK Government, is to establish a consortium led by the University of Edinburgh in partnership with HATII (at the University of Glasgow), UKOLN (formerly the UK Office for Library Networking), and the Council for the Central Laboratory of the Research Councils.

Digital curation is a new phrase coined to encompass data archiving, digital preservation, and the active management and appraisal of data over all of its life cycle. The Digital Curation Centre will, according to press releases (5 February and 7 April 2004), 'provide a national focus for research into curation

issues and ... promote expertise and good practice, both national and inter-
national, for the management of all research outputs in digital format'. The
'overriding purpose' of the Digital Curation Centre is 'continuing improvement
in the quality of data curation and digital preservation'. It is important to note
that the Digital Curation Centre will not act as a data repository. Specifically,
it will lead a research programme addressing digital curation issues, create a
network to bring together and support curators, and provide services such as
evaluation of tools.

A report was commissioned by JISC to establish the current state of, and
future requirements for, the curation of research data in the UK (Lord and
Macdonald, 2003). The report was in part prompted by the increasing use of
large and dynamic datasets in scientific research. Its findings feed into the Digital
Curation Centre and endorse the need for it, and suggest an agenda for research
for the Digital Curation Centre. Funding was provided for three years, begin-
ning in April 2004, and the Digital Curation Centre was officially launched in
November 2004.

The activities of the Digital Curation Centre will be watched with consider-
able interest throughout the world. It has the potential to significantly advance
understanding of digital preservation practice by indicating viable large-scale
solutions. (This section is based on Lord and Macdonald (2003), Ross *et al.* (2004)
and the Digital Curation Centre's web site (www.dcc.ac.uk).)

AHDS (ahds.ac.uk)

The Arts and Humanities Data Service (AHDS) is a federation of five data
archive services: AHDS Archaeology, AHDS History, AHDS Literature,
Language and Linguistics, AHDS Performing, and AHDS Visual Arts. The five
AHDS centres 'collect, preserve, catalogue, and distribute digital resources
which are relevant to their subject areas, facilitate good practice in their creation
and use, and offer some user services' (ahds.ac.uk/about/index.htm). The
AHDS was established in 1996 as an outcome of a JISC feasibility study which
recommended and funded a centrally managed distributed service. Its aims
were to 'preserve the rapidly growing unpublished primary digital research
materials being generated within the higher education arts and humanities
community and beyond' (Beagrie, 2001, p.222). It was based on the already
existing Oxford Text Archive (established in 1976 at the University of Oxford)
and the History Data Service (established in 1993 at the University of Essex),
plus three newly-established data archives: the Archaeology Data Service (at the
University of York), the Performing Arts Data Service (at the University of
Glasgow), and the Visual Arts Data Service (at the Surrey Institute of Art and
Design).

The holdings of the AHDS include electronic texts, databases, still images,
audio, GIS data, geophysics data, and metadata sets. At September 2004 it held
approximately one terabyte of data, projected to rise to four terabytes by the
end of 2004. A new data repository was planning for a capacity of 10 terabytes.
The AHDS sets and guides the overall policy for the management of each of its
component services, provides outreach services, sets standards, and encourages
best practice. One example is its web-based guides to best practice, such as
Digitising History: A Guide to Creating Digital Resources from Historical Documents
(Townsend, Chappell and Struijvé, 1999).

The AHDS is significant for digital preservation as an early example of collaboration in data archiving, that is, a centrally managed distributed model. (This section is based on Beagrie (2001) and information from the AHDS web site (ahds.ac.uk)).

UK Web Archiving Consortium (www.webarchive.org.uk)

The UK Web Archiving Consortium was launched in June 2004 as one of the key outcomes of a web archiving feasibility study commissioned in 2002 by JISC and the Wellcome Library. A coalition of the British Library as the lead partner, JISC, the National Archives (UK), the Wellcome Trust, and the national libraries of Scotland and Wales, the Web Archiving Consortium has the goal of investigating archiving solutions for UK web materials. Each institution will focus on a particular subject area, for instance the Wellcome Library on medical sites. The National Library of Australia's PANDAS software, further developed to match UK requirements, and software based on the open source web crawler HTTrack will be used. The project is planned to run for two years and has an initial target of 6000 sites. (This section is based on information from the Web Archiving Consortium's web site (www.webarchive.org.uk)).

National alliances

Digital Preservation Coalition (www.dpconline.org)

The idea of a national digital preservation alliance was developed in 1999 at a workshop on digital preservation held at the University of Warwick, which recommended the establishment of a coalition to promote digital preservation activities in the UK. To further the development of a coalition, JISC established a Digital Preservation Focus in 2000 (Beagrie, 2001). The Digital Preservation Coalition (DPC) was established in 2001 with seven founding members. Membership is open to all collectives and non-profit organizations from all sectors in the UK. It had 26 members at January 2004, plus JISC. Its Board of Directors represent the British Library, HEFCE (the Higher Education Funding Council for England), CURL (the Consortium of University Research Libraries), the e-Science Core Programme, National Archives of Scotland, National Archives (UK), OCLC, Public Record Office Northern Ireland, Resource (the Council for Museums, Archives and Libraries), and the University of London Computer Centre (DPC *Annual Report, 2002–03*, p.1).

The DPC's aim is 'to secure the preservation of digital resources in the UK and to work with others internationally to secure our global digital memory and knowledge base.' To do this it carries out a wide range of activities:

- 'producing, providing and disseminating information on current research and practice and building expertise among its members'
- getting digital preservation 'on the agenda of key stakeholders'
- securing funding
- 'providing a common forum for the development and co-ordination of digital preservation strategies in the UK'
- promoting standards, services, and technology
- 'forging strategic alliances with relevant agencies nationally and internationally'

- 'working collaboratively together and with industry and research organisations, to address shared challenges in digital preservation' (DPC *Annual Report*, 2003–04, p.1).

Its activities in 2002–2004 included an advocacy campaign (for example, publishing articles and issuing news items), representation and advocacy (such as making presentations at conferences), dissemination and current awareness (through its web site, collaboration with the National Library of Australia to produce the e-newsletter *What's New in Digital Preservation*, and e-mail discussion lists), forums and training workshops, a survey of industry vendors, work on a National Needs Survey on Digital Preservation, its Technology Watch, and surveying DPC members as part of a UK-wide needs assessment exercise (DPC *Annual Report*, 2002–03, 2003–04). The DPC co-sponsors a Digital Preservation Award as part of the Pilgrim Trust Conservation Awards. The inaugural award, in 2004, went to National Archives (UK) for their Digital Archive; other shortlisted projects were the CAMiLEON Project, the JISC Continuing Access and Digital Preservation Strategy, the National Library of New Zealand's Preservation Metadata Extraction Tool, and the Wellcome Library/JISC Web Archiving Project. The DPC's collaborative activities are not limited to the UK: for example, it has signed Memoranda of Understanding with the National Library of Australia and the Library of Congress's NDIIPP (Jones, 2004).

The significance of the DPC for digital preservation lies in its active encouragement of digital preservation through its lobbying and promotional activities. It is being emulated in other countries; for example, the German Network of Expertise in Long-Term Storage of Digital Resources (NESTOR), led by Deutsche Bibliothek, states that its long-term goal is to develop 'a permanent distributed infrastructure for long-term preservation and long-term accessibility of digital resources in Germany comparable to e.g. The Digital Preservation Coalition in the UK' (www.langzeitarchivierung.de). (This section is based on Beagrie (2001), the DPC *Annual Reports* for 2002–03 and 2003–04, Jones (2004), Simpson (2004b) and information from the Digital Preservation Coalition's web site (www.dpconline.org)).

NDIIPP *(www.digitalpreservation.gov)*

The US-based National Digital Information Infrastructure and Preservation Program (NDIIPP) is led by the Library of Congress. Federal legislation established this programme in December 2000 with US$100 million in funding, US$25 million being made available to the programme and a further US$75 million to be made available if it matched the amount from non-federal government sources. NDIIPP's goals are to develop a national digital collection and preservation strategy, to work with other stakeholders to establish partnerships and form networks, to help identify and preserve at-risk digital content, and to support the development of tools, models, and methods for digital preservation.

Collaboration lies at the heart of the NDIIPP, and is in fact mandated by the legislation that created it, with collaboration expected between the Library of Congress, National Archives and Records Administration, National Library of Medicine, National Agricultural Library, National Institute of Standards and Technology, and other federal agencies as well as non-federal organizations and institutions. Since its establishment the NDIIPP has sought participation from a wide range of organizations (Hodge and Frangakis, 2004, p.62).

Principal activities of the NDIIPP to date have included convening stakeholder meetings in 2001, commissioning environmental scans, and presenting a plan to Congress in 2003. The NDIIPP commissioned a report on international digital preservation activities for its own information, the initiatives surveyed being selected for their relevance and interest to NDIIPP (Beagrie, 2003). In mid-2004 Version 2.0 of the Technical Architecture for NDIIPP was released for review and comment, and NDIIPP entered into a partnership with the National Science Foundation to fund research programmes in digital preservation. In June 2004 the Library of Congress announced that it would collaborate with Old Dominion, Johns Hopkins, Stanford and Harvard Universities in an Archive Ingest and Handling Test that would investigate strategies for the ingest and preservation of digital archives. Each partner would work with the same collection of digital materials, 12 gigabytes of materials with a wide range of file formats relating to the events of 11 September 2001 made available by George Mason University. The outcomes of this research will include better identification of possible architectures, better costing data, and clearer identification, documentation and dissemination of working methods for preserving digital materials.

In September 2004 the NDIIPP awarded US$15 million to eight US consortia for three-year projects to identify, collect and preserve digital materials within a nationwide digital preservation infrastructure. To illustrate the extent of these projects, one of these consortia is led by the California Digital Library (University of California) with New York University Libraries, University of North Texas Libraries, and the Texas Center for Digital Knowledge as partners, and the San Diego Supercomputer Center, Stanford University Computer Science Department, and Sun Microsystems as collaborators. It will develop web archiving tools to capture and preserve web-based collections of government and political information. Another programme is aimed at establishing procedures, structures and national standards for preserving public television programmes produced in digital formats, and a third will develop criteria for determining which digital materials to capture and preserve. The NDIIPP is in 2005 exploring collaborative arrangements with US state and territory governments to develop strategies for preserving information produced by state and local government jurisdictions in digital form.

After five years, the NDIIPP considers its achievements to include developing a network of 50 to 75 partners, establishing a large archive of at-risk content, and making recommendations to the US Congress about the long-term governance of a national digital preservation programme. The NDIIPP is being keenly observed by digital preservation interest groups throughout the world. With such large resources at its command it stands a good chance of providing tools that will revolutionize how digital preservation is carried out. (This section is based principally on information from the NDIIPP's web site (www. digitalpreservation.gov).)

Digital Preservation Testbed (*www.digitaleduurzaamheid.nl/home.cfm*)

The Digital Preservation Testbed (Testbed Digitale Bewaring) was established by the Dutch Government as a three-year project to run from October 2000 to September 2003. It was part of a wider initiative, the Digitale Duurzaamheid Project, which established a Taskforce Digitale Duurzaamheid (Digital Longevity Taskforce) to coordinate and share the expertise of government organizations in

the Netherlands about digital information management. The Digital Preservation Testbed project was launched as part of this initiative. Based at the Nationaal Archief of the Netherlands, it carried out research into the digital preservation techniques of migration, emulation, and XML, applying them to a range of digital materials such as text documents, spreadsheets, e-mail messages, and databases. Each technique was assessed for its technical effectiveness as a long-term preservation method, as well as for cost factors and other aspects. Reports of the project are available on the web. (This section is based on Beagrie (2003, p.28) and information available on the web site of the Nationaal Archief of the Netherlands (www.digitaleduurzaamheid.nl/home.cfm)).

Sectoral initiatives and collaborations

The term *sectoral* refers to a sector such as a discipline, interest group, or industry. Examples of sectors included in the examples below include the higher and further education sector in the UK, and a discipline-based service aimed at linguists and ethnomusicologists. Case studies of other sectors in Europe are available in the ERPANET case studies, for example the pharmaceutical, publishing and government sectors. (For more information see the section on ERPANET above, the ERPANET web site, and Ross, Greenan and McKinney (2003)). The sectoral services considered here are PARADISEC and CEDARS, and the sectoral alliance noted is JISC.

Sectoral services

PARADISEC (paradisec.org.au)

PARADISEC (Pacific and Regional Archive for Digital Sources in Endangered Cultures) recognizes Australia's location in a region of linguistic and cultural diversity, and addresses concern about the likely loss of languages spoken in the Pacific region (broadly defined to include Oceania and East and Southeast Asia) from 2000 to only a few hundred in the next hundred years. It is creating an archive of sound recordings of languages of the Pacific Islands, most of which are endangered and sparsely documented. PARADISEC's focus is on preservation of the content of field tapes from the 1950s and 1960s, most of which are on magnetic tape that is now deteriorating. It therefore provides a facility for accessioning, cataloguing, digitizing and preserving this material.

PARADISEC, which received grant funding in 2001, is a collaboration of the Australian National University and the Universities of Sydney, Melbourne, and New England. It is managed from the University of Melbourne, and its facilities are at the University of Sydney. It digitizes the audio data at 24-bit, 96kHz in BWF (Broadcast Wave Form) using a Quadriga system and AudioCube workstation, and adds metadata that conforms to Dublin Core and OLAC (Open Languages Archives Community) standards. Backup copies are stored in Canberra. Other activities include hosting workshops, and providing services on a cost recovery basis.

PARADISEC is an example of the value of collaboration to achieve large-scale digital preservation outcomes. (This section is based on Pawley (2003), a PARADISEC information brochure of August 2004, and the PARADISEC web site (paradisec.org.au)).

CEDARS (www.leeds.ac.uk/cedars)

CEDARS (CURL Examplars in Digital Archives) was a collaborative research project funded by JISC that ran from 1998 to 2002 and hosted at the Universities of Leeds, Oxford and Cambridge. It is included here because it was 'an important test-bed for digital preservation within research libraries in the higher education sector' (Beagrie, 2001, p.219). Its aim was to provide guidance to others in the sector about best practice for digital preservation. Among its outcomes are a preservation metadata schema and an archiving demonstrator project based on OAIS. Reports generated by the project are available from its web site. Some of the activities of CEDARS are noted in Chapter 5. The significance of CEDARS for digital preservation lies in its reports (available on the CEDARS web site) and its development of a prototype distributed archiving system. (This section is based on Beagrie (2001) and the CEDARS site (www.leeds.ac.uk/cedars)).

Sectoral alliances

JISC (www.jisc.ac.uk)

JISC (the UK Joint Information Systems Committee) represents over 700 institutions in the UK higher and further education sector. Its mission is to promote the use of ICT in that sector. It has energetically pursued digital preservation activities through collaborations such as the AHDS, CEDARS, and CAMiLEON (all of which are referred to elsewhere in this chapter).

Beagrie's description of JISC's Continuing Access and Digital Preservation Strategy (one of the finalists in the Pilgrim Trust's inaugural Digital Preservation Award), notes that JISC has three major objectives in its digital preservation activities:

- 'establish best practice and guidelines for digital preservation and to disseminate them' – here a major outcome has been the publication of *Preservation Management of Digital Materials: A Handbook* (Jones and Beagrie, 2001)
- 'generate support and collaborative funding from, and promote interworking with, agencies worldwide' – the DPC is the principal outcome of this objective
- 'develop a long-term digital preservation strategy for digital materials of relevance to Higher and Further Education in the UK' – the major outcome is JISC's Continuing Access and Digital Preservation Strategy and implementation plan (Beagrie, 2004).

JISC's Continuing Access and Digital Preservation Strategy is wide-ranging. It includes the provision of a wide range of resources on its web site, for example internet resources, e-journals, e-prints, feasibility studies and risk assessments that recommend actions for specific categories of digital material of interest to JISC members. It lobbied successfully for a Digital Curation Centre (described above). Beagrie notes other JISC achievements in progressing digital preservation in the UK:

- Advocacy and funding, for example over £6 million in funding has been secured over the next three years, representing a substantial increase over previous funding
- Infrastructure, most notably the Digital Curation Centre

- Supporting a 'life-cycle' approach to the management of digital resources
- Scoping studies: an example is the 2003 *Feasibility and Requirements Study on Preservation of E-Prints: Report Commissioned by the Joint Information Systems Committee (JISC)* (James *et al.*, 2003).
- Partnerships, for example with DPC, and the UK Web Archiving Consortium (Beagrie, 2004).

JISC is significant because it has been an important catalyst for digital preservation in the UK, not only in the higher and further education sector, but also more widely in the UK and internationally. (This section is based on Beagrie (2004) and on the JISC web site (www.jisc.ac.uk).)

Conclusion

The intention in describing this selection of digital preservation programmes and initiatives is to illustrate the range and nature of current digital preservation activities, and to emphasize their increasingly collaborative nature. They may, perhaps, prompt the reader to reflect on digital preservation activities, and in doing so, to derive some value from them. Many other activities could have been included, such as those listed in the UNESCO *Guidelines* (UNESCO, 2003, pp.68–69):

- The Austrian On-Line Archive (AOLA), an archive of snapshots of Austrian web space (www.ifs.tuwien.ac.at/~aola/)
- The Academic Research in the Netherlands Online (ARNO) which links the document servers of three Dutch universities to keep their digital academic output accessible (www.uba.uva.nl/en/projects/arno/)
- The Australian Digital Theses Project, a distributed database of digital versions of theses produced by postgraduate research students at the participating institutions (adt.caul.edu.au/)
- The Digital Image Archive of Medieval Music (DIAMM), a collaboration between the University of Oxford, the University of London and AHDS, a permanent electronic archive of European medieval polyphonic music (www.diamm.ac.uk/)
- the European Visual Archive (EVA), providing easy and preserved access to the integrated collections and information held in European archives (www.eva-eu.org/).

A useful starting point to locate other digital preservation services and initiatives is the *erpaDirectory*, available online from the ERPANET web site (www.erpanet.org). Descriptions of other digital preservation services and initiatives are found in the case studies in the Appendix of this book, which include descriptions of activities at the National Library of Australia (PANDORA and PADI), VERS at the Public Record Office Victoria, the National Archives of Australia, and the Department of Family and Community Services.

The reader should be aware that these descriptions are of activities up to the end of 2004. Given the rapid rate of progress in the field of digital preservation, frequent reference to the web sites of these programmes and initiatives, and to sources such as the PADI portal, is recommended to update knowledge of each of them.

Chapter 10

Challenges for the Future of Digital Preservation

Introduction

The lack of awareness of digital preservation issues by stakeholders, the lack of the necessary skill sets to preserve digital materials, the lack of agreed international approaches, a shortage of practical models on which to base preservation practice, and a lack of funding on an ongoing basis to address digital preservation issues, all contribute to the problem (Beagrie, 2003, p.6)

We have more technology than we can deal with . . . we lack stable structures (financial, expertise, organizational) to build on to (Geser and Pereira, 2004, p.59)

This chapter attempts to provide some pointers to those challenges that are likely to be the focus of digital preservation activities in the future. Predicting futures is, of course, always a risky business; in this attempt to do so the views of many experts are drawn upon to derive a consensus about what the challenges will be.

A brief reiteration of the key threats to digital continuity is worthwhile to remind us of the issues. The list of obstacles to preserving digital heritage in CASL (Council of Australian State Libraries) member libraries is one brief statement of the threats; it includes uncertainty about selection for preservation, archiving and storage, authenticity, intellectual property rights/digital rights management, technological obsolescence, costs, and roles and responsibilities (Council of Australian State Libraries, 2002). A fuller list comes from Jones and Beagrie (2001, p.27–34):

- rapid obsolescence resulting in large part from a market-driven ethos
- the creators of digital materials and other stakeholders may lose interest
- the lack of awareness of digital preservation issues by stakeholders

- the lack of the necessary skill sets to preserve digital materials
- the lack of agreed international approaches
- a shortage of practical models on which to base preservation practice
- a lack of funding on an ongoing basis to address digital preservation issues
- traditional organizational structures that do not readily accommodate digital preservation activities
- lack of agreement about which institutions should preserve digital materials
- lack of applicable selection principles
- legal issues, such as intellectual property rights and legal deposit.

What have we learned so far?

How far have we gone towards countering the threats to digital continuity? What do we now know about digital preservation? Some of our knowledge to date is summed up in three aphorisms developed from the experiences of participants in Canadian Conservation Institute workshops: something is better than nothing; move it or lose it; don't throw out the original (Strang, 2003). Webb's six points also summarize a significant body of experience:

- selection is necessary
- benign neglect does not work
- someone needs to accept responsibility
- working together is effective and increasing
- we already know much, including much about what we need to do
- action is possible now, even if we do not have all of the answers (Webb, 2004, p.50 (paraphrased)).

A third statement of 'emerging Practices' – the authors suggests that 'it may be premature to identify Best Practices') – is provided in the responses to the PREMIS survey carried out in 2003–2004. It includes:

- Use of the OAIS model as a framework and starting point for designing the preservation repository . . .
- Maintenance of multiple versions (originals and at least some normalized or migrated versions) . . .
- Choice of multiple strategies for digital preservation (OCLC/RLG PREMIS Working Group, 2004, p.54).

These, however, are only summaries; closer examination of the challenges is worthwhile to reinforce how much we still need to do and to delineate more precisely those challenges. The challenges are not just technical; in fact, there is a school of thought that we have most of the technical solutions that we need at hand. The challenges also include 'key social, political, and economic issues . . . including the need to develop a "will to preserve and provide permanent access"' (Hodge and Frangakis, 2004, p.3). The 14 challenges here do not constitute a comprehensive list, but are those about which there is a high level of consensus.

1) Developing standards for digital preservation and encouraging their use. The development and implementation of standards (discussed in Chapters 7 and 8)

are a key aspect of most digital preservation activities. The benefits of using standards include the opportunity for increased interoperability, fewer problems and greater economies associated with limiting the number of file formats handled, and facilitation of collaboration. The rapid rate of change associated with technologies, for instance, the rapid obsolescence of file formats as new formats replace them, means that monitoring and maintenance of standards needs to be constant and ongoing.

2) Influencing data creation where possible. Encouraging the application of standards such as metadata standards, persistent identifiers and non-proprietary file formats 'that will prolong the effective life of the available means of access and reduce the range of unknown problems that must be managed' (UNESCO, 2003, p.37) is a challenge that must be addressed to ensure effective digital preservation. This is related to the need to engage all stakeholders in the process, noted in Chapter 2 and also below.

3) Increasing collaboration and engaging stakeholders in digital preservation. Chapter 9 noted in some detail the value of collaboration and Chapter 2 the value of engaging stakeholders in digital preservation activities. 'Working collaboratively is often a cost effective way to build preservation programmes with wide coverage, mutual support and the required expertise' (UNESCO, 2003, p.25). The greatest challenges are in identifying stakeholders and potential partners and engaging them in collaborative activities; other challenges lie in managing collaborative activities so that they are effective and benefit all participants.

4) Developing policy about digital preservation. Clearly articulated policies, such as a written policy framework with 'digital longevity as an explicit goal' (B. Smith, 2002, p.136), although not noted in detail in preceding chapters, is considered an essential requirement for effective digital preservation. One aspect of policy, and perhaps the one where the greatest challenges lie, is the decision about who will take responsibility, critical because digital materials require constant and ongoing attention to ensure their preservation. 'Acceptance of responsibility should be explicitly and responsibly declared' (UNESCO, 2003, p.23).

5) Ensuring that legal rights do not impede digital preservation. A major challenge (noted in Chapter 4) results from the conflict between ownership and control of intellectual property, on the one hand, and the needs of cultural heritage institutions to collect and copy for preservation purposes, on the other. Ongoing efforts are required in order to change legislation to ensure adequate rights to collect and copy digital materials for preservation purposes.

6) Determining which digital materials, and what attributes of them, it is crucial to maintain access to. Although some maintain that we will soon be at the stage where it is technically feasible to collect all digital materials, most commentators appreciate that it is not practical to collect everything, so selection of digital materials is required (noted in Chapter 4). In addition, decisions about the attributes of digital materials that we should preserve are required (noted in Chapter 5). Clearly articulated selection policies and guidelines must be developed and a better understanding of the attributes of digital materials that affect their authenticity must be reached.

7) Integrating digital preservation into mainstream operations. It is now recognized that the viability of ongoing digital preservation programmes is compromised if they depend on short-term project funding, and that they need to be fully incorporated into the mainstream activities of institutions. The challenge is to

build sufficient awareness of this so that digital preservation is appropriately funded and resourced as part of mainstream activities. Aspects of this challenge are discussed further later in this chapter.

8) Taking action now, even if on a small scale. There are, as yet, no widely agreed-upon techniques for digital preservation, although (as noted in Chapters 6, 7 and 8) the seeds of agreement are beginning to germinate. Current advice from heritage institutions with significant digital preservation experience is to 'take active steps now, even small ones, which will preserve access for the "manage-able future", while also planning for whatever long-term approaches appear to be the most practical' (UNESCO, 2003, p.124). Waiting until reliable techniques are available will almost certainly result in the loss of material. This challenge is not explicitly noted in preceding chapters; Chapter 5 of the UNESCO *Guidelines* (2003) stresses its importance. The challenge is to promote greater awareness of this and provide appropriate guidelines about how to do it. There is more detail about aspects of this challenge later in this chapter.

9) Maintaining access to the preserved digital materials. Perhaps the greatest challenge faced in digital preservation is to maintain access – 'the ability to present the essential elements of authentic digital materials' (UNESCO, 2003, p.22) – to preserved digital materials. The numerous challenges in achieving this are noted throughout this book, and the strategies and techniques available to us are noted in Chapters 6, 7, and 8.

10) Maintaining the authenticity and integrity of the preserved digital materials. This challenge is noted in detail in Chapter 5. Although authenticity is not a primary requirement for all digital materials, for many categories (for example, where the digital materials are used for evidential purposes) it is essential. One challenge, as noted above, is to determine the attributes that determine authenticity for different categories of materials; another is to maintain those attributes into the future.

11) Developing better costing data. There is a lack of reliable data about the costs of digital preservation, in part because the techniques are rapidly evolving as our knowledge of the requirements matures, in part because of the massive quantities of digital data, and in part because of the ongoing costs (the 'digital mortgage' referred to in Chapter 4). Better costing data is needed immediately; lacking it, actions such as securing funding and determining responsibilities for digital preservation will be impeded.

12) Securing funding for digital preservation. As noted above, an emphasis on short-term project funding is not conducive to long-term viability of digital preservation. Securing long-term funding requires that funding agencies and political masters must be convinced of the need for the preservation of digital information. It may, in part, be addressed by success in addressing one of the challenges mentioned above – integrating digital preservation into mainstream operations

13) Increasing awareness about digital preservation. Digital preservation will be incorporated into mainstream activities, will attract secure funding, will attract appropriate resources such as skilled personnel, and in other respects will achieve maturity only when awareness of it is heightened at all levels, from the political to the individual.

14) Developing the skills required for digital preservation. Skilled personnel with appropriate knowledge of digital preservation requirements are in short supply around the world (noted briefly in Chapter 1). The challenge is to identify more

precisely the skill sets that are required, and to encourage their acquisition. This challenge is discussed in more detail later in this chapter.

Four major challenges

Of these 14 challenges, four emerged as the most intractable during interviews with Australian digital preservation experts in 2004:

- challenge 1: managing digital preservation, especially the importance of integrating digital preservation into mainstream operations
- challenge 2: funding digital preservation, especially without available costing data for digital preservation activities
- challenge 3: peopling digital preservation, especially finding the skills required in the future and ensuring that they remain available
- challenge 4: making digital preservation fit, especially achieving scalability of practice to both large systems and the smallest institutions.

The views and comments gathered during the interviews form the basis of the following discussion. Unattributed quotations in the rest of this chapter come from these interviews.

Challenge 1: managing digital preservation

One frequently voiced issue is that digital preservation has not become a normal part of mainstream practice in most institutions. Much of the development to date has been carried out as special projects. The project approach has some merit as a response to the magnitude of the problem, where project-based approaches that bring stakeholders together to collaborate are desirable and effective. It also has merit as a way of securing funding for scoping studies, or of exploring a technique, or of testing the waters. However, project-based funding is by definition short-term and engenders short-term ways of thinking. Project-based digital preservation activities get in the way of an appropriate recognition that digital preservation is here to stay and can only be addressed if all institutions and stakeholders play a part. Beagrie states that

> ultimately, digital preservation will be successful when it can be seen not as a stand alone institutional activity but as an activity embedded in how institutions manage and approach digital information and resources on an ongoing basis . . . It remains a simple objective, yet one immensely challenging to achieve (Beagrie, 2004).

The project-based approach has achieved some notable successes, but it will not ensure sustainability in the medium or long term. The challenge is to integrate digital preservation fully into normal operations of libraries, archives, museums and other institutions with responsibility for digital sustainability. As one Australian digital preservation specialist put it, 'the challenge we've got . . . around digital preservation . . . [is] that it just becomes the way we do things'. An example of the dangers of short-term thinking was provided from a museum context:

the emphasis is on not only short-term but immediate access within an exhibition environment, and as soon as that's over, they move onto the next exhibition . . . Gather[ing] documentation . . . was seen as being totally irrelevant . . . it was something that was done for the short-term, but not seen as relevant for the long-term, whereas in fact it is vitally relevant for the long-term, but there was no interest in the long-term, because the interest was only for as long as the exhibition. And this was just a different set of values . . . a curatorial value . . . that was the space they operated in. And that tended to suck the resources away from any long-term thinking.

Another person interviewed described the issue in the library context. Because digital materials have not been incorporated into the normal processes, they 'are treated as a different acquisition process, or as a different this or a different that'. One of the difficulties arises with

the interactions across different areas, because when you talk about a process that produces a digital outcome . . . typically they go across all the more standard business units within the library, and we're often quite split up between technical services and reader services and systems services . . . Whereas a new electronic service cuts across all three of them, and in fact has no business owner at all. And again, I guess that's one of the issues about digital preservation. Who is the business owner? Who owns that within the library environment? In our case it has come out of being owned by the systems area, which is what I'm responsible for, but ultimately it needs to be owned by the normal processes and not be seen just as an IT problem, an IT issue.

The principal reason for this concern is that sustaining digital materials over time requires ongoing, unbroken activity, expressed variously by Australian digital preservation specialists in this way: 'preservation is not something that you ever achieve. It's just a process you're in the middle of, or at the start of, but never at the end of'; 'one of the things that is key . . . is recognition that it is an active process, because . . . you do have to think about . . . active management of that object through its life, through time'; we need to 'move away from the sort of proselytizing kind of mode into just making it mainstream'.

How do we make the change from project-based, short-term support for digital preservation to integration into mainstream activities? What changes will be required? One action suggested by an Australian digital preservation specialist to break down the existing structures in his library was to create a new position at senior level called an E-services Integration Manager, whose job is to 'work across different areas and ensure . . . that the disconnects don't happen, but the connects are in place between this business unit and that business unit. So that the ultimate electronic service that emerges is a proper continuum of the working out internal inputs and outputs'. He also acknowledged that 'it's not as simple as getting . . . new staff dedicated to doing this'; it has to be built into the workflows of current staff. Some institutions have already successfully integrated digital preservation into their normal operations, or are well on the way to doing it. One Australian example is the National Archives of Australia. Its approach was described in this way:

We say: Well the preservation programme is concerned to preserve all formats of records – one of the formats is digital preservation. It requires different skill sets and so on, but it's about preservation. It's not about digital . . . just as AV preservation is about preservation of the record – there are special skill sets for people needed in that too, but it's still fundamentally about preservation.

Another is the National Library of Australia, who 'has been able to institutionalize [digital preservation] or operationalize it'. This has proved successful because digital preservation is 'moved out of the realms therefore of just being fashionable' and is therefore, less vulnerable to changes in funding.

Two approaches to encourage integration are gaining popularity. One is a risk management approach, increasingly being applied to digital preservation activities. This was described as 'both identifying potential risks more comprehensively and taking action within a whole range of different ways to manage those risks. It also does mean accepting some risk as inevitable'. Another approach is to use business planning methodologies (see Bishoff and Allen, 2004).

Challenge 2: funding digital preservation

The UNESCO *Guidelines* note that two aspects should characterize reliable digital preservation programmes. One is 'organisational viability' which is based on 'an ongoing mandate' and appropriate resources and infrastructure. The other is

> financial sustainability: a likely prospect of the organisation being able to continue to provide the required resources well into the future, with a sustainable business model to support its digital preservation mandate (UNESCO, 2003, pp.43–44).

As noted in the discussion above, digital preservation is vulnerable unless it becomes part of core business activities. This means that its funding must become a core business expense and, in the library context, that preservation 'needs to be viewed as an activity just as essential as is cataloging' (A. Smith, 2002, p.5). Funding should be sustained to pay the digital mortgage. Adequate sustained funding is critical; in fact, one interviewee suggested that it was the issue for digital preservation, that the technical issues such as the 'intellectual challenge in working out what the essence of those new data formats are as they get invented and developed and making sure we capture those . . . really resolve into resourcing issues, because the expertise to do that stuff, to do the technical work is around, we just have to be able to afford to buy it'. There is 'a reliance on an industrial infrastructure which becomes ever more complex'; high-level computer systems are needed and 'they're not cheap and they're not cheap to run. Furthermore you've got to replace everything every five years'. Repositories typically continue to grow in size, so the funding requirements also continue to grow. Even for one well-established Australian digital preservation programme, 'one of the hardest things has been to continue the funding. It's been an ongoing challenge to continue funding the program'. This programme has succeeded in securing funding, in part because 'we implemented practical projects as we've moved forward'.

Short-term thinking based primarily on business need was described by one Australian digital preservation expert. For his organization, preservation 'is only seen by the business as being valuable if it's continuing to meet a business need'. If he wished to fund digital preservation activities, 'the only way I'm going to be able to do that is to link it into the drivers in that particular sector'. Where the business reasons for keeping materials disappears,

> the default will be that we will dispose of them. Or we will maybe start selectively disposing of it, so we'll start prioritizing those that we're going to preserve into the future and we'll be pretty ruthless about doing that.

One problem that continues to get in the way of securing ongoing funding is our lack of concrete knowledge of how much it will cost. Earlier projects such as CEDARS attempted to develop firmer costing data as part of their research activities, but despite their efforts the outcomes are still not well defined. Research is ongoing, with initiatives like the NDIIPP in the US including the development of better costing data as part of the research it promotes. Schonfield *et al.* (2004) report on their investigations into the ongoing costs to libraries of maintaining periodicals in print and digital forms. Sanett and Cloonan point out that the major factor that influences decisions in many institutions is how much it will cost, and they urge the development of better cost modeling (Cloonan and Sanett, 2000, p.210). Sanett notes elsewhere that 'a cost model makes intelligent planning possible' (Sanett, 2003). One attempt to cost repository storage at OCLC notes a 1996 prediction by Lesk that '"the costs of the digital and traditional library operations [would] cross over in about five years," and that electronic storage would offer a "major cost advantage" within ten' (Chapman, 2003, p.8). The OCLC experience concluded that this cross-over point had not been reached for one type of digital material, compressed 600 dpi images, but had been for ASCII files. The study concluded that 'there are many variables to the equation of managed storage costs', such as formats, numbers of items, number of versions, and number of collections, to allow firm costings at present (Chapman, 2003, p.13). James *et al.* (2003) have also researched costs of repository storage, in this case cost models for preserving e-prints in institutional repositories.

Lavoie has developed a model that describes the economic issues of funding digital preservation in terms of incentives, which need to be sufficient so that stakeholders will participate. The key stakeholders are the owners of the intellectual property rights, the archive that provides the services, and the entity that benefits from the long-term preservation of the materials. Lavoie characterizes the incentives as 'perceived motivation sufficient to 1) induce a party to recognize a need to take action to secure the long-term viability of digital materials in which they are a stakeholder, and 2) induce a party to develop and implement technologies aimed at ensuring the long-term viability of digital materials' (Lavoie, 2003, p.ii). He notes that the absence of empirical data about costing has required that values for many of the variables be estimated (2003, p.7). He examines five organizational models and concludes by providing an agenda for further research:

> A thorough understanding of the nature and extent of the incentives to preserve is fundamental to more focused research into the economics

of digital preservation. Future research activity should include the accumulation and synthesis of digital preservation case studies; the development of appropriate policies for enhancing incentives based on the characteristics of the underlying organizational model; characterizing and analysing the structure of aftermarkets associated with digital preservation services; and devising sustainable pricing strategies for digital preservation services (Lavoie, 2003, p.iii).

Lavoie has since expanded his view of the economic issues to encompass the responsibilities of stakeholders, strategies for organizing preservation resources most efficiently (Lavoie, 2004), and public good in relation to responsibilities and costings for digital preservation (Lavoie and Dempsey, 2004).

There are some hopeful signs. In Australia, changes to public administration policy and accounting practice at federal and state government levels has had the effect of providing more funding for digital preservation. The move to accrual accounting has valued collections as assets and enabled funding to be provided for asset maintenance and replacement (Stuckey, 2003). In the case of the National Archives of Australia this has meant that AUD$15 million in funding was available from the federal government that can only be spent on 'activities that make the collection last longer, including digital preservation'.

Challenge 3: peopling digital preservation

Commentators regularly lament the lack of people with the expertise needed to further the digital preservation agenda. This is not a new situation. 'Lack of staff expertise is a common problem both in institutions with digital preservation responsibilities and in institutions that have not yet assumed responsibility for digital materials', noted Hedstrom and Montgomery in 1999, adding that those with the required information technology skills typically did not have an understanding of long-term preservation – 'The lack of expertise in digital preservation appears to be a significant obstacle to developing digital preservation programs' (Hedstrom and Montgomery, 1999, pp.16–18). More recently the International Council on Archives noted 'the lack of adequate training of, and human resources development for, records personnel' and the impediment this was to the efforts of archivists to 'protect archives as evidence and to preserve an "authentic digital heritage"' (Millar, 2004, p.5).

What new knowledge, what new skill sets are needed? Chapter 1 noted that new skills would be required to implement new policies and develop new procedures. Jones and Beagrie describe the digital preservation work environment and identify some of its requirements. The general work environment is one of rapid and constant change, blurring of boundaries of responsibilities, and increased weight given to collaboration and accountability. For digital preservation activities specifically, formal training opportunities are rare, so that much is learned on the job, and informal contacts with others working in the field are valuable (Jones and Beagrie, 2001, p.54).

The Australian digital preservation specialists interviewed provided some informative perspectives. While most of them considered that a new kind of digital preservation specialist was required, one counter view was expressed. One archivist could not 'see that there is a new profession in digital preservation because ... digital preservation is just a process for preserving digital

records and it's an IT process', so anyone with IT skills can do it. He made an exception for some research and development work in digital preservation, which would require new skills.

These Australian specialists considered that general professional skills were required to a high level. One indicated that a preservation specialist in any medium (digital being no exception) 'needs to first understand the purpose of the whole activity'. The need for 'thinking about [digital preservation] holistically as opposed to in a narrow way' was also noted by another interviewee. Others described the general characteristics and skills that were required: for example, 'the most important characteristics of people who work in this area are things such as [an understanding that] . . . there's no such thing as a wrong answer'; 'the open mind, the inquiring mind' was needed. Specific skills required were 'incredibly good project management skills', diplomacy ('you've got to have an ability to work across complex organizations without treading on anybody's toes'), and communication skills (the ability 'to write a sentence which more than two people agree with'). People able to take a strategic perspective, and who could put a business case were considered necessary. The major qualification required, one interviewee suggested, was 'managerial skills, because it's a process, so you have to manage the IT specialists who are delivering it'.

Technical skills to a higher degree than previously required were considered necessary. At a broader technical level, digital preservation specialists are 'obviously going to need to know a lot about metadata and databases' and about the specific media that they are working with. Additionally there is a need for 'a layer of specialist information about how metadata works in the preservation context and how digital preservation systems work . . . there is a specialty there and it probably needs to be available as an add-on to things that are more content-related'. All interviewees agreed that new combinations of skills were required, 'adding digital knowledge to analogue knowledge'. The IT skills needed to be at the level where 'you've got the literacy to be able to get down into that bitstream and extract things and pull things out of corrupted disks, and all of that – all that technical nous', and, in addition to this computer literacy, digital preservation specialists need to have skills in

> change management and an ability to liaise with owners and creators of digital collections, to provide ongoing guidance and write comprehensible guidelines for depositors, and to ensure rigorous documentation and ongoing maintenance procedures are undertaken. Working as a team will also be a pretty important as they'll certainly need to do that! The important thing to note is that it won't just be technical skills which are required.

This new curriculum should be based on 'a common body of knowledge which can form the basis of a set of competencies' and should be available in a variety of modes, such as 'learning by doing', secondments, workshops which include practical case studies, as continuous professional development courses or formal training courses at undergraduate and postgraduate levels. The people who would become digital preservation specialists could potentially come from any background. However, the experience of one interviewee was that 'the people we are finding really good are actually coming out of history and the humanities'. He continued that this was not to say that IT people weren't appropriate;

however, his experience was that they 'will often come with limitations set by the technology ... they'll be thinking about the technology underneath [rather than] thinking much more broadly about why we are doing this and what this could mean in the future'.

Some formal training programmes are available. HATII (the Humanities Advanced Technology and Information Institute) at the University of Glasgow offers a full award, the Master of Philosophy in Information Management and Preservation, and other schools of information management or librarianship offer individual subjects. Less formal programmes, such as online self-study programmes, are being developed. One example is the Cornell University Library's online tutorial *Digital Preservation Management: Implementing Short-term Strategies for Long-term Problems* (Kenney *et al.*, 2003). Digital preservation training is recognized by the DPC as a major issue: 'it remains difficult to recruit individuals with appropriate skills and the need for such skills is growing' (Cornwell Management Consultants, 2004, p.1). The DPC, therefore, carried out a training needs analysis in 2004, which recommended that courses be developed and offered (Cornwell Management Consultants, 2004); in conjunction with JISC and the British Library, the DPC is developing a modular training programme (JISC, 2004).

The challenge of meeting the 'pressing need for education and training in new digital archiving methods, tools, and technologies' (Workshop on Research Challenges in Digital Archiving and Long-term Preservation, 2003, p.xix), is large and will take time to fully address.

Challenge 4: making digital preservation fit

Anne Kenney, in an unpublished address to the UNESCO Regional Consultation on the Preservation of Digital Heritage meeting, Canberra, Australia, 4–6 November 2002, noted that digital preservation activities can be characterized as being too high (conceptual rather than pragmatic), too low (narrowly defined), too little (failing to acknowledge the problem), or too late (occurring reactively rather than anticipating the problem). If digital preservation activities are to be fully integrated into standard practice they need to be applicable to all sizes and shapes of institutions. People who work in these institutions must be aware of the need for digital preservation and must have ready access to advice that is applicable to their institutions. Discussion about digital preservation has too frequently been couched in terms that apply only to large well-resourced institutions, without sufficient regard to the requirements of smaller organizations and of individuals. Yet it has become abundantly clear that there is a need to engage all and to approach the issue at all levels.

To date, the responses to the challenges of digital preservation have largely been developed by large, well-resourced libraries and archives. So, what can be done about digital preservation in smaller institutions? How can small libraries and archives respond to the challenges of preserving digital materials? The issue here is one of scalability: scaling down, as well as scaling up. Some guides are starting to be produced, for example a guide to contracting out digital preservation services produced by the DPC in response to its members' concerns that smaller organizations are not as well-equipped to deal with digital preservation as its larger member organizations (Simpson, 2004a).

A close look at the lessons learned by institutions that have been active in digital preservation to see how they could apply in other contexts repays attention. The National Library of Australia's experience provides some guidance and assistance. One of its responses is

> stages of action . . . Our most pressing demands were to make some decisions about what we should try to preserve and to put those materials in a safe place . . . We have formalized these processes into two broad terms: archiving and long-term preservation. For the NLA, archiving refers to the process of bringing material into an archive; long-term preservation refers to the process of ensuring that archived material remains authentic and accessible (Webb, 2002, p.66).

This translates into a staged approach: start now, do what you can now, and then consider the possibilities.

Other experiences of the National Library of Australia provide guidance for smaller institutions. Its migration experience is one area where the benefits of its expertise have already been provided in the form of guidelines for low-end users, for instance a staff paper *Practical Advice for Preserving Publications on Disk*, 'a basic guide for beginning the process of managing and preserving physical format digital publications' (Woodyard, 1999). Similarly, the experience encapsulated in Woodyard's description of the Library's migration experiences (Woodyard, 1998) can be applied in smaller institutions. The National Library of Australia's experience with CD-R provides ready information for wider dissemination about what types of CD-Rs are best to use, and advice about testing procedures and why they are important. Lessons from the PANDORA experience applicable to smaller institutions are less obvious, but could include guidelines for determining significance of sites aimed at the local level (for example schools, local history collections, and company web sites) which would assist in raising awareness and in developing selection policies, an essential early step in digital preservation.

Stakeholders have expressed interest in learning from the experience of the National Library. One is CAUL (the Council of Australian University Librarians) whose report at the 2002 UNESCO Regional Consultation on the Preservation of Digital Heritage specifically requests 'best practice models . . . as well as guidelines' and notes that 'leadership from the National Library of Australia (NLA) is welcomed' (Horn, 2002). The publication of UNESCO's *Guidelines for the Preservation of Digital Heritage* (UNESCO, 2003), prepared by the National Library of Australia for UNESCO, is an important step towards disseminating the lessons learned from practice. Although these *Guidelines* are aimed at preservation managers and their audiences are defined as policy makers, high level managers, line managers and technical practitioners (UNESCO, 2003, pp.18–19), they include suggestions aimed specifically at 'those people struggling to set up programmes with extremely limited resources' (UNESCO, 2003, p.20); many of its chapters have a section headed 'For preservation programmes with few resources'. While they are undoubtedly valuable, it is debatable that they will reach two important groups needing advice on digital preservation – small libraries and organizations, and individuals.

We can readily envisage a local history collection in a small public library. Such collections are of considerable significance to the area they serve. We can

also realistically expect that this library will be offered photographs of its locality in digital form; indeed, if this has not happened already, it will happen in the near future. Similar situations apply to a wider range of institutions, for instance the one-person special library, or the small archive, perhaps staffed largely by volunteers, or the school library, many of which are already attuned to the need to preserve the school's heritage and are finding that much of it now resides on servers or on short-lived media. What these small institutions have in common are digital objects in their collections, staff that are time poor, and very limited resources. These institutions urgently need guidance in the form of precise directions that are concise and able to be readily implemented. The challenge is to codify the lessons learned into guidelines and action lists for smaller institutions. The National Library of Australia has in fact produced such guidelines in their *Recommended Practices for Digital Preservation* (National Library of Australia, 2004?) and in an earlier guide, *First Steps in Preserving Digital Publications* (National Library of Australia, 2000?). Guidelines have also been issued by other organizations, for instance recommendations for creators of and those interested in electronic literature (Montfort and Wardrip-Fruin, 2004). There is definitely still room for more.

Many digital preservation strategies are centred around digital mass storage systems (noted in Chapter 8). These are major investments requiring large initial outlay and significant ongoing costs. There is as yet no equivalent for smaller institutions, although the 'personal' digital mass storage system – one that is affordable by small libraries and archives – has been promoted (Schüller, 2000). Until solutions are more universally scalable, what should small libraries and archives who want to begin digital preservation do?

Research and digital preservation

Digital preservation is characterized by a high level of research activity. This is evident in many of the initiatives and collaborations described in Chapter 9. All of them conduct research, or have done so; in some of them, research has a very high priority. Early examples include research commissioned by the British Library to compare methods and costings (Hendley, 1998) and the National Library of Australia's *Draft Research Agenda for the Preservation of Physical Format Digital Publications* (National Library of Australia, 1999a). Some of the most prominent examples are: CEDARS and CAMiLEON, both established as research collaborations; initiatives that were established specifically to test strategies and services, such as the Digital Preservation Testbed; and others where research is one major activity along with others, such as the Digital Curation Centre and ERPANET.

The high levels of research activity in digital preservation can be explained in part by the novelty of most of the ways of thinking and activities that are needed. Few of the pre-digital paradigm approaches are transferable and (with the exception of the experience of the data archiving community) there was no significant body of knowledge to fall back on. Another reason is the urgency of the issues: these have, Lavoie suggests, 'motivated an ambitious, community-wide research agenda aimed at an improved understanding of what digital preservation entails' (Lavoie, 2003, p.3). Certainly the engagement of a large number of stakeholders – the 'community-wide' support noted by Lavoie – is

clear, collaboration being a hallmark of digital preservation, as Chapter 9 notes. Research has resulted in many responses to the technical challenges, such as preservation metadata schemes, increased understanding of the longevity of media, and requisite architectures for digital repositories. Other challenges, too, have been addressed: the social challenges, such as a better understanding of risks, and increased knowledge of authenticity requirements.

Statements about the digital preservation research agenda abound – general statements, those that are sectorally focused, and some that have a national focus (such as Kerry, 2001 for Australia). One of the general statements is Smith's 2002 identification of five challenges for digital preservation (policy, benchmarking cost models, awareness building, networking, and technical and research issues), all of which – with the possible exception of awareness building – require significant research activity. Smith expands the list in considerable detail (B. Smith, 2002, pp.136–139). Two others are apparent in the joint US National Science Foundation (NSF) and Library of Congress report, *It's About Time: Research Challenges in Digital Archiving and Long-term Preservation* (Workshop on Research Challenges in Digital Archiving and Long-term Preservation, 2003), and with the joint NSF and European Union's DELOS report, *Invest to Save: Report and Recommendations of the NSF-DELOS Working Group on Digital Archiving and Preservation* (NSF-DELOS Working Group on Digital Archiving and Preservation, 2003). These agenda demonstrate a high degree of consensus.

An early statement (Bennett, 1997) posed some key questions that are still valid and can usefully motivate our current research:

- *Why?* What is the rationale for preservation? When an object is retrieved from the archive will it still be valuable in 50 years time? Will it still be recognizable and comprehensible? . . . what costs are non-discretionary, how do they apply to an item's life-cycle in archive, and when will costs start to be discretionary? What benefits are measurable, how can they be achieved, and who can be tasked with capturing them?
- *How much?* What contextual information is necessary for preservation? . . . what contextual information is sufficient, so that when it is retrieved it can be interpreted correctly? How the object will eventually be accessed, and for what purpose, how will this affect the approach to preservation? . . .
- *How?* What are the preservation processes' procedural needs in order to achieve a long term archive? Who are the stakeholders, who will influence the way the archive is built up and managed? What quick, cost-saving routes are there, which do not adversely affect the quality of the archive? What safety nets exist which can provide a fall-back for the archive should accidental loss or deliberate sabotage to the archive occur?
- *Where?* While technology is in a state of continuous transition, when will technology be resilient and stable enough for any item to be assured of its long term preservation? (Bennett, 1997, pp.9–11).

Hedstrom in 1998 noted four areas for research that are likely to be fruitful: storage media, migration, conversion, and management tools (Hedstrom, 1998, pp.197–200). More recently, the outcomes from the joint US NSF and Library of Congress workshop to consider research challenges in digital preservation provide a comprehensive map of the digital preservation research agenda based on four themes:

1) Technical architectures for archival repositories: specification, system and tool development, pilot implementation, and evaluation of repository models; develop a spectrum of repository architectures; develop a spectrum of digital archiving services; alternative repository models and interoperability; scalability and cost
2) Attributes of archival collections: articulating and modeling of curatorial processes; developing appropriate preservation methods for diverse digital objects and collections; aggregation of items and objects into collections; decision models
3) Digital archiving tools and technologies: acquisition and ingest; managing the evolution of tools, technology, standards, and metadata schema; naming and authorization; standards and interoperability
4) Organizational, economic, and policy issues: metrics; economic and business models (Workshop on Research Challenges in Digital Archiving and Long-term Preservation, 2003).

The joint working group of the NSF and the European Union's DELOS Programme outlines an ambitious agenda. It groups its recommendations for future research into three areas:

1) Preservation strategies: emerging research domains (including research into repository models, software and format repositories, archival media, salvage and rescue, accelerated aging)
2) Re-engineering preservation processes (including research into modeling preservation processes, automation of processes, scalability, distributed and grid storage)
3) Preservation of systems and technology (research into areas such as formats, managing complex and dynamic digital materials, automated metadata creation, acceptable loss) (NSF/DELOS Working Group on Digital Archiving and Preservation, 2003, pp.v-ix).

This report noted that three research areas are most likely to have the greatest impact: self-contextualizing objects, metadata and the development of ontologies, and mechanisms for preservation of complex and dynamic objects (NSF/DELOS Working Group on Digital Archiving and Preservation, 2003, p.ix).

There are frequent calls for more reports on practical experiences of digital preservation. The predominant theme of a 2004 DPC forum about the global context of digital preservation was 'the need to develop and share practical experience' (Digital Preservation Coalition, 2004). Lynch suggests that the digital preservation experience to date is most applicable to the largest organizations and so for smaller organizations at the state and local government level, and for corporations of all sizes, 'we need a research agenda to give guidance and assistance for those who manage these valuable resources; we need to offer them affordable and implementable approaches, and supporting systems. There is a place not just for analytical research but also descriptive research' (Lynch, 2004).

Although much research has been carried out, there is much more to be done. There are also some notable gaps in research carried out so far. Lavoie notes one of the most significant:

> as digital preservation moves beyond the realm of small-scale, experimental projects to become a routine component of a digital asset's

life-cycle management, the question of how it can be shaped into an economically sustainable process begins to overshadow other concerns . . . Digital preservation can hardly be classified as a new topic anymore, yet we still find ourselves not very far from the beginning in terms of exploring its economic ramifications. No systematic study of the economics of digital preservation has yet emerged (Lavoie, 2003, pp.41–42).

Research into digital preservation continues, and will continue into the fore-seeable future, to be a pressing requirement if digital preservation is to make real progress.

Conclusion – the future of digital preservation

Although there is still considerable wariness and skepticism surrounding our ability to maintain and provide access to digital materials in the long term, it is lessening. One demonstration of this is the 2004 Association of Research Libraries statement *Recognizing Digitization as a Preservation Reformatting Method*, in which 'the Association of Research Libraries endorses digitization as an accepted preservation reformatting option for a range of materials'. Although this report recognizes that there are still many issues associated with the long-term preservation of digital materials, it acknowledges that the means for short-term preservation are available, that considerable activity is taking place to develop long-term solutions, and it concludes that 'libraries cannot wait for these solutions to be completely settled before testing the waters. Therefore, we must be prepared for persistent technological change' (Arthur *et al.*, 2004). Similar points have been made by others, for example Woodyard who four years earlier noted that at the National Library of Australia 'we have . . . analyzed the situation, recognized problems and made a good start on implementing some solutions. We have not waited until they are all thoroughly tested and proven because we believe there is limited time to find solutions due to the rapid rate of technological change' (Woodyard, 2000).

Few are brave enough to attempt to prophesy what will happen in the future, but one attempt was the outcome of a consensus-gathering exercise carried out in 2004 by DigiCULT, an EU-funded technology watch project. Comments were solicited from a wide range of international experts. One area reported on is persistent and perpetual access (Geser and Pereira, 2004, p.58). The experts' suggestions are grouped into four time periods: 2004 (current limitations/barriers), 2005–2009, 2010–2014, and 2015 and beyond. From 2005 to 2009 we can expect 'maturing base technologies and procedures, including many more Open Source applications'; the examples given include software for unattended reformatting, monitoring, and risk management. 2010 to 2014 will see the avail-ability of 'more powerful distributed preservation services'. From 2015 and beyond we might expect digital ontologies that allow all aspects of digital mate-rials to be described in ways that assist their preservation. In the next 10 to 15 years we can expect to see techniques and software developed for digital preser-vation in smaller organizations (Geser and Pereira, 2004, p.64).

Digital preservation has now reached a point of maturity where its require-ments can be codified. At the end of a comprehensive overview of archiving in

the digital age, Tibbo provides seven dicta that need to be met to secure the future of digital preservation:

1. Society must recognize, understand, and actively support the efforts to solve the challenges of digital archiving
2. The challenges that electronic records, and more broadly, digital objects, pose in respect to their long-term preservation and access must be fully explored as a priority research and development area that receives both strategic planning and extensive funding
3. Preservation and access must be viewed as having an inseparable relationship
4. Archivists, information scientists, librarians, policy makers, and computer scientists must address the full range of issues integral to digital preservation in a coordinated and collaborative fashion
5. The information technology industry must produce tools to support digital preservation and access
6. The notion of responsible custody of digital assets must pervade society; digital archiving must become ubiquitous
7. Archivists must take a leading role in educating society regarding digital preservation (Tibbo, 2003, pp.43–52).

Are we, as information professionals, capable of meeting these challenges? Do we have the will, the skills, and the influence to manage this at the institutional level? Or is the best chance for large-scale, affordable digital archiving likely to be linked to individuals needing to preserve their own digital materials, with the consequence of affordable software solutions being readily available? To this end Microsoft is developing software to offer as part of its Microsoft Office suite, in its MyLifeBits project:

> MyLifeBits is a lifetime store of everything . . . Gordon Bell has captured a lifetime's worth of articles, books, cards, CDs, letters, memos, papers, photos, pictures, presentations, home movies, videotaped lectures, and voice recordings and stored them digitally. He is now paperless, and is beginning to capture phone calls, television, and radio (MyLifeBits Project, 2003).

Microsoft is here linking in to the larger trend of life caching (Life Caching, 2004), but, while this is currently in fashion, it may not be a lasting trend. If it does persist, it could be the lever that digital preservation so urgently needs to generate public interest, leading to public support and, eventually, adequate resourcing of those institutions that are charged with the responsibility of maintaining access to information and cultural heritage, regardless of its form, into the future.

Appendix: Case Studies

These case studies provide examples of Australian digital preservation practice. They are drawn from a range of activities in organizations of varying sizes and with varying resources. Case Study 1 examines digital storage at the National Film and Sound Archive and illustrates the topics of media longevity (Chapter 3) and migration (Chapter 8). PANDORA, the National Library of Australia's web archiving initiative, is examined in Case Study 2. This case study illustrates many of the topics found in this book, in particular selection (Chapter 4). Case Study 3, which notes digital preservation activities at the National Archives of Australia, illustrates the topics of normalizing and XML (Chapter 8). VERS (Victorian Electronic Records Strategy) is the subject of Case Study 4; it illustrates the topic of encapsulation (Chapter 8). Case Study 5 describes migration at the Department of Family and Community Services and illustrates the topic of migration (Chapter 8). PADI (Preserving Access to Digital Information) is the topic of Case Study 6. This case study illustrates collaborative activity (Chapter 9) and the importance of education and raising awareness (Chapter 10).

Case Study 1
Digital Storage at the National Film and Sound Archive, Australia

The National Film and Sound Archive (NFSA), previously ScreenSound Australia, is Australia's national audiovisual archive. Established in 1984, its role is to collect, store, preserve and make available screen and sound material relevant to Australia's culture. This case study is provided by Matthew Davies.

As a modern collecting institution, the National Film and Sound Archive's involvement in digital storage technology is inevitable. The proliferation of digital formats for recording and distribution has resulted in a large body of information that has as its original form a digitally encoded signal. The most

powerful tools we can use to restore degraded historical material depend on manipulation of digital data, and all predictions for the future indicate that storage and distribution of sound recordings will ultimately be carried out exclusively in the digital domain.

The NFSA's earliest operations with digitally encoded sound depended on technologies which were not developed specifically with the requirements of archiving in mind, so choices had to be made about the suitability of available media for the various functions undertaken by the Archive. More recently, a digital archiving system based on Quadriga audio archiving workstations and Storagetek digital mass store systems, integrated with the Archive's MAVIS database, has been implemented. What then are the reasons behind the choices that have been made at the NFSA and what affect has the system had on its operations?

The standard

The widespread acceptance of 16-bit quantization and 44.1kHz sampling rate demands that any system used for archiving meets or exceeds those specifications. Compressed or otherwise inferior systems would compromise the requirement to maintain the integrity of material in the collection. Systems with higher quantization and sampling frequencies are increasingly being adopted for more critical applications. Initially the NFSA's operations depended on Digital Audiotape (DAT) and CD-R and conformed to the 16 bit 44.1 kHz system, but, with the introduction of the audio digital archive, a range of standards for different materials have been implemented, as shown in the figure below.

Source material	Quality requirement	Sampling rate	Quantization	Compression
Audio Cassette	Low to Moderate	48 kHz	16 or 24 bit	No
RTR Audio Tape – recorded at 7.5 IPS (19 cm/s)	Moderate to High	48 kHz	24 bit	No
RTR Audio Tape – recorded at 15 IPS (38 cm/s)	High to Very High	96 kHz	24 bit	No
Audio disk and cylinder records	Very High	96 kHz	24 bit	No
Digital audio recordings	Variable	As per the original recording	As per the original recording	No
Standards for distribution copies	Moderate to High	44.1 kHz	16 or 24 bit	No
Standards for browsing (reference) copies	Low	44.1 kHz	16 bit	MP3 at 128 kbps

Standards for Different Materials at the National Film and Sound Archive

Functions and requirements

One of the NFSA's main criteria for accepting material into the collection is that the recording should be the most original or earliest generation possible. With digital recordings, the absence of any generation loss makes this less critical, so if a choice of formats is offered, the most stable, standard format is preferred. If the material has been published on CD from a 16 bit digital master then the stability and wide acceptance of the CD format make it a natural choice for acquisition. The Archive has accepted a variety of formats of master or one-off recordings, including PCM F-1, 701 and 501, 1610, DAT and CD-R, but to date it has not acquired many recordings on formats such as Sony PCM-900 Masterdisc where the digital encoding exceeds the CD standard.

Sound preservation operations require copies to be made of the heritage material in the collection for a variety of reasons. These would have been initially recorded onto DAT tapes prior to introduction of the digital archive but are now captured as files on the audio workstation. As sonic restoration, editing or compilation work proceeds, new files are created for any intermediate copies and the final recording is saved on the mass store and accessioned into the collection management system.

Analogue preservation copies are no longer made as a standard practice, so, for long-term survival and accessibility of historic and contemporary recordings, the NFSA now depends on a strategy of migration of digital data. Factors influencing the choice of media for this purpose are cost of blank media, data capacity of the media, consequent cost of copying, stability of the media, and the expectations of continued availability of media and hardware. In the absence of an ideal digital preservation format, the Archive previously used DAT and CD-R for digital recording with a view to migrating the data as more suitable systems become available. With the introduction of the digital archive for audio materials the Archive has moved to a system employing LTO Ultrium data tapes, which are regularly copied for backup.

Analogue recordings at high risk due to deterioration or obsolescence are given the highest priority for copying. After any necessary conservation work the original recordings are re-played and digitized using high quality analogue to digital converters manufactured by Prism and Digital Audio Denmark. Safety copies are made of unstable originals at the earliest opportunity in the copying process to ensure that any damage to the original in the copying process will not result in the recording being lost. Digital files are created according to the standards shown above, stored on the mass storage system and accessioned into the MAVIS collection management system.

Recordings in the Archive's collection on obsolete formats like PCM F-1 are also queued for copying, and any recordings received on non-standard digital formats are being added to this queue. DAT tapes of restored recordings made by the Archive have been copied to CD-R for access purposes, but also as a safeguard against the failure of the DAT media. The Archive began with the oldest DATs in the collection, which were then approaching six years, and, at this stage, only a very small number of irrecoverable errors have been noted. A checking program has been instituted for DAT tapes, and tapes will be copied when their error rates approach a level of risk.

Access copies on CD-R are generated as part of sound preservation programmes, and targeted compilations are also produced to meet existing and

expected demand. CDs provide a suitable level of audio quality for these value-added materials, and the convenience that has ensured their popular success is equally relevant to their use in client servicing. CDs are sufficiently familiar so as not to present difficulties to clients without a technical background, and are sufficiently simple and robust to minimize the likelihood of damage when used by people without operational skills. While not providing truly random access, the CD, with indexed tracks, provides a convenient package for browsing, and this also simplifies copying. Clients of the Archive can request copies of recordings on the media of their own choice. The CD is increasingly popular with the Archive's private clients, and for some professional uses. DAT has been quickly superseded as a distribution format for production uses, and production quality audio is now generally supplied on CD-R or via file transfer.

MP3 files are produced for any content with an anticipated high level of access demand. These files are stored on the mass storage system and accessible directly from the MAVIS record. Where copyright has been cleared these files are also accessible from the National Film and Sound Archive's online catalogue on the web. In all cases the Archive retains the original analogue recordings due to their value as primary source materials.

The media

The National Film and Sound Archive currently holds approximately 15 000 mass-produced CDs. In general, the mass-produced CD performs well as a medium for acquisition, preservation and access to audio recordings. The stability of properly manufactured disks would seem to ensure their survival beyond the obsolescence of the format, and the relative number of disks with manufacturing faults is comparable to analogue disks. Cheap replay equipment is available, and the reproduction process poses minimal danger to the disks. CDs are widely accepted, easy to use, have simple storage requirements and are really cheap to make.

In 1994 the National Film and Sound Archive standardized on recordable CDs as an access medium for material in high demand, and production of CD-Rs continues, although the NFSA is moving to use MP3 files over its network as its preferred access method. The Archive has about 1500 CD-Rs in the collection, and there is an expectation that this will increase by about 100 next year. Reductions in the price of blank CD-Rs have increased the cost effectiveness of CD-R so that it compares favourably with other digital storage solutions. Compilation of CDs has proven to be labour-intensive, but becomes easier when one has a more complete digital signal chain. Wide acceptance of the format has ensured that the Archive's efforts in producing disks have been well received, and this is also an important factor for the long term.

DAT has been used by the Archive for the past 10 years as an intermediate or working copy, and the Archive now holds about 3400 DAT tapes. Most of the DATs produced in-house are recordings that have been sonically enhanced by a variety of systems. These DATs were used as a source for client copies and compilations, but are now largely redundant for this role. A small subset of the DAT collection comprises original unique recordings, mostly field recordings, and these will be copied to the digital archive within a few years.

Total holdings of other digital formats are less than one per cent of the Archive's collection. These recordings include location and oral history recordings and unpublished master tapes. The proliferation of semi-professional and

special purpose digital formats poses a significant challenge to collecting institutions, as the range of reproduction equipment required steadily increases. Many of the recordings on these media are unique, and they are likely to remain in the hands of private individuals until the effects of age begin to cause problems with the recordings. By the time any significant items are acquired by a collecting institution, it is possible that reproduction equipment may no longer be available, and the complexity of digital reproducing machines makes it unlikely that the Archive will be able to easily re-create players for formats which have failed in the marketplace.

Strategies

The National Film and Sound Archive's effort began with transferring recordings onto the two most widely accepted physical digital formats – DAT and CD-R – and has now progressed to a centralized mass store-based system. Digital recordings generated in the course of earlier preservation and access programmes serve to replace recordings on obsolete formats or unstable carriers, and will be used as a source for digital migration to the digital archive in the near future. The Archive's growing digital holdings will demand regular sampling, monitoring, and error checking to plan and implement migration or copying programmes. Cooperation between institutions and an active involvement in setting and maintaining standards will be important to the Archive's success. To this end the NFSA is involved in cooperative projects with the National Library of Australia, the International Association of Sound and Audiovisual Archives (IASA), and the Association of Moving Image Archivists (AMIA) to establish standards and guidelines for digitization and management of audiovisual heritage. The publication of IASA TC-04 *Guidelines on the Production and Preservation of Digital Audio Objects* in August 2004 (International Association of Sound and Audiovisual Archives Technical Committee, 2004) represents an important milestone in this cooperation.

Case Study 2
PANDORA (Preserving and Accessing Networked Documentary Resources of Australia)

The National Library of Australia's PANDORA (Preserving and Accessing Networked Documentary Resources of Australia) Project is examined in this case study. It illustrates many of the topics covered in this book, in particular selection (Chapter 4).

Approaches to preserving web sites fall into two camps. One, exemplified by the National Library of Australia's PANDORA, is based on selection of web resources in order to preserve and provide access to them in the long term; the other, the 'whole domain harvesting' approach, is exemplified by The Internet Archive. The PANDORA archive is 'the only real example' of collaboration and coordination in the collection of digital information resources that Beagrie encountered in his four-country survey of best-practice digital preservation (Beagrie, 2003). While it is not the only example of web archiving – the Internet Archive and the National Library of Canada's Electronic Publications Pilot

Project are other pioneering projects – it is one of the earliest and has provided experience on which other institutions have drawn.

PANDORA, sometimes also known as 'Australia's Web Archive', began life as a project to collect and preserve the digital national heritage in the form of online publications. It is based on 'the conviction that the Library has a responsibility to collect and preserve the published national heritage, regardless of format' (Webb, 2002, p.69). From a small start in 1995 with 36 titles, PANDORA is now an archive of selected, significant Australian web sites and web-based online publications, an 'operational National Collection of Australian Online Publications' (Webb, 2002, p.70). It is based on the principles of retaining the 'look and feel' of the material it archives, of being selective rather than comprehensive, of selecting titles which are available in online format only, and of creating records of archived material for the National Bibliography (Webb, 2000c, pp.184–187). As the Library insists that what it collects and preserves must be accessible, this raises resource issues to provide accessibility, so selectivity is considered to be the only realistic approach.

Smith (1997) describes PANDORA's early history. It commenced with a modest pilot project in 1995, at the time of the establishment of the National Library's Electronic Unit, which experimented to see what would work in capturing selected publications. A selection policy for online materials was developed based on the Library's existing collection development policy: collecting would not be comprehensive, as was attempted for Australian printed materials, but selected items should have significant Australian content or authorship, and the work should be authoritative with reasonable research value. Permission to archive would be sought from owners. By 1998 procedures were well established and the involvement of other libraries was sought. The State Library of Victoria became a partner in 1998. Although by 1999 the procedures were well established, internet sites had been archived, and access provided to them, there were still challenges: methodological (such as applying selection criteria), resourcing (such as maintaining staff and equipment at satisfactory levels), and technical (the harvesting software and archive management process were giving concern) (Morrison, 1999). A case study of adding the web site *Lighthouses of Australia* illustrates how cumbersome and time-consuming the process could be (Morrison, 1999, pp.282–283).

The concept on which PANDORA is based is one of a national distributed archive with other stakeholders playing a role. After the State Library of Victoria had become the first partner in 1998, other state libraries followed: the State Library of South Australia in 2000, Western Australia in 2001, and New South Wales (which had begun its own web archiving operation earlier) and the Northern Territory Library and Information Service in 2002. PANDORA closely cooperates with the State Library of Tasmania, which maintains its own web archiving operation, *Our Digital Island* (odi.statelibrary.tas.gov.au). Other organizations also joined: the National Film and Sound Archive (then ScreenSound Australia) in 2000, and in 2004 the Australian War Memorial and the Australian Institute of Aboriginal and Torres Strait Islander Studies. Statistics from June 2004 indicate that the partners are contributing significantly to PANDORA: the National Library was responsible for about 57 per cent of archived titles, for instance. Collaboration extends to cooperation with publishers and resource creators. The National Library and the Australian Publishers' Association have developed a *Code of Practice for Providing Long-Term Access to Australian Online*

Publications, and in 2000 the Library issued *Safeguarding Australia's Web Resources*, a set of guidelines providing advice on creating, describing, naming, and managing web resources.

Even with its selective approach PANDORA has grown rapidly. In 2000 it had archived over 900 titles (40 gigabytes) and selected about 35 new titles each month. At the end of May 2003 it contained 3936 titles (over 440 gigabytes) and was growing by 141 titles (six gigabytes) per month. About one-third of these titles had been gathered more than once to illustrate the changing nature of web sites, and many are gathered on an ongoing basis to capture new issues of serial publications. PANDORA had already clearly proved its worth: many of the sites captured by that date, such as the Sydney 2000 Olympic Games web site, are now only accessible through PANDORA. In August 2004 the number of titles had grown to 6608 (702.1 gigabytes) and by October 2004 to 7000 titles, of which 150 had access restrictions placed on them by publishers, and an estimated 7.4 per cent of which were no longer available on the live web. At the end of February 2005 there were 7813 titles archived (802 gigabytes).

As noted above, the big debate in the web archiving field is whether to take a selective approach or a 'whole domain harvesting' approach. PANDORA believes in a selective approach to archiving, choosing material that most strongly represents Australian social, intellectual and cultural life. Selection is based on well-defined selection guidelines that fit within the Library's overall collection development policy. The National Library's policy of selective acquisition is influenced by resource issues and by its goal that what it collects and preserves must be accessible. It maintains that this approach, compared with the harvesting approach, allows an emphasis on quality – for example, checking each title to ensure it has been fully captured. The selective approach was developed in the early years of PANDORA and was justified in this way:

> The main reason was the insubstantial nature of most web publishing: the library does not attempt to collect printed ephemera comprehensively, and could see no justification for collecting its electronic equivalents ... The key point about selectivity: it is our [that is, libraries'] normal practice (Morrison, 1999, p.275).

There were also issues associated with the Library's legal ability to collect all resources, so that publishers' permissions were required as Australia has no legal deposit legislation for digital publications (Webb, 2002, p.70). The selective approach also allows the Library to devote some resources to quality assurance procedures, checking each title to make sure that it has been copied in its entirety and is fully functional.

The selection process used by PANDORA places content before format. To be selected the materials should be about Australia, be on a subject of significance and relevance to Australia and be written by an Australian author, or be written by an authoritative Australian author. The location of the server from which the material is harvested is irrelevant: it may be in Australia, but need not be. If material exists in both a print version and a digital version, the print version is collected. There is no attempt to collect all versions or editions of sites; rather, PANDORA sets a schedule for harvesting that site on a regular basis (Phillips, 2004, p.3). The placing of content above format causes some issues on occasion, for example there are technical issues about making sure that some

dynamic sites are accessible. About 40 per cent of the sites selected need further work. This is an unusual aspect of PANDORA compared with other web archiving programmes. The selection guidelines are available on the PANDORA web site (pandora.nla.gov.au/selectionguidelines.html). They were reviewed and revised in 2003 and currently indicate six priority categories: Commonwealth and Australian Capital Territory government publications, publications of tertiary education institutions, conference proceedings, e-journals, items referred by indexing and abstracting agencies, and sites in nominated subject areas and sites documenting key issues of current social or political interest (for example election sites, the Sydney 2000 Olympics, and the 2003 Canberra bushfires).

PANDORA's selectivity does raise questions about the usefulness of this approach. Libraries always face the problem of guessing the future when they develop selection policies, of course, but they must frequently revisit such policies if evidence suggests that changes are required. To take one example, there are significant discrepancies between the number of instances of the Ansett Australia web site available on PANDORA, compared with the Internet Archive through its Wayback Machine, as noted in the table below. (Ansett Airlines' sudden collapse in 2001 caused much anxiety in Australia.) Of course, these figures say nothing about the quality of the archived sites in terms of how functional they are, how many images are captured, and other characteristics.

	1996	1997	1998	1999	2000	2001	2002	2003	2004
PANDORA						4	4	1	
Internet Archive	3	3	4	9	11	0	11	15	2

Archived instances of the Ansett Australia web site at 22 March 2005

Smith (2005) has investigated a sample of sites in more depth and makes the observation that of her sample, selected as having some Australian significance, after nearly ten years

> a large proportion ... can still be found online, even though they are not at the original URL. However, accessibility continues to drop, and, in another five years or so, only 50% of the titles are likely to be found online. The Internet Archive provides the only mechanism for ongoing access to the content of the majority of these titles.

What would be of interest are some studies, from the user's perspective, comparing PANDORA with the Internet Archive for the presence of Australian material. This study would, of course, need to recognize that the scope of what each collects is different, as are the resources available to each organization, and the quality of what each captures.

The National Library is of course well aware that there are disadvantages to PANDORA's selective approach. Webb noted in 2002 that 'while the Library recognizes many advantages in taking a more comprehensive approach to Web archiving, we have yet to be convinced that such advantages outweigh the benefits of quality control and accessibility that we have been able to achieve only

while collecting selectively'. He indicated that the National Library would like their selective approach to be 'complemented by periodic capture of more comprehensive snapshots of the Australian domain' and in 2001 had employed a consultant to investigate this possibility (Webb, 2002, p.70). Phillips summed up both the disadvantages and the advantages. The advantages are that the archived materials are quality assessed and are functional, they are fully catalogued in Australia's National Bibliographic Database and are therefore accessible, items can be made available immediately because permission from publishers has been negotiated, and publicly inaccessible sites are gathered and made accessible. The disadvantages noted include that selection involves making a subjective judgment about value and future usefulness, that resources are taken out of context and links to material referred to are not functional, a tiny amount (estimated at less than one per cent) is collected, and the process is labour-intensive and has a high unit cost (Phillips, 2004, p.1). In 2005 the National Library of Australia will consider strategies to increase its rate of harvesting web resources into PANDORA. The possibilities include thematic or domain harvesting, developing different models in which partners can contribute, and active deposit of digital publications by Australian publishers, where the initial focus will be on Commonwealth government online publications.

Organizationally, PANDORA is integrated into the selection, acquisition and collection management processes of the Library. It is managed by the Electronic Unit, which forms part of the Collections Management Division of the Library. Catalogue records for every web site are included in the Library's catalogue, the National Bibliographic Database, and on the PANDORA web site, providing multiple paths for resource discovery. PANDORA's system architecture and workflows are described by Koerbin (2004). Initially the web harvesting software WebZIP was used, later replaced by HTTrack (Koerbin, 2004). At the beginning an Access database combined with a paper-based system were used for archive management. This was replaced in June 2001 by PANDAS, built in-house and developed after unsuccessful attempts to locate an off-the-shelf system to provide an integrated web-based archiving management system. A new version of the PANDORA digital archiving system was released in August 2002. It included an improved search interface, automated many of the processes, and was web accessible by partners who no longer needed locally mounted software. A successful trial migration of files was carried out to investigate whether there were any issues caused by superseded formatting tags in HTML (Webb, 2002, p.71). Future developments are likely to include development of PANDAS to accept metadata from Kinetica (the National Library of Australia's host for the National Bibliographic Database) which will trigger automatic harvesting, and applying the International Internet Preservation Consortium (IIPC) tools for harvesting, when they are available.

PANDORA has also contributed significantly to the development of digital preservation awareness and knowledge in Australia and actively collaborates with other web archiving initiatives, most recently through its participation in the IIPC (noted in Chapter 9). PANDORA has also provided an excellent training ground for the National Library to work out how to select Australian online publications and how to manage and provide access to them over time. Through it the National Library has 'been able to achieve tangible web archiving outcomes while continuing to develop, extend and refine its systems and workflows' (Koerbin, 2004, p.23). Phillips notes that

one of the most important lessons we have learned from this Project is – Take Small Steps. Initially it was very hard to know how to break the chaos barrier. Where could we begin? By taking one first small step – developing selection guidelines for what we would want to collect and preserve, if only we could find the wherewithal to do so – we started on a long steep learning curve (Phillips, 2000).

PANDORA is heavily used, according to survey results noted by Phillips (2004, pp.6–7), who adds that 'there is a little bit of anecdotal evidence to suggest that PANDORA is used not just for unique material, but because it is recognized as a reliable and well-organized source for high quality Australian content'. This might be wishful thinking. PANDORA's focus is still narrow, and its revised 2003 selection guidelines, suggest one commentator, restrict its collecting even further (Smith, 2005). It specifically excludes 'more innovative forms of publishing such as blogs' and other forms that the web is giving rise to which have no equivalent in the print world (Smith, 2005). However, PANDORA is likely to widen its focus. A paper summarizing the *Archiving Web Resources Conference* held at the National Library of Australia in November 2004 observes that the three models of collecting web publications are moving towards similar models. (The three models are the global model, represented by the Internet Archive; the regional model, exemplified by the Swedish Royal Library's Kulturarw3 project; and the selective and thematic model, exemplified by the National Library of Australia, the British Library, and the Library of Congress.) The paper notes that 'what appears to be emerging is a dual strategy of occasional complete snapshots and more selective, in depth collection of individual sites of interest' (Archiving Web Resources, 2004, pp.26–27).

Case Study 3
Changing Preservation Activities at the National Archives of Australia

The National Archives of Australia (formerly Australian Archives) has for many years been concerned with the preservation of records in electronic format and, in common with other national archives, was an early player in digital preservation. This case study describes the way in which its digital preservation activities have changed over the last three decades. It is based in part on a conference paper presented by Stephen Ellis (Ellis, 2003). It illustrates the topics of normalizing and XML (Chapter 8).

In common with other national archives, the National Archives of Australia was confronted at an early date with the preservation challenges posed by digital materials (or electronic records, the term more commonly used in the record-keeping context). An early experience was with the electronic records resulting from petroleum exploration. Australian law requires that a copy of all exploration results, including seismic data on tape, is provided to the Commonwealth government. Over 600 000 tapes of seismic data in a wide range of formats came under the control of the National Archives of Australia in 1974, posing issues such as physical decay of the tapes, and the inability to appraise them because equipment was not available to access them. Lessons were learned from this experience, such as the need to be able to access the data in order to effectively

appraise and manage them and assure their authenticity, and that all stake-holders must be clear about their roles and responsibilities, which need to be formally agreed to at the outset (Yorke, 1997, p.70). This material has since been transferred to Geoscience Australia, which has the skills and knowledge to appraise, maintain and use it. The Archives provided advice to government agencies, such as *When It's Gone It's Gone!!: Keeping and Disposing of Information on Office Automation Systems and Personal Computers* (1998) which advocates care in deleting files, sets out criteria for deciding what to retain, and recommends printing final versions of documents and emails. Other advice was produced as *Managing Electronic Records: A Shared Responsibility* (1995) and the more detailed *Keeping Electronic Records: Policy for Electronic Record Keeping in the Commonwealth Government* (1995) which articulated the strategy of keeping electronic records in agency custody.

In the early 1990s the National Archives of Australia declared publicly that the problems presented by electronic records were not soluble using contemporary methods. The solution they proposed for government was to leave such records with their originators in what was then a controversial tactic of 'distributed custody' (Ellis and Stuckey, 1994), sparking years of intense debate between 'post-custodialists' and their opponents (described in Boadle, 2004). In 2000 the Archives again changed its custody policy and resumed accepting transfers of electronic records. Some history of what the archival world was like when this series of vehement debates erupted, and of developments in archival theory and practice that led to the present solutions, can assist us to understand these changes.

The first half of the 1990s was a period of intense interest in archival circles about the problems presented by electronic records, and even about what constituted a record. The nature of the problem had by that time become clear to even the most technologically unsophisticated archivist – electronic records were inherently ephemeral because of the short time for which the software that created them was available in forms that were useable, an evanescence that was almost equally shared with the hardware upon which such software had to be operated and the media on which they were written. But at the beginning of the decade, even the terms *hardware* and *software* were not in the common vocabulary of archivists. Several quite long-established organizations had custody of large bodies of various forms of electronic data and even preservation of the physical media was beyond their resources.

Further difficulties were added by conceptions of what constituted a record. At the University of Pittsburgh the Americans, ignoring centuries of European archival science and their own history of office management, embarked on an ambitious project to reinvent the wheel from scratch and establish the Functional Requirements for Authentic and Reliable Records Project. Provoked by the callow tone of this work, protagonists like Luciana Duranti and her team at the University of British Columbia entered the lists to remind both the Americans and the Australians of the centuries-old fundamentals of archival science and their relevance to the preservation of electronic records. Distinguished Canadian archivists such as Terry Eastwood and Terry Cook contributed to the theoretical debates, while long-serving members of the profession such as NARA's Charles Dollar continued to bring a practised perspective to the forum.

This period can be seen as one of considerable development, many of the issues that were debated having passed into common practice. From these

debates came the fundamental practical work that led directly to the Australian Standard for Records Management, which in turn led to the International Standard. In Australia this development owed more to the practical requirements provoked by the problem of addressing electronic records than it did to the theoretical work at Pittsburgh and the University of British Columbia. Similarly, within Australia the conceptual work that led to the explicit articulation of the continuum metaphor to replace the life-cycle metaphor for the management of records and archives came directly out of the debates about the way forward with electronic records. Australian archivists recognized clearly from their experience that the life-cycle approach offered no solution to the electronic records problem. By the time electronic materials had reached the 'secondary stage' stage of the life-cycle model they had moved beyond the point of no return for preservation – sustaining both software and hardware over the time-spans common for such a model was impractical. So Australians turned to the more predictive model originally articulated in Canadian Treasury Board procedures of the 1950s and 1960s for traditional-format records – get in early, establish comprehensive recordkeeping systems based on agency business functions, and integrate disposal decisions within the structure of the systems. One practical outcome of this was the DIRKS methodology developed by the National Archives in collaboration with the State Records Authority of New South Wales.

These debates and discussions also led to being much more specific about what we perceived as adequate metadata for records, work that led directly to the AGLS (Australian Government Locator Service) metadata standard and its successors. It is likely that much of this work in Australia would not have been done without the stimulus of the electronic records problem and the debates it provoked. Some investigations were productive, and some were less so. Productive investigations included the International Standard, which defined the nature of a record and the essential requirements of systems adequate to capture and keep them. The metadata standards similarly establish fundamental characteristics required for authentic and reliable records. In the DIRKS methodology we have a systematic, accountable and replicable process for implementing this suite of standards.

A less productive trail evident in the discussions around the earlier part of the decade revolved around the relationship of records to data and to the applications that created them. The Archives' most recent advances in solving the long-term preservation problem have come from adopting a data-centric approach to records rather than an application-based one, an approach that recognizes that records *are* data and should be dealt with as data. The Archives also believes that another false lead has been the emulation trail – the attempt to ensure preservation of records by emulating the software and/or the hardware on which they were created. With the exception of a few peculiar instances, this work has simply transformed the problem of preserving records into one of maintaining emulation software in a constantly changing environment, without in any way addressing the media-dependence issues.

The National Archives of Australia believes that, while it does not yet have a once-and-for-all solution, it does have a solution that will serve adequately for at least the next generation and will ensure that authentic and reliable records can be sustained in an accessible state over time within an archival institution. This solution is economically and technologically sustainable and is currently

in various stages of being implemented in at least three government archives in Australia. It is the XML-based treatment of records as data objects derived from DIRKS-compliant recordkeeping systems, transferred to the Archives with associated recordkeeping and series-system metadata and maintained by the Archive in a quarantined fashion so as to preserve their authenticity.

Descriptions of the standards, process models and procedures for implementing such an approach can be found on the web sites of the National Archives and of the Public Record Office of Victoria. Both National Archives and the PROV are currently actively implementing such an approach. The National Archives has developed freely available software, Xena, which enables the normalization of digital records created in most common office formats to a platform-independent state that ensure they will be retrievable into the foreseeable future. The State Records Authority of NSW is also in the course of adopting this approach, although they are at an earlier stage. These three archival institutions have agreed to collaborate together to form the Digital Archives and Records Coalition of Australia (DARCA) to harmonize and further develop standards and guidelines for an Australian digital preservation method.

The Agency to Researcher Digital Preservation Project brings together the National Archives of Australia's current digital preservation activities. The AtoR Project began in 2001 and aims to 'create a way of accepting Commonwealth agencies' electronic records – those that are addressed as being 'national archives' – and preserving them so that they can be made available to researchers in the future'. It has done this by developing a digital preservation strategy and building the digital preservation tools that are required to make this a functioning program. The basic conceptual approach is to get electronic records into 'appropriate open (ie non-proprietary) and well-documented data formats' based on XML, and providing tools that handle these XML formats (National Archives of Australia, 2004). A National Archives Green Paper describes this approach in detail (Heslop, Davis and Wilson, 2002, p.6). It articulates the 'performance model': 'In the case of digital records, archivists are not interested in the "original" records but in capturing and recreating the fleeting and temporary performance of that record on the screen when it was viewed' (Heslop, Davis and Wilson, 2002, p.8). This report notes some lessons learned from a study of migration and emulation, such as that most of the investment in digital preservation is required at the start rather than in 'continual emulator maintenance or data conversion'. It developed the concept of 'a record's "essence" as a way of providing a formal mechanism for determining the characteristics that must be preserved for the record to retain its meaning over time' (Heslop, Davis and Wilson, 2002, p.13). Five principles underpin the AtoR Project. It

1. must be able to preserve any digital record that is brought into National Archives' custody regardless of the application or system it is from or data format it is stored in
2. must determine and preserve the essence of the digital records . . . and recreate their essential performance over time
3. will be based on non-proprietary technologies
4. will minimise the number of preservation treatments applied to each digital record
5. will not limit the accessibility choices of the National Archives or of future researchers (Heslop, Davis and Wilson, 2002, p.14–17).

The National Archives of Australia's approach is based on the use of XML. It has developed a range of XML data formats (or schema) which it will use as archival data formats. Agency records first undergo normalization (conversion of the original digital materials into XML), then transformation (the XML is converted into an archival format). Specifications of the XML data formats/ schema developed are available on the National Archives' web site. The process is handled by the Xena (XML Electronic Normalising of Archives) tool, developed by the National Archives. Version 1 of Xena was released in 2004. It converts a range of file formats to XML representations for longer term access, currently handling MS Word, Excel and Powerpoint, OpenOffice formats, Rich Text Format, several email formats, comma separated files, relational databases, JPEG, GIF, TIFF, PNG and BMP, HTML and web sites, and plain text. The National Archives believes that these formats will cover a high proportion of the files it receives from agencies, and will add more in future. Xena's development as open source software and its availability free on the web (xena. sourceforge.net) assist in making the tool itself *archival*. Because it is open source and freely available it can be adopted by others and adapted to meet their own requirements. It is 'implemented in Java, with comments included within the code' (Rushbridge, 2004b, p.32), which means that documentation about Xena is integral to it; availability of documentation is essential for ensuring the longevity of software. Rushbridge assesses Xena in this way: 'among the steps being taken to preserve our cultural heritage, Xena and its development principles form an addition that should not be overlooked' (Rushbridge, 2004b, p.33).

The National Archives of Australia also makes available policies and guidelines that assist agencies in digital preservation. In 2001 it made available a policy for government departments for keeping web resources (National Archives of Australia, 2001a) and accompanying guidelines, which include technical detail for capturing web sites (National Archives of Australia, 2001b). In 2004 it produced guidelines for digital recordkeeping: *Digital Recordkeeping: Guidelines for Creating, Managing and Preserving Digital Records*, and a *Digital Recordkeeping Self-Assessment Checklist*. These stress the need for early intervention for preservation of digital records.

Case Study 4
VERS (Victorian Electronic Records Strategy)

VERS is an initiative of the Public Record Office of Victoria, in Australia. This case study, provided by Rachel Salmond, illustrates the topic of encapsulation (Chapter 8).

VERS is a strategy – not a system of any sort, nor a piece of software. It is a strategy in the sense used in Chapter 6, that is, a long-term plan to achieve a long-term aim. As such it encompasses the development of practices, the identification and implementation of standards and the assembling of appropriate technologies. VERS describes itself, in the brochure that is in itself a part of the strategy (making sure that the strategy is known and understood by those who will be required to implement its outcomes), as a world-leading solution to the problem of capturing, managing and preserving electronic records. VERS is a framework of standards, guidance, training, consultancy and implementation

projects, which is centred around the goal of friendly and authentically archiving electronic records (Public Record Office of Victoria, 2004).

Those who will be required to implement VERS outcomes are those responsible for managing recordkeeping throughout the government of the Australian state of Victoria. Those responsible for developing and promoting the strategy are based in the VERS Centre of Excellence at the Public Record Office of Victoria (PROV) in Melbourne. The overriding motivator for the strategy is the Victorian Government's commitment to ensuring that its electronic records are not lost, but are managed in the most effective and cost-efficient way for present and future purposes.

The story of VERS reveals an exemplary model of the collaborative nature of a large-scale preservation initiative. The Victorian government, industry partners and academic researchers have collaborated in developing this strategy since its inception in 1996. Ernst and Young Consulting, in conjunction with CSIRO (the Australian government's research body) and the University of Melbourne, formed the Project Team engaged by the PROV to produce the conceptual business case to solve the problem of ensuring the retention of digital records. Their recommendation was based

> on the examination of techniques which support the separation of content from application. As a result, the team believes it is possible to develop a solution that allows long term access to content and context for the majority of records without the need to migrate the application in which the records was created . . . Accordingly, the solution proposes that records be "frozen" into a static view/print only format at the time of their creation. <u>The "frozen" image of the document is captured into a to-be-developed or determined Representation Format through which the same record will be retrieved in years to come with satisfactory and evidentiary quality replicability</u> (Public Record Office of Victoria, 1996, p.6 (underlining as in the original)).

The project that arose out of this recommendation was charged with proving that a 'frozen' image could be captured. It also involved CSIRO and Ernst and Young services and personnel who demonstrated that capture and archiving of electronic was possible, recommending:

- that PROV specify a preferred long term electronic record format, based on the format described in this report
- that PROV specify a minimum metadata set that should be associated with every electronic record, informed by the metadata set used in this project
- that the Victorian Government proceed to implement an electronic archiving strategy based on a long term electronic record format (Public Record Office of Victoria, 1998, pp.3–4).

Encapsulation was chosen as the technique for storing documents in their long-term format, together with the information, in XML, about their context (the when, where, how, by whom of the creation and use of the documents). The encapsulated bundle has a digital signature attached to it to ensure the integrity and authenticity of the document or documents it contains. In April 2000 version 1 of the document (PROS 99/007), containing the standard, specifications, and

advices for the mandatory implementation of VERS throughout the state government, was launched. Version 2 was released in 2003 (Public Record Office of Victoria, 2003). Specification 1 (System Requirements for Preserving Electronic Record) gives all the functions that a recordkeeping system must support and describes specific requirements: record authenticity and integrity; document conversion; metadata capture; modifying information associated with records and folders; documenting folder and record history; reliability; media refreshing; record export. Specification 2 (VERS Metadata Scheme) defines all the types of metadata required and the elements of each. The self-describing digital object for preservation, called a VEO (VERS encapsulated object) is specified in Specification 3 (VERS Standard Electronic Record Format), which includes details of XML and digital signature requirements. The long-term formats for electronic documents within the VEOs are specified in Specification 4 (VERS Long Term Preservation Formats) as PDF or TIFF; these are seen as providing the best chance of ensuring that documents are in their original form into the future. Specification 5 (Export of Electronic Records to PROV) gives details of the mechanisms for transfer of records for permanent storage at PROV – physical mechanism of transfer, the encoding of the VEOs on the physical transfer media, and the mechanism for the indication to an agency of PROV's acceptance of responsibility for preserving upon transfer.

The pilot implementation of the strategy began in the Department of Infrastructure in 1999. By 2002 that Department was capturing electronic records into an electronic repository and making available the benefits of its experience and the software it had developed to other government agencies as they proceeded with implementation of VERS.

Once the capture practices for electronic records had been established and tested, and the roll-out to all government agencies commenced, the next major project in the VERS programme was the development of a repository for long-term storage of those records identified for long-term preservation as archives; processes for the transfer and management of, and for access to these archives also needed to be developed. Tenders were called for the building of a Digital Archive for the PROV, and DMR Consulting, with their partners, Fujitsu, began work on the project in 2004. It is expected that the Digital Archive repository, developed on a Documentum platform that interfaces with PROV's Archives One system, will be ready to receive transfers of electronic records from July 2005. A new web site will also be available as a single point of access for searching and ordering paper and digital archives that are stored by the PROV. Viewing of digital and digitized archives will also be enabled through the web site.

Funding of VERS projects has come from the Victorian state government, stemming from $20 million announced during the state election campaign in 1996 for the establishment of an electronic archive system for the state. VERS Program Director, Howard Quenault, has reported regularly on the VERS strategy and has shared the lessons learnt during the implementation of its component projects (for example, Quenault, 2001, 2003, 2004). Several of the lessons relate to the apparent lack of awareness in the administrators of public business of the issues relating to the management and retention of electronic records. These people wanted 'to get on with the business of doing business' and expected that their agencies' IT infrastructure would capture the records automatically (Quenault, 2003, p. 4). To raise and maintain awareness of the

purpose, process and progress of VERS, the project team has paid particular attention to communicating information about VERS to those who need to know about it – in meetings, presentations, training programmes, and industry briefings. This communication has not only been directed at the government recordkeeping community, but also at the IT vendor community to ensure that the electronic document management products they supply to Victorian government departments are VERS-compliant. They have sustained this information dissemination role in the programme's web site (www.prov.gov.au/vers), where all the documents needed for understanding and implementing the strategy can be located.

Case Study 5
Migration at the Department of Family and Community Services, Australia

This case study is based on a conference paper presented by Liz Reuben (Reuben, 2004). It illustrates the labour- and time-intensive nature of even small-scale migration projects, and the benefits of automating as much of the process as possible consistent with quality assurance. It also illustrates the topic of migration (Chapter 8).

In 2002 it became apparent to the Library and Information Services of the Australian Government Department of Family and Community Services (FaCS), that unless action was taken an important corporate record would be lost. FaCS serves several other federal government departments and its potential client group numbers 35 000, all except 2000 of whom are in several hundred locations across Australia. It provides as many services as possible direct to people's desktops via their PCs.

Much of the work of FaCS and other government departments is governed by three related acts, the *Social Security (Administration) Act 1999*, the *Social Security Act 1991*, the *Social Security (International Agreements) Act 1999*, and associated subordinate legislation. These were based on the *Social Security Act 1991* and, earlier still, the *Social Security Act 1947*. One of the primary tools used to interpret the social security law, explain eligibility for payments, and uphold appeals is the *Guide to the Social Security Law*, an electronic serial available initially via the desktop or on floppy disk/CD-ROM, and, for the last five years, via either departmental intranets or the internet. Its historical releases provide evidentiary value for the appeals process and for understanding how policy has developed.

Superseded releases were originally kept on floppy disk. Each release of the *Guide* took up 10 to 14 floppy disks and needed to be installed on a standalone PC in the library to run, partly because of the proprietary software, but also because of the security requirements for staff desktop PCs, which required administrator access to install the releases. Releases of the *Guide* were produced using a proprietary software package, Epublish, dating from the early 1990s; it was written in Visual Basic and consisted of two tools: a desktop publishing program, and a browser. Over its life it became an extremely sophisticated publishing product that enabled hypertext linking within the *Guide* and between the *Guide* and its support documentation. At around the time of the major rewrite

of the *Guide* in 1998/99, Epublish moved to publishing .doc files directly in HTML, including making the links within and between documents, and to documents held on other internet sites. The company producing and supporting Epublish decided that the product was outside their core area of expertise and that they would no longer support the product from March 2003, although this date was later extended.

The demise of Epublish was a catalyst for action. In 2002, funding was obtained for a project to extract the data from the proprietary software format of all the releases held, and then migrate it to formats that would support archival best practice and provide greater accessibility. Releases from 1994 were available, except for several gaps, of which the most significant was 18 months in 1996/7 for which a box of floppy disks had been lost during a move before the material was lodged with the Library; a few other releases had either been lost or had become corrupted.

The project team of one began by looking for missing releases, researching best archival practice for digital media, ascertaining the relevant records management and archival practices of the organization, and planning for client input into the final product. In late November 2002 it was discovered that the owners of Epublish had Rich Text Format (RTF) copies of a product that incorporated *Guide* releases. This product had been released quarterly, rather than fortnightly. This discovery allowed some of the largest gaps to be filled. Also located were duplicate copies of other releases and some releases from 1991 to 1993.

Investigations in December 2002 led to the National Archives of Australia (NAA), which provided several important directions to explore. The three formats preferred by NAA for digital archiving were XML, HTML and PDF, each of which is a format with open specifications. NAA also suggested that attention be paid to the process of extracting the data, and to establishing the *essence* of the document – what was vital to be retained in the migration process, and what could be altered or lost without affecting the 'look and feel' or the evidentiary value of the records. A focus group then provided feedback about what was important to retain, features that might add value, aspects of 'look and feel', and so on.

For the rest of December 2002 and into January 2003 detailed planning continued. Data needed to be extracted from the Epublish software and converted to RTF, which would form the basis of the preservation files. The RTF files would be converted to HTML for display via the Department's intranet. XML would be either wrapped around the HTML files, or used to create a separate set of files that, with the metadata, would provide maximum archival content and protection. This would give the greatest flexibility to migrate files, while still allowing for lower level browsers that would not support the presentation of data in XML and its associated style sheets. Word was also added as a final presentation format so that staff using assistive technologies would have the easiest possible access to historical releases. Each of these formats would be stored in a separate directory on a RAID server, using two mirrored hard drives acting as one.

After some experimentation, only one reliable way to extract data from the Epublish format was identified – to copy and paste the files. Accurate replication of the files was essential because changes in the way the information was presented could affect its interpretation. There were 41 releases to convert this

way. Each release had between 35 and 54 chapters, some broken into multiple parts, with at least one table of contents for each chapter, and each of these was a separate file. Files ranged from 6kb to almost 720kb. The associated material for each release would also need to be treated. As the files could only be accessed on a standalone PC, two contractors were employed to begin this task.

To convert the RTF files into HTML, a third contractor was engaged to write a prototype. The first version of the prototype was received in the middle of January 2003. At around the same time, the additional releases found by the software company were delivered, and it was realized that the amount of supplementary materials had been underestimated. The feasibility of a script to automate the Epublish to RTF conversion process was investigated and the script commissioned. Copying and pasting releases continued and the possible overlap of effort was treated as a risk management approach.

At the end of January 2003 the prototype HTML format was loaded onto the server, a checklist was created, and a small test was carried out. The results showed that there were no major problems with the design. One issue identified was that the prototype reflected the 'look and feel' of later versions of the *Guide*, rather than earlier ones. The practical outcome was that the original look was reproduced wherever possible, although early releases look far more similar to later ones than they did originally.

The conversion script arrived in late February 2003. It was fast and it retained all the important formatting, including bolding, bulleted points, underlining, tables and columns. By comparison, the copy and paste versions had several problems. Early versions of the *Guide* included coding that was not easily translated to RTF. Underlining, in particular, copied across as coding that replaced the first and last letter of the underlined segment, and some segments of underlining would not copy at all and had to be retyped. Tabulated data was often columns separated by tabs, and the conversion translated these tabs into single spaces, increasing the difficulty of reconstruction. In the end, it was faster to go back to the original Epublish files and run the conversion script over them, and then convert columns to tables.

At the same time metadata schemes were examined. The VERS metadata specifications were adopted and the metadata was embedded in the head of each master record. XML was investigated in more depth and it was decided to create a separate set of XML files, rather than the XML shell originally considered. This approach provided the flexibility needed for display in all browsers and for future migration.

By April 2003 the contractors had completed editing the RTF files and were ready to begin the quality control. Attempts were made to rescue data from a number of corrupted files, but none was recovered. The HTML prototype was progressing well, despite the difficulties created by the two types of RTF files (scripted and supplied), and the XML and metadata work was well-placed to begin. In May 2003 additional funding was secured to recreate some of the missing releases. Further investigation led us to believe that recreation of most, if not all, of the missing releases was possible, but a significant amount of work would be required given the lack of a script to automate this process. To recreate a release, the preceding release was copied, and then, guided by the historical update list, the appropriate changes were copied in from a later release, if it existed in an unaltered form, or manually typed in from the paper registry files, if it did not.

Also in May 2003 the XML conversion work commenced. Again, due to the complexity of the *Guide*, and the lack of available expertise, the XML scripting took longer than anticipated. The style sheets needed to store the data in XML and then display it in XHTML (eXtensible HTML) were complex, because of the required high degree of compliance with the original layout. This resulted in several style sheets (called 'transformations') used in a cascading fashion to convert the data. FaCS IT staff created an application that would go over the top of the conversion process. This program steps through the processes of taking HTML files, converting them to XHTML, then to XML, and finally cleaning up the final product. Behind the front end is an off-the-shelf product to convert the HTML files to XHTML, and then another to convert the XHTML to XML, using the customized style sheets. This process was chosen because it will retain the internal hypertext links and formatting. Different style sheets have been created for the different versions of the *Guide*, and also for the Act.

The HTML conversions of the completed releases were also delivered. These files were put through a sampled quality control process designed to pick up as many problems as possible with the least effort. Problems discovered included tables that had not formatted correctly, paragraphs that had failed to split appropriately, and other formatting issues, requiring only minor corrective work. Releases from the most recent years needed far less work because they had been created directly in HTML. Nevertheless, they needed their links checked and broken links modified, especially those to external sites. The releases around the time of the rewrite in 1998 have proved time-consuming. At this time the creators were experimenting with the 'look' of these releases, so the banners and graphics change with every release. In a twelve-month period at the rewrite stage, releases had only been stored as 'project' files – in an interim editorial stage – rather than as finished HTML, resulting in additional work to publish these releases.

Unforeseen issues in this migration process included a major change in the Library's IT infrastructure which had the unintended consequence of cutting all access to the *Guide* project data. To solve this, 40 gigabytes of data was transferred to a temporary storage platform during this change. Despite this, the project is close to completion. The HTML version went live on 16 November 2004, and the XML version is expected to be available in 2006 (when the Department rolls out infrastructure able to support XML).

The project fulfilled a clear, identifiable and urgent need – to preserve data that was becoming corrupted and/or inaccessible. This data is essential corporate history, and there are clear drivers to preserve access to it. Besides the legal responsibility of being able to justify decisions based on data as it was at the time they were made, there is an important need to trace how the management of individual pensions or benefits evolved and changed. In some cases significant changes in meaning have occurred because a word or a bit of formatting has altered. In other cases, understanding the natural progression of changes through time due to legislative and stylistic changes is important to work groups in understanding why a piece of legislation is now interpreted the way that it is. However, at the start of the project the project team had no clear idea of what it was getting into and initial funding for the project was insufficient and more had to be sought. XML was selected with the best of intentions, and it is certainly capable of everything required of it, but lack of experience with it, and the consultant's lack of familiarity with the *Guide*, led to underestimating the

amount of work involved in creating the transformations. HTML could have been selected as a reasonable medium for archival purposes, or PDF could have been investigated; these may have ended up being more cost-effective for archiving the material. Using XML means that not all of each complete release is preserved in XML; associated acts and handbooks were not covered due to insufficient funds, and it was decided not to preserve in XML legislation that is not the responsibility of FaCS. This will not change in the foreseeable future.

Case Study 6
PADI (Preserving Access to Digital Information)

This case study describes PADI (Preserving Access to Digital Information), a subject gateway to digital preservation resources It is one of two activities of the National Library of Australia described here, the other being PANDORA (Case Study 2). This case study illustrates the topics of collaboration (Chapter 9) and the importance of education and raising awareness (Chapter 10).

PADI (www.nla.gov.au/padi) is 'a subject gateway to digital preservation resources'. PADI is simply described. It was established in 1997 by the National Library of Australia to respond to the growing recognition of the need to safeguard digital heritage. It is intended as an educational tool to share information about and support digital preservation in Australia and worldwide. PADI is now a comprehensive subject gateway to resources dealing with a wide range of digital preservation issues, containing pages about events, policies, strategies, guidelines, and projects, and providing information about organizations, web sites, bibliographies, discussion lists, journals, newsletters, and glossaries. It also offers explanatory text about digital preservation topics. Its significant amount of explanatory text provides excellent starting points for its users. It is often the only port of call needed for queries about digital preservation matters.

PADI also provides other services. One is a moderated discussion list, padi-forum-l, for the exchange of news and ideas about digital preservation issues. Its archive is accessible on the web. It also issues an electronic newsletter, *DPC/PADI: What's New in Digital Preservation*, in collaboration with the Digital Preservation Coalition. This is a quarterly digest of selected recent digital preservation activity, such as events and publications, compiled from the PADI database, the padiforum-l mailing list, and the digital-preservation mailing list operated by the Digital Preservation Coalition. A feature introduced in 2004 is PADI trails, offering introductions to digital preservation topics by providing guided pathways through materials on the PADI web site.

PADI was established in 1997. (Howell and Berthon (2000) give its early history.) Its aims included providing a forum for cross-sectoral cooperation on digital preservation activities, and it is guided by an international advisory group which in 2002 had representatives from the UK, the US, Finland, Norway, Germany, Sweden, Switzerland, Canada, Holland, Norway, as well as Australia. Collaboration is a key characteristic of PADI. Although overall management of PADI is in the hands of the National Library of Australia, it received assistance from CLIR (the US Council on Library and Information Resources) for the Safekeeping Project (see below). The National Library signed a Memorandum of Understanding with the Digital Preservation Coalition (UK) in 2002, resulting

in UK input into PADI and in the joint compilation of the newsletter *What's New in Digital Preservation*. ERPANET and the National Library of Australia also signed a Memorandum of Understanding in 2003, to encourage sharing of information resources; this has resulted in increased material from European sources in PADI. A partnership with Nestor, which would bring additional German material to PADI, was being discussed in 2004.

Some of the resources on PADI are noted as 'Safekept'. Safekept items are selected as being of long-term value, for example, seminal papers in the field, or papers that summarize important issues in digital preservation. These are archived and managed by the National Library of Australia in the same way as PANDORA material so that it will be accessible in the long term. The Safekeeping Project is supported by CLIR. Materials are selected for safekeeping by a panel of international selectors. The National Library of Australia contacts the owners of the resources selected to inform them that they will be archiving their resources, and that the owners can reject the offer. This 'opt-in' approach is reported as being 100 per cent successful (Hanley, 2004).

PADI is clearly achieving its goals. 97 per cent of a survey of users and stakeholders carried out in 2000 had the PADI site bookmarked in their web browser (Howell and Berthon, 2000, p.12) and it was described by one respondent as a 'campfire around which this community of interest can gather' (Howell and Berthon, 2000, p.13). One aspect of the National Library of Australia's standard practice in digital preservation appears to be that when a problem is identified, the full range of possible solutions is explored; this proactive process takes place early in the process. PADI exemplifies this approach, and also other characteristics of Australian digital preservation practice: sharing of experiences, and a refreshing lack of proprietal ownership. PADI exemplifies the cooperative approach that 'the Library believes will be crucial in securing our global digital memory' (Berthon, 2002b).

Bibliography

The Preface to this book notes that there is a considerable amount of high-quality information available about preserving materials in digital form, and that much of it is available on the web. The accessibility that this provides is countered by the impermanence of much web material, as noted in several chapters in this book. All URLs in this Bibliography were correct at the time of writing.

Abbott, D. (2003) Overcoming the dangers of technological obsolescence: rescuing the BBC Domesday Project. *DigiCULT.Info: A Newsletter on Digital Culture*, **4**, 7–10

Abrams, S.L. and Seaman, D. (2003) Towards a global digital format registry. Paper presented at the *69th IFLA General Conference*, Berlin, 1–9 August 2003. Also available at www.ifla.org/IV/ifla69/papers/128e-Abrams_Seaman.pdf

Access in the future tense. (2004) Washington, D.C.: Council on Library and Information Resources

Adcock, E.P. (1998) *Principles for the care and handling of library materials.* International Preservation Issues, no. 1. Paris: IFLA PAC

Adelstein, P.Z. (1993) The stability of optical disks: a science-standards review. *The Commission on Preservation and Access Newsletter*, **58**, 3–4

Adelstein, P.Z. (2003) Preservation of electronic records: status of ISO standards. In *Symposium 2003: Preservation of Electronic Records: New Knowledge and Decision-making, Ottawa, 15–18 September 2003: preprints*

AMOL (2003) Conservation [amol.org.au/craft/conservation/conservation_index.asp]

ANICA: Australian Network for Information on Cellulose Acetate (2002) [www.nla.gov.au/anica]

Archives Association of Ontario (2001) What to keep and what to destroy? [aao.fis.utoronto.ca/aa/appraisal.html]

Archiving Web Resources (2004) Themes emerging from Archiving Web Resources – Issues for Cultural Heritage Organisations [Conference], National Library of Australia, Canberra, 9–11 November 2004 [www.nla.gov.au/webarchiving/ConferenceReport.rtf]

Arkival Technology Corporation (2002) *An evaluation of life expectancies, media stability and performance characteristics of denser magnetic media with special reference to IBM 3590 and digital linear tape systems.* Nashua, NH: Arkival Technology Corporation.

Arps, M. (1993) CD-ROM: some archival considerations. In *Preservation of electronic formats and electronic formats for preservation*, ed. J. Mohlhenrich, pp.83–107. Fort Atkinson, Wisc: Highsmith

Arthur, K. *et al.* (2004) Recognizing digitization as a preservation reformatting method [www.arl.org/preserv/digit_final.html]

AS ISO 15489.2–2002 (2002) *Records management – guidelines*. Sydney: Standards Australia

Aschenbrenner, A. (2004) The bits and bites of data formats: stainless design for digital endurance. *RLG DigiNews*, **8** (1) [www.rlg.org/preserv/diginews/v8_n1_feature3.html]

Australian Scholarly Editions Centre (2001) Authenticated electronic editions [idun.itsc.adfa.edu.au/ASEC/aueledns.html]

Authentec International (2003) Data recovery data loss: case studies index [www.disk-tape-data-recovery.com/case-studies.htm]

Authenticity (1999) [PADI summary]. National Library of Australia [www.nla.gov.au/padi/topics/4.html]

Authenticity in a digital environment. (2000) Washington, D.C.: Council on Library and Information Resources

Ayres, M-L. (2001) Evaluating the archives: 20th century Australian literature. *Archives & Manuscripts*, **29** (2), 32–47

Baker, N. (2001) *Double fold: libraries and the assault on paper*. New York: Random House

Barrow, W. J. (1959) *Deterioration of book stock: causes and remedies: two studies on the permanence of book paper*. Richmond, VA: Virginia State Library

Barton, M.R. and Walker, J.H. (2003) Building a business plan for DSpace, MIT Libraries' digital institutional repository. *Journal of Digital Information*, **4** (2) [jodi.ecs.soton.ac.uk/Articles/v04/i02/Barton]

Beagrie, N. (2001) Preserving UK digital library collections. *Program*, **35** (3), 217–226

Beagrie, N. (2003) *National digital preservation initiatives: an overview of developments in Australia, France, the Netherlands, and the United Kingdom and of related international activity*. Washington, D.C.: Council on Library and Information Resources and Library of Congress

Beagrie, N. (2004) The Continuing Access and Digital Preservation Strategy for the UK Joint Information Systems Committee (JISC). *D-Lib Magazine*, **10** (7/8) [www.dlib.org/dlib/july04/beagrie/07beagrie.html]

Beagrie, N. and Greenstein, D. (1998) *A strategic policy framework for creating and preserving digital collections* (final draft, 14/7/98). London: Arts and Humanities Data Service

Bearman, D. (1998) *Archival methods*. Archives and Museums Informatics Technical Report, 9. Pittsburgh: Archives and Records Informatics

Bellinger, M. *et al.* (2004) OCLC's digital preservation program for the next generation library. *Advances in Librarianship*, **27**, 29–48

Bennett, J.C. (1997) *A framework of data types and formats, and issues affecting the long term preservation of digital material: JISC/NPO studies on the preservation of electronic materials*. British Library Research and Innovation Paper, 50. London: British Library Research and Innovation Centre

Berthon, H. (2002a) Nurturing our digital memory: digital archiving and preservation at the National Library of Australia [www.nla.gov.au/nla/staffpaper/2002/berthon1.html]

Berthon, H. (2002b) Understanding for digital preservation. *Gateways*, **56** [www.nla.gov.au/ntwkpubs/gw/56/p09a01.htm]

Besser, H. (2000) Digital longevity. In *Handbook for digital projects: a management tool for preservation and access*, ed. M. Sitts. Andover, Mass.: Northeast Document Conservation Center [www.nedcc.org/digital/dighome.htm]

Betts, M. (1999) Businesses worry about long-term data losses: will we access our saved data in 20 years? *Computerworld News*, Sept 20 [www.computerworld.com/news/1999/story/0,11280,37036,00.html]

Bishoff, L. and Allen, N. (2004) *Business planning for cultural heritage institutions*. Washington, D.C.: Council on Library and Information Resources

Boadle, D. (2004) Reinventing the archive in a virtual environment: Australians and the non-custodial management of electronic records. *Australian Academic & Research Libraries*, **35** (3), 242–252

Borgman, C.L. (2000) *From Gutenberg to the global information infrastructure: access to information in the networked world*. Cambridge, Mass.: MIT Press

Brabazon, T. (2000) He lies like a rug: digitising memory. *Media International Australia*, **96**, 153–161

Bradley, K. (1995) Preservation at the National Library of Australia's Oral History Collection. Paper presented at *Multimedia Preservation: Capturing the Rainbow Conference*, Brisbane, 28–30 November 1995 [www.nla.gov.au/nla/staffpaper/npokb.html]

Bradley, K. (2000) CD-R archiving: case study of an interim media. Paper presented at *A Future for the Past: IASA-SEAPAVAA Conference*, Singapore, 3–7 July 2000.

Bradley, K. (2003) Critical choices, critical decisions: sound archiving and changing technology. Paper presented at the *Researchers, Communities, Institutions, Sound Recordings Workshop*, University of Sydney, 30 September-1 October 2003 [conferences.arts.usyd.edu.au/viewpaper.php?id=57&cf=2]

Bradley, K. and Woodyard, D. (2000) Preservation metadata for digital collections: presentation for workshop, Metadata for Long Term Preservation in NEDLIB, Paris, 25 February 2000 [www.nla.gov.au/nla/staffpaper/2000/webb1.html]

Breeding, M. (2002) Preserving digital information. *Information Today*, **19** (5), 48–49

Brindley, L.J. (2000) Keynote address to the Preservation 2000 Conference. *New Review of Academic Librarianship*, **6**, 125–137

Brown, A. (2003) Preserving the digital heritage: building a digital archive for UK government records. Paper presented at *Online Information 2003*, 2–4 December 2003 [www.nationalarchives.gov.uk/preservation/digitalarchive/pdf/brown.pdf]

Bryan, R.E. (2003) Survey results: preservation management of born-digital documents in United States manuscripts repositories. In *Symposium 2003: Preservation of Electronic Records: New Knowledge and Decision-making, Ottawa, 15–18 September 2003: preprints*

BS4783 (1988-) *Storage, transportation and maintenance of media for use in data processing and information storage*. London: British Standards Institution

Bullock, A. (1999) Preservation of digital information: issues and current status. *Network Notes*, 60 [www.collectionscanada.ca/9/1/p1–259-e.html]

Burrows, T. (2000) Preserving the past, conceptualising the future: research libraries and digital preservation. *Australian Academic & Research Libraries*, **31** (4), 142–153

Byers, F.R. (2003) *Care and handling of CDs and DVDs: a guide for librarians and archivists*. Washington, D.C.: Council on Library and Information Resources and National Institute of Standards and Technology

CAMiLEON (2002?) BBC Domesday [www.si.umich.edu/CAMiLEON/domesday/domesday.html]

Caplan, P. (2004) PREMIS – Preservation Metadata – Implementation Strategies update 1. Implementing preservation repositories for digital materials: current practice and emerging trends in the cultural heritage community. *RLG DigiNews*, **8** (5) [www.rlg.org/en/page.php?Page_ID=20462#article2]

Casson, L. (2002) *Libraries in the ancient world*. New Haven: Yale Nota Bene

Cedars Project Team (2002) The Cedars Project Report, April 1998-March 2001 [www.leeds.ac.uk/cedars/OurPublications/cedarsrepmar01exec.html]

Chapman, S. (2003) Counting the cost of digital preservation: Is repository storage affordable? *Journal of Digital Information*, **4** (2), 1–15 [jodi.ecs.soton.ac.uk/Articles/v04/i02/Chapman]

Chivers, A. and Feather, J. (1998) The management of digital data: a metadata approach. *Electronic Library*, **16** (6), 365–372

Christensen, N.H. (2004) Towards format repositories for web archives. Paper presented at the *4th International Web Archiving Workshop (IWAW04)*, Bath, 16 September 2004. Available at www.netarchive.dk/website/publications/FormatRepositories-2004.pdf

Clausen, L.R. (2004) *Handling file formats*. Århus: State and University Library

Cloonan, M.V. (1993) The preservation of knowledge. *Library Trends*, **41** (4), 594–605

Cloonan, M.V. (2001) W(h)ither preservation? *Library Quarterly*, **71** (2), 231–242

Cloonan, M.V. and Sanett, S. (2000) Comparing preservation strategies and practices for electronic records. *New Review of Academic Librarianship*, **6**, 205–216

Cloonan, M.V. and Sanett, S. (2002) Preservation strategies for electronic records: where are we now – obliquity and squint? *American Archivist*, **65**, 70–106

Condron, F. *et al.* (1999) *Strategies for digital data: findings and recommendations from digital data in archaeology: a survey of user needs.* York: Archaeology Data Service [ads.ahds.ac.uk/project/strategies/index.html]

Consultative Committee for Space Data Systems (2002) *Reference Model for an Open Archival Information System (OAIS).* CCSDS 650.0-B-1 Blue Book. Washington, D.C.: NASA

Conway, P. (1996) *Preservation in the digital world.* Washington, D.C.: Council on Library and Information Resources

Conway, P. (2000) Overview: rationale for digitization and preservation. In *Handbook for digital projects: a management tool for preservation and access*, ed. M. Sitts. Andover, Mass.: Northeast Document Conservation Center [www.nedcc.org/digital/dighome.htm]

Cook, T. (1995) It's 10 o'clock: do you know where your data are? *Technology Review* **January** [web.mit.edu/erm/tcook/tr1995.html]

Cook, T. (2000) Beyond the screen: the records continuum and archival cultural heritage. Paper presented at the *Australian Society of Archivist Conference*, Melbourne, 18 August 2000 [www.archivists.org.au/sem/conf2000/terrycook.pdf]

Cornwell Management Consultants (2004) *Training needs analysis: final report.* London: Digital Preservation Coalition

Council of Australian State Libraries (2002) *Background paper [for] the Regional Consultation on the Preservation of Digital Heritage for Asia and the Pacific*, National Library of Australia, Canberra, 4–6 November, 2002

Cox, R.J. (2000?) The functional requirements for evidence in recordkeeping [www2.sis.pitt.edu/~rcox/FunReqs.htm]

Cox, R.J. (2001) *Managing records as evidence and information.* Westport, Conn.: Quorum Books

Cox, R.J. (2002) *Vandals in the stacks: a response to Nicholson Baker's assault on libraries.* Westport, Conn: Greenwood Press

Dack, D. (2001) Persistence is a virtue. Paper presented at the *Information Online 2001 Conference*, Sydney, 16–18 January 2001 [www.nla.gov.au/nla/staffpaper/2001/dack.html]

Dale, R.L. (2004) Consortial actions and collaborative achievements: RLG's preservation program. *Advances in Librarianship*, **27**, 1–23

Darlington, J., Finney, A. and Pearce, A. (2003) Domesday Redux: the rescue of the BBC Domesday Project videodiscs. *Ariadne*, **36** [www.ariadne.ac.uk/issue36/tna]

Day, M. (2004) Preservation metadata. In *Metadata Applications and Management* ed. G.E. Gorman and D.G. Dorner, pp.253–273. London: Facet

Day, R. (1989) Where's the rot?: a special report on CD longevity. *Stereo Review*, **April**, 23–24.

de Lusenet, Y. (2002) *Preservation of digital heritage: draft discussion paper prepared for UNESCO.* European Commission on Preservation and Access [www.knaw.nl/ecpa/PUBL/unesco.html]

Deegan, M. and Tanner, S. (2002) The digital dark ages. *Update*, **May** [www.cilip.org.uk/publications/updatemagazine/archive/archive2002/may/update0205b.htm]

Digital Curation Centre (2004) What is digital curation? [www.dcc.ac.uk/what.html]

Digital Domesday Book unlocked. (2002) *BBC News*, 2 December [news.bbc.co.uk/1/hi/technology/2534391.stm]

Digital Preservation Coalition (2003) *Annual company report 23 July 2002–31 July 2003* [www.dpconline.org/docs/DPCAR02–03.pdf]

Digital Preservation Coalition (2004) *Annual company report 1 August 2003–31 July 2004* [www.dpconline.org/docs/DPCAR03–04.pdf]

Digital Preservation Coalition (2004) Digital preservation: the global context: report on the DPC Forum held at the British Library Conference Centre, Wednesday 23 June 2004 [www.dpconline.org/graphics/events/for040623.html]

Digital Preservation Testbed (2003) *From Digital Volatility to Digital Permanence: Preserving Email*. The Hague: ICTU [www.digitaleduurzaamheid.nl/bibliotheek/docs/volatility-permanence-email-en.pdf]

DSpace communications kit. (2003) [dspace.org/implement/communications-kit.html]

DSpace FAQ. (2003) [dspace.org/faqs/index.html]

Dunning, A. (2001) *Excavating data: retrieving the Newham Archive*. London: Arts and Humanities Data Service [ahds.ac.uk/creating/case-studies/newham]

Duranti, L. (2003) Authenticity requirements for electronic records. In *Symposium 2003: Preservation of Electronic Records: New Knowledge and Decision-making, Ottawa, 15–18 September 2003: preprints*

Dureau, J.M. and Clements, D.W.G. (1986) *Principles for the preservation and conservation of library materials*. IFLA Professional Reports, no. 8. The Hague: IFLA

Eastwood, T. (2002) The appraisal of electronic records: what is new? *Comma*, 2002–**1/2**, 77–87

Eastwood, T. (2003) Appraising digital material for preservation as cultural heritage. In *Symposium 2003: Preservation of Electronic Records: New Knowledge and Decision-making, Ottawa, 15–18 September 2003: preprints*

Edmondson, R. (1998) *A philosophy of audiovisual archiving*. Paris: UNESCO [unesdoc.unesco.org/images/0011/001131/113127eo.pdf]

Edmondson, R. (2002) *Memory of the World: general guidelines* rev. edn. Paris: UNESCO

Edmondson, R. (2004) *Audiovisual archiving: philosophy and principles*. Paris: UNESCO [unesdoc.unesco.org/images/0013/001364/136477e.pdf]

Electronic Literature Organization (2005) [www.eliterature.org]

Ellis, J. (1993) (ed.) *Keeping archives* 2nd edn. Melbourne: Thorpe in association with the Australian Society of Archivists

Ellis, S. (2003) The moving frontier: the preservation of authentic and reliable digital records over time. In *GLAM: galleries, libraries, archives and museums: conference proceedings, Australian Society of Archivists 2003 National Conference, 17–20 September 2003, Adelaide*, pp.121–125. O'Connor, A.C.T.: Australian Society of Archivists

Ellis, S. and Stuckey, S. (1994) Australian Archives' approach to preserving long-term access to the Commonwealth's electronic records. *Playing for keeps – the proceedings of an electronic records management conference*, pp.113–132. Canberra: Australian Archives

ERPANET (2003) *Selecting technologies tool* [www.erpanet.org/guidance/docs/ERPANETSelect_Techno.pdf]

ERPANET/CODATA Workshop (2004) The selection, appraisal and retention of digital scientific data: final report, ERPANET/CODATA Workshop, Biblioteca Nacional, Lisbon, December 15–17, 2003. [www.erpanet.org/events/2003/lisbon/LisbonReportFinal.pdf]

ERPATraining (2004) File formats for preservation: briefing paper [www.erpanet.org/events/2004/vienna/erpaTrainingWien_BriefingPaper_v02.pdf]

Exon, M. (1995) The long-term management issues in the preservation of electronic information. Paper presented at *Multimedia Preservation: Capturing the Rainbow Conference*, Brisbane, 28–30 November 1995 [www.nla.gov.au/niac/meetings/npo95me.html]

Farley, J. (1999) *An introduction to archival materials: new media*. Kew, Surrey: Public Record Office.

Faulds, F. and Challinor, A. (1998) Archiving from the data warehouse. *Information Management & Technology*, **31** (6), 278–280

Flesch, J. (1996) A labour of love?: the story behind the compilation of *Love brought to book: a bio-bibliography of 20th century Australian romance novels. Australian Academic &Research Libraries*, **27** (3), 182–190

Flesch, J. (2004) *From Australia with love: a history of modern Australian popular romance novels.* Fremantle: Curtin University Books.

Gatenby, P. (2002a) Legal deposit, electronic publications and digital archiving: The National Library of Australia's Experience. Paper presented at the *68th IFLA General Conference*, Glasgow, August 18–24, 2002 [www.ifla.org/IV/ifla68/papers/071–124e. pdf]

Gatenby, P. (2002b) Report on Senior Executive Fellowship to research digital archiving in national libraries [www.nla.gov.au/nla/staffpaper/2002/elect.html]

George, J. (2003) What users are telling us: a symposium. *CLIR Issues*, **33**, 1–2, 6

Gertz, J. (1998) Selection guidelines for preservation. Paper presented at the *Joint RLG and NPO Preservation Conference: Guidelines for Digital Imaging*, University of Warwick, 28–30 September 1998 [www.rlg.org/preserv/joint/gertz.html]

Gertz, J. (2000) Selection for preservation in the digital age. *Library Resources & Technical Services*, **44** (2), 97–104

Geser, G. and Pereira, J. (2004) (eds) The future digital heritage space: an expedition report. *DigiCULT Thematic Issue*, **7**

Gilliland-Swetland, A.J. (2000) *Enduring paradigm: the value of the archival perspective in the digital environment.* Washington, D.C.: Council on Library and Information Resources.

Gilliland-Swetland, A.J. (2002) Testing our truths: delineating the parameters of the authentic archival electronic record. *American Archivist*, **65**, 196–215

Gilliland-Swetland, A.J. (2005) Electronic records management. *ARIST: Annual Review of Information Science and Technology*, **39**, 219–253

Global Data Vault Inc. (2005) dataVault service overview [www.globaldatavault.com/v3/ howitworks/serviceoverview.asp]

Gorman, M. (1997) What is the future of cataloguing and cataloguers? Paper presented at the *63rd IFLA General Conference*, Copenhagen, Denmark, August 31-September 5, 1997 [www.ifla.org/IV/ifla63/63gorm.htm]

Gracy, K.F. (2001) The imperative to preserve: competing definitions of value in the world of film preservation. PhD Thesis, University of California Los Angeles, USA

Granger, S. (2000) Emulation as a digital preservation strategy. *D-Lib Magazine*, **6** (10) [www.dlib.org/dlib/october00/granger/10granger.html]

Green, A., Dionne, J. and Dennis, M. (1999) *Preserving the whole: a two-track approach to rescuing social science data and metadata.* Washington, DC: Council on Library and Information Resources

Greenan, M. (2003) Dspace. *DigiCULT.Info: A Newsletter on Digital Culture*, **3**, 8

Guenther, R. (2004) PREMIS: Preservation Metadata Implementation Strategies update 2: core elements for metadata to support digital preservation. *RLG DigiNews*, **8** (6) [www.rlg.org/en/page.php?Page_ID=20492#article2]

Gunton, T. (1993) *A dictionary of information technology and computer science* 2nd edn. Manchester: NCC Blackwell

Gwinn, N.E. (1993) A national preservation program for agricultural literature. [preserve. nal.usda.gov:8300/npp/presplan.htm]

Hafner, K. (2004) Even digital memories fade. *New York Times*, 10 November 2004.

Hanley, M. (2004) PADI (Preserving Access to Digital Information) and safekeeping *High Energy Physics Libraries Webzine*, **9**. Also available at www.nla.gov.au/nla/staffpaper/ 2004/hanley1.html

Harris, C. (2000) Selection for preservation. In *Preservation: issues and planning*, ed. P.N. Banks and R. Pilette, pp.206–224. Chicago: American Library Association.

Harter, R. (1999) Piltdown Man [home.tiac.net/~cri_a/piltdown/piltdown.html]

Harvey, R. (1993) *Preservation in libraries: principles, strategies and practices for librarians.* London: Bowker-Saur

Harvey, R. (1995) From digital artefact to digital object. Paper presented at *Multimedia Preservation: Capturing the Rainbow Conference,* Brisbane, 28–30 November 1995 [www.nla.gov.au/niac/meetings/npo95rh.html]

Harvey, R. (2003) Preserving digital documentary heritage in libraries: what do we select? In *Symposium 2003: Preservation of Electronic Records: New Knowledge and Decision-making, Ottawa, 15–18 September 2003: preprints*

Heazlewood, J. (2000) ePreservation in the archive: theories, practices. *Australian Academic & Research Libraries,* **31** (4), 173–187

Heazlewood, J. (2002) *Public Record Office Victoria: background report to the UNESCO Regional Consultation on the Preservation of Digital Heritage,* Canberra, 4–6 November 2002.

Hebditch, M. (1998) Foreword. In Orna, E. and Pettitt, C. *Information Management in Museums* 2nd edn, p.viii. Aldershot: Gower

Hedstrom, M. (1998) Digital preservation: a time bomb for digital libraries. *Computers and Humanities,* **31**, 189–202

Hedstrom, M. and Lampe, C. (2001) Emulation vs. migration: do users care? *RLG DigiNews,* **5** (6) [www.rlg.org/legacy/preserv/diginews/diginews5–6.html#feature1]

Hedstrom, M. and Lee, C.A. (2002) Significant properties of digital objects: definitions, applications, implications. *Proceedings of the DLM-Forum 2002: @ccess and Preservation of Electronic Information: Best Practices and Solutions, Barcelona, 6–8 May 2002,* pp. 218–223. Brussels: European Commission

Hedstrom, M. and Montgomery, S. (1999) *Digital preservation needs and requirements in RLG member institutions: a study commissioned by the Research Libraries Group.* Mountain View, CA: Research Libraries Group

Hendley, T. (1998) *Comparison of methods & costs of digital preservation.* London: British Library Research and Innovation Centre

Heslop, H., Davis, S. and Wilson, A. (2002) *An approach to the preservation of digital records.* Canberra: National Archives of Australia.

Heterick, B. (2002) Applying the lessons learned from retrospective archiving to the digital archiving conundrum. *Information Services & Use,* **22**, 113–120

Higgs, E. (1998) (ed.) *History and electronic artefacts.* Oxford: Clarendon Press

Hodge, G. and Frangakis, E. (2004) Digital preservation and permanent access to scientific information: the state of the practice: a report sponsored by the International Council for Scientific and Technical Information (ICSTI) and CENDI [cendi.dtic.mil/publications/04–3dig_preserv.html]

Hodge, G.M. (2003) Digital preservation: overview of current developments. *Information Services & Use,* **22**, 73–82

Hofman, H. (2002) Review: some comments on preservation metadata and the OAIS Model. *DigiCULT.Info: A Newsletter on Digital Culture,* **2**, 15–20

Holdsworth, D. and Wheatley, P. (2001) Emulation, preservation, and abstraction. *RLG DigiNews,* **5** (4) [www.rlg.org/preserv/diginews/diginews5–4.html]

Horn, A. (2002) [Background paper on Council of Australian University Librarians for] The Regional Consultation Meeting on the Preservation of Digital Heritage for Asia and the Pacific, National Library of Australia, Canberra, 4–6 November 2002 [www.anu.edu.au/caul/preservation/DigitalHeritage-CAUL.doc]

Howell, A. (2000) Perfect one day – digital the next: challenges in preserving digital information. *Australian Academic & Research Libraries,* **31** (4), 121–141

Howell, A. (2001) Preserving information in a digital age: what's the difference? *Paper Conservator,* **25**, 133–149

Howell, A.G. (2004) Preserving digital information: challenges and solutions: workbook [www.alanhowell.com.au/dpw/pdi_wkb.pdf]

Howell, A. and Berthon, H. (2000) http://www.nla.gov.au/padi/: Preserving Access to Digital Information (PADI) – an opportunity for global cooperation. Paper presented

at *IFLA Symposium on Managing the Preservation of Periodicals and Newspapers*, Paris, 21–24 August 2000 [www.ifla.org.sg/VI/4/conf/howell.pdf]

Humphrey, C. (2003) Preserving research data: a time for action. In *Symposium 2003: Preservation of Electronic Records: New Knowledge and Decision-making, Ottawa, Canada, 15–18 September 2003: Preprints.*

Inera Inc. (2001) *E-journal archive DTD feasibility study prepared for the Harvard University E-Journal Archiving Project.* Newton, Mass. [www.diglib.org/preserve/hadtdfs.pdf]

Integrity and authenticity of digital cultural heritage objects (2002) DigiCULT Thematic Issue, 1. Salzburg: DigiCULT Project [www.digicult.info/downloads/thematic_issue_1_final.pdf]

International Association of Sound and Audiovisual Archives Technical Committee (2004) *Guidelines on the production and preservation of digital audio objects.* Aarhus: IASA.

International Council on Archives Committee on Electronic Records (1997) *Guide for managing electronic records from an archival perspective.* ICA Studies, 8. Paris: ICA

International DOI Foundation (2004?) Welcome to the digital object identifier system [www.doi.org]

James, H. *et al.* (2003) *Feasibility and requirements study on preservation of e-prints: report commissioned by the Joint Information Systems Committee.* London: JISC [www.jisc.ac.uk/uploaded_documents/e-prints_report_final.pdf]

James, M.S. (2001) Fading bits of history as computer records replace paper. *Good Morning America World News Tonight*, 9 July 2001. Available at www.thearchivecompany.com/Forms/Fading%20bits%20of%20history.htm

Janes, J. (2003) Internet librarian: authority by community. *American Libraries,* **January,** 92

Jenkinson, H. (1965) *A manual of archive administration* 2nd edn rev. London: Lund, Humphries

JISC (2004) Digital preservation training programme [www.jisc.ac.uk/index.cfm?name=project_dptp]

Jones, M. (2004) Editor's interview: Digital Preservation Coalition. *RLG DigiNews*, **8** (1) [www.rlg.org/preserv/diginews/diginews8–1.html]

Jones, M. and Beagrie, N. (2001) *Preservation management of digital materials: a handbook.* London: British Library.

Kasteren, J. van (2002) Analogue versus digital storage of our history: an interview with Hartmut Weber, President, Bundesarchiv, Germany. *DigiCULT Thematic Issue, 1,* 9 [www.digicult.info/downloads/thematic_issue_1_final.pdf]

The KB e-Depot: Permanent Access to Digital Publications (2004) [publicity brochure]

Kenney, A.R. and Rieger, O.Y. (2000) *Moving theory into practice: digital imaging for libraries and archives.* Mountain View, CA: Research Libraries Group

Kenney, A.R and Rieger, O.Y. (2001) The National Library of Australia's Digital Preservation Agenda: an interview with Colin Webb. *RLG DigiNews*, **5** (1) [www.rlg.org/legacy/preserv/diginews/diginews5–1.html#feature1]

Kenney, A.R. and Stam, D.C. (2002) *The state of preservation programs in American college and research libraries: building a common understanding and action agenda.* Washington, D.C.: Council on Library and Information Resources

Kenney, A. *et al.* (2003) *Digital preservation management: implementing short-term strategies for long-term problems [tutorial].* Ithaca, N.Y.: Cornell University Library [www.library.cornell.edu/iris/tutorial/dpm/index.html]

Kerry, A. (2001) Digital preservation: the research and development agenda in Australia. Paper prepared for the *Digital Continuity Forum*, Swinburne University of Technology, 19 November 2001. Melbourne: Australian Foresight and Information Resources Group, Swinburne University of Technology

Knight, S. (2003) Preservation metadata and digital continuity. *DigiCULT.Info: A Newsletter on Digital Culture*, **3**, 18–20

Koehler, W. (2004) A longitudinal study of web pages continued: a consideration of document persistence. *Information Research* **9** (2) [informationr.net/ir/9–2/paper174.html]

Koerbin, P. (2004) Managing web archiving in Australia: a case study. Paper presented at the *4th International Web Archiving Workshop (IWAW04)*, Bath, 16 September 2004 [www.iwaw.net/04]

Kranch, D.A. (1998) Beyond migration: preserving electronic documents with digital tablets. *Information Technology and Libraries,* **17** (3), 138–146

Kunej, D. (2004) The Use of CD-Rs for archival storage and preservation: vulnerability of CD-Rs based on the susceptibility to sunlight experiment. *IASA Journal,* **23,** 65–80

Kuny, T. (1998) The digital dark ages?: challenges in the preservation of electronic information. *International Preservation News,* **17,** 8–13

Lacken, C. (2001) Prioritising for migration to digital formats in television archives. *IASA Journal,* **17,** 25–28.

Lavoie, B. (2000) Meeting the challenge of digital preservation: the OAIS Reference Model. *OCLC Newsletter,* **Jan/Feb,** 26–30

Lavoie, B.F. (2003) *The incentives to preserve digital materials: roles, scenarios, and economic decision-making.* Dublin, Ohio: OCLC [www.oclc.org/research/projects/digipres/incentives-dp.pdf]

Lavoie, B.F. (2004) Of mice and men: economically sustainable preservation for the twenty-first century. In *Access in the future tense* (2004), pp.45–54

Lavoie, B. and Dempsey, L. (2004) Thirteen ways of looking at . . . digital preservation. *D-Lib Magazine,* **10** (7/8) [www.dlib.org/dlib/july04/lavoie/07lavoie.html]

Lawrence, G.W. *et al.* (2000) *Risk management of digital information: a file format investigation.* Washington, D.C.: Council on Library and Information Resources

Lazinger, S.S. (2001) *Digital preservation and metadata: history, theory, practice.* Englewood, Colo: Libraries Unlimited

LeFurgy, W.G. (2003) PDF/A: developing a file format for long-term preservation. *RLG DigiNews,* **7** (6) [www.rlg.org/legacy/preserv/diginews/diginews7–6.html#feature1]

Legal deposit (2003) [PADI summary]. National Library of Australia [www.nla.gov.au/padi/topics/67.html]

Lieberman, P. (1995) Taking measure of magnetic, optical, and magneto-optical media and drives, *CD-ROM Professional,* **8** (7), 62–74

Life Caching (2004) [www.trendwatching.com/trends/LIFE_CACHING.htm]

Lim S. L., Ramaiah, C. K. and Pitt K.W. (2003) Problems in the preservation of electronic records. *Library Review,* **52** (3), 117–125

Linden, J. *et al.* (2005) *The Large-Scale Archival Storage of Digital Objects: Technology Watch Report.* DPC Technology Watch Series Report, 04–03. York: Digital Preservation Coalition [www.dpconline.org/docs/dpctw04–03.pdf]

LOCKSS (2004?) About LOCKSS [lockss.stanford.edu/about/about.htm]

Lord, P. and Macdonald, A. (2003) *E-science curation report: data curation for e-science in the UK: an audit to establish requirements for future curation and provision.* Prepared for the JISC Committee for the Support of Research (JCSR). London: Digital Archival Consultancy

Lorie, R. (2002) *The UVC: a method of preserving digital documents – proof of concept.* Long-term preservation study report series, no. 4. Amsterdam: IBM Netherlands

Lowenthal, D. (1985) *The past is a foreign country.* Cambridge: Cambridge University Press

Lukesh, S.S. (1999) E-mail and potential loss to future archives and scholarship or the dog that didn't bark. *Firstmonday,* **4** (9) [firstmonday.org/issues/issue4_9/lukesh/index.html]

Lupovici, C. (2001) Technical data and preservation needs. Paper presented at the *67th IFLA Council and General Conference,* Boston, August 16–25, 2001 [www.ifla.org/IV/ifla67/papers/163–168e.pdf]

Lyall, J. (1993) Determining the significance of documentary heritage materials. *Australian Academic & Research Libraries,* **24,** 69–77

Lyman, P. and Kahle, B. (1998) Archiving digital cultural artifacts: organizing an agenda for action. *D-Lib Magazine,* **July/August** [www.dlib.org/dlib/july98/07lyman.html]

Lynch, C. (1999) Canonicalization: A fundamental tool to facilitate preservation and management of digital information. *D-Lib Magazine*, **5** (9) [www.dlib.org/dlib/september99/09lynch.html]

Lynch, C.A. (2004) Editor's interview with Clifford A. Lynch. *RLG DigiNews*, **8** (4) [www.rlg.org/en/page.php?Page_ID=19481#article0]

Marcum, D. and Friedlander, A. (2003) Keepers of the crumbling culture: what digital preservation can learn from library history. *D-Lib Magazine*, **9** (5) [www.dlib.org/dlib/may03/friedlander/05friedlander.html]

McKnight, S. and Livingston, H. (2003) Reuse of learning objects? why, how and when? *Educause in Australasia*, University of Adelaide, 6–9 May 2003 [www.deakin.edu.au/learningservices/staff/publications/sue/ReuseLearningObjects.doc]

Meeting of Experts on Digital Preservation (2004) *Report on the Meeting of Experts on Digital Preservation: Metadata Specifications*. Washington, D.C.: USGPO [www.gpoaccess.gov/about/reports/metadata.html]

Mellor, P. (2003) CAMiLEON: Emulation and BBC Domesday, *RLG DigiNews*, **7** (2) [www.rlg.org/legacy/preserv/diginews/diginews7–2.html#feature3]

Millar, L. (2004) *Authenticity of electronic records: a report prepared for UNESCO and the International Council on Archives*. ICA Study, 13–2. Paris: ICA.

Moehle, F. (2004) The role of file formats in digital preservation: opportunities and threats. Paper presented at the ERPANET *File Formats for Preservation* seminar, Vienna, 10–11 May 2004 [www.erpanet.org/events/2004/vienna/index.php#papers]

Montfort, N. and Wardrip-Fruin, N. (2004) *Acid-free bits: recommendations for long-lasting electronic literature*. Los Angeles, CA.: Electronic Literature Organization [www.eliterature.org/pad/afb.html]

Morris, S. (2002) The preservation problem: collaborative approaches. *Information Services & Use*, **22**, 127–132

Morrison, I. (1999) www.nla.gov.au/pandora: Australia's internet archive. *Australian Library Journal*, **48** (3), 271–284

Müller, E. (2004) DiVA: academic archive online. *DigiCULT.Info: A Newsletter on Digital Culture*, **9**, 22–25

Muir, A. (2004a) Digital preservation: awareness, responsibility and rights issues. *Journal of Information Science*, **30** (1), 73–92.

Muir, A. (2004b) Issues in the long-term management of digital materials. In *Managing preservation for libraries and archives: current practice and future developments*, ed. J. Feather, pp.67–81. Aldershot, Hants: Ashgate

MyLifeBits Project (2003) [research.microsoft.com/barc/MediaPresence/MyLifeBits.aspx]

National Archives (U.K.) (2004?) *1986 Domesday Community* [www.nationalarchives.gov.uk/preservation/research/domesday.htm]

National Archives of Australia (2001a) *Archiving web resources: a policy for keeping records of web-based activity in the Commonwealth Government*. Canberra: National Archives of Australia

National Archives of Australia (2001b) *Archiving web resources: guidelines for keeping records of web-based activity in the Commonwealth Government*. Canberra: National Archives of Australia

National Archives of Australia (2001c) Recordkeeping metadata standard for Commonwealth agencies [www.naa.gov.au/recordkeeping/control/rkms/summary.htm]

National Archives of Australia (2004) Digital Preservation Project (previously known as the Agency to Researcher (AtoR) project) [www.naa.gov.au/recordkeeping/preservation/digital/summary.html]

National Library of Australia (1999?) Voluntary deposit scheme for physical format electronic publications [www.nla.gov.au/policy/vdelec.html]

National Library of Australia (1999a) A draft research agenda for the preservation of physical format digital publications [www.nla.gov.au/policy/rsagenda.html]

National Library of Australia (1999b) Preservation metadata for digital collections [www.nla.gov.au/preserve/pmeta.html]

National Library of Australia (2000?) First steps in preserving digital publications [www.nla.gov.au/pres/epupam.html]

National Library of Australia (2001) Use of Australian CD-ROMs & other electronic materials acquired by deposit, version 2 [www.nla.gov.au/policy/cdrom.html]

National Library of Australia (2002a) Digital preservation policy [www.nla.gov.au/policy/digpres.html]

National Library of Australia (2002b) Persistent identifiers [www.nla.gov.au/initiatives/persistence.html]

National Library of Australia (2004?) Recommended practices for digital preservation [www.nla.gov.au/preserve/digipres/digiprespractices.html]

National Research Council (1995) *Preserving scientific data on our physical universe: a new strategy for archiving the nation's scientific information resources.* Washington, D.C.: National Academy Press

NISO (2004) *Understanding metadata.* Bethesda, MD: National Information Standards Organization Press

Norsam Technologies (2001) *HD-Rosetta Archival Preservation Services* [www.norsam.com/hdrosetta.htm]

NSF-DELOS Working Group on Digital Archiving and Preservation (2003) *Invest to save: report and recommendations of the NSF-DELOS Working Group on Digital Archiving and Preservation.* National Science Foundation & The European Union

Nunberg, G. (1995) The places of books in the age of electronic reproduction. In *Future libraries,* ed. R.H. Bloch and C.A. Hesse, pp.13–37. Berkeley: University of California Press

OCLC/RLG Working Group on Preservation Metadata (2002) A metadata framework to support the preservation of digital objects [www.oclc.org/research/projects/pmwg/pm_framework.pdf]

OCLC/RLG PREMIS Working Group (2004*) Implementing preservation strategies for digital materials: current practice and emerging trends in the cultural heritage community.* Dublin, OH: OCLC

O'Mahony, D.P. (1998) Here today, gone tomorrow: what can be done to assure permanent public access to electronic government information? *Advances in Librarianship,* **22,** 107–121

Ontrack Data Recovery (2004) Understanding data loss [www.ontrack.com/understandingdataloss/index.asp]

Pacey, A. (1991) Developing selection criteria for special collections. *Canadian Library Journal,* **48,** 187–190

Parkes, M. (1999) A review of the preservation issues associated with digital documents. *Australian Library Journal,* **48** (4), 358–377

Parliament of Australia Joint Committee of Public Accounts and Audit (2004) *Report 399: inquiry into the management and integrity of electronic information in the Commonwealth, March 2004.* Canberra: Parliament of Australia

Pawley, A. (2003) The need for a Pacific languages archive. Paper presented at the *Researchers, Communities, Institutions, Sound Recordings* Workshop, 30 September-1 October 2003 [conferences.arts.usyd.edu.au/viewpaper.php?id=45&cf=2]

Peasley, J. (1993) Australian-created electronic information: preservation issues and guidelines. *Australian Library Journal,* **42,** 147–141

Persistent identifiers (2002) [PADI summary]. National Library of Australia [www.nla.gov.au/padi/topics/36.html]

Phillips, M. (2000) Managing chaos in the cyberworld. Paper presented at CONSAL 2000, the 11th Congress of Southeast Asian Librarians Conference, Singapore, 26–28 April 2000 [www.nla.gov.au/nla/staffpaper/mphillips5.html]

Phillips, M. (2002) Archiving the Web: the National Collection of Australian Online Publications. Paper presented at the International Symposium on Web Archiving, National Diet Library, Tokyo, Japan, 30 January 2002. [www.nla.gov.au/nla/staff-paper/2002/phillips1.html]

Phillips, M. (2004) What to collect and how to do it: the National Library of Australia's selective approach. Paper presented at the *Archiving Web Resources International Conference, National Library of Australia,* Canberra, 9–11 November 2004 [www.nla.gov.au/webarchiving/PhillipsMargaret.rtf]

Piggott, M. (2001) Appraisal: the state of the art: paper delivered at a professional development workshop presented by ASA South Australia Branch 26 March 2001 [www.archivists.org.au/sem/misc/piggott.html]

Pockley, S. (1995–) Killing the duck to keep the quack [www.duckdigital.net/FOD/FOD0055.html]

Pockley, S. (2002) *Australian Centre for the Moving Image: background report to the UNESCO Regional Consultation on the Preservation of Digital Heritage,* Canberra, 4–6 November 2002.

Potter, M. (2002) Researching long term digital preservation approaches in the Dutch Digital Preservation Testbed (Testbed Digital Bewaring). *RLG DigiNews,* **6** (3) [www.rlg.org/legacy/preserv/diginews/diginews6–3.html#feature2]

Preservation metadata (2003) [PADI summary]. National Library of Australia [www.nla.gov.au/padi/topics/32.html]

Public Record Office (2000) *Evaluating information assets: appraising the inventory of electronic records.* Kew, Public Record Office [www.nationalarchives.gov.uk/electronicrecords/advice/pdf/appraisal_toolkit.pdf]

Public Record Office of Victoria (1996) *Keeping records forever: records management vision development.* Melbourne, Vic. [www.prov.vic.gov.au/vers/pdf/kerf.pdf]

Public Record Office of Victoria (1998) *Victorian Electronic Records Strategy final report.* Melbourne, Vic. [www.prov.vic.gov.au/vers/pdf/final.pdf]

Public Record Office of Victoria (2003) *Management of electronic records PROS 99/007* (Version 2). Melbourne, Vic. [www.prov.vic.gov.au/vers/standard/version2.htm]

Public Record Office of Victoria (2004) *VERS: Forever Digital.* Melbourne, Vic.

Quenault, H. (2001) VERS implementation project at the Department of Infrastructure, Melbourne, Australia. *Records Management Journal,* **11** (2), 71–82

Quenault, H. (2003) Case study: implementation of the VERS strategy for electronic records within the Government of the State of Victoria, Australia. Paper presented at *Symposium 2003: Preservation of Electronic Records: New Knowledge and Decision-making,* Ottawa, Canada, 15–18 September 2003

Quenault, H. (2004) VERS: building a digital record heritage. Paper presented at *VALA 2004 12th Biennial Conference and Exhibition,* Melbourne, 3–5 February, 2004 [www.vala.org.au/vala2004/2004pdfs/13Quena.PDF]

Read, J. (1999) Parish map preservation project: the use of digital holography, CD's [sic] and computers to copy, view (and preserve) old maps. *LASIE,* **30** (3), 45–53

Redefining film preservation: a national plan (1994) Washington, D.C.: Library of Congress

Reich, V.A. (2002) Lots of Copies Keep Stuff Safe as a cooperative archiving solution for e-journals. *Issues in Science and Technology Librarianship,* **36** [www.istl.org/02-fall/article1.html]

Reich, V. and Rosenthal, D.S. (2000) LOCKSS (Lots Of Copies Keep Stuff Safe). *New Review of Academic Librarianship,* **6,** 155–161

Reuben, L. (2004) From proprietary format to open source – preserving digital resources. Paper presented at the *Digital Library Technology Conference,* Sydney, July 2004.

RLG/OCLC Working Group on Digital Archive Attributes (2002) *Trusted digital repositories: attributes and responsibilities.* Mountain View, CA: Research Libraries Group

Robertson, A. and Cunningham, A. (2000) Documenting the business of government: archival issues in the digital age. *Australian Academic & Research Libraries,* **31** (4), 188–201

Rosenthal, D.S. *et al.* (2005) Transparent format migration of preserved web content. *D-Lib Magazine*, **11** (1) [www.dlib.org/dlib/january05/rosenthal/01rosenthal.html]

Ross, S. (2000) *Changing trains at Wigan: digital preservation and the future of scholarship.* London: National Preservation Office, British Library [www.bl.uk/services/preservation/occpaper.pdf]

Ross, S. (2002) Position paper on integrity and authenticity of digital cultural heritage objects. *DigiCULT Thematic Issue*, **1**, 7–8 [www.digicult.info/downloads/thematic_issue_1_final.pdf]

Ross, S. (2004) The role of ERPANET in supporting digital curation and preservation in Europe. *D-Lib Magazine*, **10** (7/8) [www.dlib.org/dlib/july04/ross/07ross.html]

Ross, S. and Gow, A. (1999) *Digital archaeology: rescuing neglected and damaged data Resources: a JISC/NPO study within Electronic Libraries (eLib) Programme on the Preservation of Electronic Materials.* London: Library Information Technology Centre [www.ukoln.ac.uk/services/elib/papers/supporting/pdf/p2.pdf]

Ross, S., Greenan, M. and McKinney, P. (2003) Cross-sectoral development of digital preservation strategies: ERPANET and the expansion of knowledge. In *Symposium 2003: Preservation of Electronic Records: New Knowledge and Decision-making, Ottawa, 15–18 September 2003: preprints*

Ross, S. *et al.* (2004) New organisational structures responding to new challenges: the Digital Curation Centre in the UK. DCC Public Lecture, Schweizerisches Bundesarchive, 25 October 2004 [www.erpanet.org/events/2004/bern/SR_DCCpresentation_BERNE_erpanet_mtg_2.pdf]

Rothenberg, J. (1995) Ensuring the longevity of digital documents. *Scientific American*, **272**, 42–47

Rothenberg, J. (1999a) *Avoiding technological quicksand: finding a viable technical foundation for digital preservation.* Washington, D.C.: Council on Library and Information Resources

Rothenberg, J. (1999b) *Ensuring the longevity of digital information.* Washington, D.C.: Council on Library and Information Resources (Expanded version of Rothenberg 1995) [www.clir.org/pubs/archives/ensuring.pdf]

Rothenberg, J. (2000) *An experiment in using emulation to preserve digital publications.* Den Haag: Koninklijke Bibliotheek [www.kb.nl/coop/nedlib/results/emulationpreservationreport.pdf]

Rothenberg, J. (2003) Digital preservation summary. Presented at *Practical Experiences in Digital Preservation Conference*, National Archives, Kew, 2–4 April 2003 [www.nationalarchives.gov.uk/preservation/news/conference/media/rothenberg.pdf]

Royal Statistical Society and UK Data Archive (2002) *Preserving & sharing statistical material.* Colchester: UK Data Archive.

Rushbridge, A. (2004a) Recognising advances in digital preservation. *DigiCULT.Info: A Newsletter on Digital Culture*, **8**, 34–36

Rushbridge, A. (2004b) XENA: electronic normalising tool. *DigiCULT.Info: A Newsletter on Digital Culture*, **7**, 32–33

Russell, K. (1999) Why can't we preserve everything?: selection issues for the preservation of digital materials: debate and discussion at the Cedars Project Advisory Board Meeting, 28 May 1999, The British Library, St Pancras [www.leeds.ac.uk/cedars/colman/ABS01.html]

Saffady, W. (1993) *Electronic document imaging systems: design, evaluation, and implementation.* Westport, CT: Meckler

Sanett, S. (2003) The cost to preserve electronic records in perpetuity: comparing costs across cost models and cost frameworks. *RLG DigiNews*, **7** (4) [www.rlg.org/legacy/preserv/diginews/diginews7–4.html#feature2]

Sassoon, J. (1998) Photographic meaning in the age of digital reproduction. *LASIE*, **29** (4), 5–15

Schonfield, R.C. *et al.* (2004) *The nonsubscription side of periodicals: changes in library operations and costs between print and electronic formats.* Washington, D.C.: Council on Library and Information Resources

Schüller, D. (2000) 'Personal' digital mass storage systems: a viable solution for small institutions and developing countries [www.unesco.org/webworld/points_of_views/schuller.shtml]

Schwirtlich, A. (2002) The functional approach to appraisal: the experience of the National Archives of Australia. *Comma*, **1/2**, 57–62.

Searle, S. and Thompson, D. (2003) Preservation metadata: pragmatic first steps at the National Library of New Zealand. *D-Lib Magazine*, **9** (4) [www.dlib.org/dlib/april03/thompson/04thompson.html]

Shenton, H. (2000) From talking to doing: digital preservation at the British Library. *New Review of Academic Librarianship*, **6**, 163–177

(Significance): a guide to assessing the significance of cultural heritage objects and collections (2001) Canberra: Heritage Collections Council

Simpson, D. (2004a) *Contracting out for digital preservation services: information leaflet and checklist*. London: Digital Preservation Coalition

Simpson, D. (2004b) (comp.) Directory of digital preservation repositories and services in the UK [www.dpconline.org/docs/guides/directory.pdf]

Sitts, M.K. (2000) (ed.) *Handbook for digital projects: a management tool for preservation and access*. Andover, Mass.: Northeast Document Conservation Center [www.nedcc.org/digital/dighome.htm]

Slats, J. (2004) Practical experiences of the Digital Preservation Testbed: office formats. Paper presented at the ERPANET *File Formats for Preservation* seminar, Vienna, 10–11 May 2004 [www.erpanet.org/events/2004/vienna/index.php#papers]

Slattery, O. *et al.* (2004) Stability comparison of recordable optical discs: a study of error rates in harsh conditions. *Journal of Research of the National Institute of Standards and Technology*, **109** (5), 517–524

Smith, A. (1999) *The future of the past: preservation in American research libraries*. Washington, D.C.: Council on Library and Information Resources

Smith, A. (2002) The cost of providing access. *CLIR Issues*, **27**, 5

Smith, A. (2003) *New-model scholarship: how will it survive?* Washington, D.C.: Council on Library and Information Resources

Smith, B. (2002) Preserving tomorrow's memory: preserving digital content for future generations. *Information Services & Use*, **22**, 133–139

Smith, W. (1997) The National Library of Australia's Pandora Project. *Libri*, **47**, 169–179

Smith, W. (2004) Wine on the web: Australian wine information on the web and its prospects for long-term preservation and access. *Australian Academic & Research Libraries*, **35** (2), 111–128

Smith, W. (2005) Still lost in cyberspace?: preservation challenges of Australian internet resources. *Australian Library Journal* (forthcoming)

Sochats, K. and Williams, J. (1992) *Networking and communications desk reference*. Carmel, Indiana: SAMS

Society of American Archivists (1997) The preservation of digitized reproductions [www.archivists.org/statements/preservation-digirepros.asp]

Soete, G.J. (1997) *Preserving digital information*. SPEC Kit 228. Washington, D.C.: Association of Research Libraries

Steenbakkers, J.F. (2002) Preserving electronic publications. *Information Services & Use*, **22**, 89–96

Steenbakkers, J.F. (2004a) Digital archiving: a necessary evil or new opportunity? *Serials Review*, **30** (1), 29–32

Steenbakkers, J.F. (2004b) Treasuring the digital records of science: archiving e-journals at the Koninklijke Bibliotheek. *RLG DigiNews*, **8** (2) [www.rlg.org/en/page.php?Page_ID=17068#article0]

Strang, T. (2003) Choices and decisions. In *Symposium 2003: Preservation of Electronic Records: New Knowledge and Decision-making, Ottawa, 15–18 September 2003: preprints*

Stuckey, S. (2003) How to value a priceless asset: the experience of the National Archives of Australia or, What price archives and archivists? In *GLAM: galleries, libraries, archives and museums: conference proceedings, Australian Society of Archivists 2003 National Conference, 17–20 September 2003, Adelaide*, pp.114–120. O'Connor, A.C.T.: Australian Society of Archivists

Sturges, P. (1990) Access to information from the past: the birth of the amnesiac society? In *Conference Proceedings: Papers Presented at the Australian Library and Information Association 1st Biennial Conference, Perth, Western Australia, September 30-October 5 1990*, v.2, pp.295–306. Canberra, ACT: ALIA

Sullivan, J. (2001) True history of a writer. *The Age*, **6 October**, Extra, 3

Sullivan, S. *et al.* (2004) Bringing hidden treasures to light: illuminating DSpace. Paper presented at *VALA 2004 12th Biennial Conference and Exhibition*, Melbourne, 3–5 February, 2004 [www.vala.org.au/vala2004/2004pdfs/17SHGY.PDF]

Sullivan, S.J. (2004) ISO Standard development – overview of the draft PDF/A. Paper presented at the ERPANET *File Formats for Preservation* seminar, Vienna, 10–11 May 2004 [www.erpanet.org/events/2004/vienna/index.php#papers]

Task Force on Archiving of Digital Information (1996) *Preserving digital information*. Washington, D.C.: Commission on Preservation and Access

Task Force on the Artifact in Library Collections (2001) *The evidence in hand*. Washington, D.C.: Council on Library and Information Resources

Taylor, G. (1996) *Cultural selection*. New York: Basic Books

Thibodeau, K. (1999) Resolving the inherent tensions in digital preservation, Paper Presented at NSF Workshop on Data Archiving and Information Preservation, Washington, DC, 5 March 1999

Thibodeau, K. (2000) Certifying authenticity of electronic records, version 1, 19 April 2000. Unpublished

Thibodeau, K. (2002) Overview of technological approaches to digital preservation and challenges in coming years. In *The state of digital preservation: an international perspective*, pp.4–31. Washington, D.C.: Council on Library and Information Resources

Thibodeau, K., Moore, R. and Baru, C. (1999) Persistent object preservation: advanced computing infrastructure for digital preservation. Paper presented at *DLM Forum'99*, Brussels, 18–19 October 1999 [europa.eu.int/ISPO/dlm/fulltext/full_thib_en.htm]

Thomas, D. (2004) Digital preservation at the National Archives [www.nationalarchives.gov.uk/preservation/digitalarchive/pdf/dpattna.pdf]

Tibbo, H.R. (2003) On the nature and importance of archiving in the digital age. *Advances in Computers*, **57**, 1–67

Townsend, S., Chappell, C. and Struijvé, O. (1999) Digitising history: a guide to creating digital resources from historical documents. *AHDS Guides to Good Practice* [hds.essex.ac.uk/g2gp/digitising_history/index.asp]

Tresize, P. (2002) *Geoscience Australia: background report to the UNESCO Regional Consultation on the Preservation of Digital Heritage*, Canberra, 4–6 November 2002.

Tristram, C. (2002) Data extinction. *Technology Review*, **October** [www2.technologyreview.com/articles/02/10/tristram1002.asp]

UNESCO (2003) *Guidelines for the preservation of digital heritage*, prepared by the National Library of Australia. Paris: UNESCO [unesdoc.unesco.org/images/0013/001300/130071e.pdf]

UNESCO (2004) *Charter on the preservation of the digital heritage*. Paris: UNESCO [portal.unesco.org/ci/en/file_download.php/4cc126a2692a22c7c7dcc5ef2e2878c7Charter_en.pdf]

University of Leeds. Representation and Rendering Project (2003) Survey and assessment of sources of information on file formats and software documentation [www.jisc.ac.uk/uploaded_documents/FileFormatsreport.pdf]

Upward, F. (2005) The records continuum. In *Archives: recordkeeping in society*, ed. S. McKemmish *et al.*, pp.197–222. Wagga Wagga: Centre for Information Studies

US-InterPARES Project (2002) InterPARES interpreted: a guide to findings on the preservation of authentic electronic records [www.gseis.ucla.edu/us-interpares/pdf/InterPARESInterpreted.pdf]

Usai, P.C. (2000) *Silent cinema: an introduction*. London: British Film Institute

Usai, P.C. (2001) *The death of cinema: history, cultural memory and the digital dark age*. London: British Film Institute

Van Bogart, J. (1995) *Magnetic tape storage and handling: a guide for libraries and archives*. Washington, DC: Commission on Preservation and Access and National Media Laboratory. Also available at www.imation.com/government/nml/pdfs/AP_NMLdoc_magtape_S_H.pdf

Van de Velde, J. (1999) First Families 2001: creating and preserving Australian cultural heritage online. *LASIE*, **30** (2), 5–11

Van der Werf, T. (2002) Our digital heritage: how authentic should it be? Paper presented at *VALA 2002: 11th Biennial Conference and Exhibition*, Melbourne 6–8 February 2002 [www.vala.org.au/vala2002/2002pdf/21VndWrf.pdf]

Van Diessen, R.J. and Van Rijnsoever, B.J. (2002) *Managing media migration in a deposit system*. IBM/KB Long-term Preservation Study Report Series, no. 5. Amsterdam: IBM; The Hague: Koninklijke Bibliotheek [www.kb.nl/hrd/dd/dd_onderzoek/reports/5-mediamigration.pdf]

Van Wijngaarden, H. and Oltmans, E. (2004) Digital preservation and permanent access: the UVC for images [www.kb.nl/hrd/dd/dd_links_en_publicaties/publicaties/uvc-ist.pdf]

Vogt-O'Connor, D. (1999) Is the record of the 20th century at risk? *CRM: Cultural Resource Management*, **22**, 21–24

Vogt-O'Connor, D. (2000) Selection of materials for scanning. In *Handbook for digital projects: a management tool for preservation and access*, ed. M. Sitts. Andover, Mass.: Northeast Document Conservation Center [www.nedcc.org/digital/dighome.htm]

Walton, B. (2003) Accessibility and authenticity in digital records preservation. In *Symposium 2003: Preservation of Electronic Records: New Knowledge and Decision-making, Ottawa, 15–18 September 2003: preprints*

Warner, D. (2002) Why do we need to keep this in print? it's on the Web . . . : a review of electronic archiving issues and problems. *Progressive Librarian*, **19–20** [www.libr.org/PL/19–20_Warner.html]

Waters, D.J. (1996) Archiving digital information. A presentation to the *OCLC Research Library Directors' Conference, Dublin, Ohio, March 12, 1996*

Webb, C. (2000a) The likely impact(s) of digital technology on conservation/preservation in Australia. *AICCM Newsletter*, **75**, 3–5

Webb, C. (2000b) The role of preservation and the library of the future. Paper presented at *CONSAL 2000*, Singapore, 26–28 April 2000 [www.nla.gov.au/nla/staffpaper/cwebb9.html]

Webb, C. (2000c) Towards a preserved national collection of selected Australian Digital publications. *New Review of Academic Librarianship*, **6**, 179–191

Webb, C. (2002) Digital preservation – a many-layered thing: experience at the National Library of Australia. In *The state of digital preservation: an international perspective*, pp.65–77. Washington, D.C.: Council on Library and Information Resources

Webb, C. (2004) The malleability of fire: preserving digital information. In *Managing preservation for libraries and archives: current practice and future developments*, ed. J. Feather, pp.27–52. Aldershot, Hants: Ashgate

Webb, C. and Woodyard, D. (1998) Migration trials: from floppy disk to recordable compact disc (CD-R). *LASIE*, **29** (3), 27–32

Weinberger, E. (1999) Digital objects as manuscripts: how to select material that is born digital for long-term preservation [www.cus.cam.ac.uk/~ew206/d-as-m-article]

Weinberger, E. (2000) Towards collection management guidance. *New Review of Academic Librarianship*, **6**, 65–71

Wheatley, P. (2001) Migration: a CAMiLEON discussion paper. *Ariadne*, **29** [www.ariadne.ac.uk/issue29/camileon/intro.html]

Wiggins, R. (2001) Digital preservation: paradox & promise. *Netconnect*, **Spring**, 12–15. [www.libraryjournal.com/article/CA106209]

Wilson, A. (2003) Why the Dublin Core Metadata Initiative (DCMI) is important. *DigiCULT.Info: A Newsletter on Digital Culture*, **6**, 32–34

Woodyard, D. (1998) Farewell my floppy: a strategy for migration of digital information [www.nla.gov.au/nla/staffpaper/valadw.html]

Woodyard, D. (1999) Practical advice for preserving publications on disk. Paper presented at *Information Online and On Disc*, Sydney, 21 January 1999 [www.nla.gov.au/nla/staffpaper/woodyard2.html]

Woodyard, D. (2000) Digital preservation: the Australian experience. Paper presented at *Positioning the Fountain of Knowledge: 3rd Digital Library Conference*, Kuching 2–4 October 2000 [www.nla.gov.au/nla/staffpaper/dw001004.html]

Woodyard, D. (2001) Data recovery and providing access to digital manuscripts. Paper presented at *Information Online 2001*, Sydney, 16–18 January 2001 [www.nla.gov.au/nla/staffpaper/2001/woodyard3.html]

Woodyard, D. and Webb, C. (1997) Physical format electronic publications in the National Library of Australia: report on a preservation survey [www.nla.gov.au/nla/staffpaper/cwebb6]

Workshop on Research Challenges in Digital Archiving and Long-term Preservation (2003) *It's about time: research challenges in digital archiving and long-term preservation: final report*. Washington, D.C.: National Science Foundation and Library of Congress

Wyatt, A.L. (1990) *Computer professional's dictionary*. Berkeley: Osborne McGraw-Hill

Yorke, S. (1997) Management of petroleum data records in the custody of Australian Archives. *Archives & Manuscripts*, **25** (1), 62–73

Zwaneveld, E.H. (2000) Standards and new technology strategies to preserve content on magnetic and disc media. *SMPTE Journal*, **109**, 628–635

Index